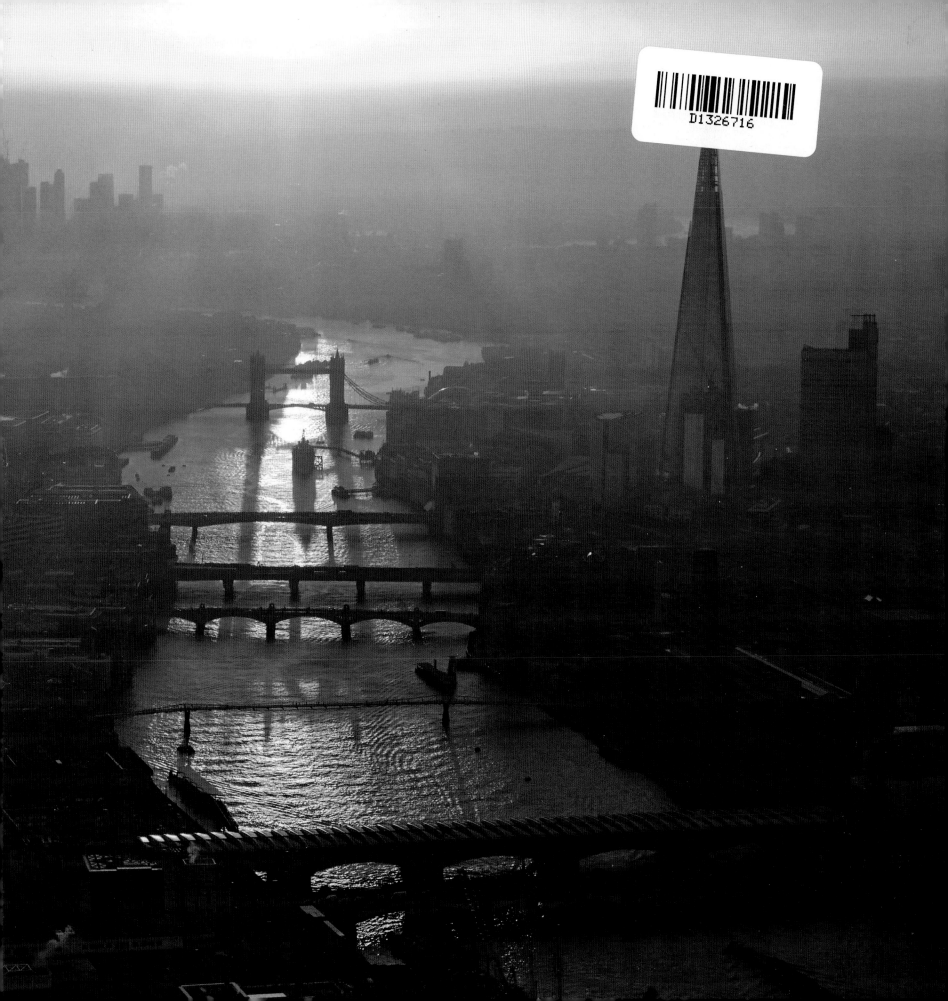

BIRD'S EYE LONDON

Paul Campbell

Bird's Eye London
Published in Great Britain in 2020 by Bird Eye Books, an imprint of Graffeg Limited.

Written and photographed by Paul Campbell copyright © 2020. Designed and produced by Graffeg Limited copyright © 2020.

Graffeg Limited, 24 Stradey Park Business Centre, Mwrwg Road, Llangennech, Llanelli, Carmarthenshire, SA14 8YP, Wales, UK. www.graffeg.com.

A CIP Catalogue record for this book is available from the British Library.

ISBN 9781913134532

1 2 3 4 5 6 7 8 9

Big Ben is the clock and Great Bell of the Elizabeth Tower. It first chimed in July 1859. The intricate fascias of the four clocks are 7m (23ft) in diameter and were designed by Augustus Pugin, with 324 pieces of opal glass held in place by the fascia. Inside, the Great Bell and four quarter bells produce the famous chimes which are the iconic sound of London.

Cover image: **The Hub**, Regent's Park.

BIRD EYE BOOKS

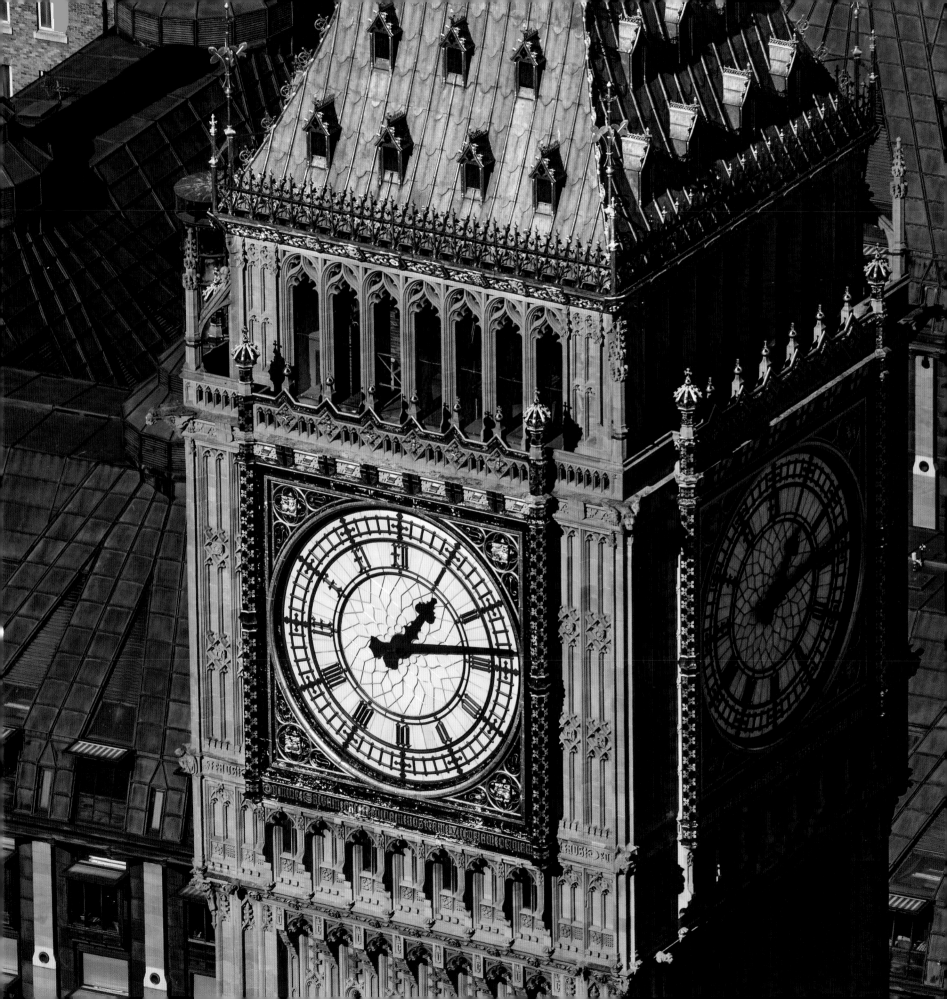

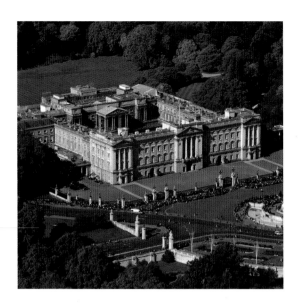

Royal London 6

Buckingham Palace, The Palm House, Hampton Court Palace, Kensington Palace, Royal Chelsea Hospital, The Tower of London.

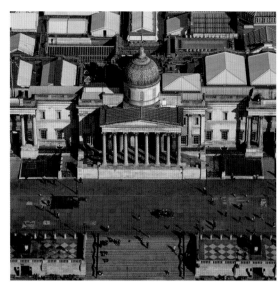

Arts and Culture 54

The National Gallery, The British Museum, The British Library, The Natural History Museum, The Victoria & Albert Museum, Tate Britain, Tate Modern, Senate House, Serpentine Gallery, The BFI IMAX Cinema, The Albert Hall and Albert Memorial.

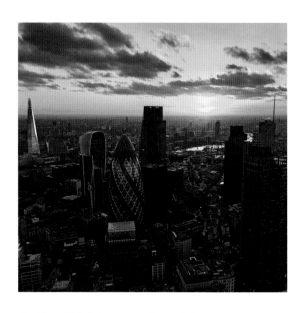

A City Within the City 96

St Paul's Cathedral, The City Hub, Smithfield Meat Market, The Barbican Centre, The Guildhall, Broadgate Circle, Exchange Square, The Bank of England, Scales of Justice, The Monument.

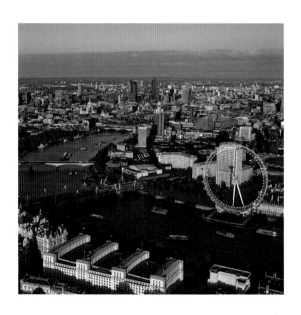

Classic London 22

The London Eye, The National Maritime Museum, The Old Royal Naval College, Greenwich Peninsula, The Cutty Sark, Trafalgar Square, Nelson's Column, Admiralty House and Horse Guards, Admiralty Arch, The Shard, Tower Bridge, Regent Street and Picadilly Circus, Somerset House, Westminster Abbey.

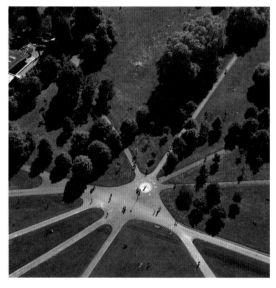

Green Spaces 78

Hyde Park, The Reformers' Tree, The Serpentine, Battersea Park, Regent's Park, The Hub, London Zoo, Tooting Bec Lido.

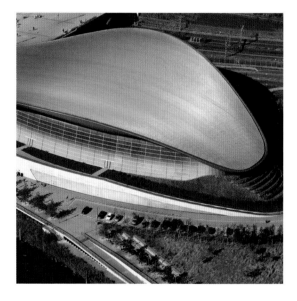

Sporting Excellence 122

The London Aquatics Centre, Wembley Stadium, The London Stadium, The Lee Valley VeloPark, Stamford Bridge, The Emirates Stadium, Wimbledon, The Media Centre (Lord's Cricket Ground), The Oval.

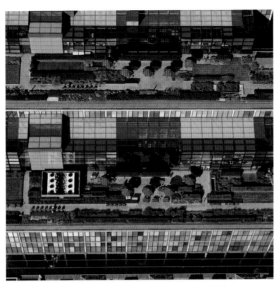

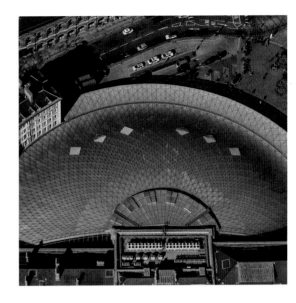

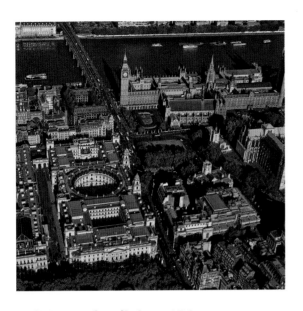

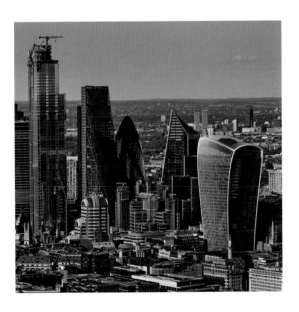

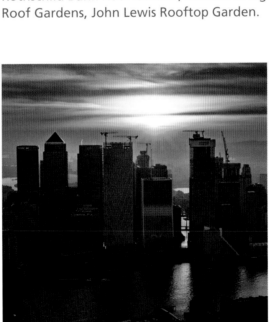

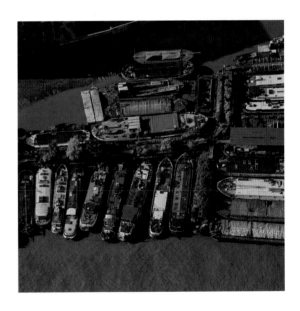

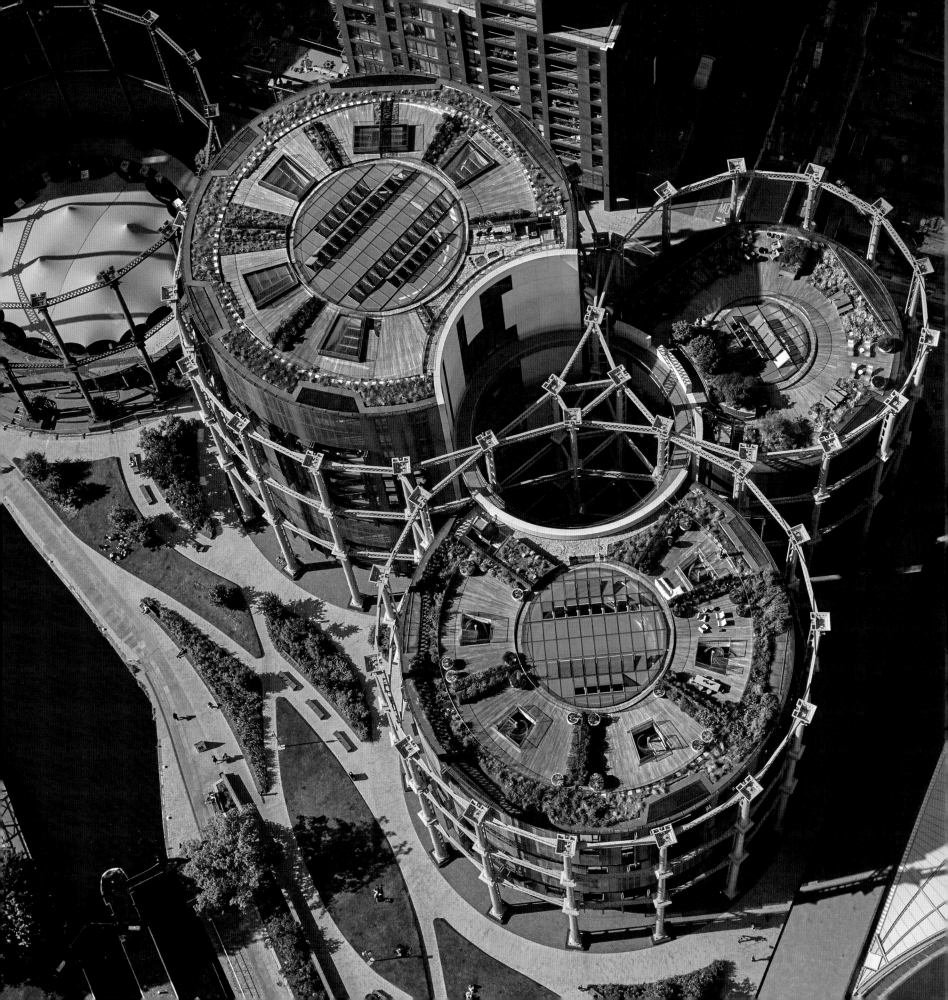

Introduction

Viewed from above, the capital gives up its best-kept secrets. Look down and you will see amazing shapes, designs and landmarks, coming together to form a unique design all of its own. Welcome to my *Bird's Eye London*.

Share with me this journey to a completely new dimension, as all that is familiar from the ground takes on a new persona from the air. For me, the greatest wonder of all is the unique beauty and design to be found on the rooftops of our architectural icons. We can only guess at just what was going through the minds of architects sitting at their drawing boards or screens, designing for an audience of birds in the sky. An architect once said to me their job finishes when the top of the building meets the sky.

As my feet dangled beneath the fuselage, I have been privileged to look down on the streets of London and reflect on the important events of everyday life that were taking place. Births, deaths, marriages, people making love, decisions in Parliament and even crime scenes were all happening as I photographed London from the air.

Bird's Eye London has taken five years of aerial sorties slotted in around other work and weather conditions. All photographs were taken from the rear of a helicopter with the doors wide open to the sky. I tend to shoot in the golden light of early morning or evening, when the sun is low and creates shadows.

For the technically minded

Aerial photography is far from just swanning around the skies of London. Unwelcome bouts of air sickness, further intensified by the toxic fumes of aviation fuel, are a regular hazard. Weather and visibility are crucial and even though weather forecasting is now very sophisticated, it can often let you down!

Last-minute decisions to cancel a flight were sometimes made even when the rotors of the helicopter were already turning. Flights also had to be cancelled for all sorts of security reasons, such as international conferences and meetings, royal events and state visits. Closing the airspace above London is a decision made by Air Traffic Control, who manage the skies above the capital.

My camera platform was a twin-engine helicopter and in most cases a Eurocopter AS355, commonly known as the Twin Squirrel. Most of the flights were made from Stapleford Aerodrome, which on average is about 7-10 minutes flying time into Central London. The cameras were Canon EOS 5D Mark 3 and Canon EOS 5DS bodies with 16-35mm, 24-70mm and 70-200mm Canon lenses coupled with a gyro stabilizer mount.

I am often asked why I didn't use drones, which would have been considerably cheaper. The simple answer is that legally it's not possible to fly a drone above 400ft in London. Putting that into perspective, the London Eye stands at 443ft while The Shard reaches a lofty 1,016ft. There was one exception: a drone was used for the shot of Kew Gardens.

Acknowledgements

This book showcases the enormous creativity of architects old and new: Sir Christopher Wren, polymath and architect, who did more to transform London than any person before or after, Charles Barry, Sir John Hawkshaw, Captain Francis Fowke, Augustus Pugin, Aston Webb, Terry Farrell, Norman Foster, Richard Rogers, Dame Zaha Hadid, Renzo Piano and many others. Their architectural visions have become realities with the assistance of countless craftsmen old and new, structural engineers and construction companies who also deserve enormous recognition for their part in creating the London landscape.

It goes without saying that the expertise of pilots Giles Dumper, Steve Ashcroft, Pete Kersey, Jonathan Penny, Dave Veysey, Tim Walker and the late Eric Swaffer, who skillfully flew me on my numerous *Bird's Eye* flights, there would have been no photography and no book!

Finally, 'with a little help from my friends', in particular John Banks for his enthusiastic research, Lorna Barran's post-production work on the RAW files and the team at Graffeg, my ideas have been turned into this book. Special thanks are also due to Peter Gill, my publisher, and to Joana Rodrigues for her excellent design and patience.

Paul Campbell

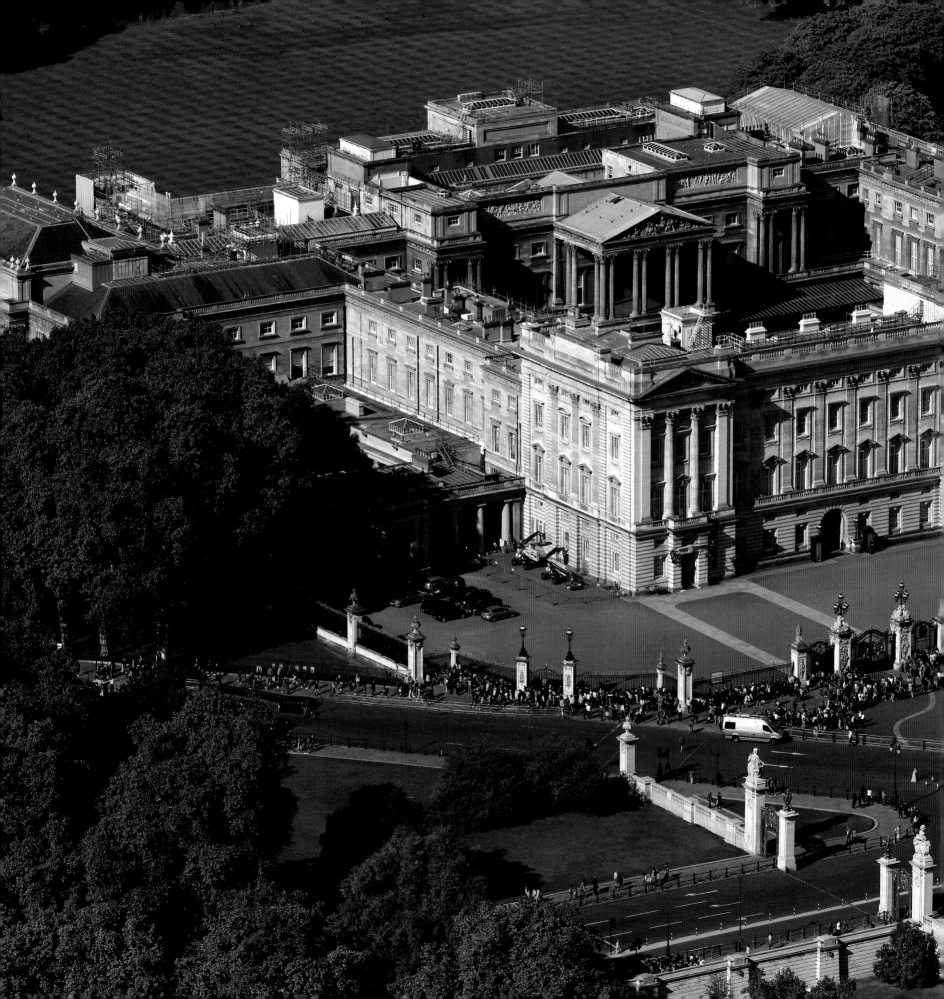

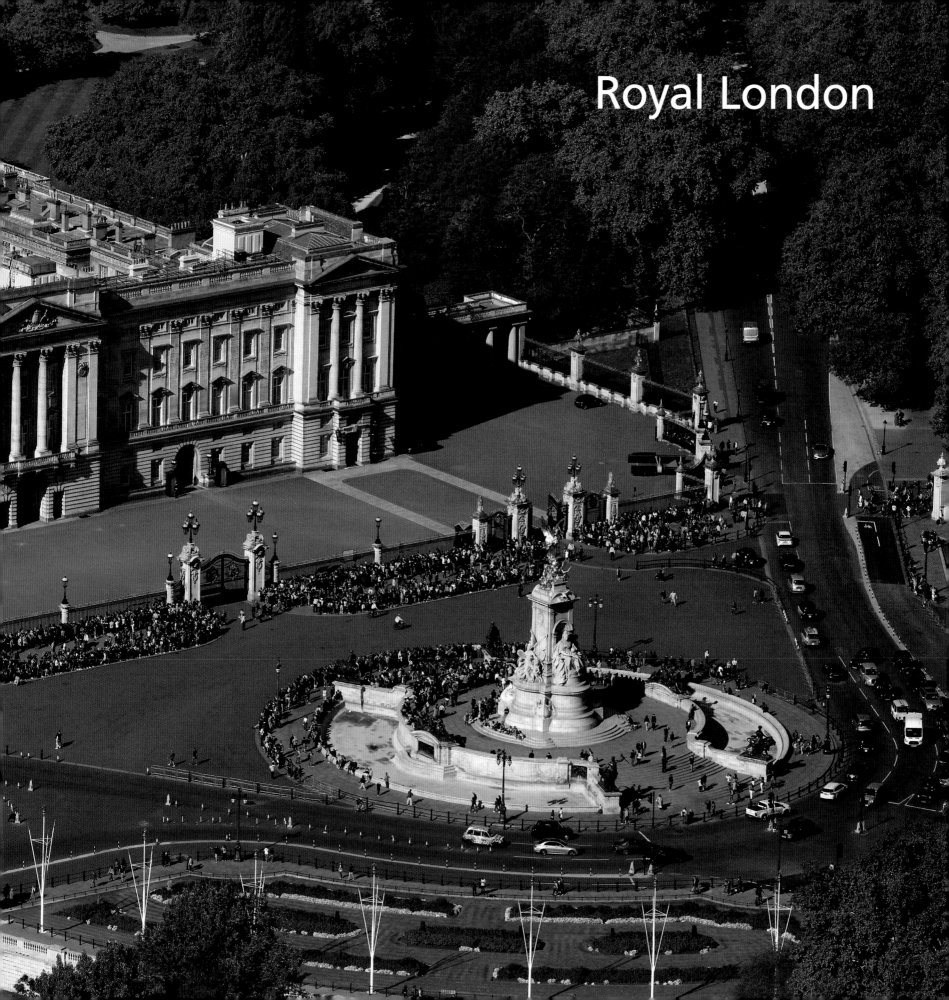

Royal London

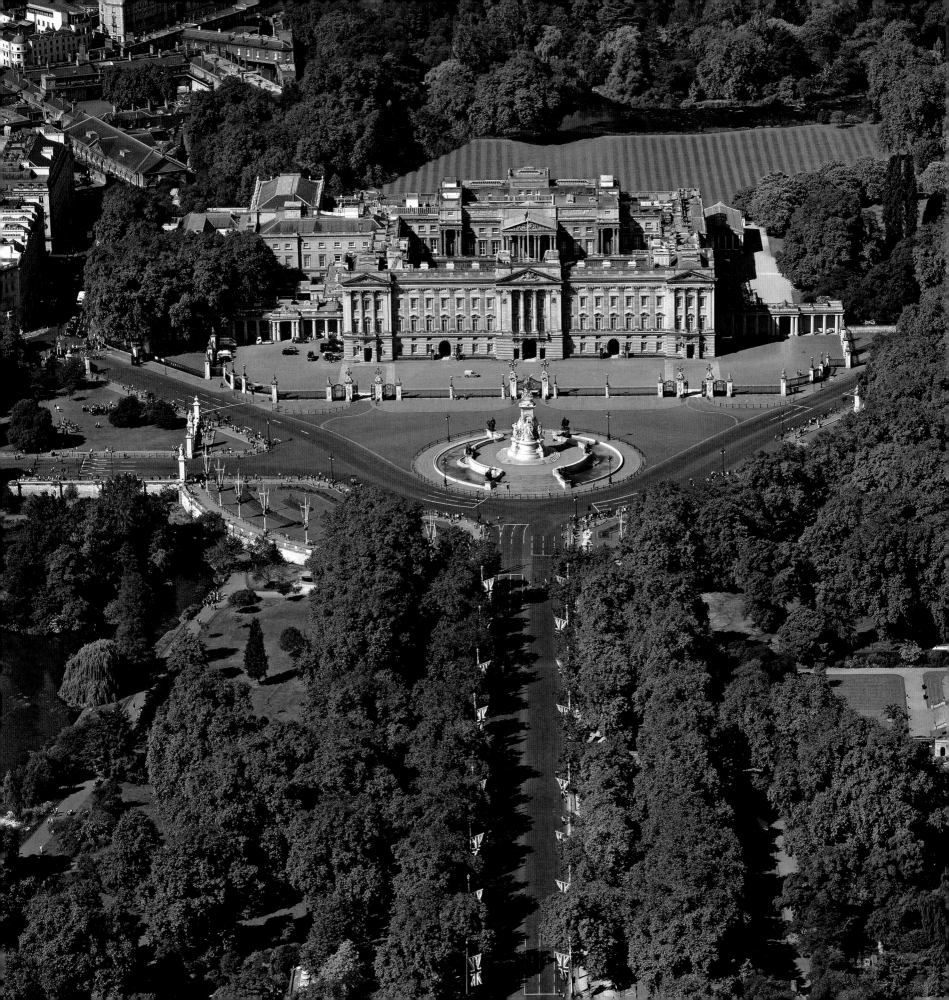

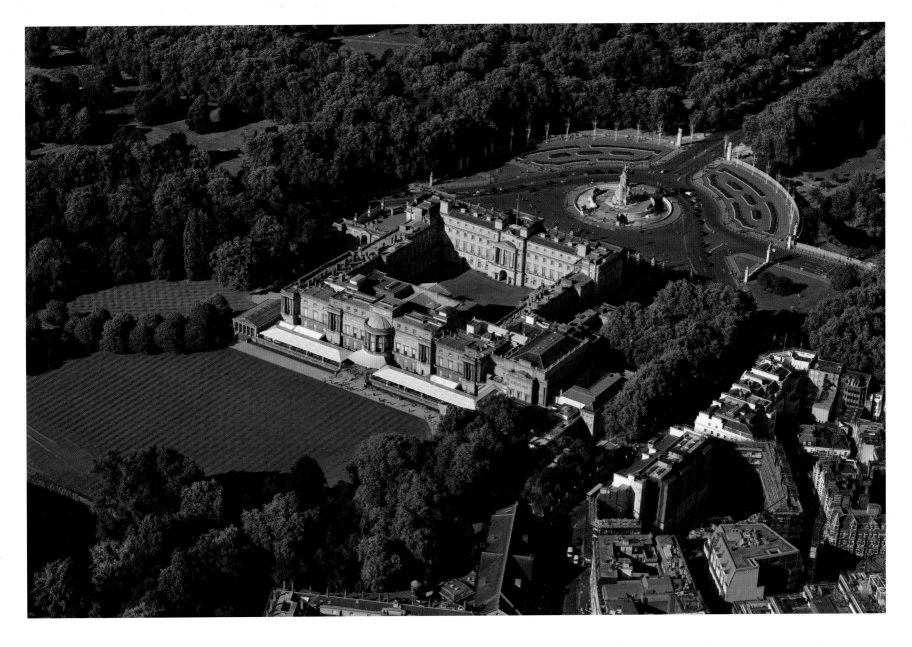

Buckingham Palace

The residence and administrative headquarters of the monarch of the United Kingdom began its life as Buckingham House when built in 1703 as a residence for the Duke of Buckingham. In the 19th century, architects Edward Blore and John Nash added three wings and the central courtyard. On the accession to the throne of Queen Victoria in 1837 it became the official residence of the monarch.

The Palace has 775 rooms and the largest private garden in London. Here, during the summer months, the monarch hosts three garden parties annually for members of the public to recognize the impact they have made in the community and work they have done for charities. The usual 30,000 guests are served 27,000 cups of tea and 20,000 cakes and sandwiches!

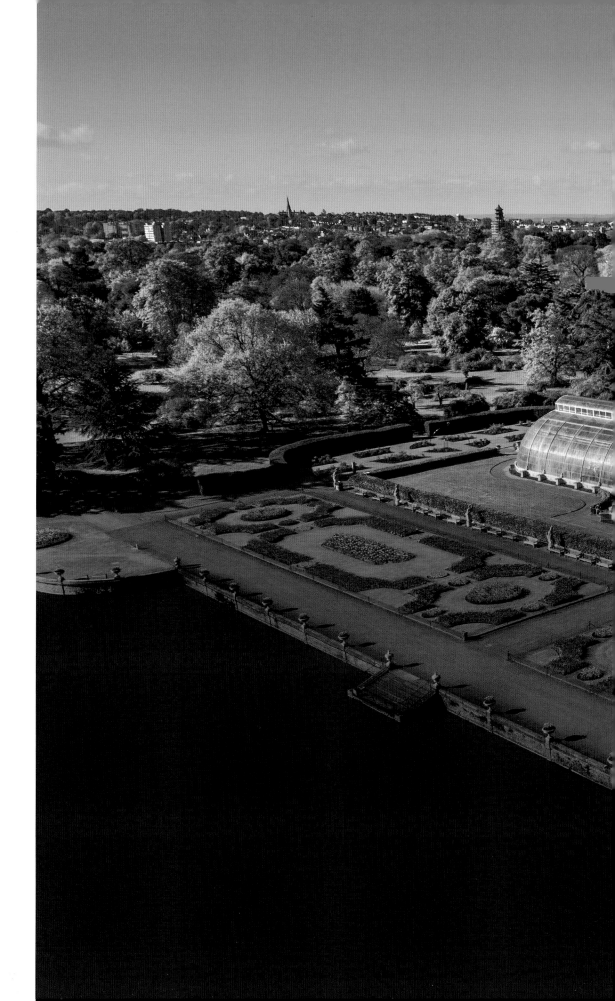

The Palm House, Royal Botanical Gardens, Kew

Built between 1844 and 1848 by the iron worker Richard Turner and designed by architects Decimus and Nicole Burton, the Palm House saw the first use of wrought iron as a major structural component. Kew has 39 other historically important buildings on its 326-acre site and a staff of 723. In 2003 it became a UNESCO World Heritage site and the botanical research it conducts is internationally acclaimed.

Photo © RBG Kew.

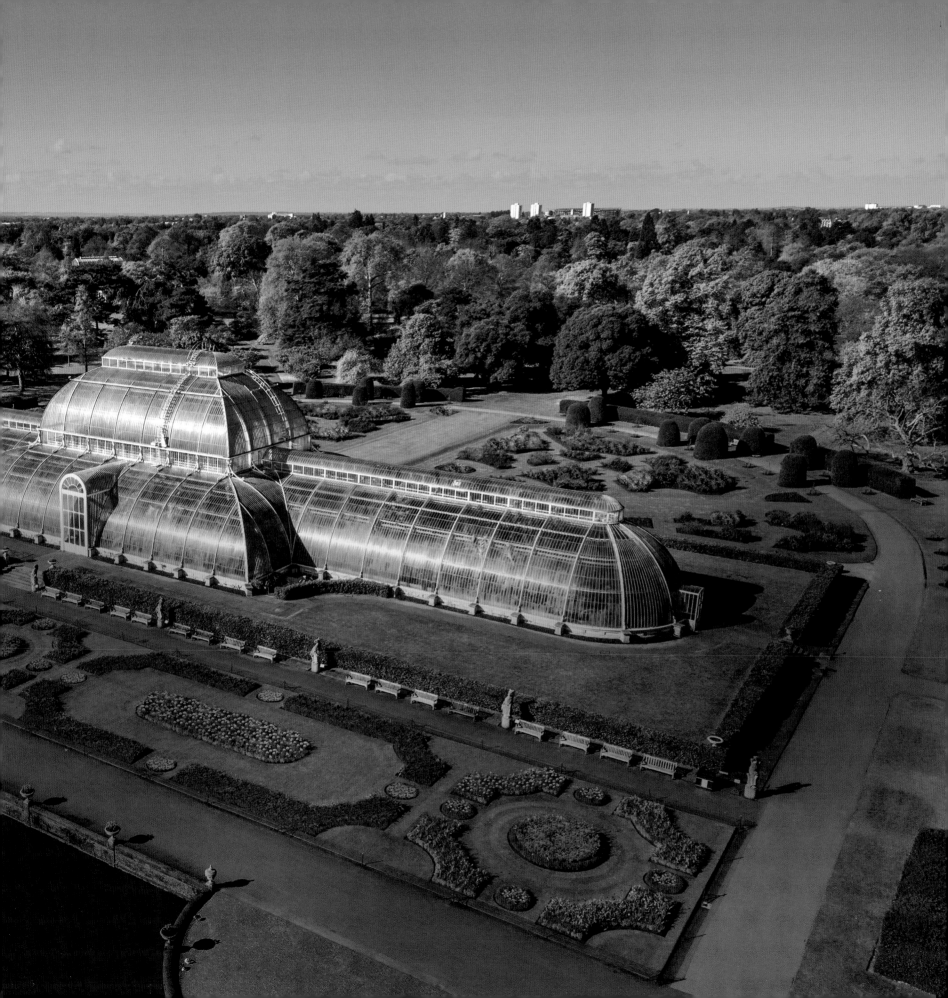

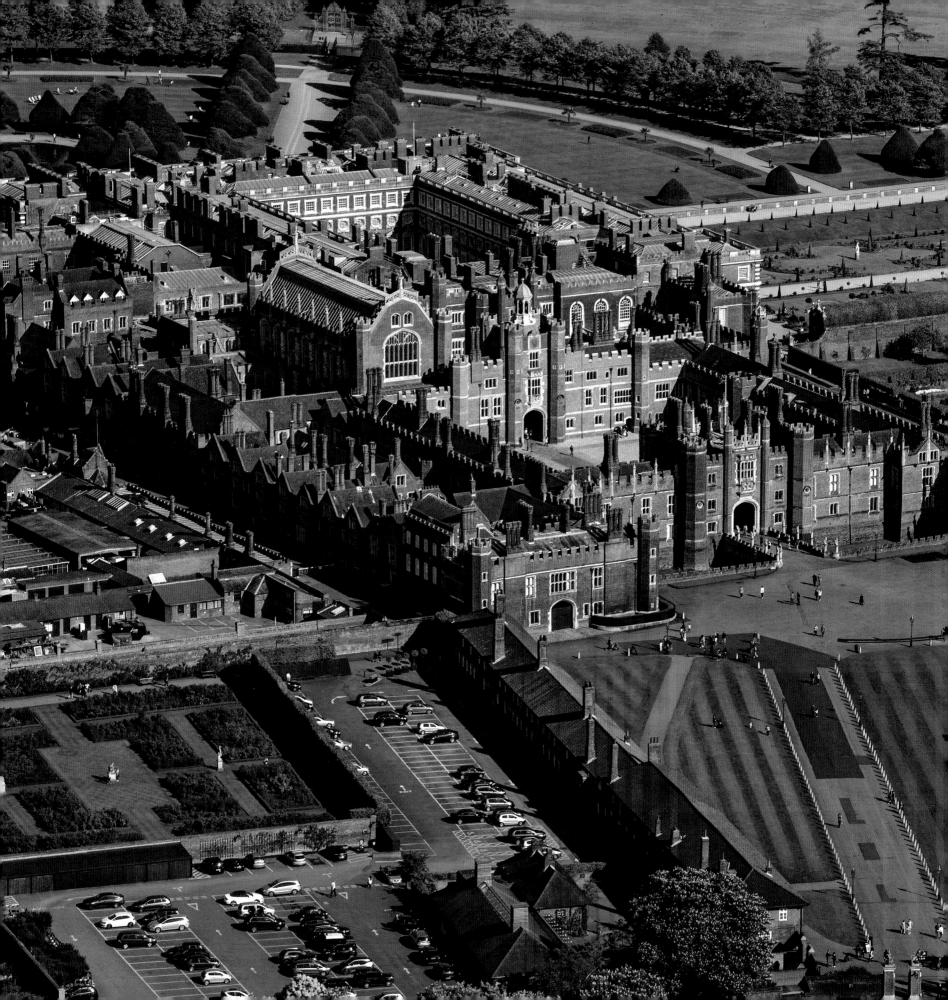

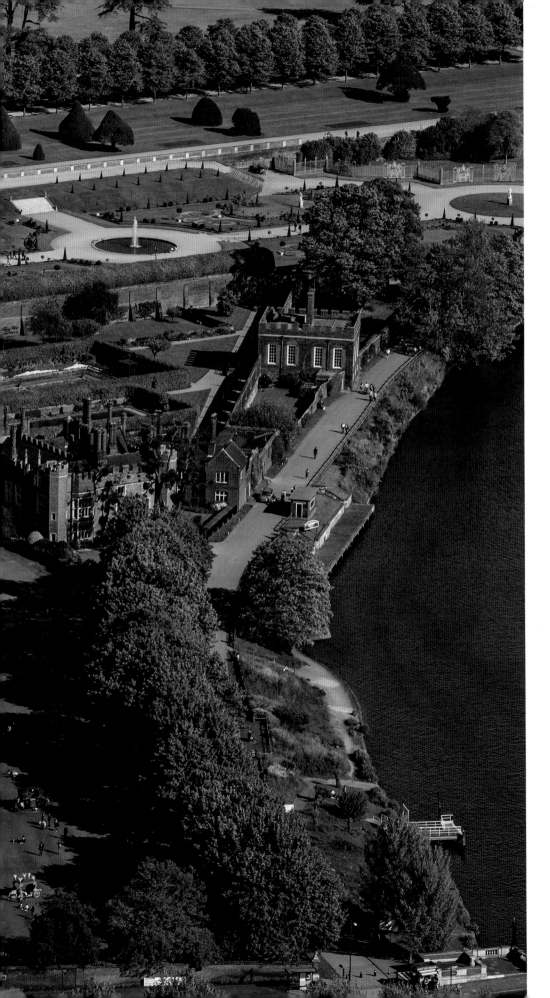

Hampton Court Palace

Overlooking the River Thames in the borough of Richmond upon Thames, Hampton Court Palace was built in 1515 by Henry VIII for Cardinal Thomas Wolsey, Lord Chancellor and the King's chief advisor. In 1529 the Cardinal fell from favour and the palace was appropriated by the King as a consequence. In the following century King William III and architect Sir Christopher Wren oversaw a massive rebuild in two distinct architectural styles, Tudor and Baroque, with the intention of rivalling the Palace of Versailles.

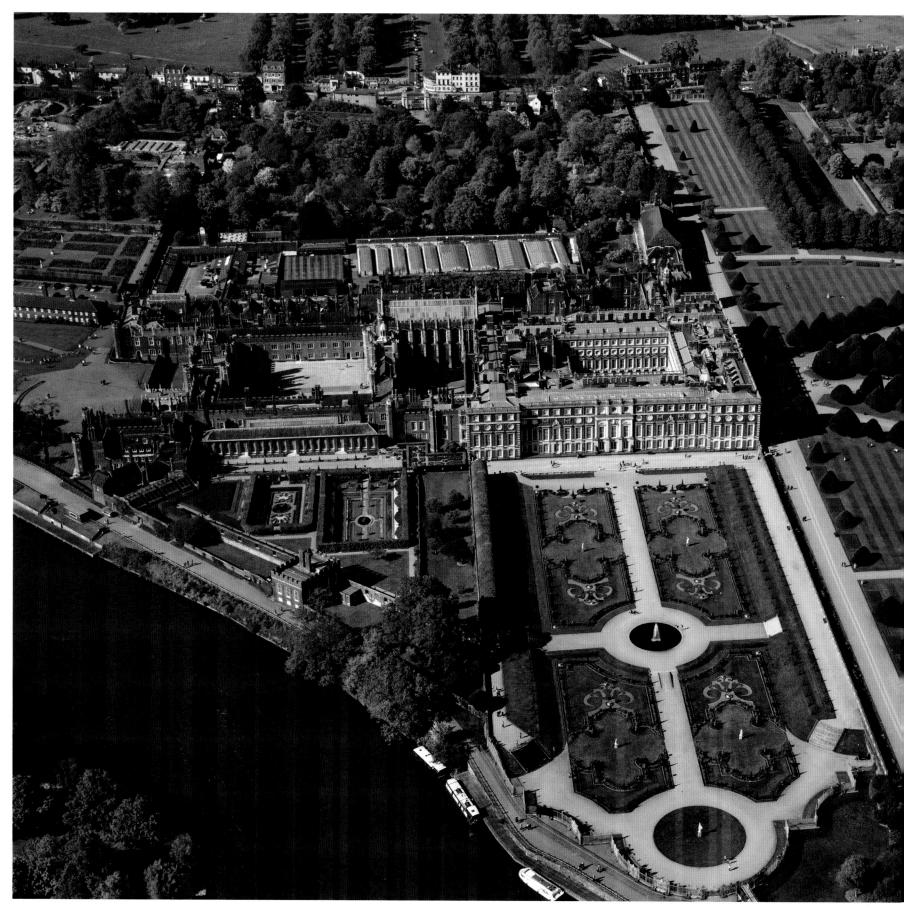

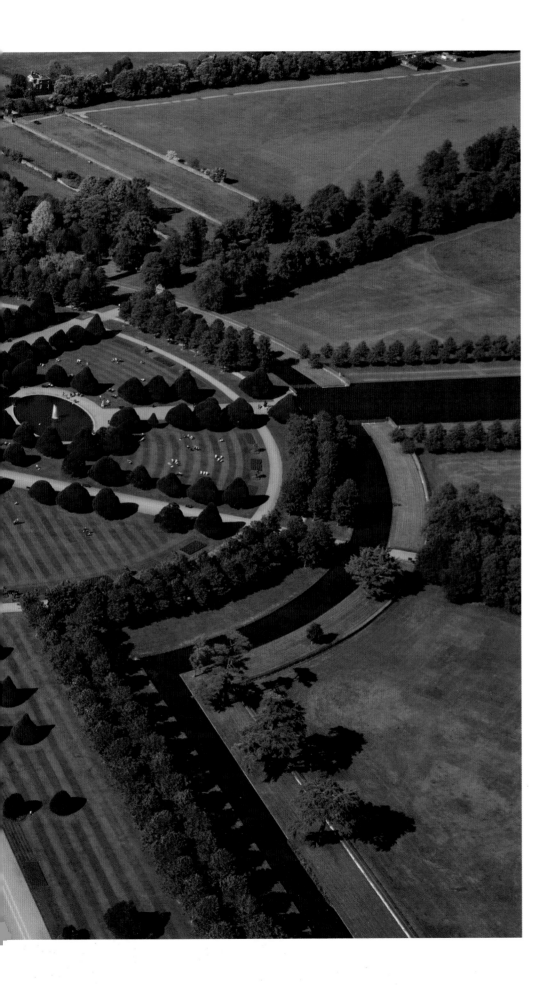

Hampton Court Palace Gardens are laid out in the grand style of the 17th century and are again an echo of Versailles. First opened to the public by Queen Victoria in 1838, highlights here include a 250-year-old vine tree, the oldest in the world. Jean Tijou, the French Huguenot ironworker, created the garden's magnificent wrought iron gates and many of the railings and screens between 1689 and 1700. In 1992 William III's private garden was replanted with topiary hollies and yews.

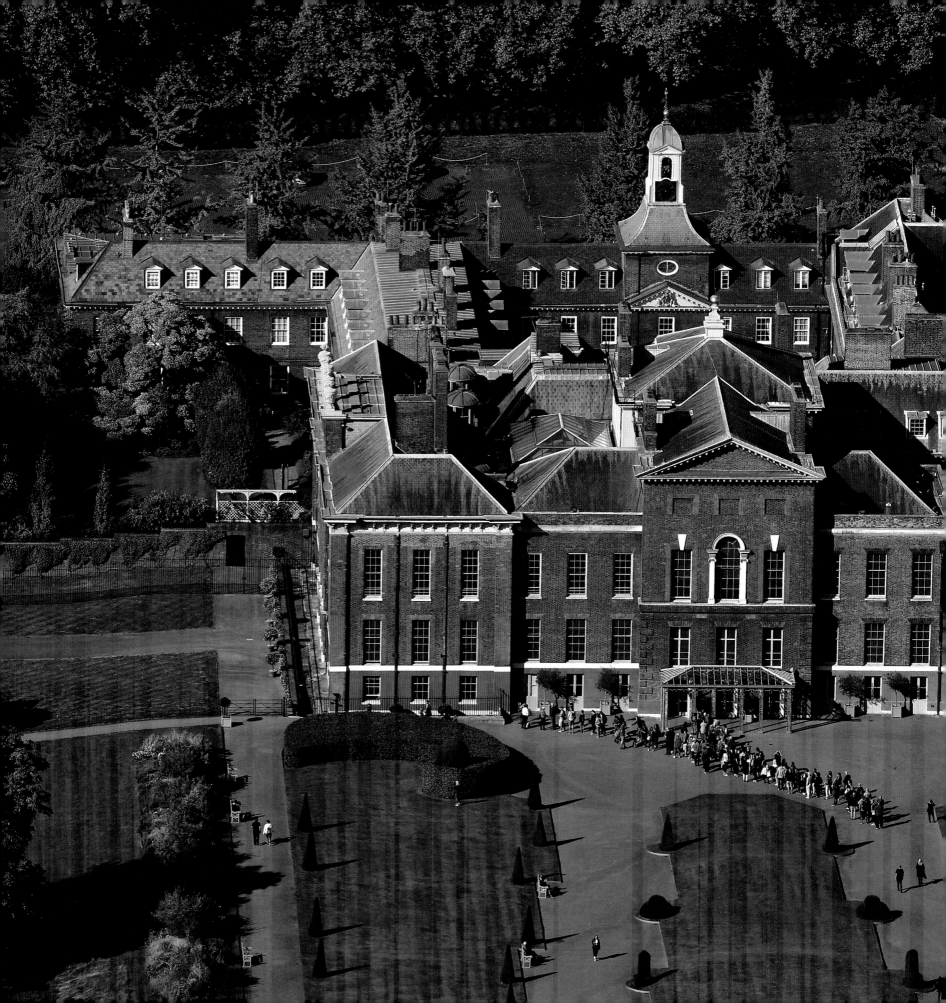

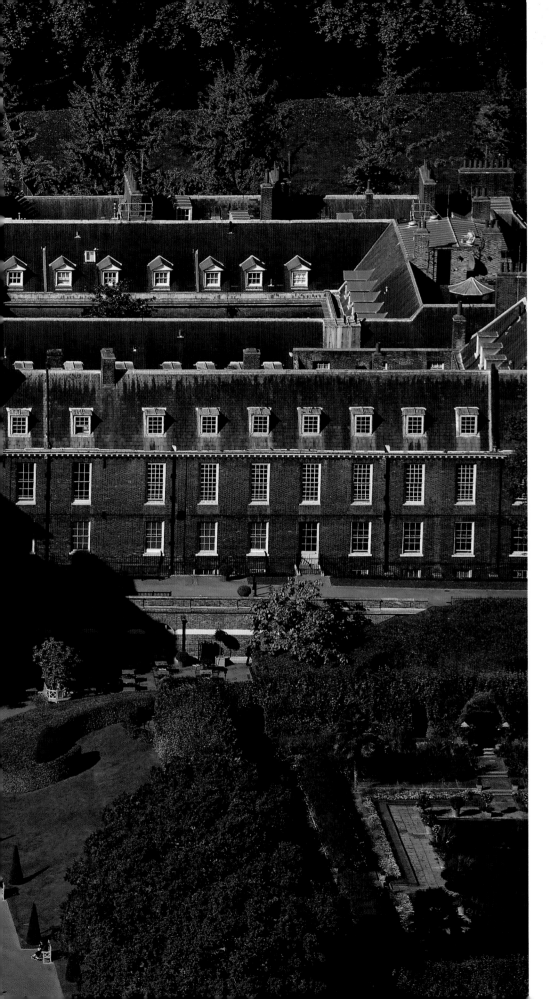

Kensington Palace, a royal residence in Kensington Gardens, is currently the home of the Duke and Duchess of Cambridge, Princess Eugenie, the Duke and Duchess of Gloucester, the Duke and Duchess of Kent and the Prince and Princess Michael of Kent. Originally a two-storey Jacobean mansion built by Sir George Coppin in 1605, the royal court of William and Mary first took residence in 1689.

Royal Chelsea Hospital, Chelsea, is a hospital and retirement home for some 300 veterans of the British Army, affectionately known as 'The Chelsea Pensioners'. King Charles II founded the hospital in 1682 and the chapel and Great Hall were designed by Sir Christopher Wren between 1687 and 1690. The elegant Figure Court lies at the heart of Wren's original design. Bordered by the State Apartments, the Chapel and the Great Hall, the courtyard's centre piece is Grinling Gibbons' gilded statue of Charles II which was presented to the King in 1682. The gardens are Grade II listed and annually host the Royal Horticultural Society's Chelsea Flower Show.

The Tower of London (pages 20-21), officially the monarch's royal palace and fortress, is situated in central London on the north bank of the River Thames. The original outer fortress dates back to the end of 1066 and the Norman Conquest, with William the Conqueror adding the infamous White Tower, noted for its beheadings, in 1078. The 16th and 17th centuries saw the castle used as a prison and celebrity inmates incarcerated there included Elizabeth I and Sir Walter Raleigh. Today it houses both the Crown Jewels and the Royal Mint. During your visit to the Tower you will be guided by a Yeoman Warder, popularly known as a Beefeater. There are 37 of them, men and women who are all ex-warrant officers with at least 22 years of military service.

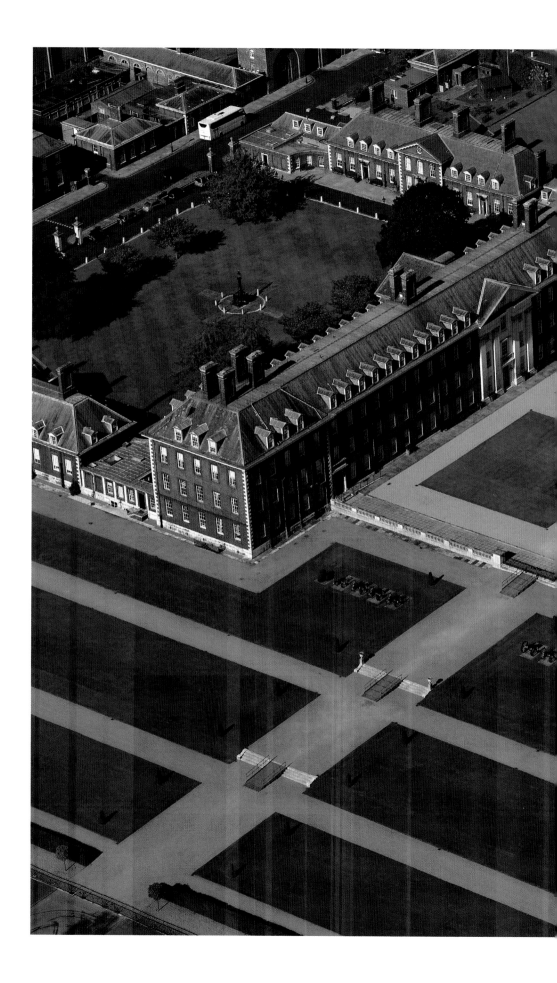

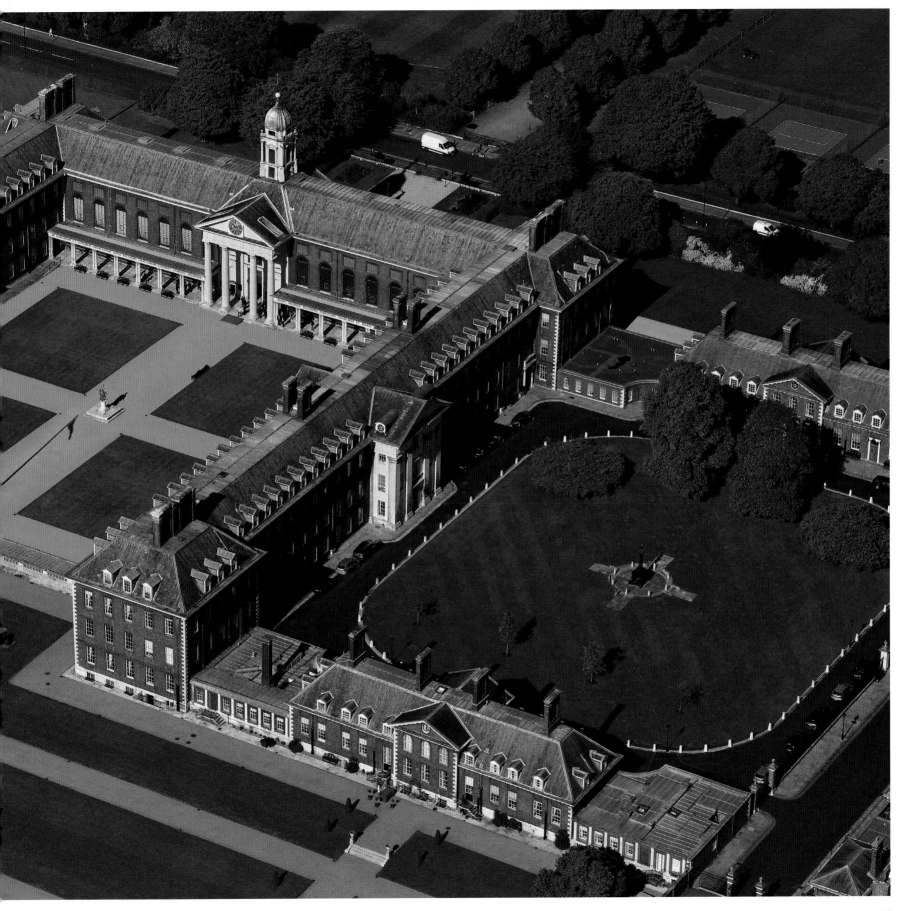

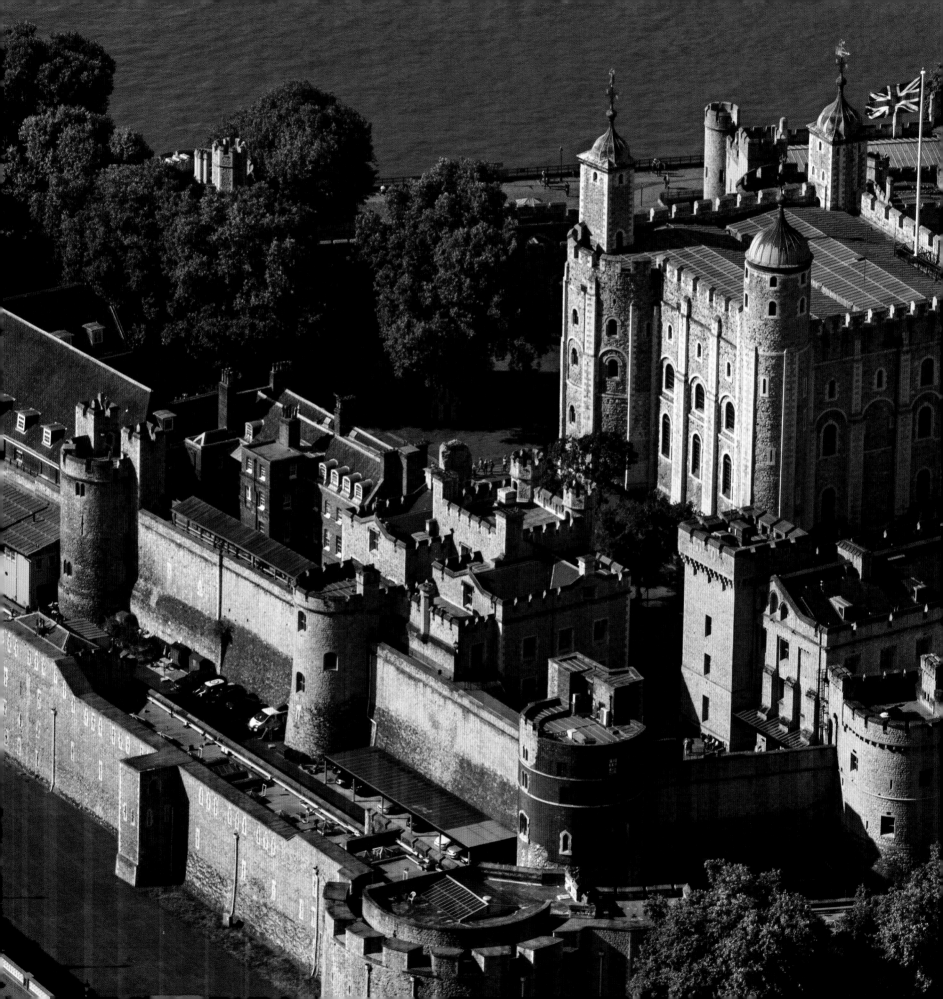

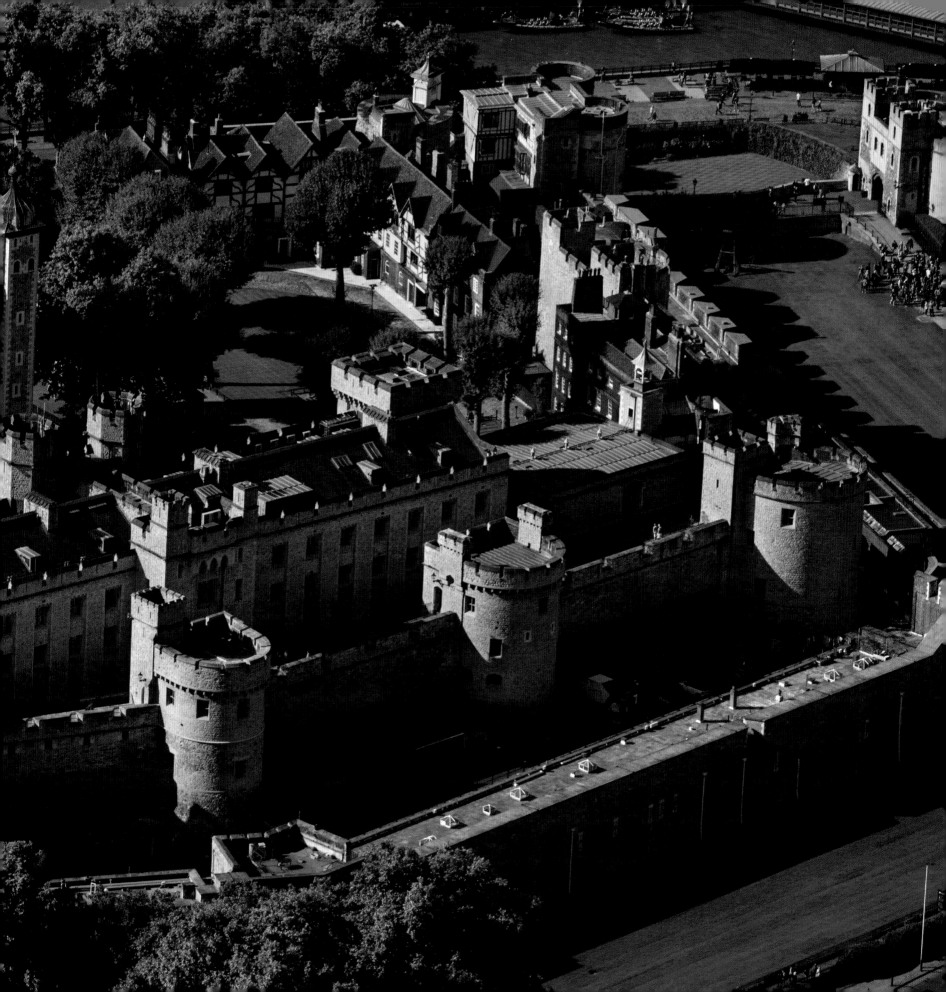

Classic London

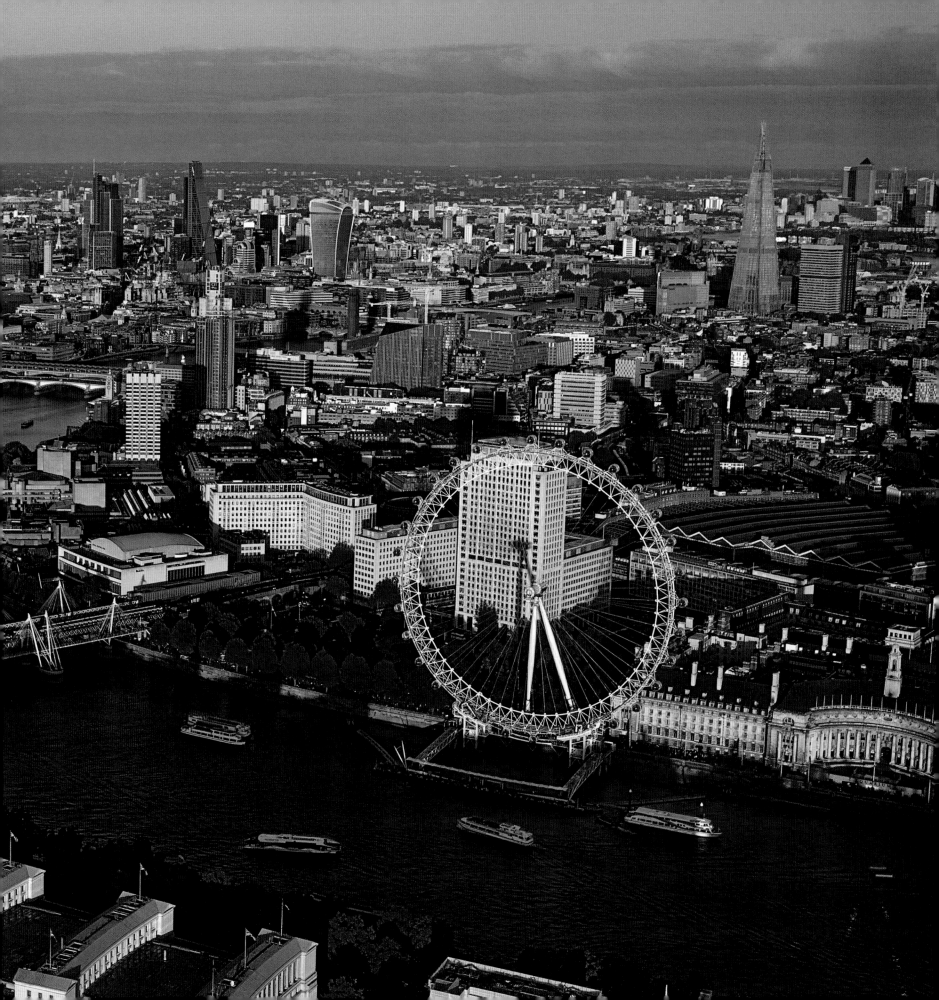

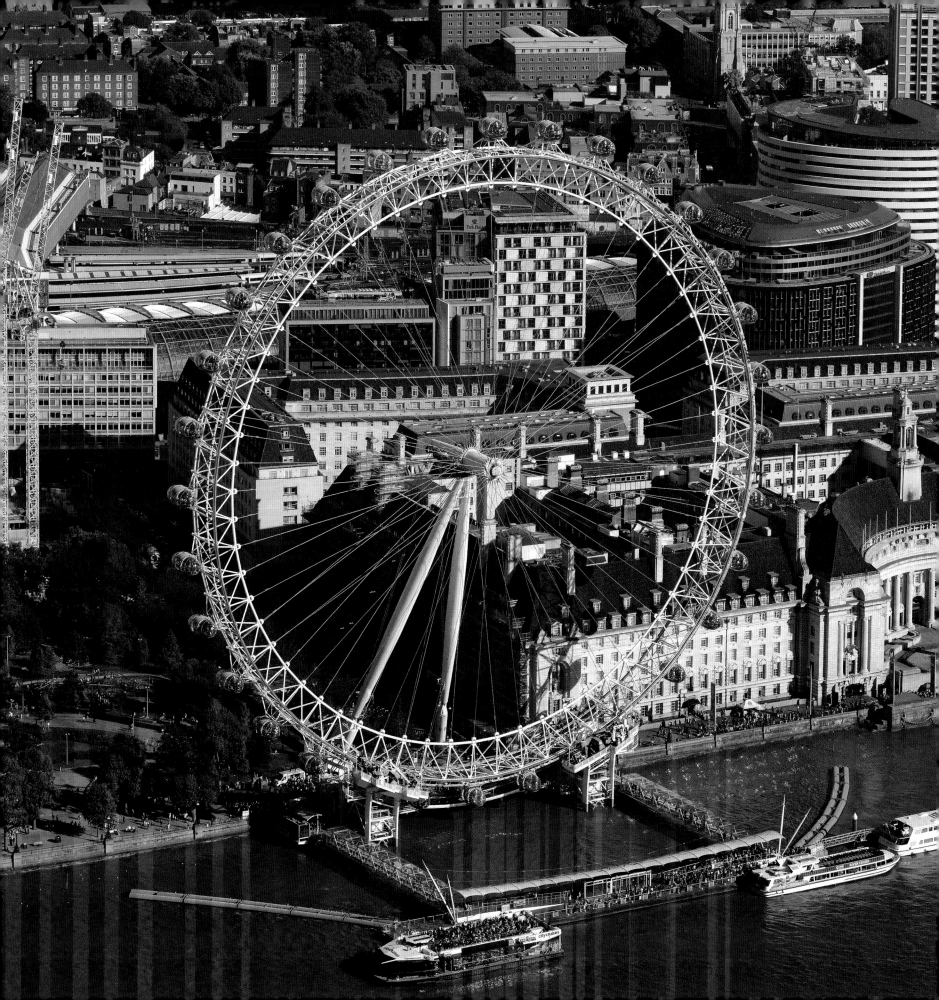

The London Eye

Arguably the most successful tourist attraction in the United Kingdom, the Eye is a giant Ferris wheel said to have done for London what the Eiffel Tower did for Paris. It is 135m (443ft) high and was designed by the husband and wife team of Julia Barfield and David Marks.

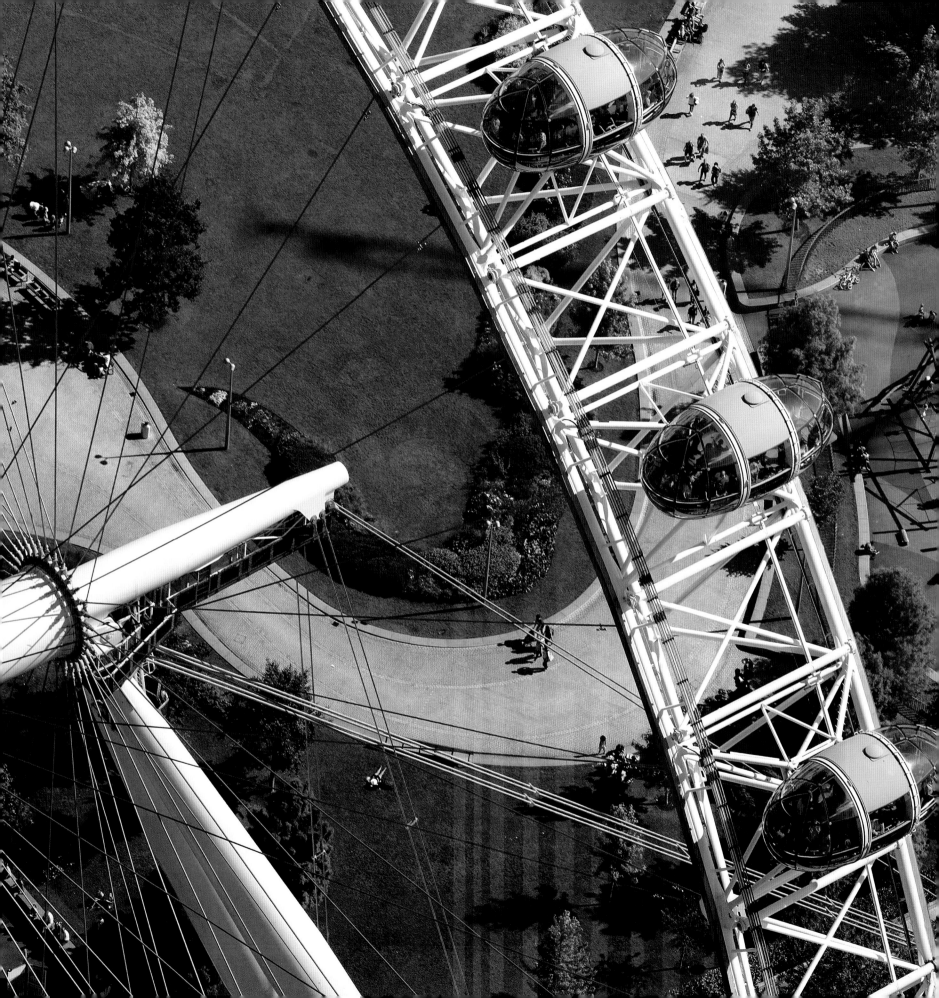

The London Eye, Jubilee Gardens, Southbank, Europe's largest cantilevered wheel, has 32 observation capsules, each one representing the 32 boroughs of Greater London. The wheel has been successfully turning since its opening in March 2000 and annually attracts 3.75 million visitors.

The National Maritime Museum and Old Royal Naval College (pages 28-29), Greenwich, with its magnificent backdrop of Canary Wharf and the Greenwich Peninsula.

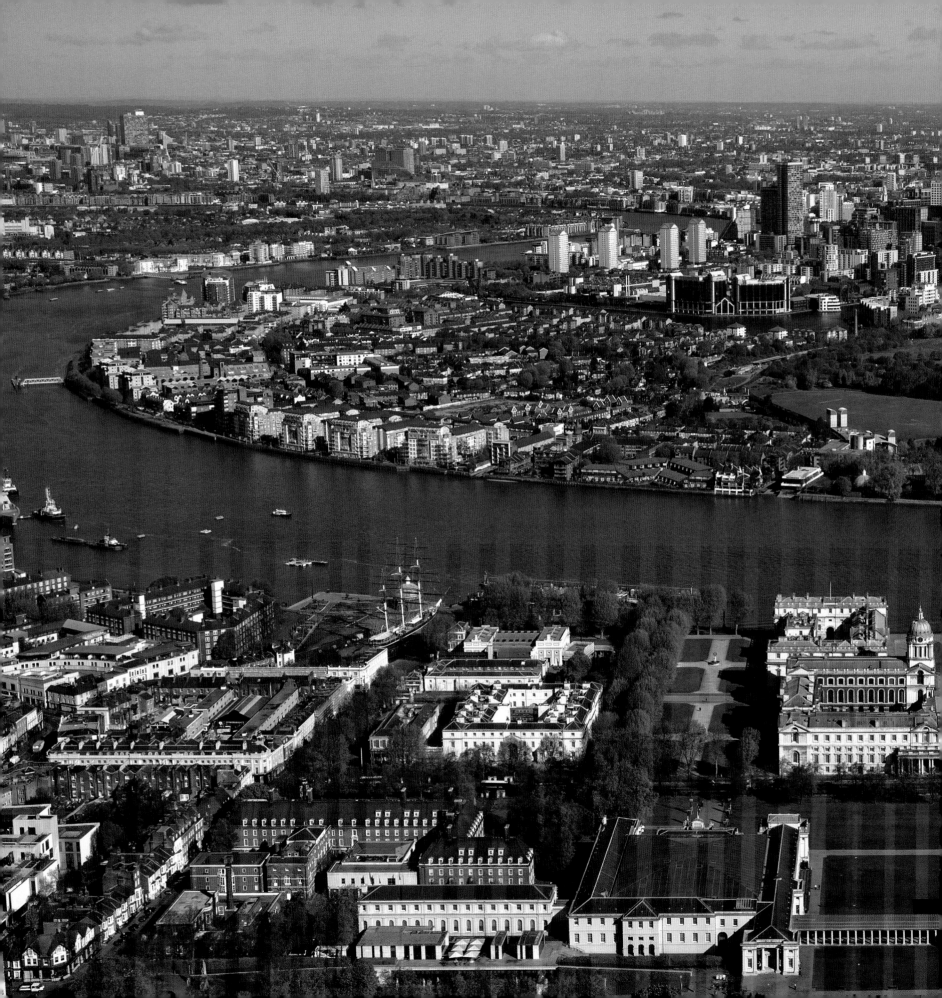

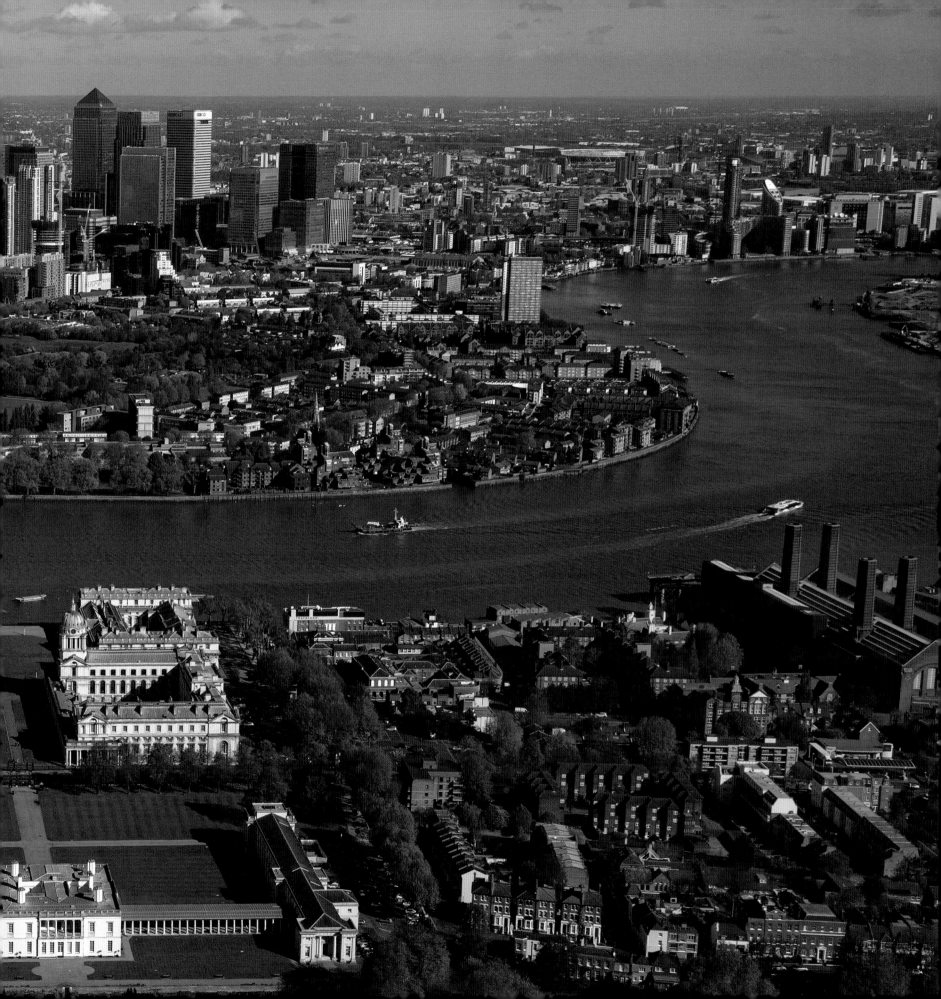

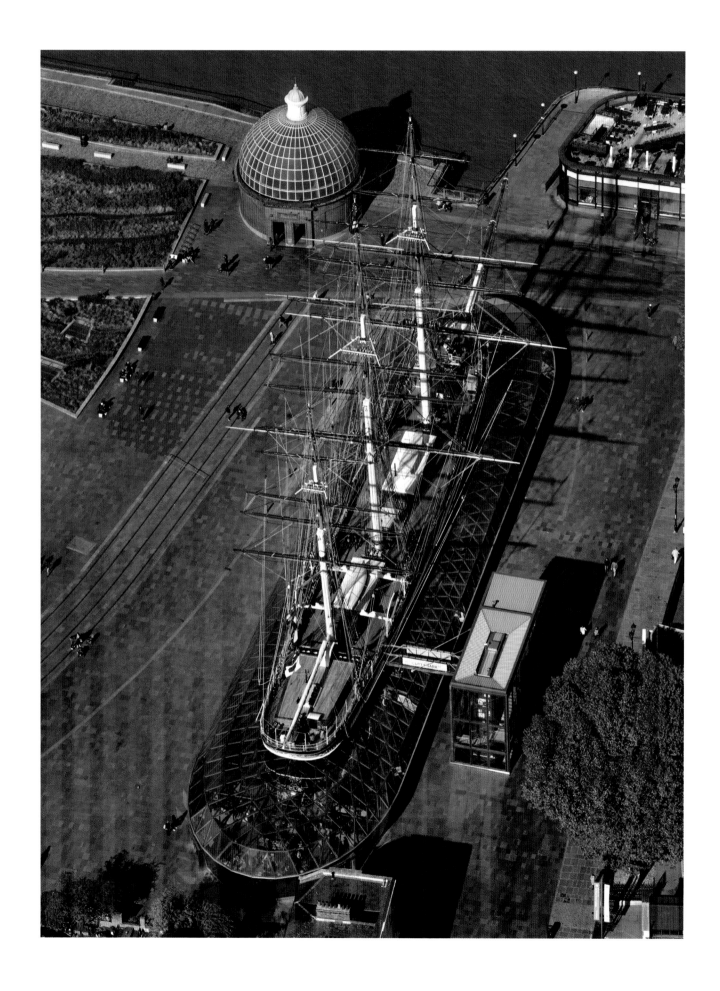

The **Cutty Sark** (left) is a tea clipper ship built in 1869 on the River Clyde, Scotland, and is now an exhibit in the National Maritime Museum. It is one of only three remaining clipper ships built with a wooden hull on a steel frame. Top left of the shot is the glazed dome entrance to the Greenwich Foot Tunnel. The cast iron tunnel is 370m (1214ft) long, runs under the Thames linking Greenwich to Millwall and is used daily by thousands of cyclists and pedestrians.

The Old Royal Naval College has several buildings designed by Sir Christopher Wren which were completed between 1696 and 1712. It was intended to serve as a hospital for seamen but this was short lived and it closed in 1869, eventually becoming a naval training establishment in 1873. Its classic buildings are a firm favourite with the makers of movie and TV period dramas.

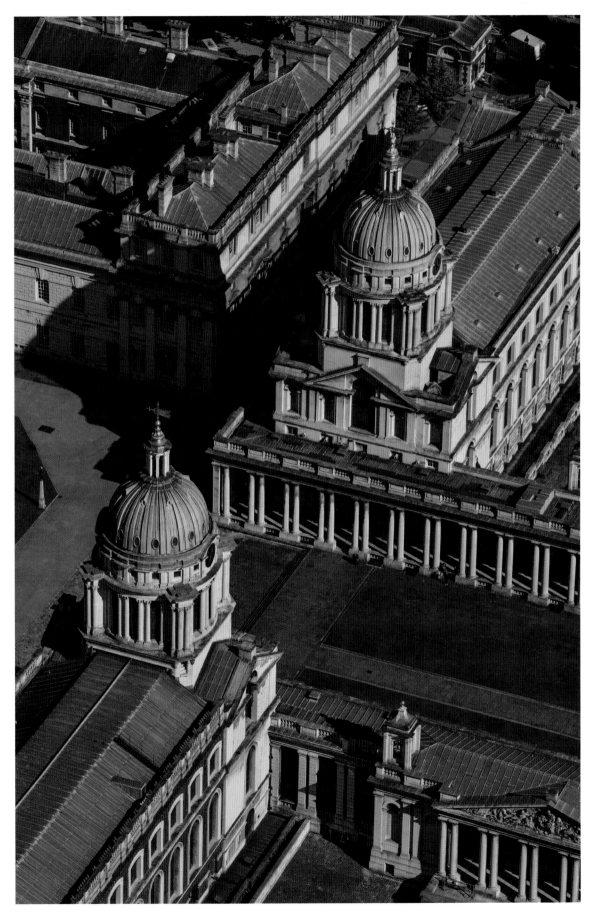

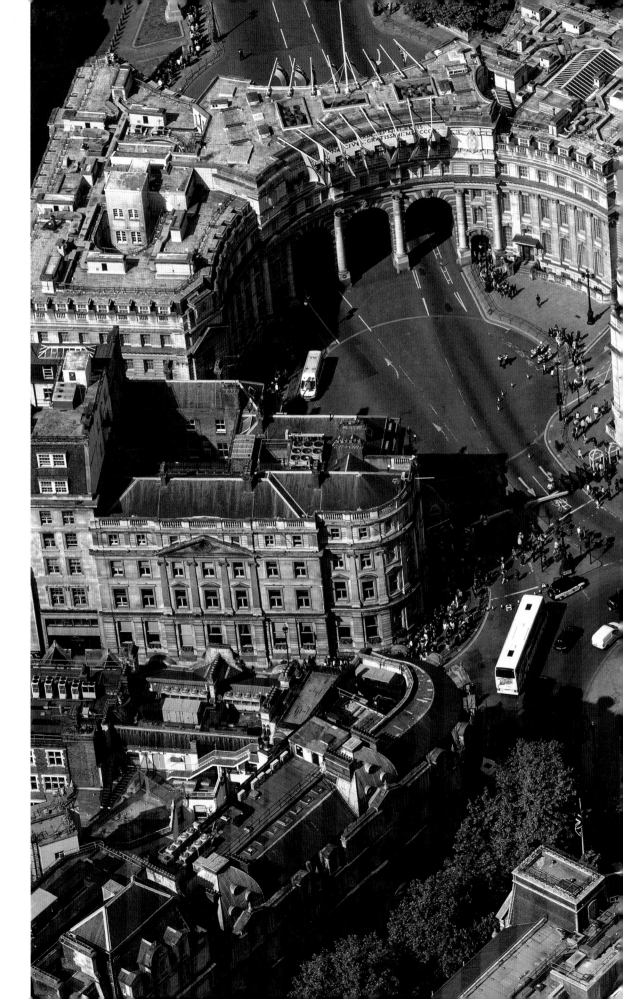

Trafalgar Square and Nelson's Column

One of London's tourist hubs and the central point for protest marches and rallies. The column, at just over 51.6m (169ft), commemorates the life of Admiral Nelson and his victory at the Battle of Trafalgar. The column is constructed of blocks of granite from Dartmoor, built between 1840-1843 and designed by William Railton, costing £47,000. Sir Edwin Landseer's four bronze lions at the base were added later, in 1867.

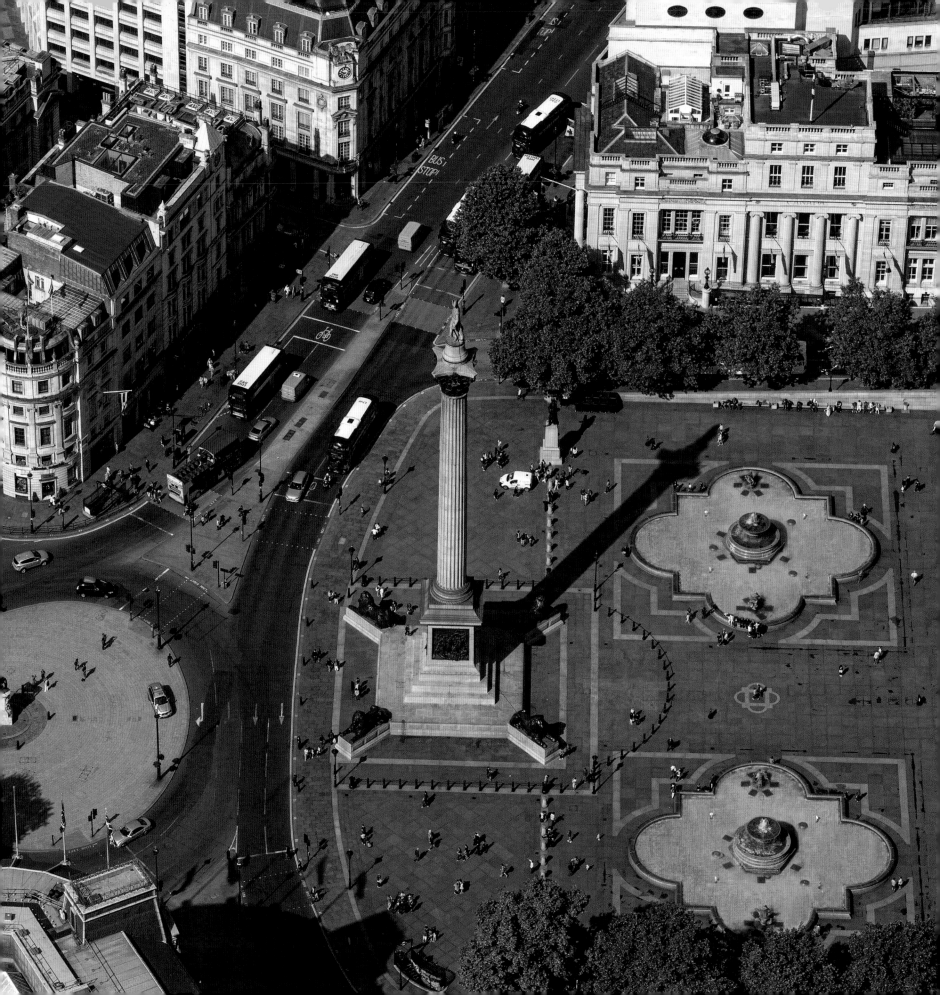

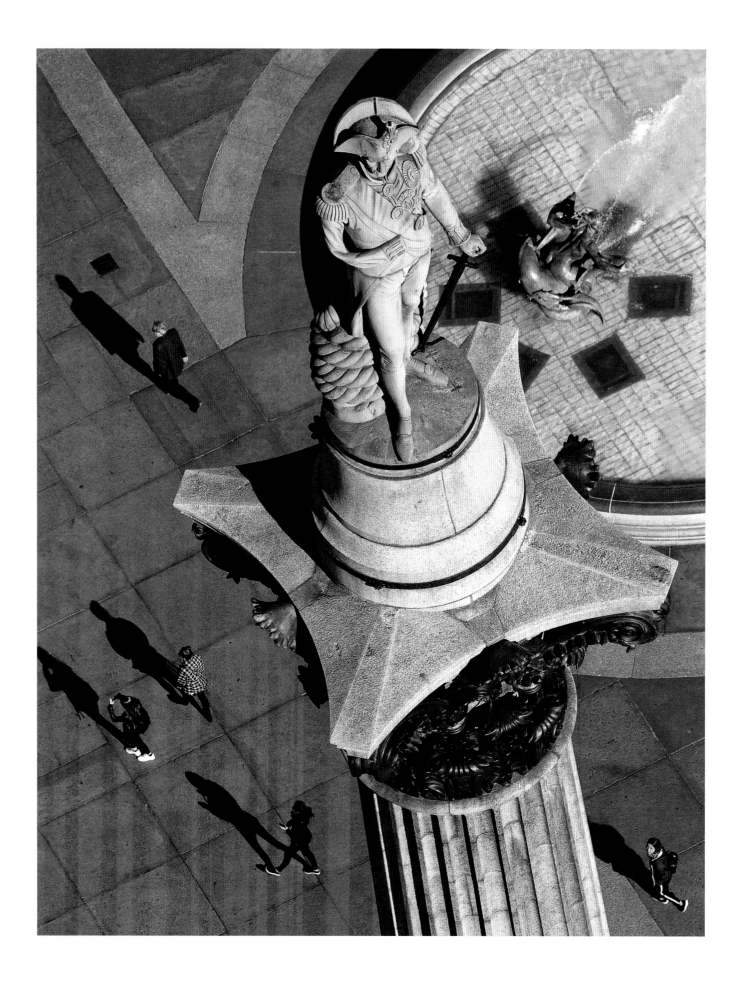

Admiral Horatio Nelson (1758–1805) stands proudly but precariously on top of his column. He was known for his grasp of strategy, inspirational leadership, and his famous signal, 'England expects that every man will do his duty'. He died in 1805 at the age of 47 during his final victory at the Battle of Trafalgar, near Cadiz, off the Spanish coastline.

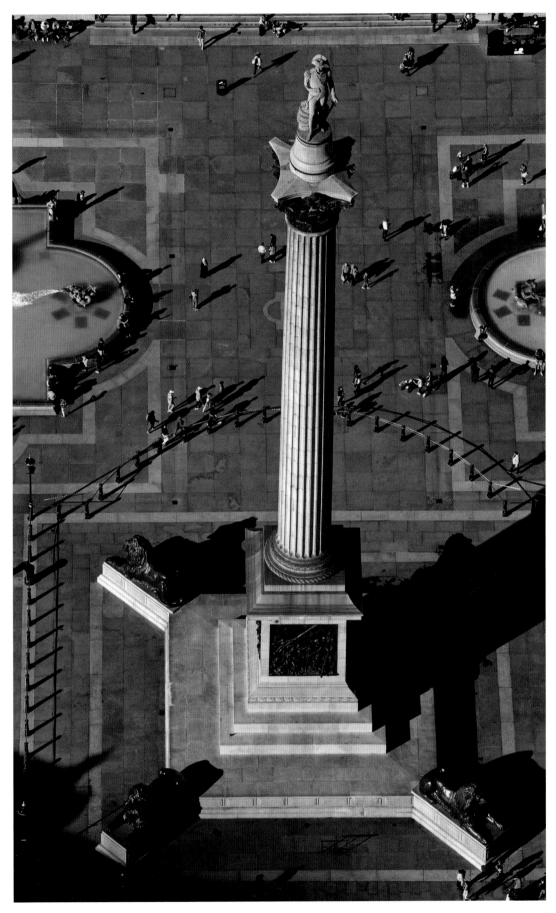

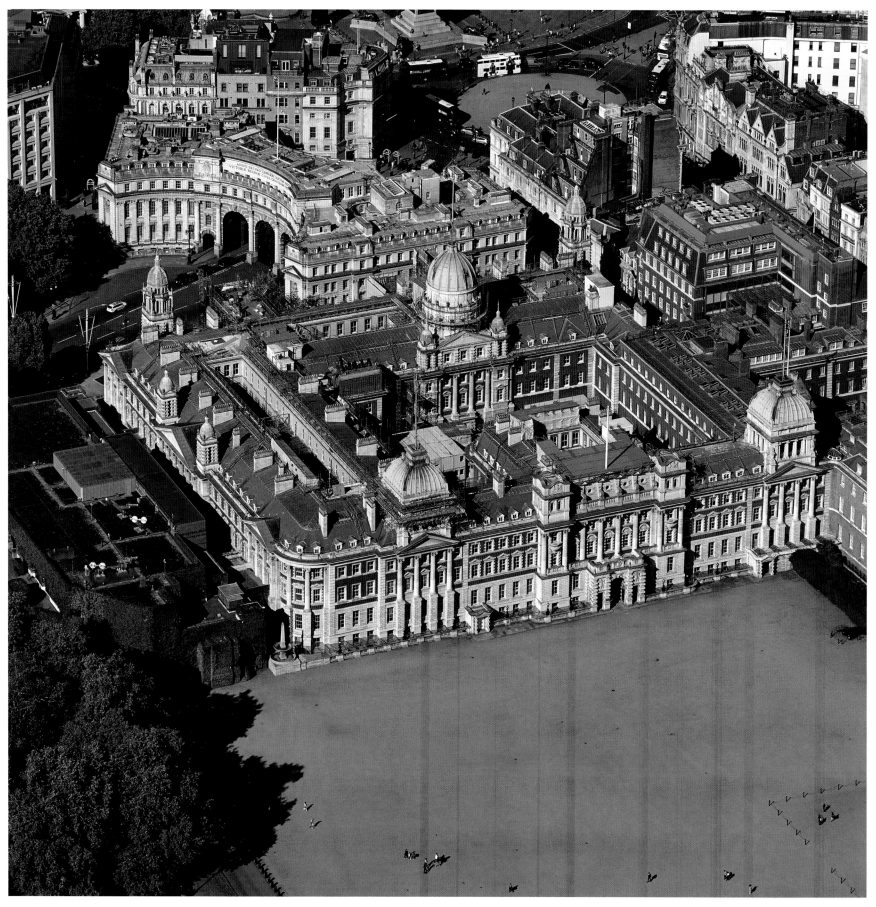

Horse Guards Parade and Admiralty House (left).
Until 1964 this Grade I listed building was the official residence of the First Lord of the Admiralty. It was designed by Samuel Pepys Cockerell and opened in 1788. Today it has ministerial flats and is used for government functions. It has a magnificent view of Horse Guards Parade which is at its front door and is the location for the annual ceremony of Trooping the Colour.

Admiralty Arch (right).
The ceremonial entrance to The Mall from Trafalgar Square plays an important part in state occasions and the central arch is reserved for use by royalty only. King Edward VII commissioned its building in memory of his mother, Queen Victoria, and Aston Webb's design was completed in 1912. The top of the building is to become the Admiralty Arch Hotel and guests will have an unrivalled view of The Mall and Buckingham Palace.

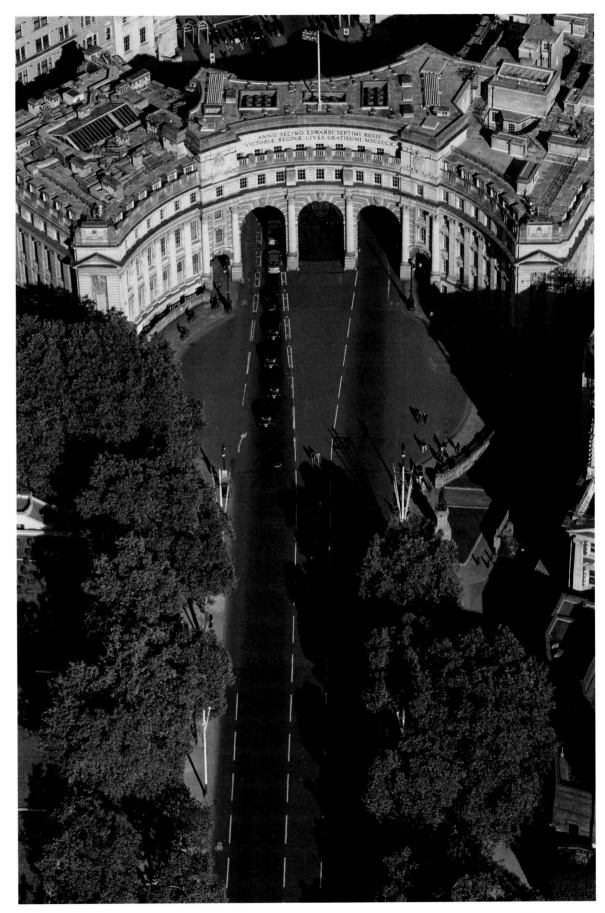

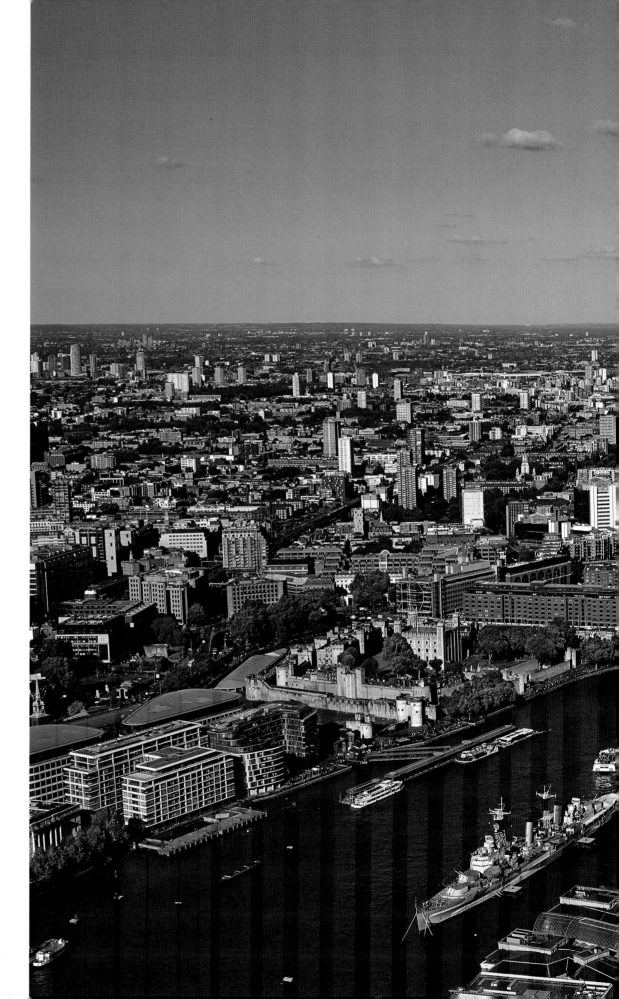

The Shard and London eastwards.
The Italian architect Renzo Piano's masterpiece is a 95-storey skyscraper standing 309.6m (1,016ft) tall. From the viewing platform on the 72nd floor there are breathtaking 360-degree panoramic views of the capital. Down below is HMS *Belfast*, a Town-class light cruiser which escorted convoys to the Soviet Union during 1943 and took part in Operation Overlord and the Normandy landings in June 1944.

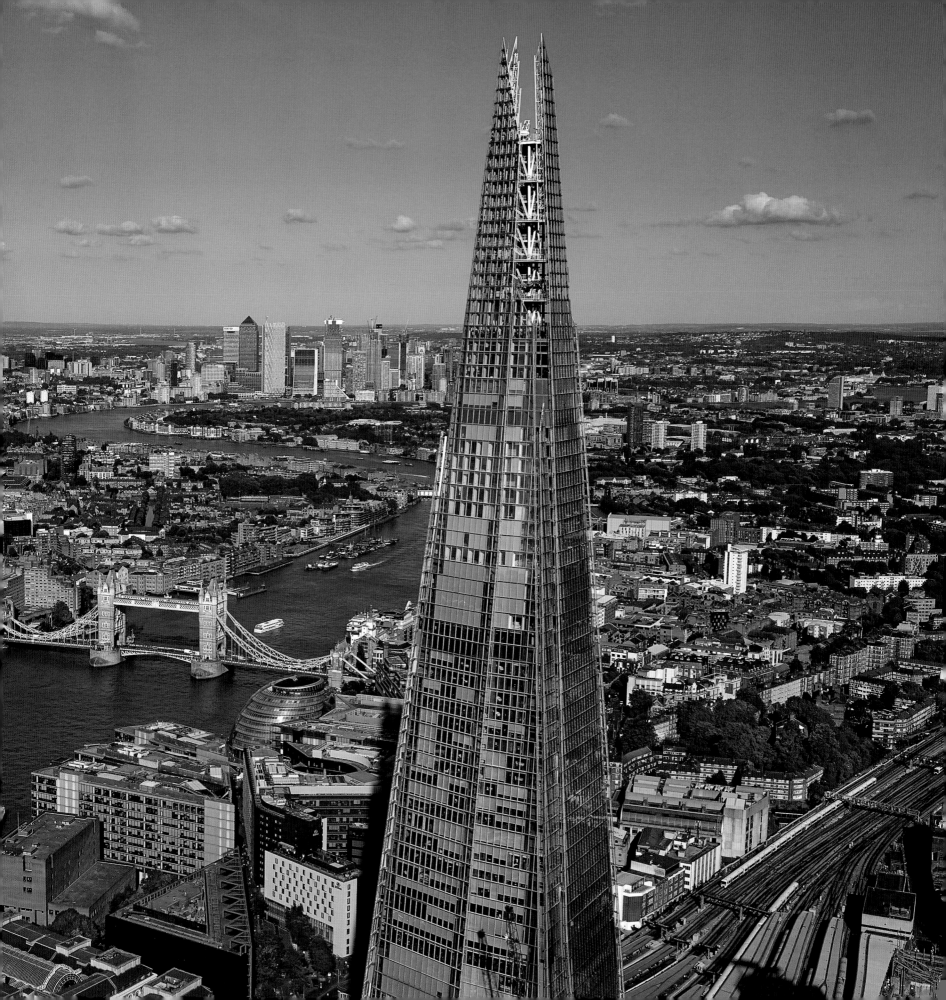

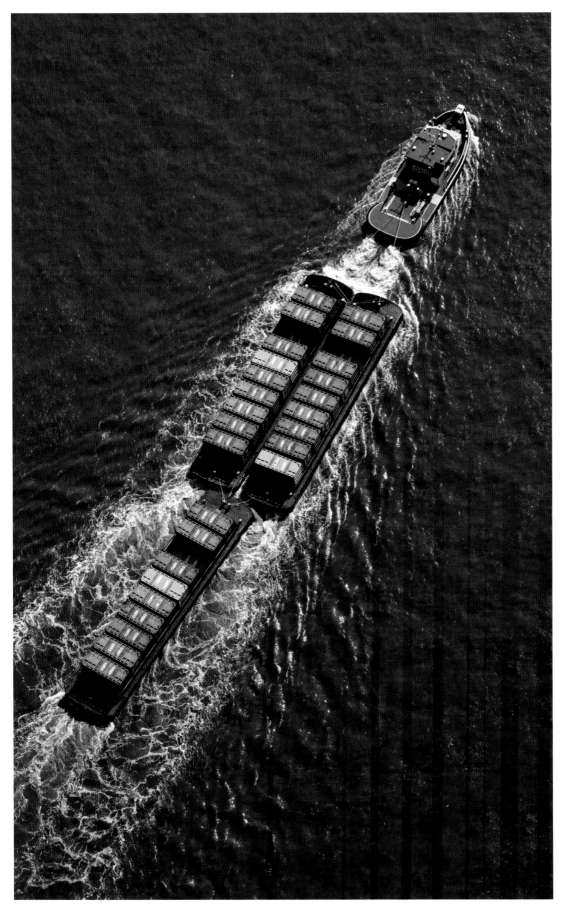

Thames Recycling Barges
The River Thames is a working river and some of its regular commercial users are tugs and barges loaded with their cargo of London's rubbish. These make numerous journeys downriver from Wandsworth to Tilbury, where they offload for recycling. The Thames is tidal and the Port of London, once the largest in the world, remains essential to the movement of goods in the UK.

Tower Bridge (right) is a combined bascule and suspension bridge. It took eight years to build and was officially opened in 1894 by the then Prince of Wales, who became King Edward VII. Its two towers are 65m (213ft) tall and the central span of the bridge is 61m (200ft). The five-minute opening of the bridge is controlled by weights of over 1,000 tons. Known worldwide, it is the iconic backdrop for thousands of selfies.

Tower Bridge and the River Thames westwards (pages 42-43). Looking upriver and behind HMS *Belfast* are some of London's bridges, starting with London Bridge in the foreground, Cannon Street Railway Bridge, Southwark Bridge, Millennium Footbridge and the twin Blackfriars bridges.

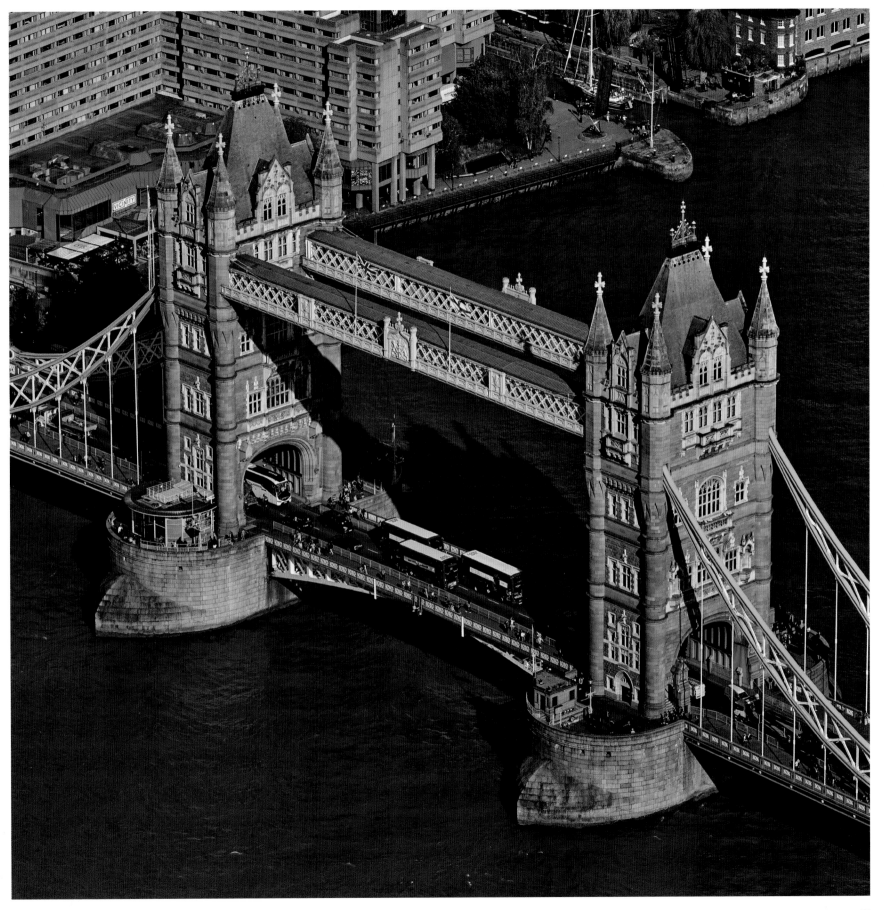

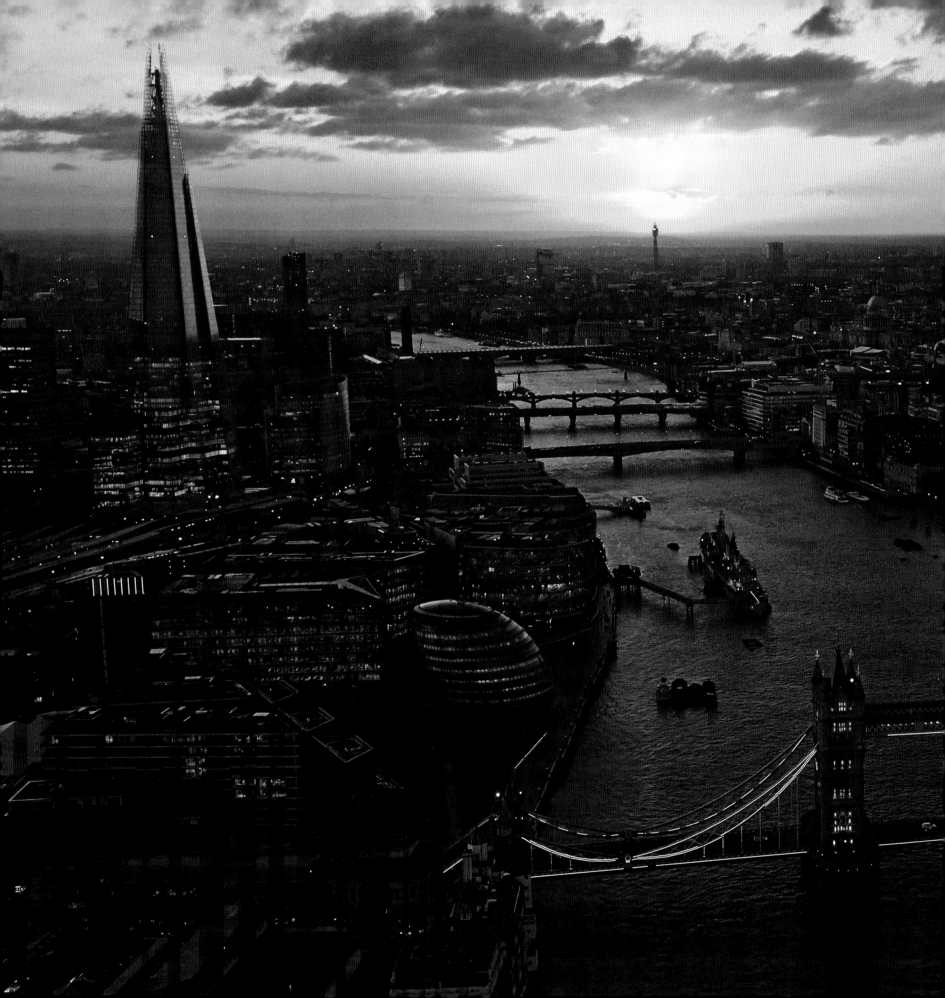

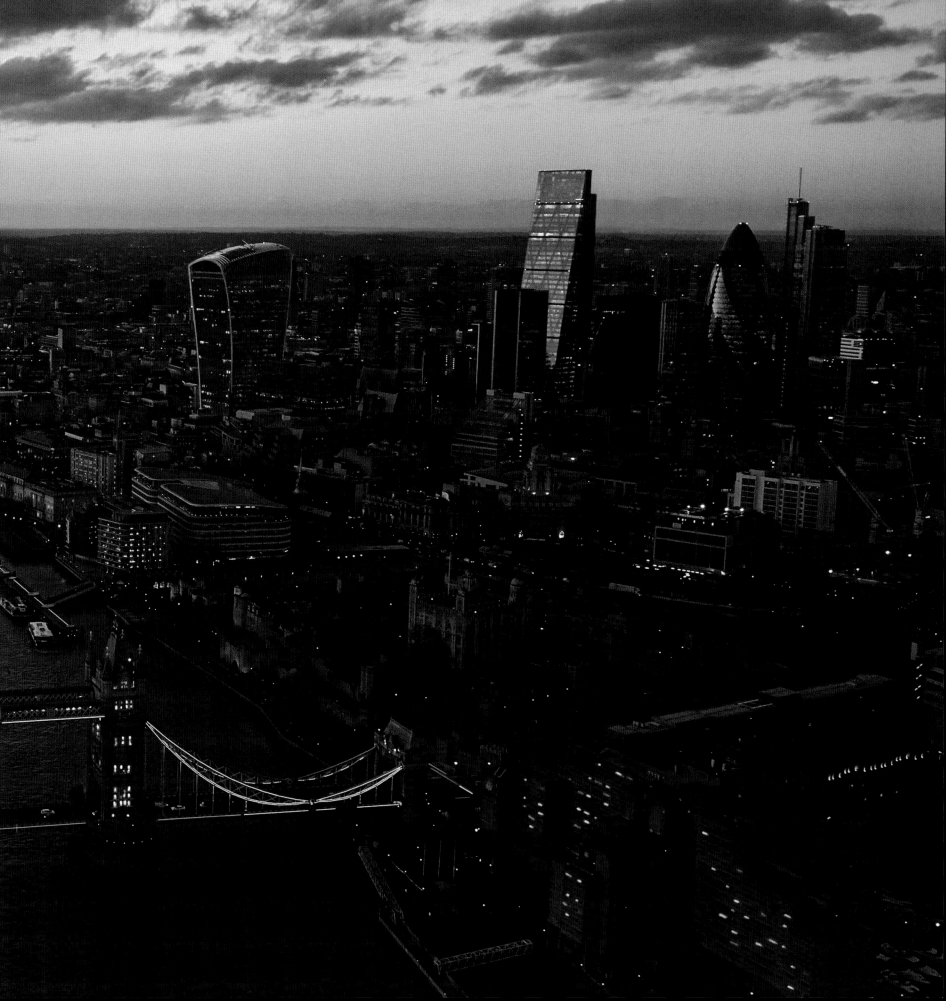

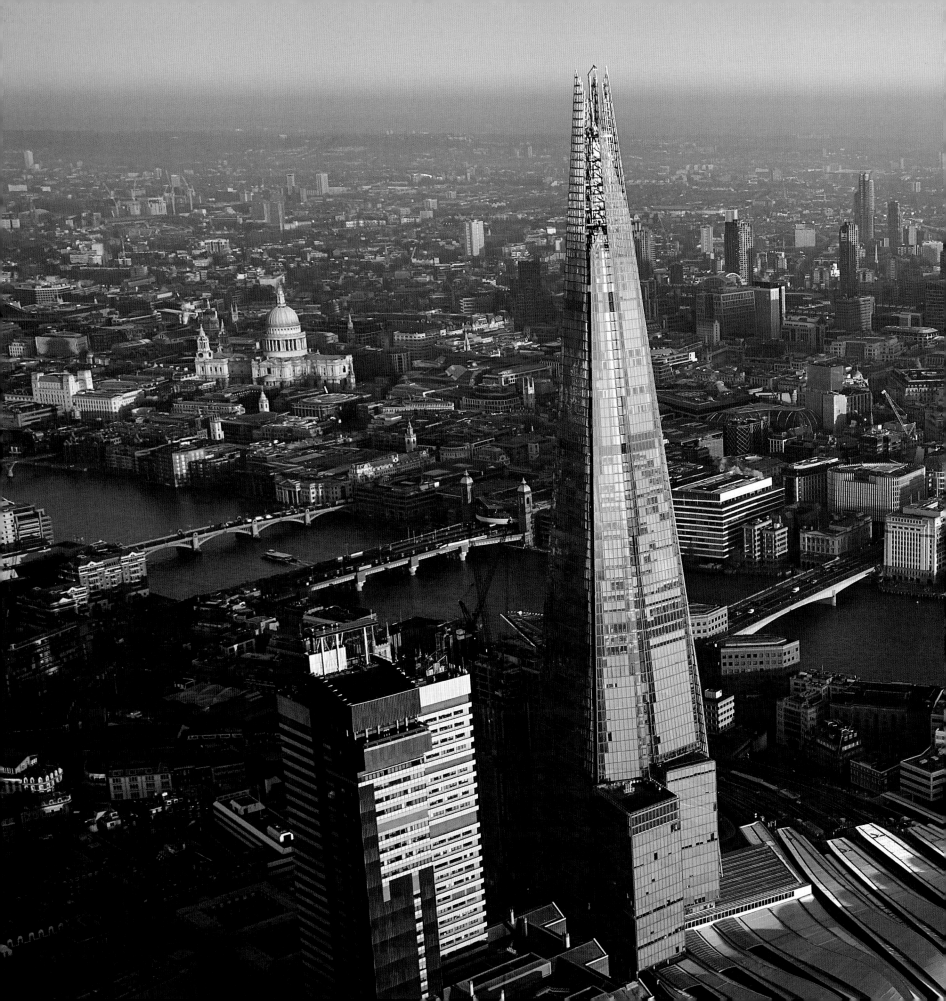

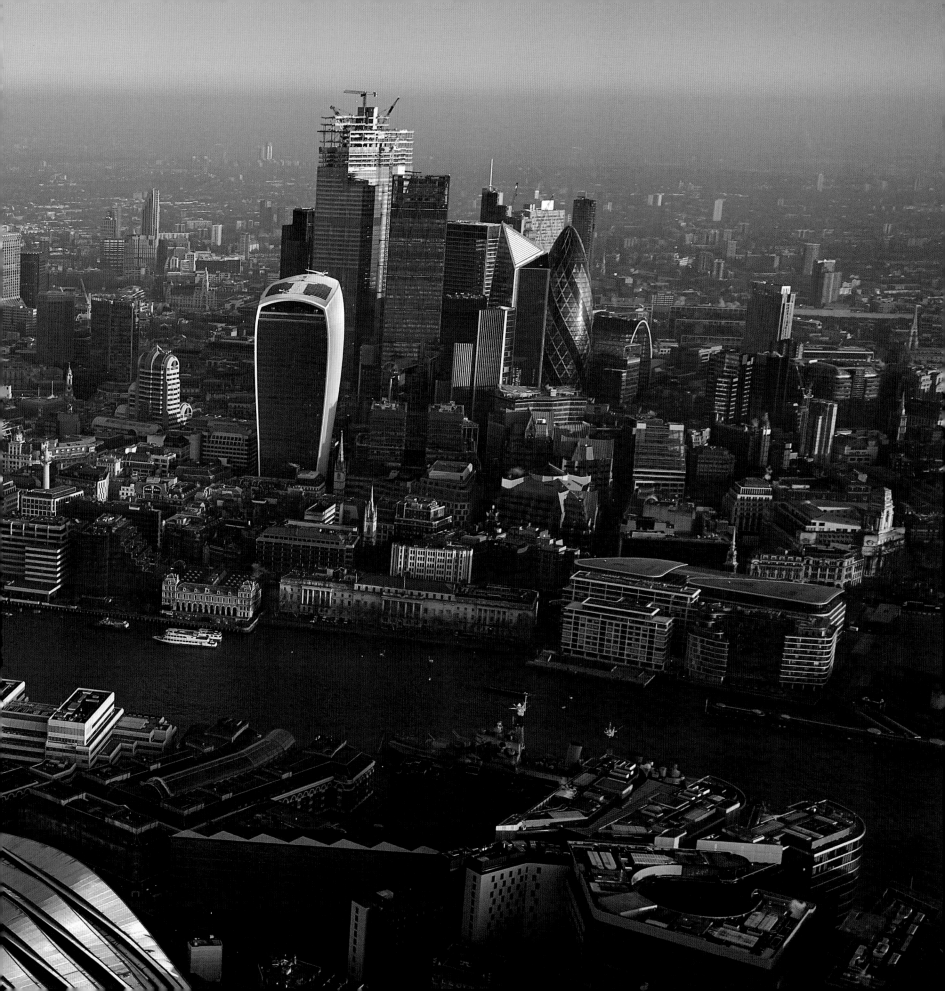

Regent Street and Picadilly Circus

A major shopping street in the West End with its iconic brand shops, Regent Street was named after George, the Prince Regent, later to become George IV, and designed by architects John Nash and James Burton. The layout of the street was completed in 1825. Piccadilly Circus is a popular hub for tourists at the junction of Regent Street and Theatreland (the West End). The fountain in the middle was erected in 1893 in memory of Anthony Ashley Cooper, 7th Earl of Shaftesbury, a former politician and social reformer concerned for the welfare of young people. Strangely, the statue has a mistaken identity: it is not the god Eros but is in fact his twin brother, Anteros!

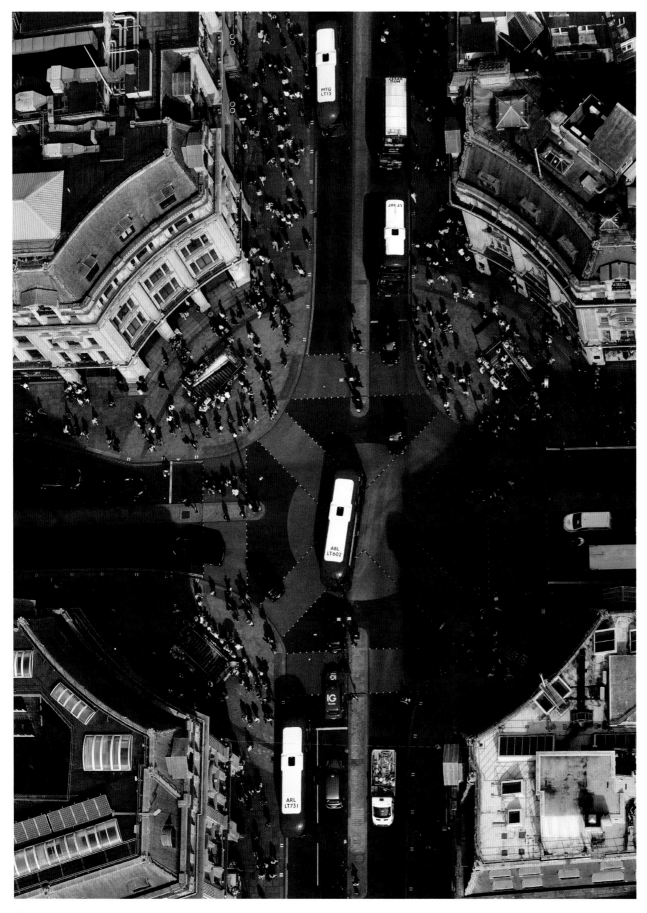

Oxford Circus, the junction of Oxford Street and Regent Street. The word 'Circus' has nothing to do with clowns, jugglers and performing animals but derives from the Latin word meaning 'circle', a round open space at a junction.

Oxford Street (right) is Europe's busiest shopping street, with a half million visitors daily. It was originally a Roman road connecting Essex and Hampshire. In the Middle Ages it was known as Tyburn Road and was the route taken from Newgate Prison to the gallows near Marble Arch. Its name changed to Oxford Street around 1729.

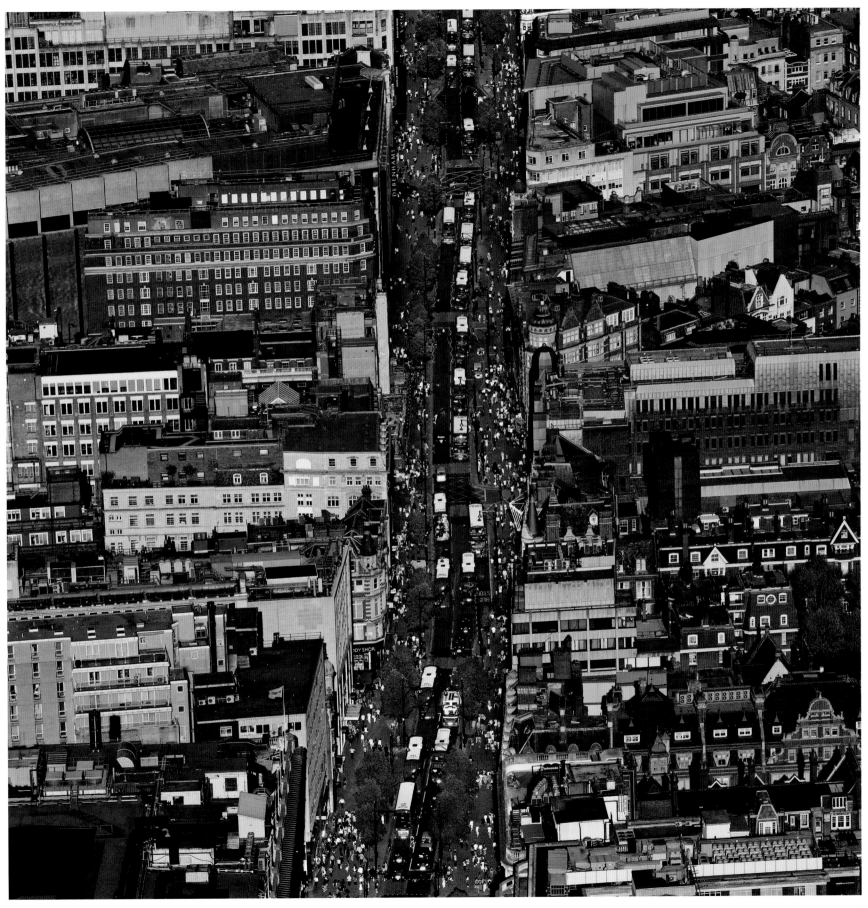

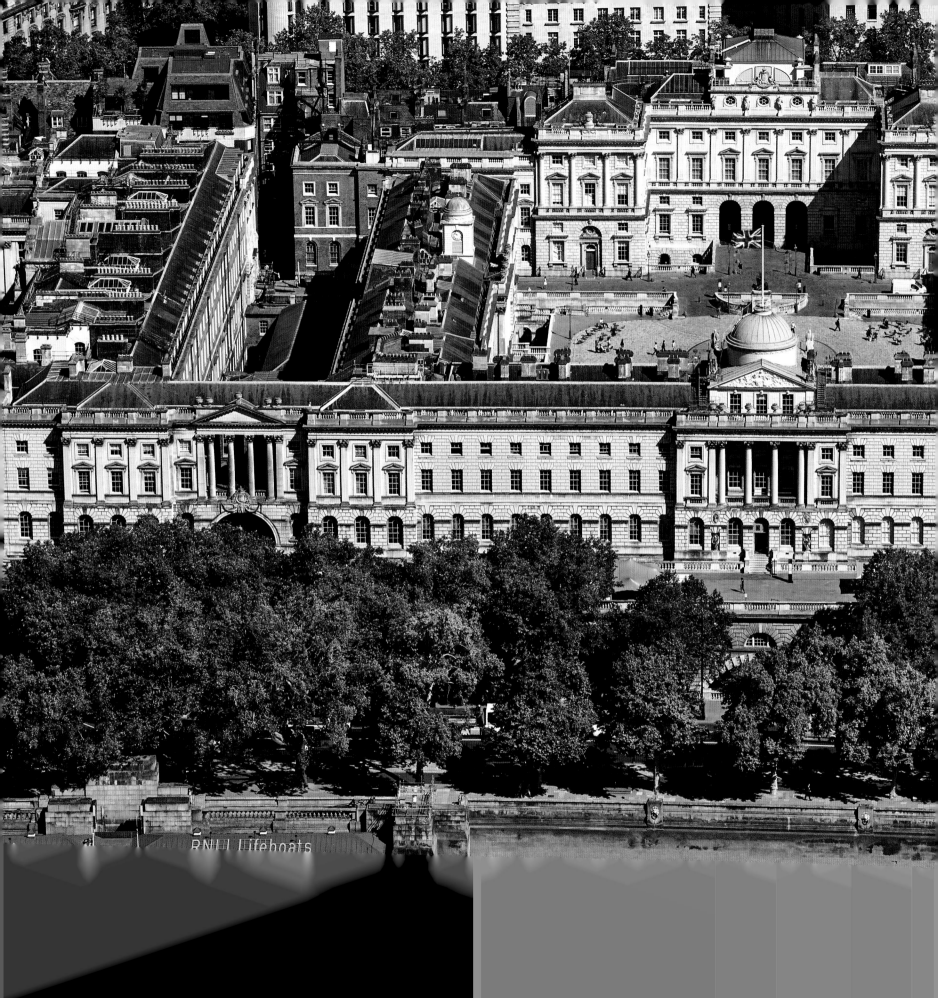

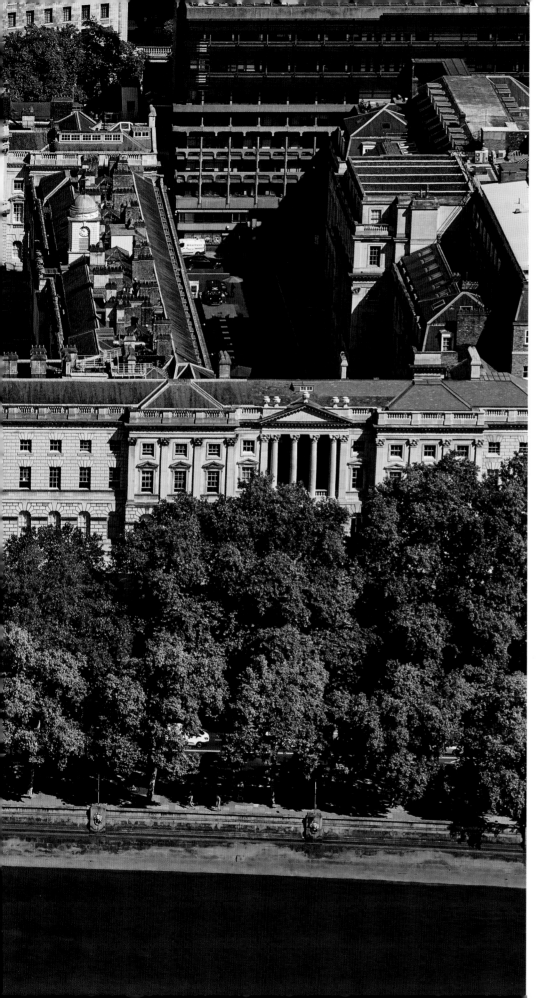

Somerset House is a stunning example of Georgian architecture in front of the Aldwych, overlooking the River Thames. Built on the site of a Tudor palace belonging to the Duke of Somerset and designed by Sir William Chambers, it originally housed public offices, the office of Hawkers & Peddlers, the Inland Revenue and the Registry of Births, Deaths & Marriages.

Today there are new tenants, including the Courtauld Institute of Art, the British Fashion Council, the Royal Society of Literature and two celebrity chef restaurants. The quadrangle in the middle is a venue for outdoor cinema, concerts and winter skating. One of London's three RNLI lifeboat stations is in view on the embankment.

Westminster Abbey

A World Heritage site with over a thousand years of history. In the 7th century the site known as Thorn Island already had a church and by the 10th century was home to a community of Benedictine monks. The abbey was built in 1060 by King Edward the Confessor and the first coronation there was that of William the Conqueror in 1066. The building of the present abbey began in 1245 and was commissioned by King Henry III. Britain's oldest door dating from the 1050s will be found in a vestibule.

The coronations of every monarch of the realm (17) have been held in the abbey since William the Conqueror's in 1066, as well as 16 royal weddings. The abbey is the burial site of 3,300 prominent persons including 16 monarchs, 8 prime ministers, numerous military leaders, scientists, poet laureates, actors and that of the Unknown Warrior, representing the many unknown British dead of the First World War.

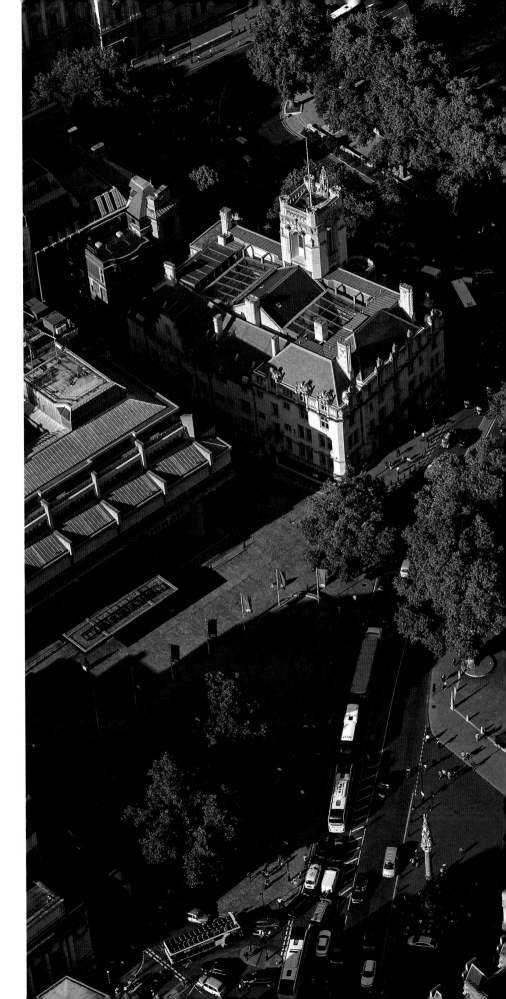

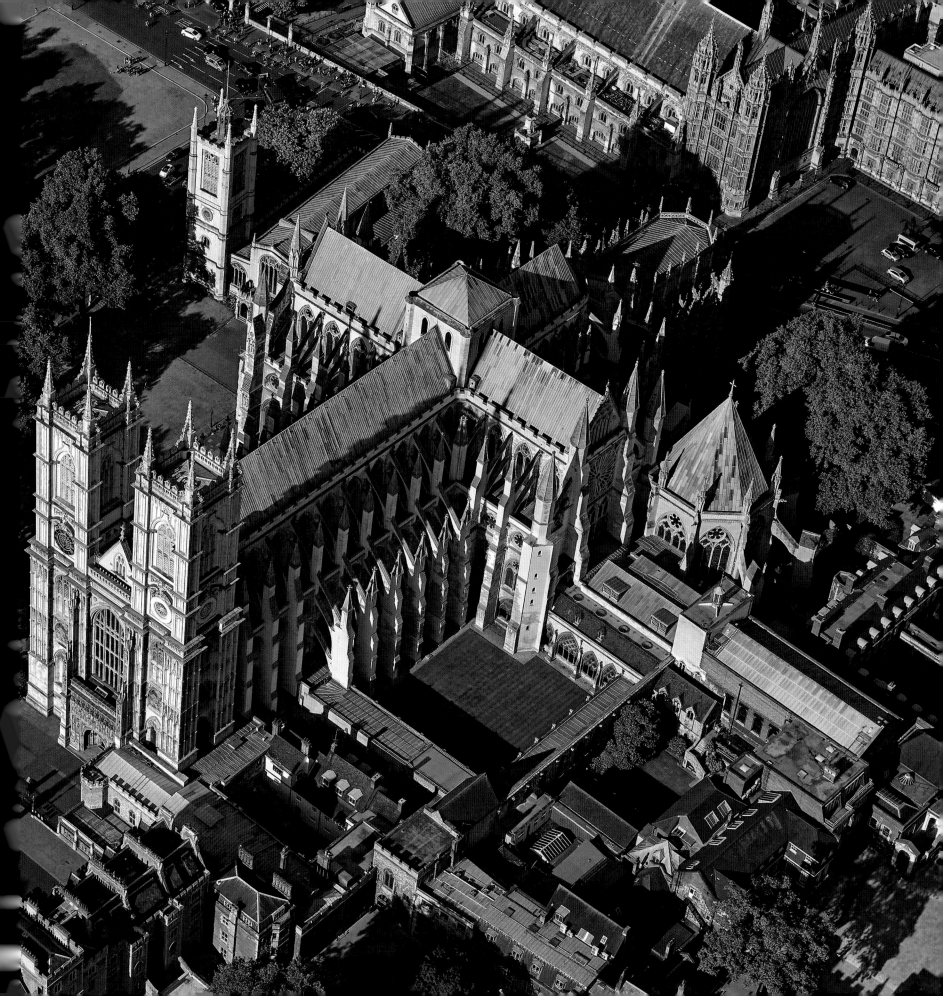

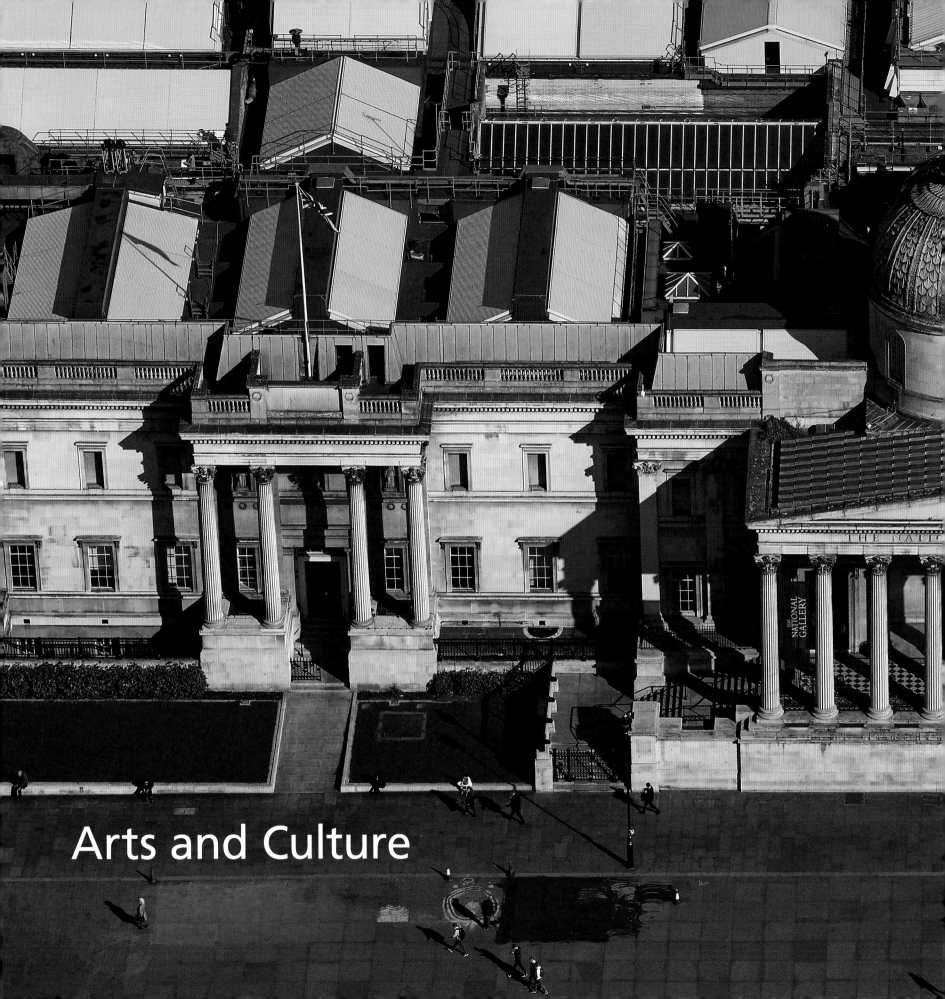

Arts and Culture

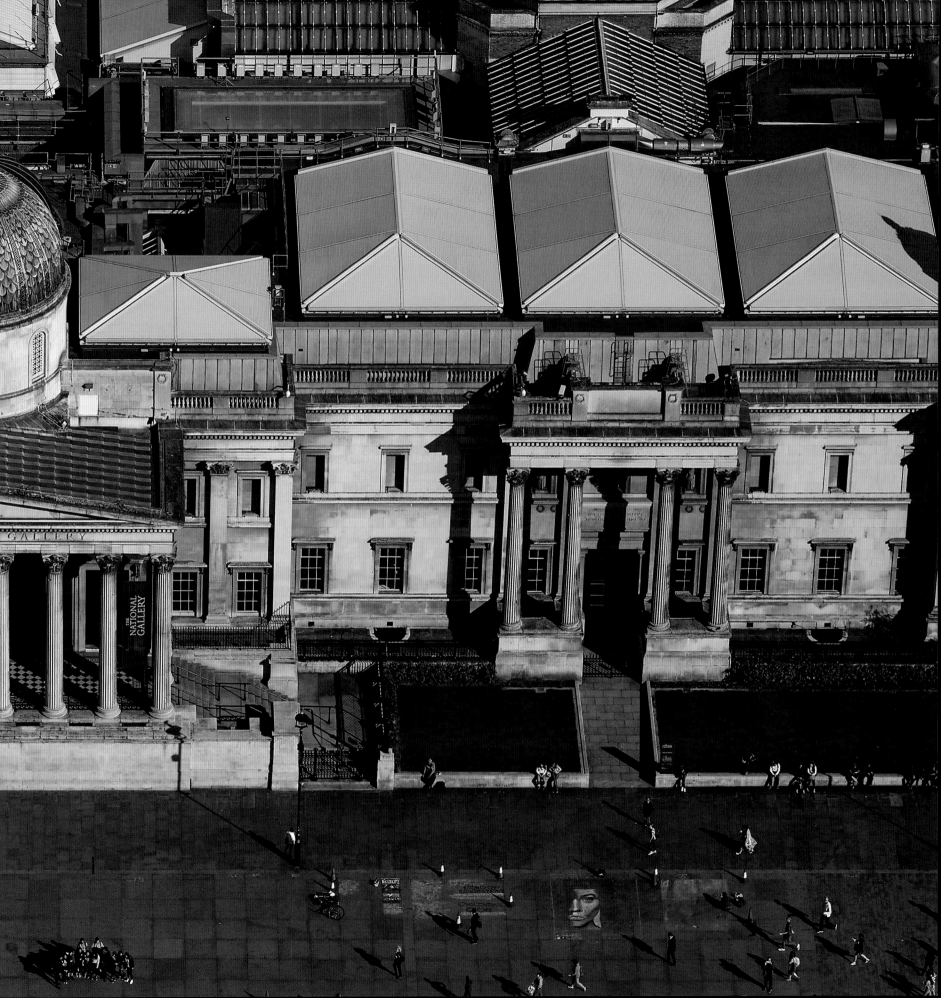

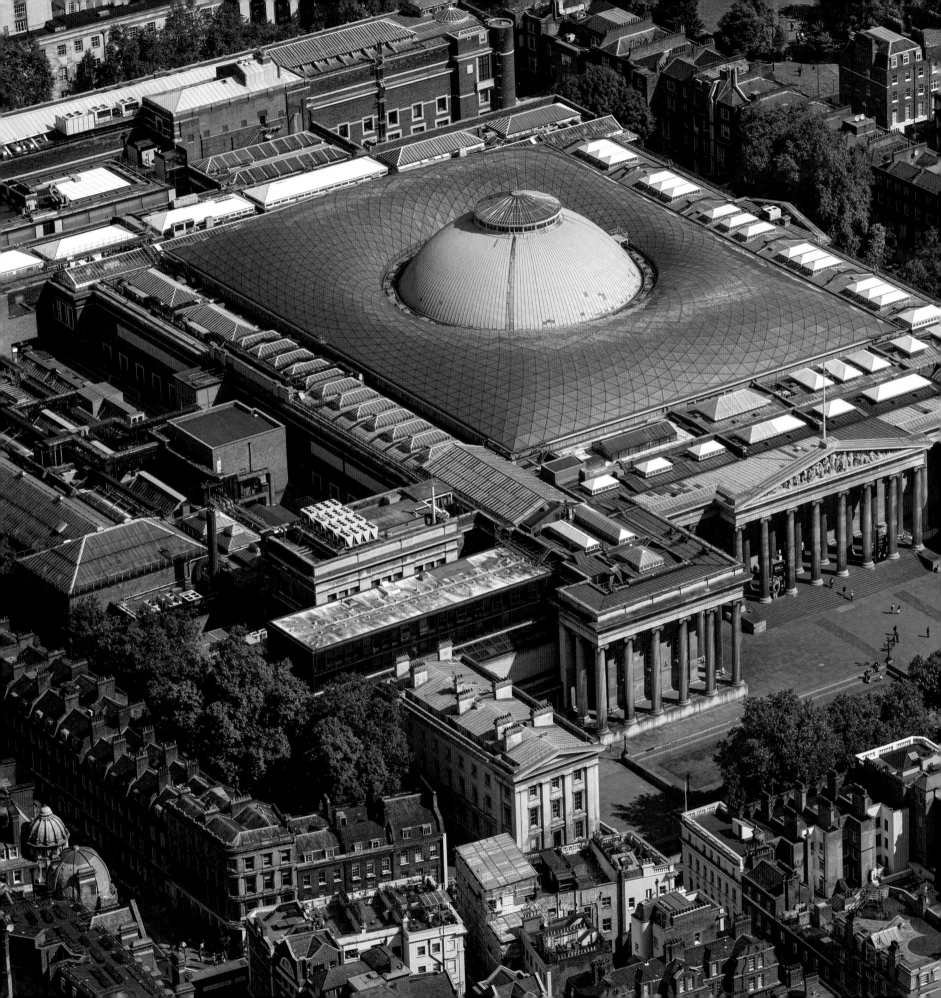

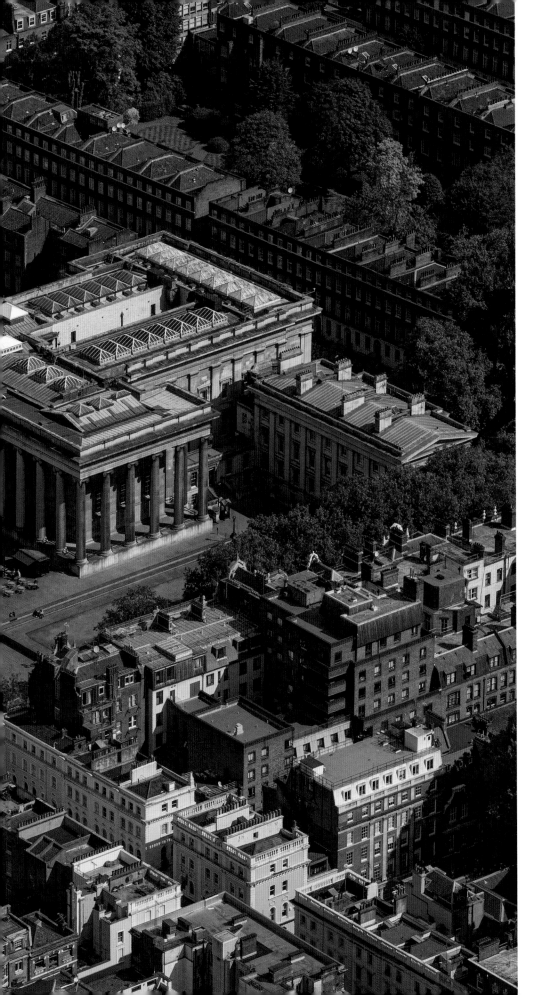

The National Gallery (pages 54-55) in Trafalgar Square, founded in 1824, houses a collection of over 2,300 paintings dating from the mid-13th century through to 1900. The building was designed by William Wilkins and built between 1832 and 1838.

The British Museum, Bloomsbury, is a public institution dedicated to art, culture and human history. Its facade, built in the Greek Revival style, has 44 columns, each 14m (45ft) high. Many architects were involved in its design but initially this was by Sir Robert Smirke. The museum was established in 1753 and has a collection of some 8 million works, among the largest and most comprehensive in the world.

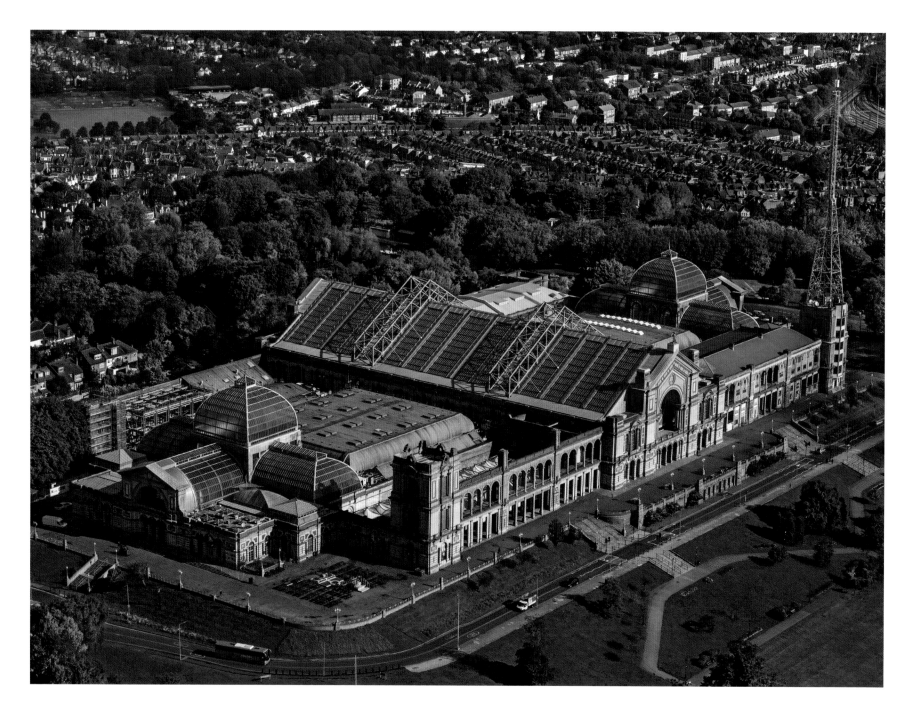

Alexandra Palace, 'Ally Pally', is a grandiose Grade II listed Victorian building located between Muswell Hill and Wood Green. Building began in 1865 to a design by John Johnson and Alfred Meeson, and its opening took place in May 1875. In 1935 the BBC began broadcasting live black and white television from the site, and today the halls are used for all manner of entertainment and sport – it even has an ice rink!

Broadcasting House (right), Langham Place, at the northern end of Regent Street. The Art Deco building, which is Grade II listed, is now the headquarters of the BBC. In front of the entrance as if a sentinel on guard is the distinct 'dunce's hat'-like spire of John Nash's All Souls Church, Langham Place.

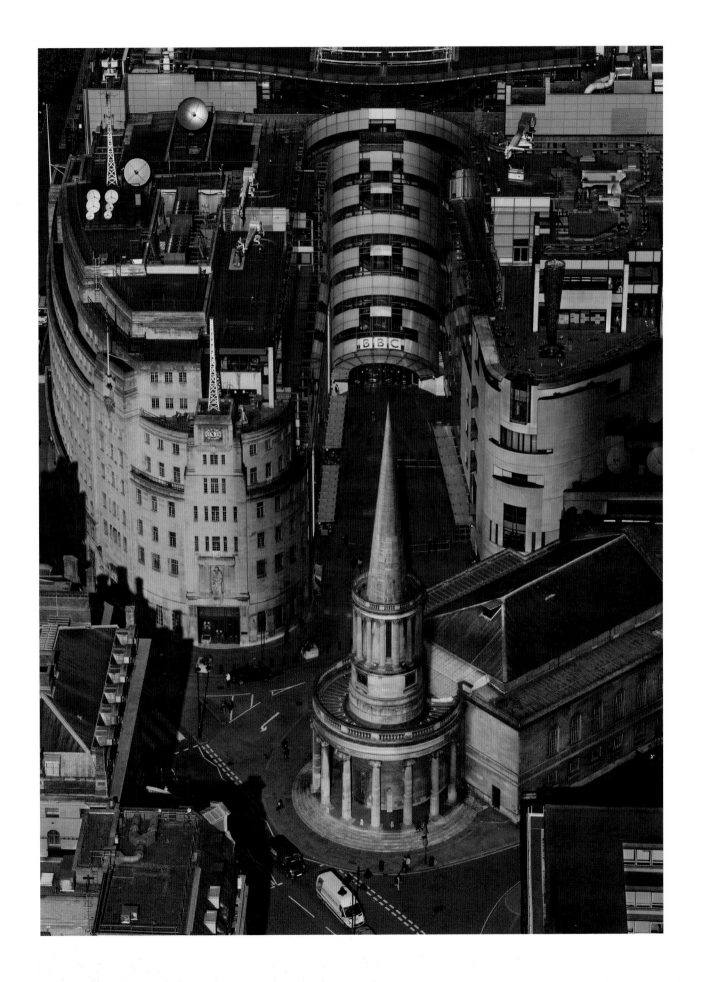

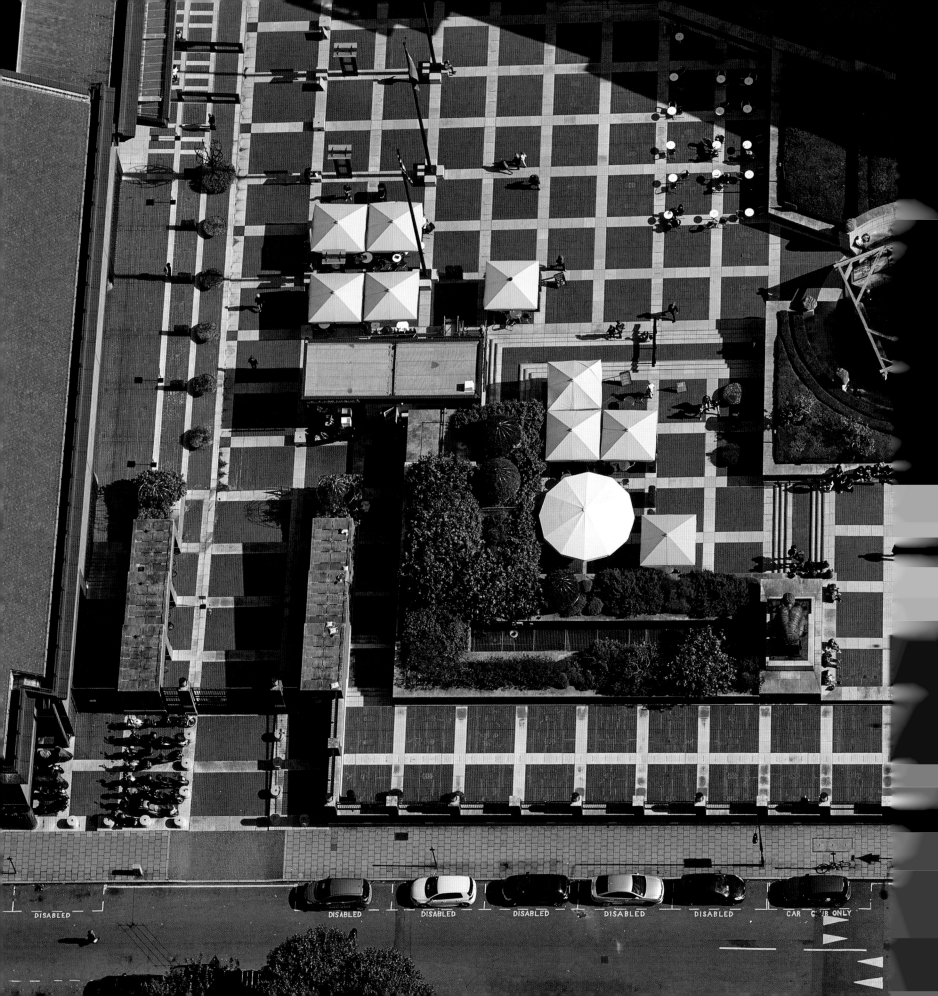

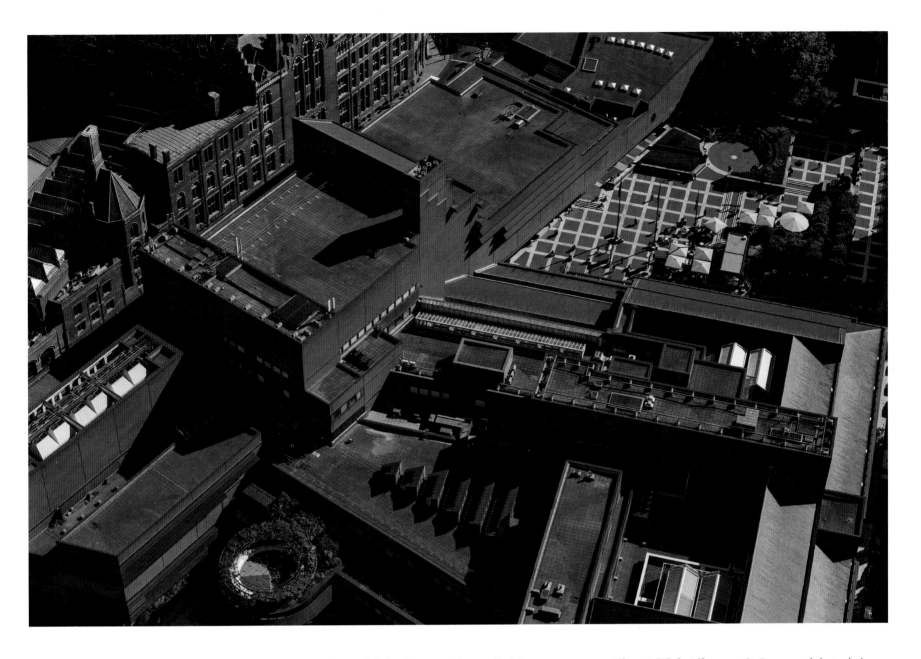

The British Library Piazza (left). Here seated is the 3.7m (12ft)-high Palozzi bronze sculpture of Newton engrossed in measuring the universe. Morning Tai Chi classes are held here and there is a small amphitheatre for cultural open-air performances.

The British Library, St Pancras (above), is the national library for the United Kingdom and the largest library in the world in terms of the size of its collection. It is estimated to have between 150 and 200 million items and receives copies of all books published in the UK. Previously the library was located at many sites in London, including the British Museum. The striking new red brick building, designed by Colin St John Wilson and his wife, M. J. Long, is Grade I listed and was opened in 1998 by Queen Elizabeth II.

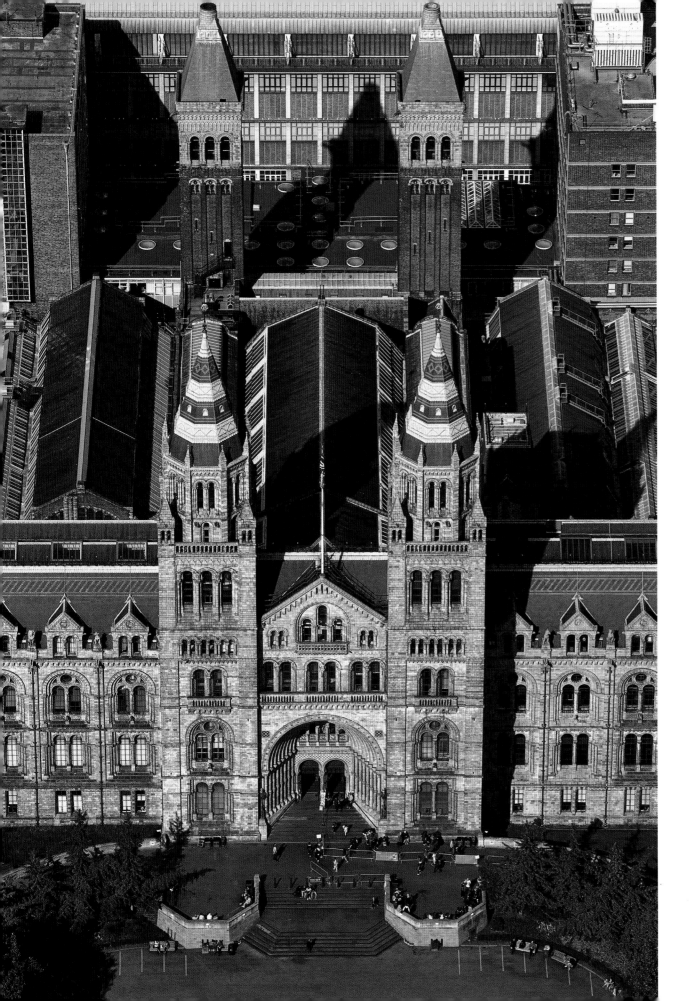

The Natural History Museum, Cromwell Road, opened in 1881, has an impressive 80 million items on display from the world of botany, entomology, palaeontology and zoology. Many of these have great historical as well as scientific value, such as those of Charles Darwin. Begun in 1859 with conceptual drawings by Richard Owen, Sir Francis Fowke became involved in 1864 but died suddenly. His commission was handed over to a then unknown architect, Alfred Waterhouse, whose work we see today.

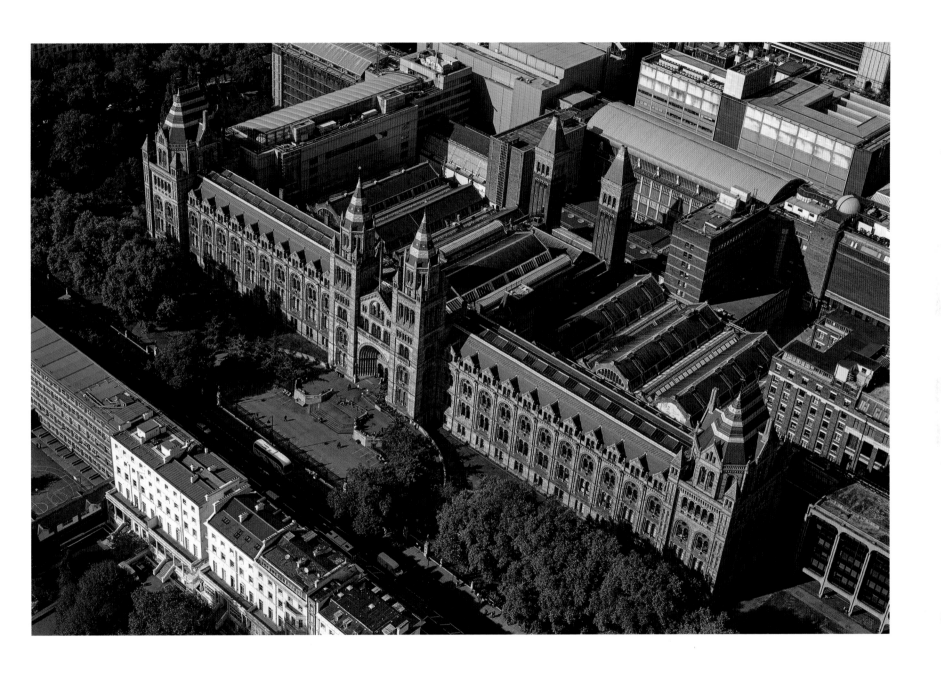

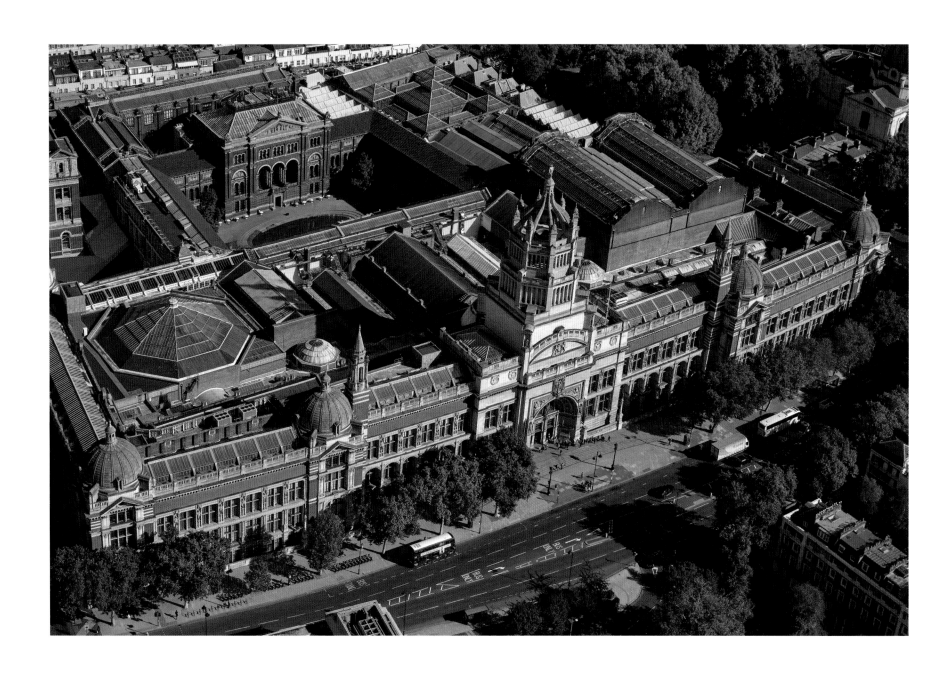

The Victoria & Albert Museum, South Kensington, is the largest museum of decorative arts and design in the world. Inside are 145 galleries, with 2.27 million items representing 5000 years of art, from ancient times to the present day. Its architectural design history is complex. The original building, designed by Aston Webb, was opened by Queen Victoria on 20 June 1857. Other noted architects were involved, in particular Sir Francis Fowkes for the building on the north side of the garden. Due to his death he was unable to complete the brief and this was subsequently taken up by Colonel Henry Young Darracott Scott, also a Royal Engineer.

The main entrance and facade is built from red brick and Portland stone. It is a hybrid style of architecture designed by Aston Webb after winning a design competition in 1891. Queen Victoria laid the foundation stone in 1899 and it opened in 1909.

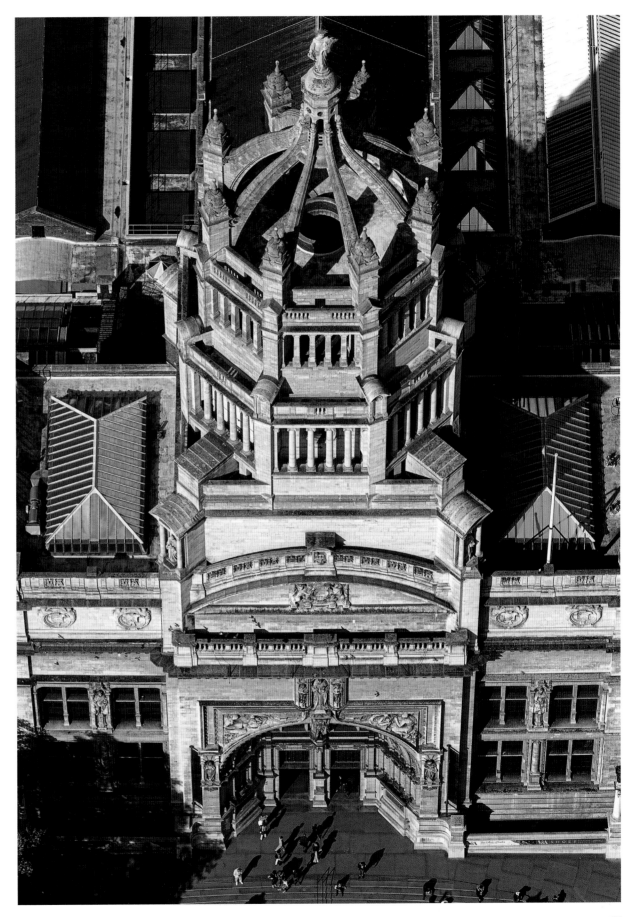

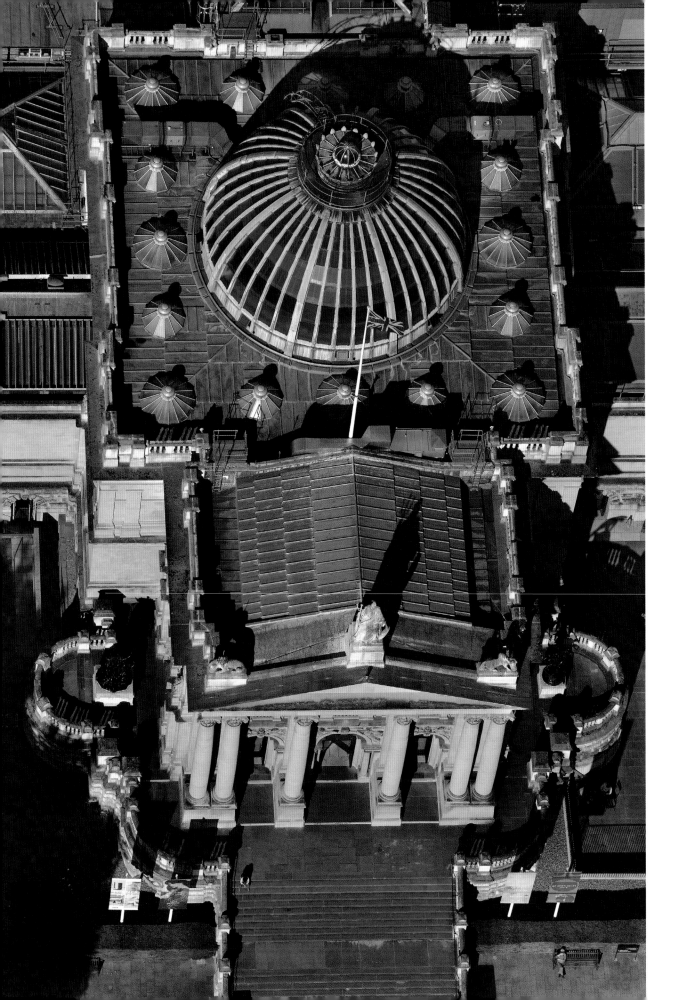

Tate Britain, Milllbank, Westminster, houses art dating back to the Tudor period (1485–1603). Built on the site of the former Millbank Prison, the front of the building was designed by Sidney R. J. Smith. It opened in 1897 and was then known as the National Gallery of British Art. The roof has some stunning intricate leadwork decorated with scallop shells.

The Tate Modern is a gallery of modern art occupying the old Bankside Power Station which was designed by Sir Giles Gilbert Scott. It was decommissioned in 1981 and opened as Tate Modern on 11 May 2000 by Queen Elizabeth II. It is one of the largest museums of contemporary and modern art in the world, holds works dating back to 1900 and attracted 5 million visitors when first opened.

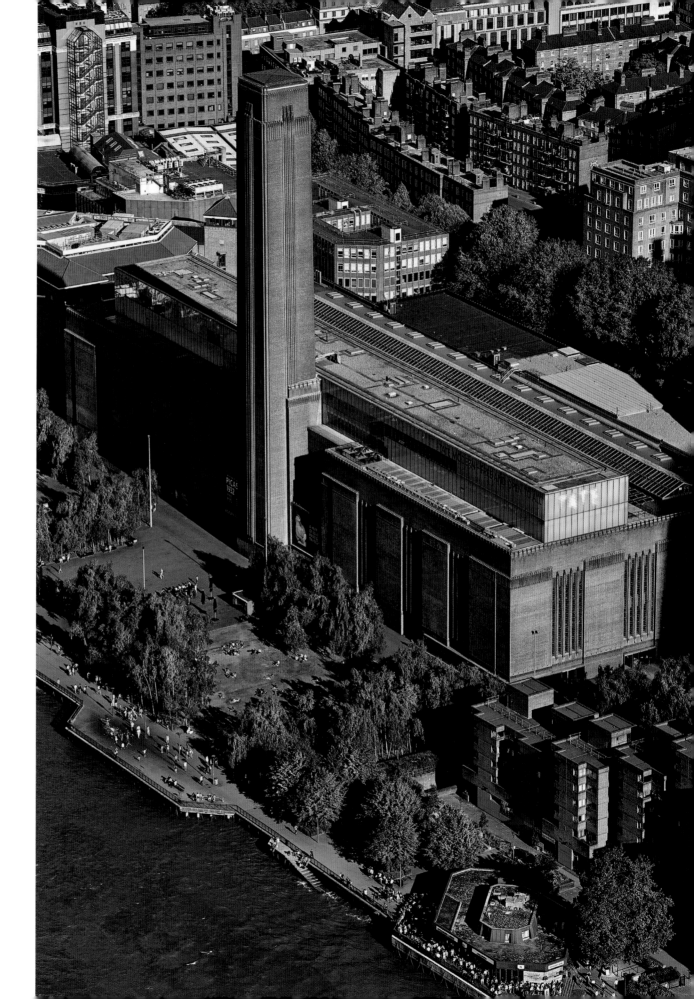

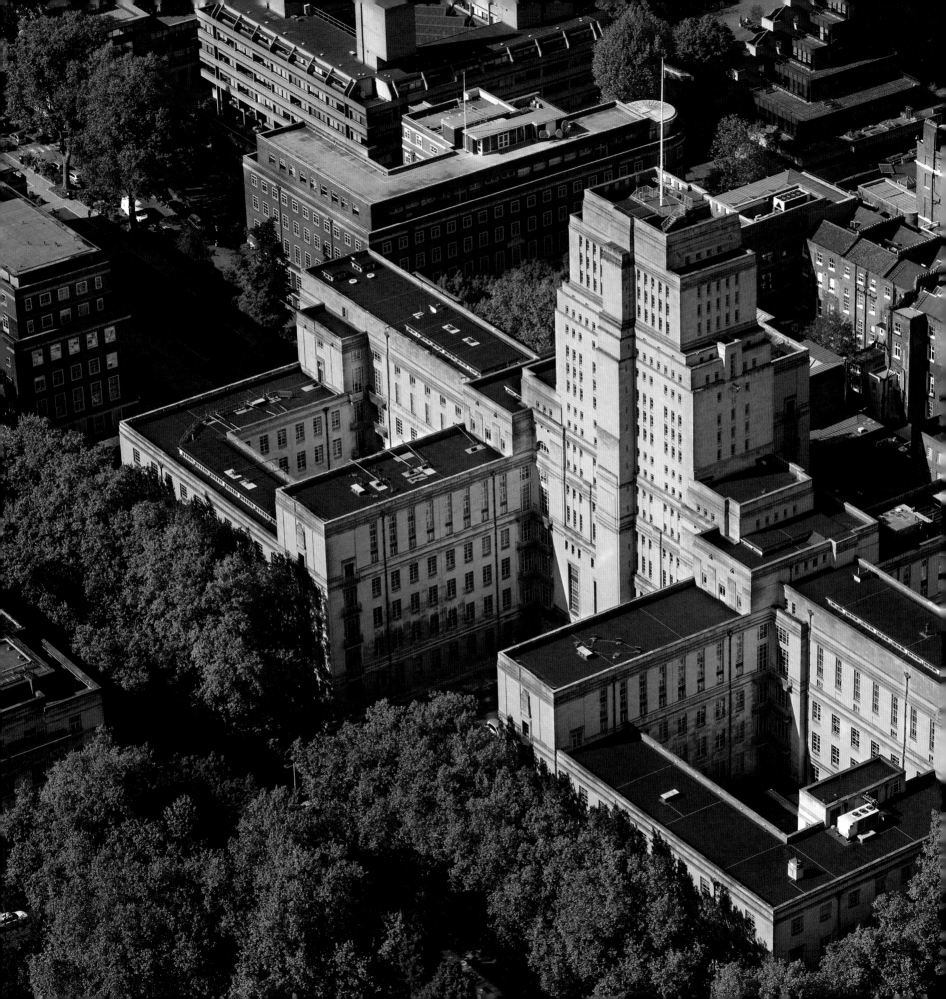

Senate House, Bloomsbury, is the administrative centre of the University of London. The 64m (210ft) Art Deco neo-classical building was designed by Charles Holden and constructed between 1932 and 1937. Inside is the Senate House Library and seven of the nine research units of the School of Advanced Study.

Serpentine Gallery (page 70), Hyde Park, is Grade II listed and was formerly a tea pavilion. Built in 1934 by James Grey West, every year the gallery commissions art to be exhibited outside. The CD-like installation by the African architect Diébédo Francis Kéré was added in 2017.

The BFI IMAX Cinema (page 71), Waterloo, with its apt address of 1 Chaplin Walk, hosts the biggest screen in the UK, measuring 26 x 20m. The cinema is surrounded by traffic and is just 4m above the London Underground, and so was built on anti-vibration bearings to minimise noise. Designed by Bryan Avery, it opened in May 1999.

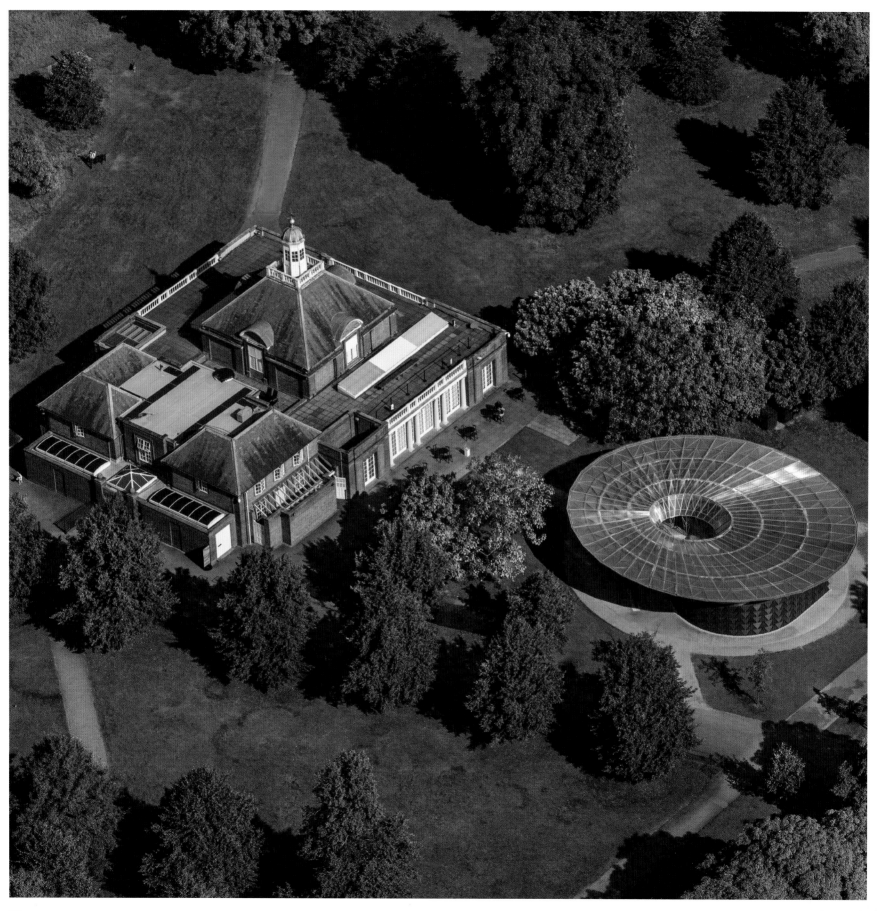

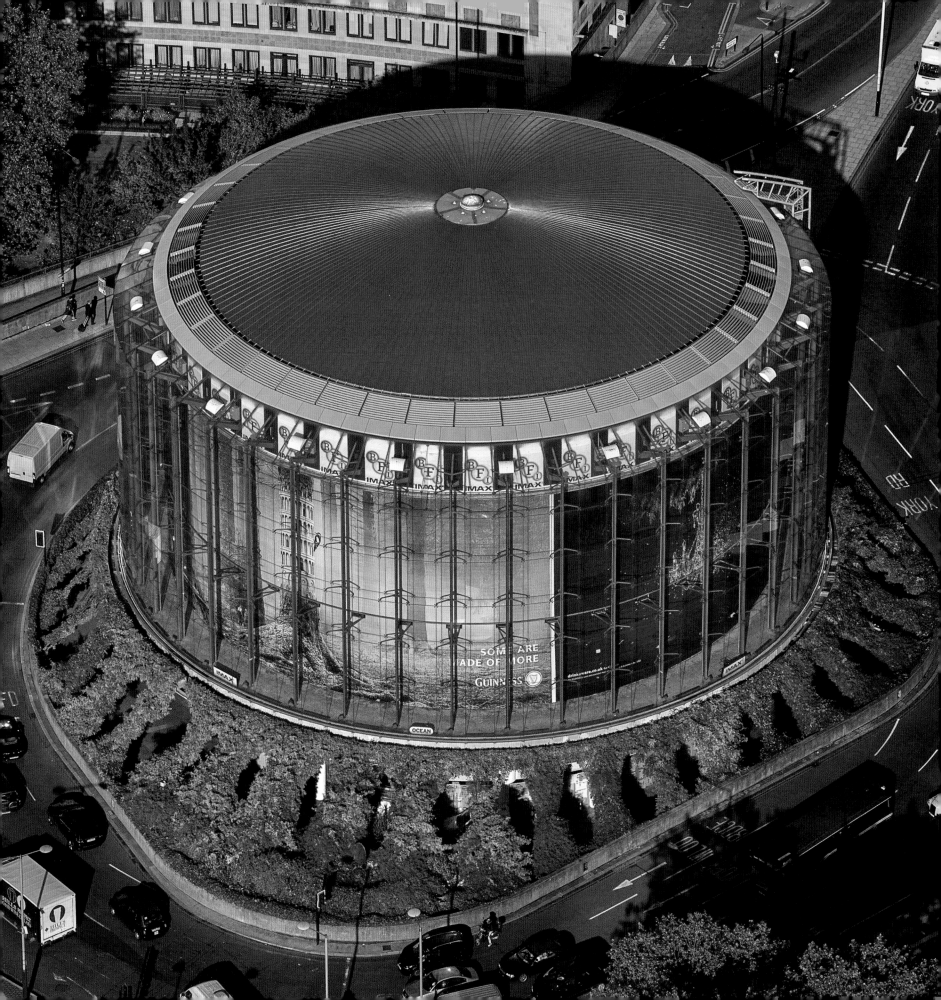

The Royal Albert Hall, Kensington Gore, is an example of the Italianate style of architecture. When opened, the hall, designed by Captain Francis Fowke and Major General Henry Y. D. Scott of the Royal Engineers, had a capacity of 8000, but today this has been reduced to just over 5,540. Queen Victoria laid the foundation stone in 1867 and it was opened in 1871 by Edward, the Prince of Wales. For many years the auditorium was troubled with acoustic problems which were finally resolved in 1969. Every year since 1941 it has hosted the eight-week season of the BBC Promenade Concerts, better known as the *Proms*.

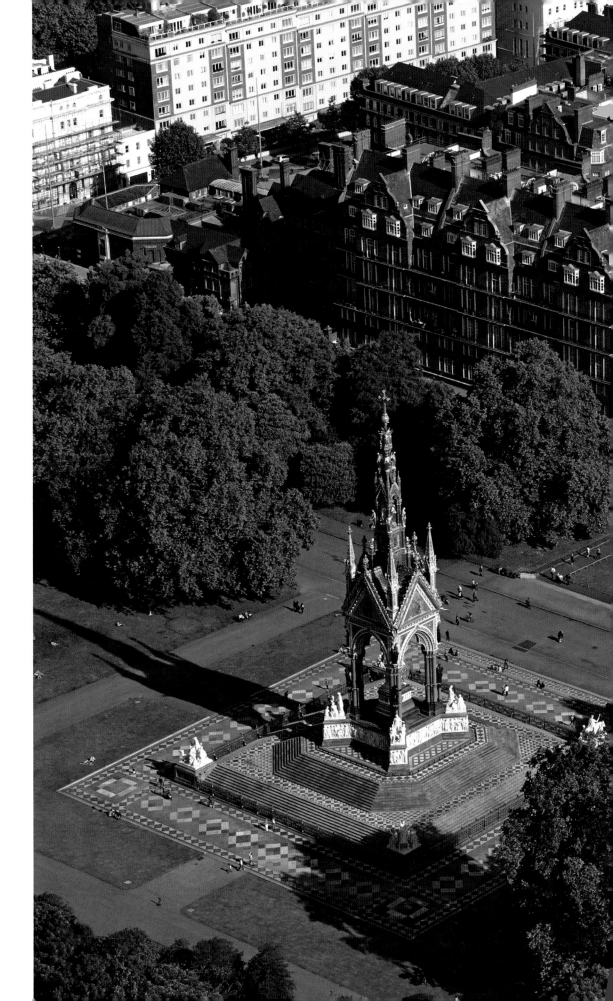

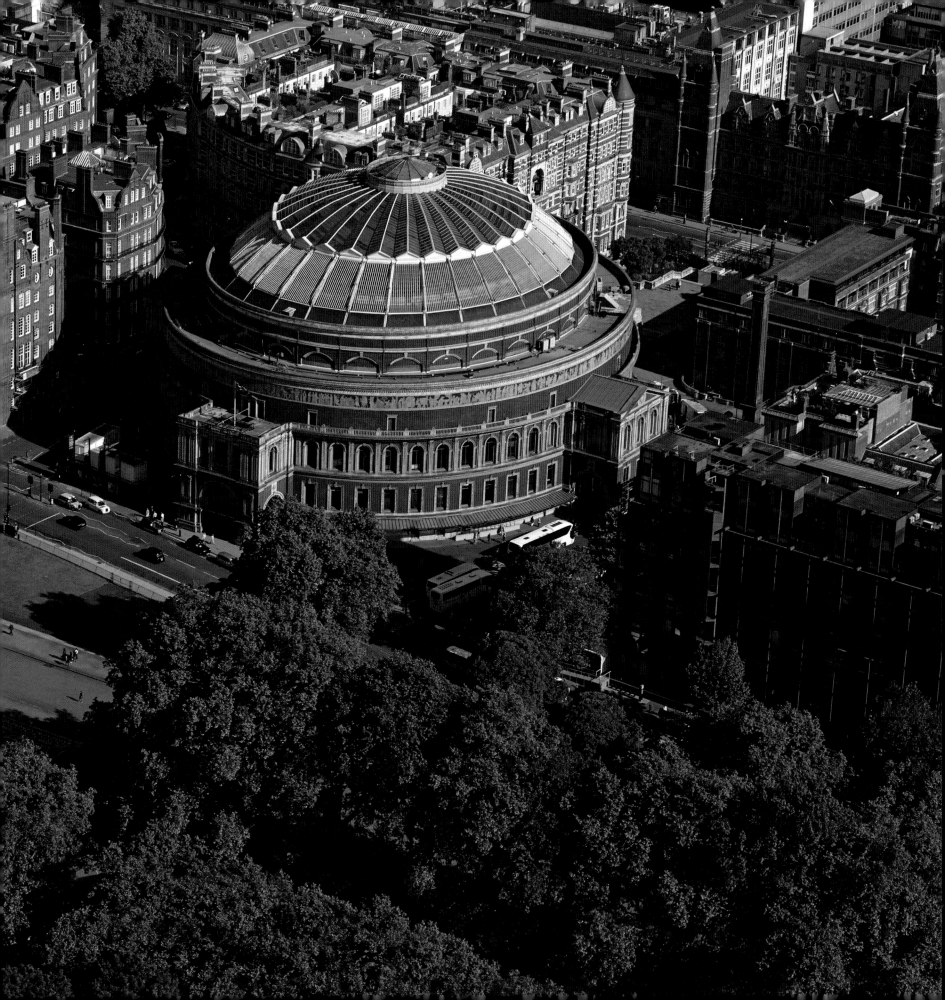

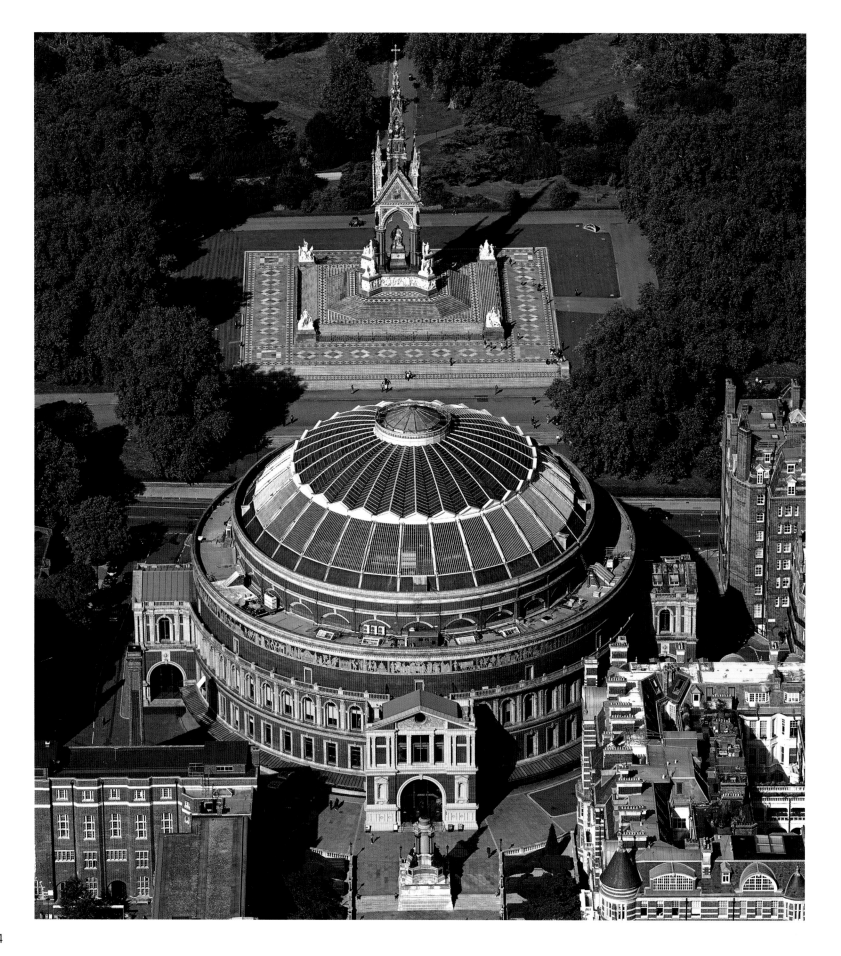

The Albert Memorial,
commissioned by Queen Victoria
in memory of her husband, Prince
Albert, the man she loved so
much. He died in 1861 at the age
of only 42. Sir George Gilbert
Scott was responsible for its
Gothic Revival-style design, which
is 54m (177ft) tall. Underneath
the canopy is the seated figure of
the prince, covered in gold leaf.
The opening ceremony took place
in 1872.

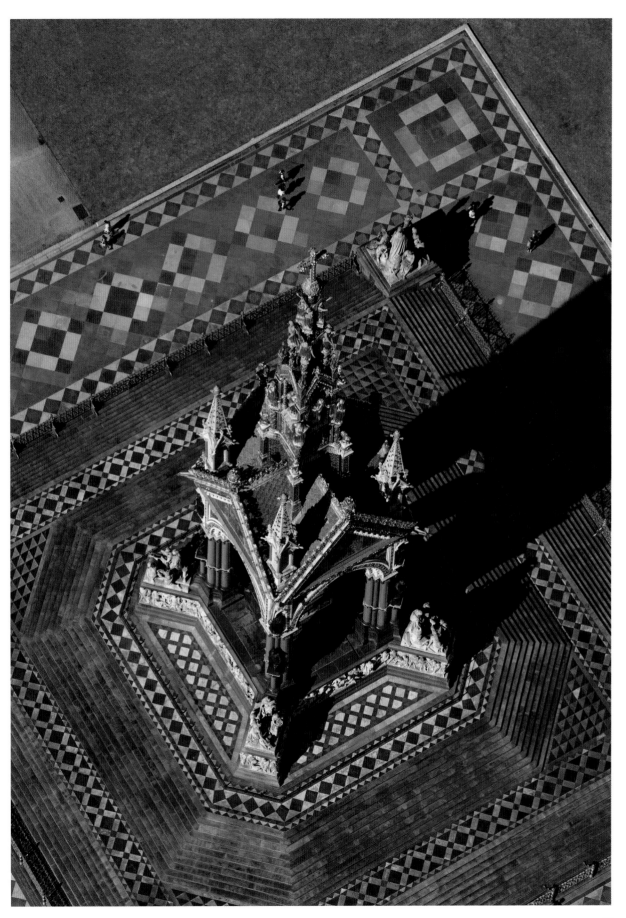

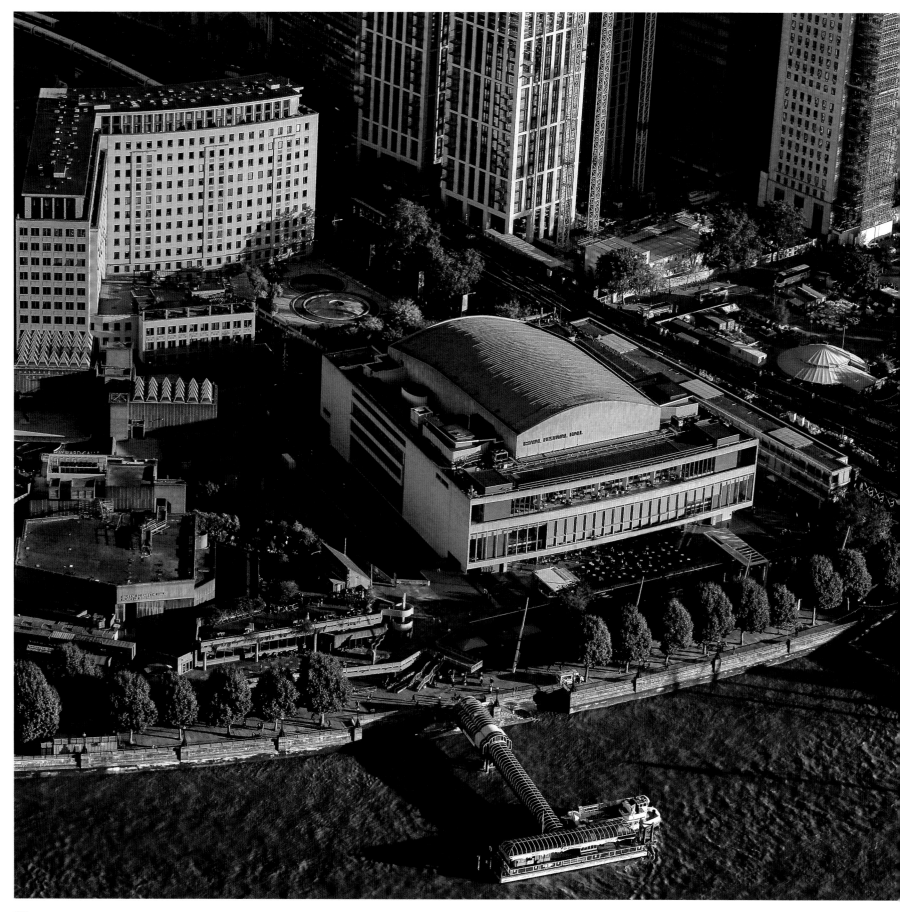

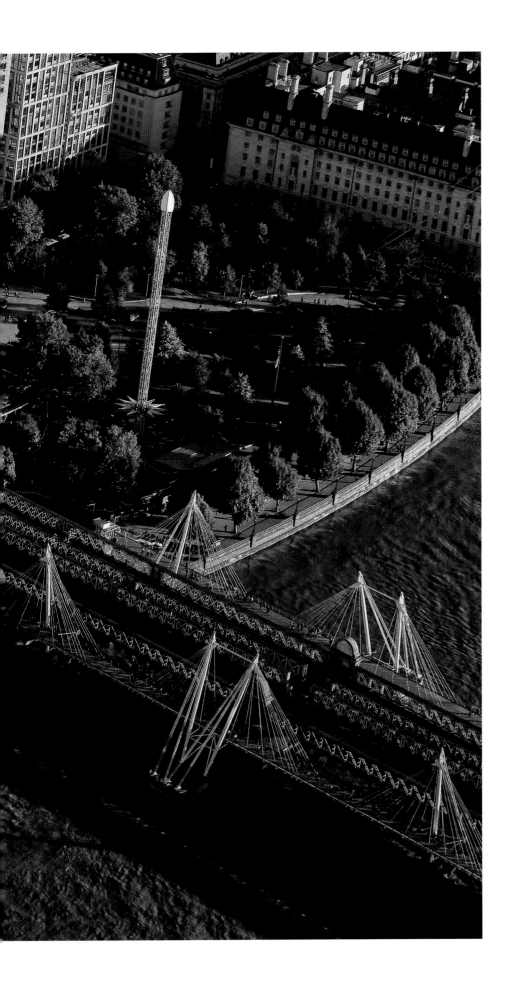

Southbank Centre, Waterloo, is an artistic concrete complex comprised of the Royal Festival Hall, the Queen Elizabeth Hall, the Purcell Room and the Hayward Gallery. The Royal Festival Hall is Grade I listed and was originally built in 1951 as part of the Festival of Britain. The National Theatre and the National Film Theatre are also located here. Below the Queen Elizabeth Hall is the Undercroft and the Southbank Skate Space, where skateboarding goes on 24/7! The South Bank always buzzes with activity and the delicious smells of street food.

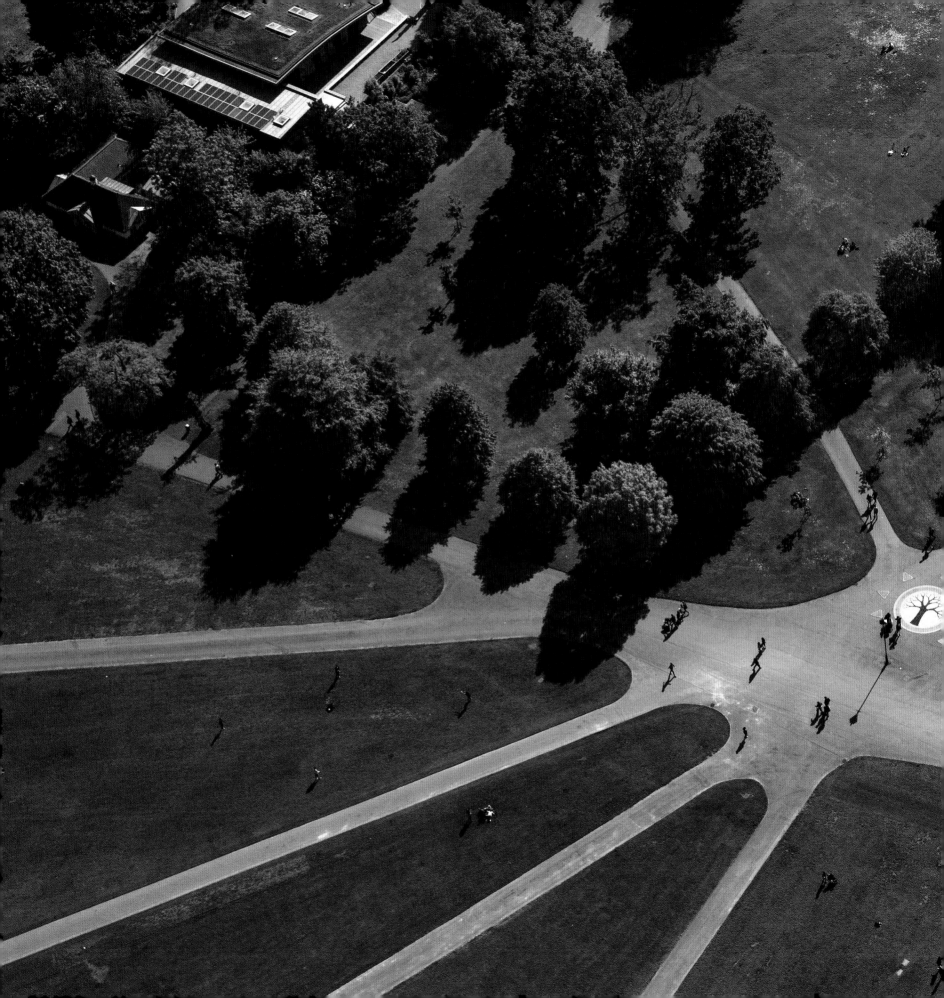

Green Spaces

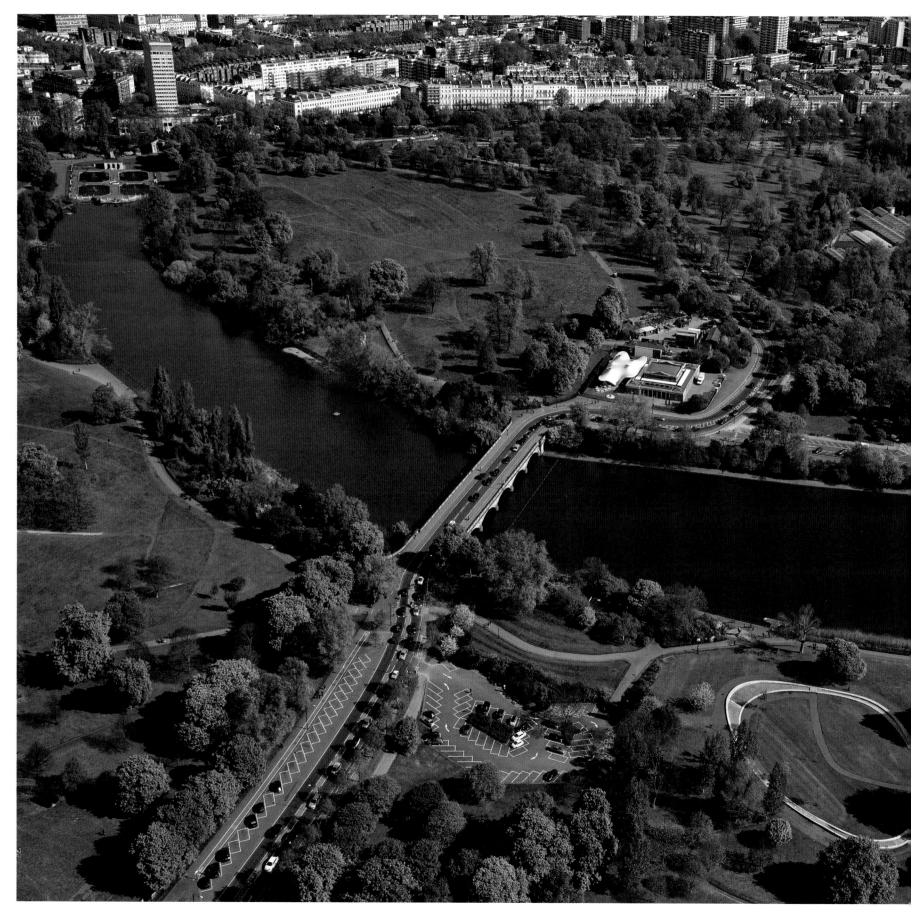

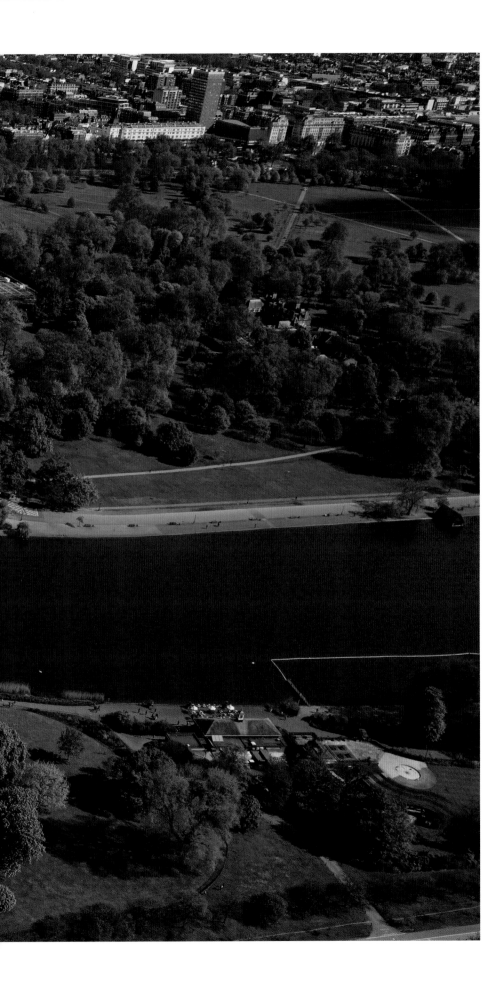

The Reformers' Tree (pages 78-79) in Hyde Park appears quite insignificant at ground level. The mosaic commemorates the burning down of an oak tree during the Reform League riots in 1866. Free speech and demonstrations have been a key feature in the park since Speakers' Corner was established in 1872.

Hyde Park is a sizable 300 acres (142 hectares) of open space and the largest Royal Park in London. It was eventually opened to the public in 1637. The park is split by the Serpentine Bridge on West Carriage Drive which divides the Long Water from the Serpentine. The Diana, Princess of Wales Memorial Fountain, which is bottom right of the picture, was officially opened by Queen Elizabeth II on 6 July 2004.

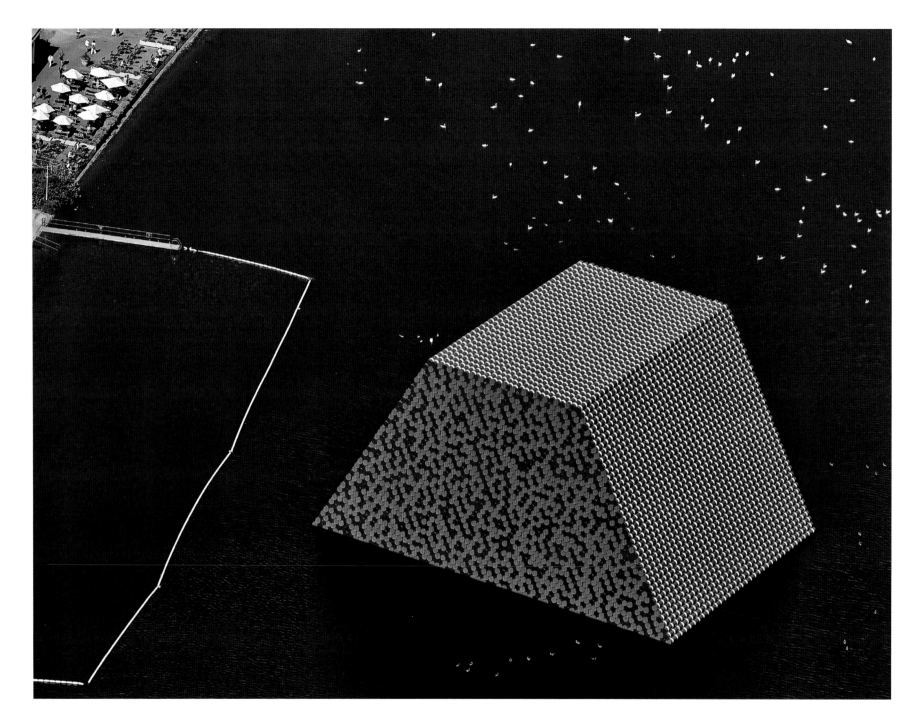

Christo's London Mastaba Installation
This suddenly appeared on the Serpentine during the summer of 2018. It consisted of 7,506 coloured oil barrels on a floating platform shaped in the form of a *mastaba* (an Arabic word for 'bench' given to Egyptian tombs and seats found outside homes in ancient Mesopotamia). This shape had for many years fascinated the Bulgarian artist Christo Vladimirov Javacheff and his late wife, Moroccan Jeanne-Claude, who have created environmental works of art worldwide. It was held in place by 32 anchors and was 20m (66ft) high.

Early morning on **the Serpentine** (right). Boats being prepared for tourists to enjoy another day of leisurely rowing on the calm waters of the lake.

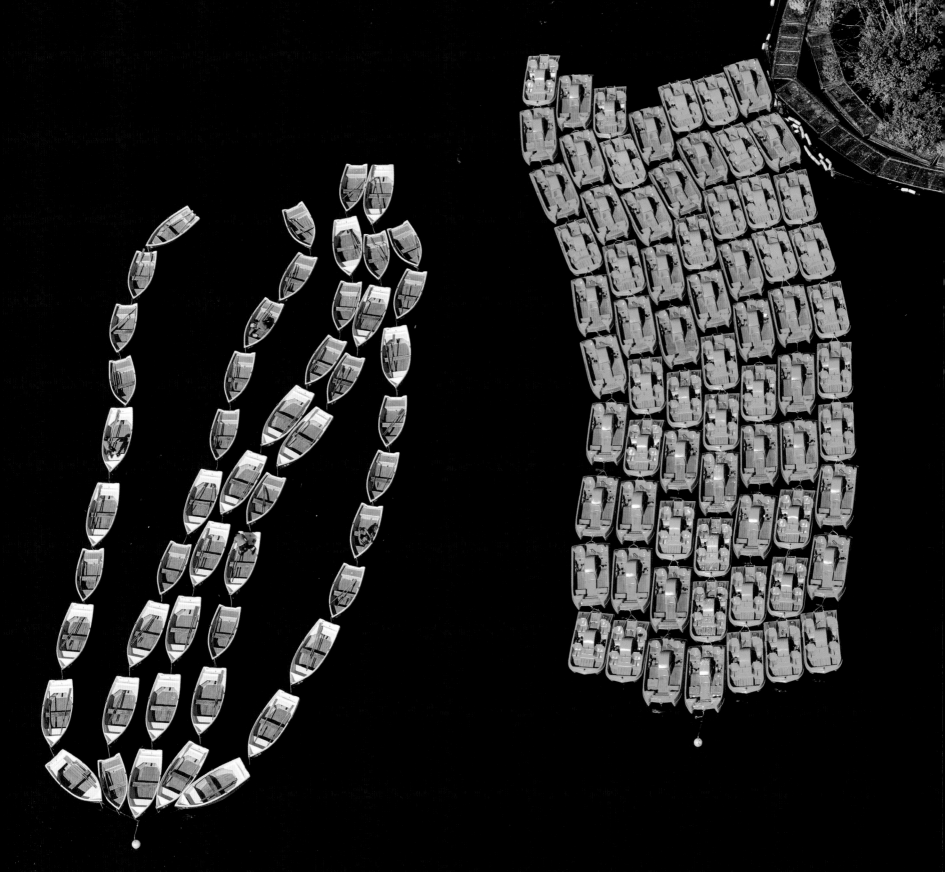

Concerts in Hyde Park attract audiences of over 50,000 during the summer months. World-class artistes such as Art Garfunkel, Bruce Springsteen, Eric Clapton, Celine Dion, Elton John, Paul McCartney, The Rolling Stones, Justin Timberlake, Paul Simon, Barbra Streisand, Rod Stewart, Stevie Wonder and other great musical luminaries have all performed here, with the concerts dating back to 1968. Both Paul McCartney and Bruce Springsteen had their microphones turned off whilst performing, as they both overshot the strict 10.30pm curfew!

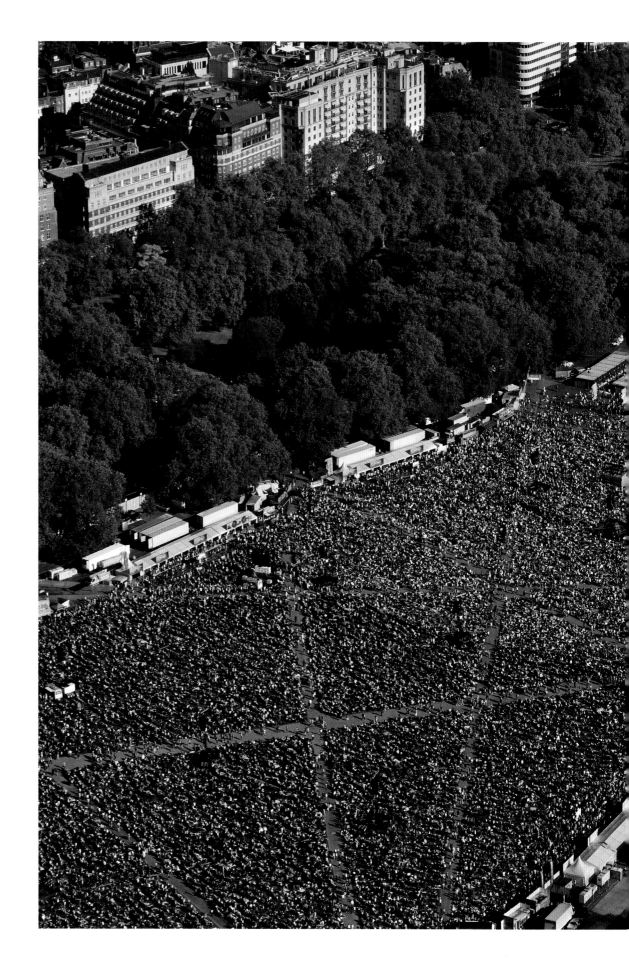

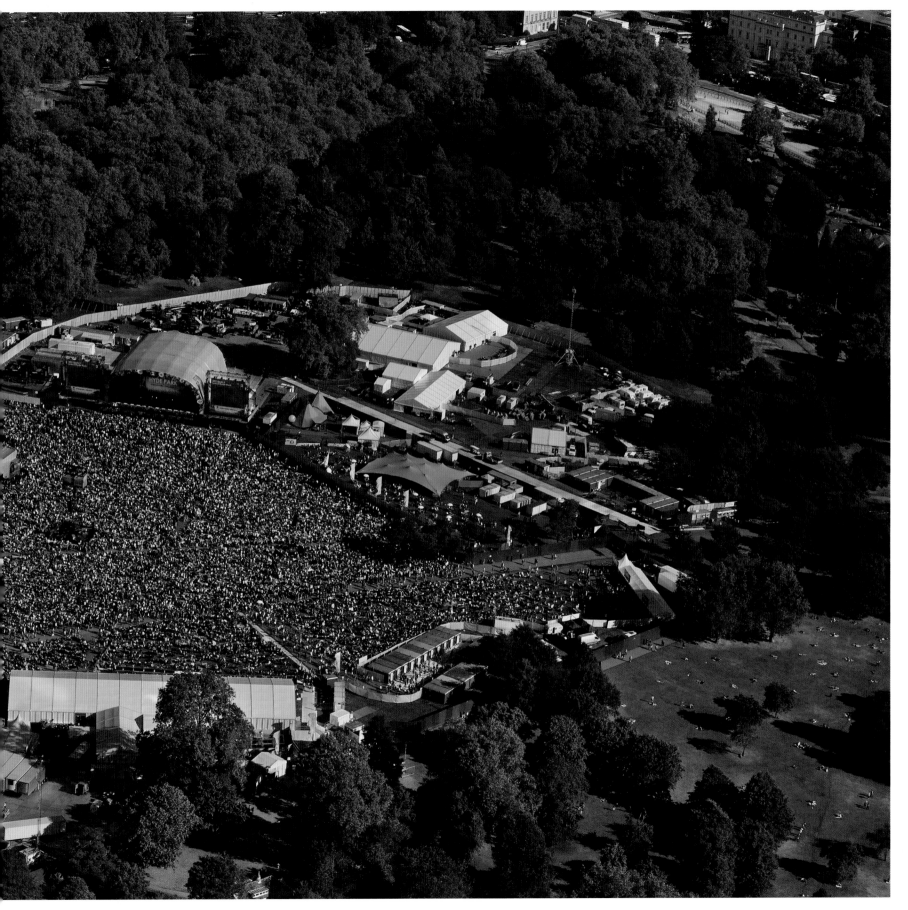

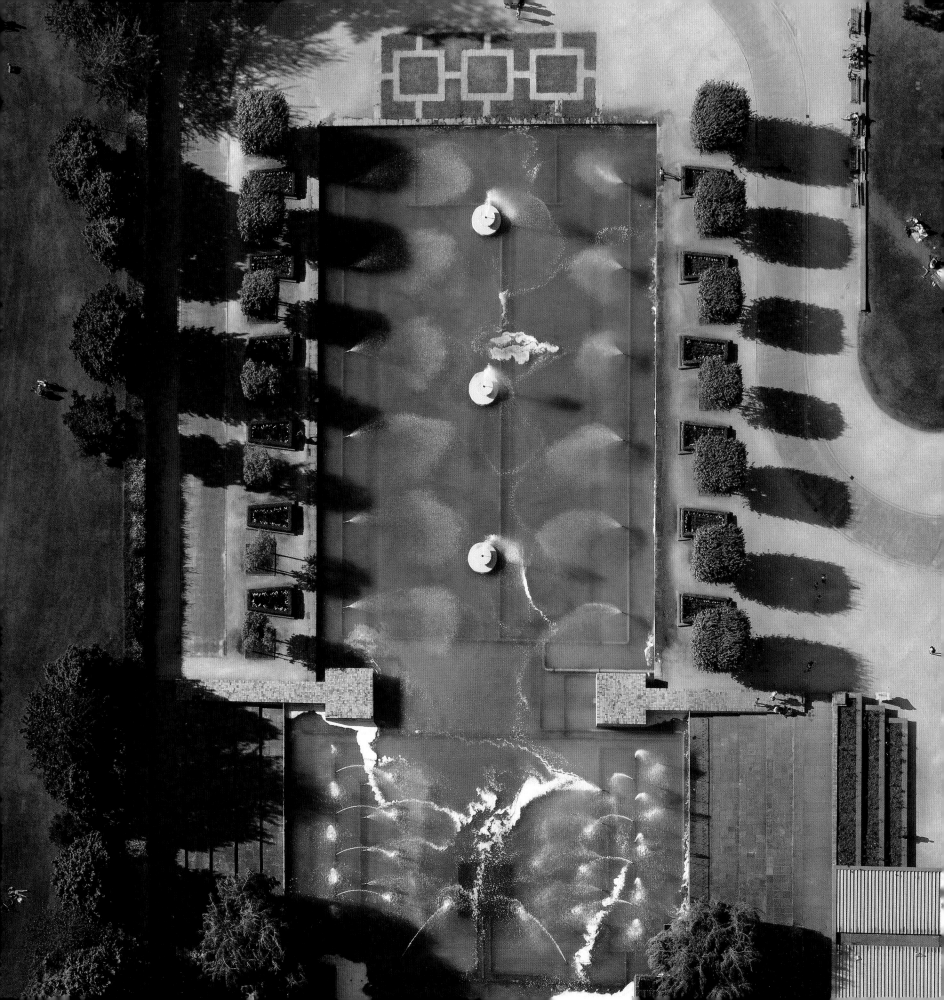

Battersea Park's Old English Garden includes 200 acres of gardens, a boating lake, the Peace Pagoda and woodland next to the River Thames. Before 1846 it was known as Battersea Fields and was a popular location for duelling. In 1864 the park hosted the first football game played under the rules of the recently formed Football Association.

Regent's Park (pages 88-89) contains London Zoo and the HQ of the Zoological Society of London. The park opened in 1835, initially for only two days a week. Running through the park is Regent's Canal, connecting the Grand Union Canal to London's historic docks.

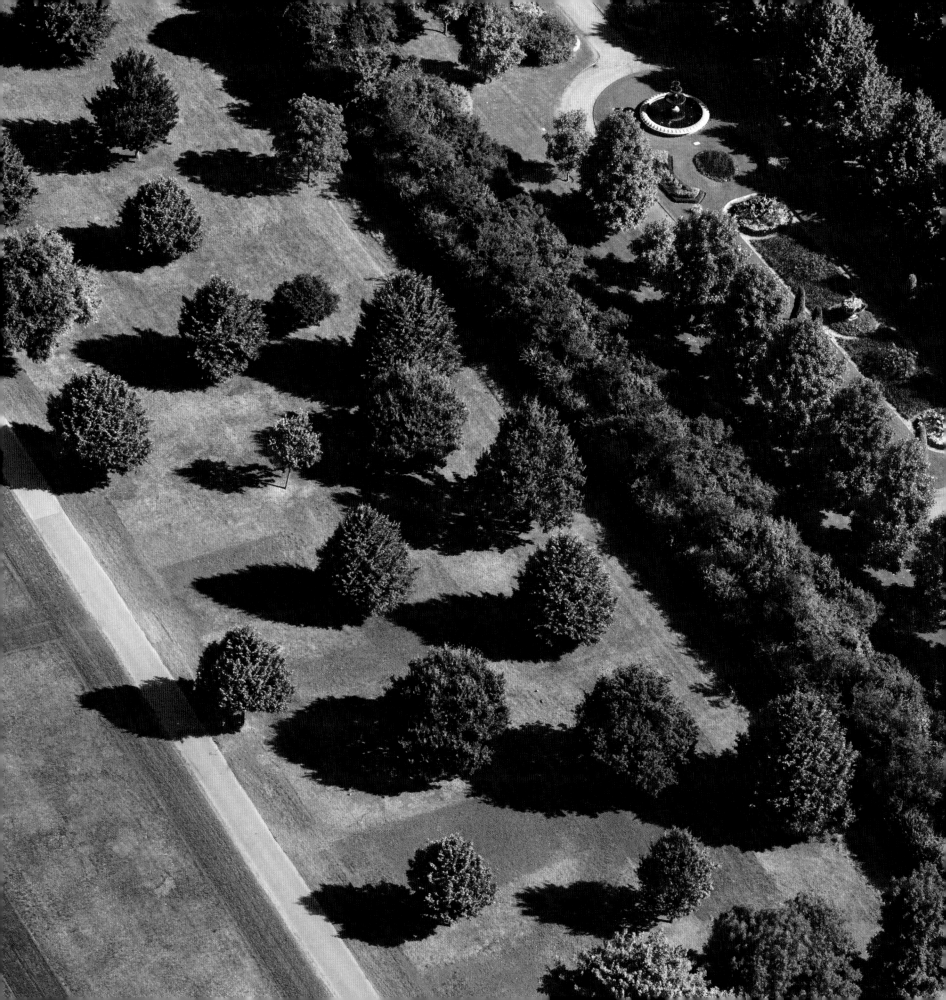

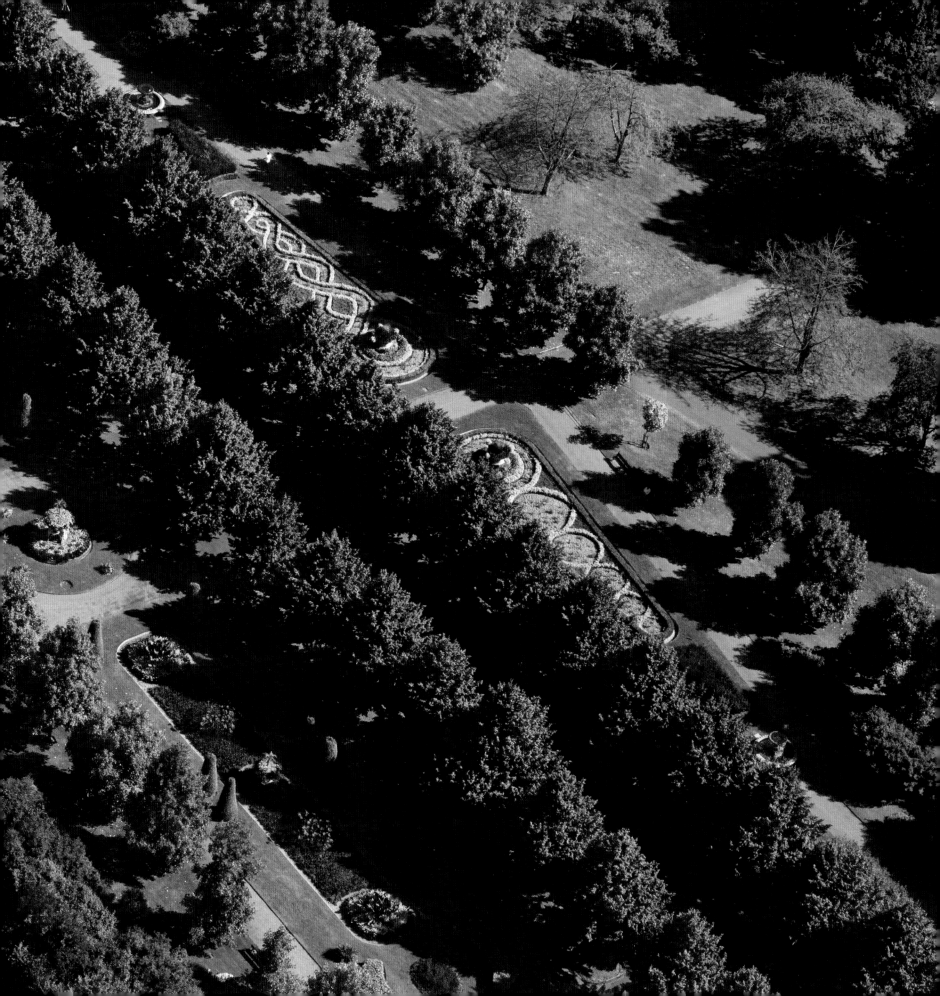

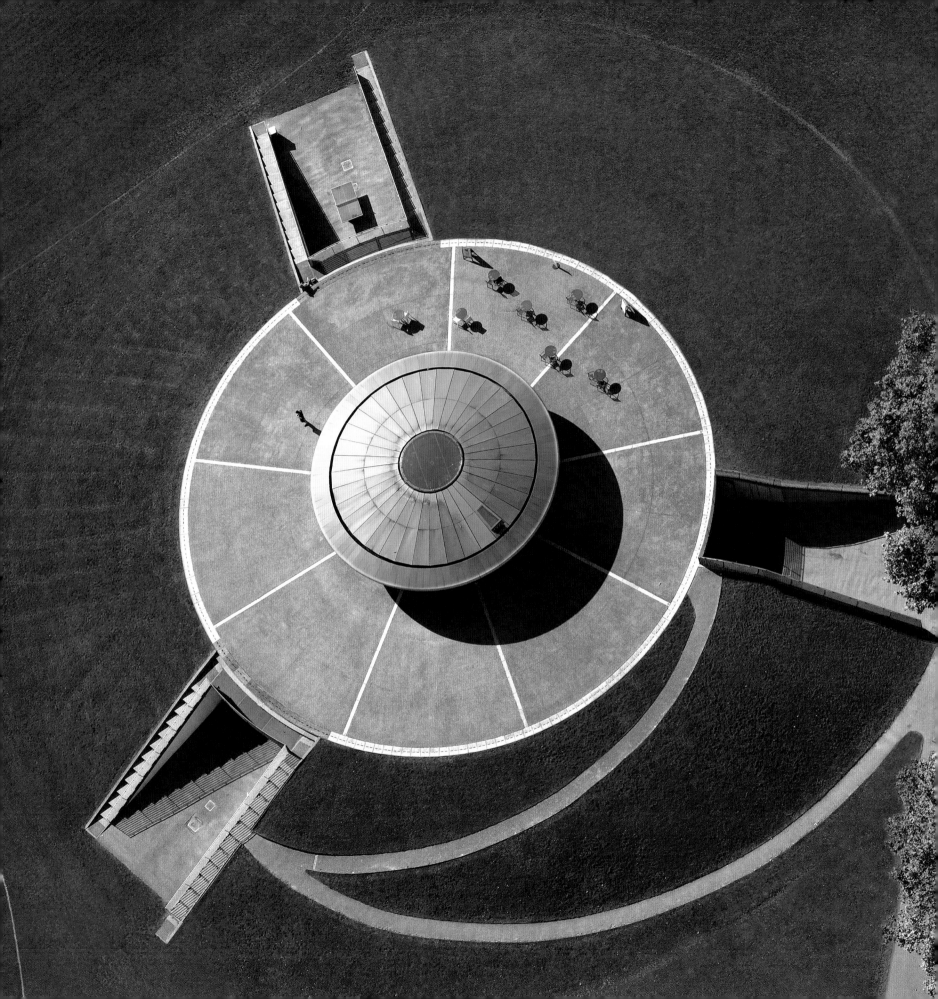

The Hub is neither a UFO nor a flying saucer but a café and sports centre in Regent's Park. The futuristic pavilion and underground sports facilities were designed by David Morley and opened by Queen Elizabeth II in 2005.

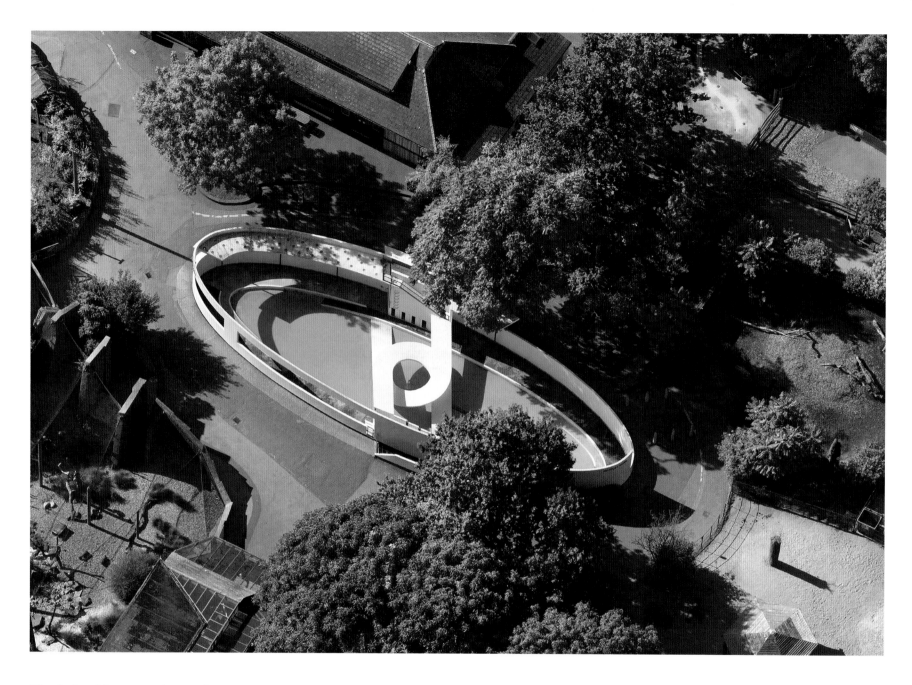

The Lubetkin Penguin Pool at London Zoo is Grade II listed and was designed in 1930 by Soviet émigré architect Berthold Romanovich Lubetkin. The penguins have long since departed and moved to a more natural habitat in the zoo.

The Old Elephant House at London Zoo (right) was designed by the distinguished architect and artist Sir Hugh Casson.

London Zoo is the world's oldest scientific zoo and opened on 27 April 1828. However, access to the public did not follow until almost 20 years later, in 1847. It currently houses 673 different species of animals.

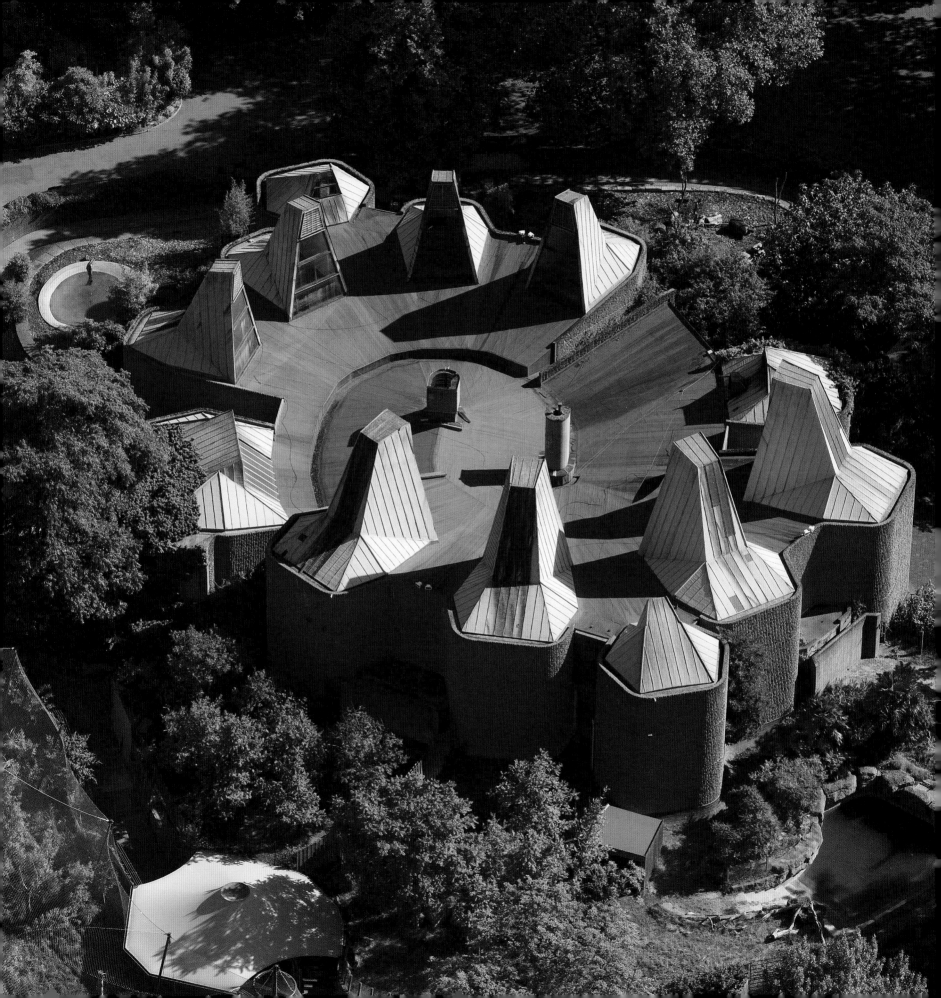

Tooting Bec Lido is large – at 91.44m (300ft) long and 30.18m (99ft) wide, it holds 1 million gallons of water and offers seasonal swimming from May to September in unheated fresh water.

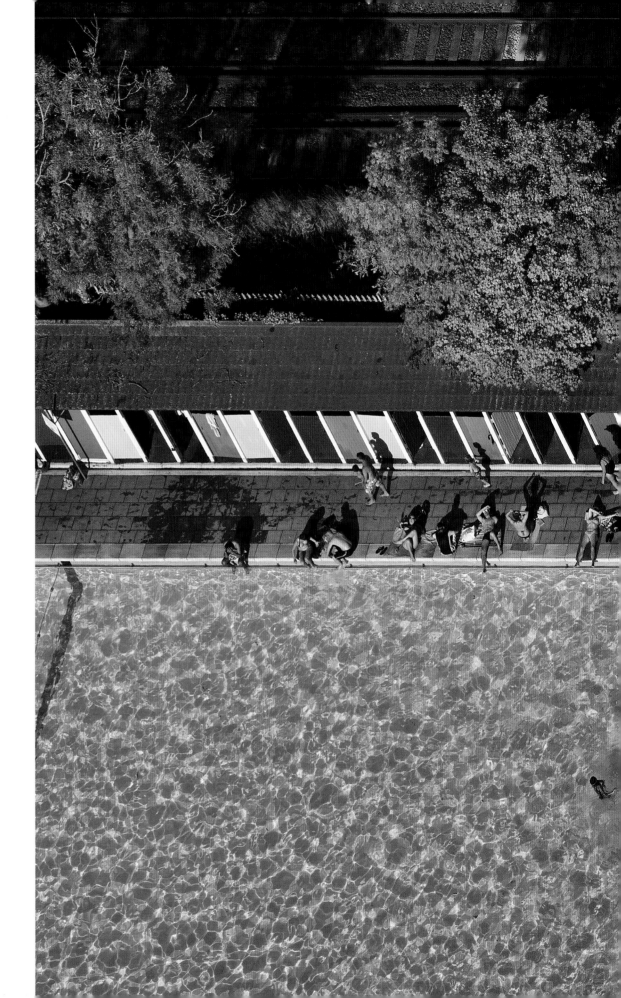

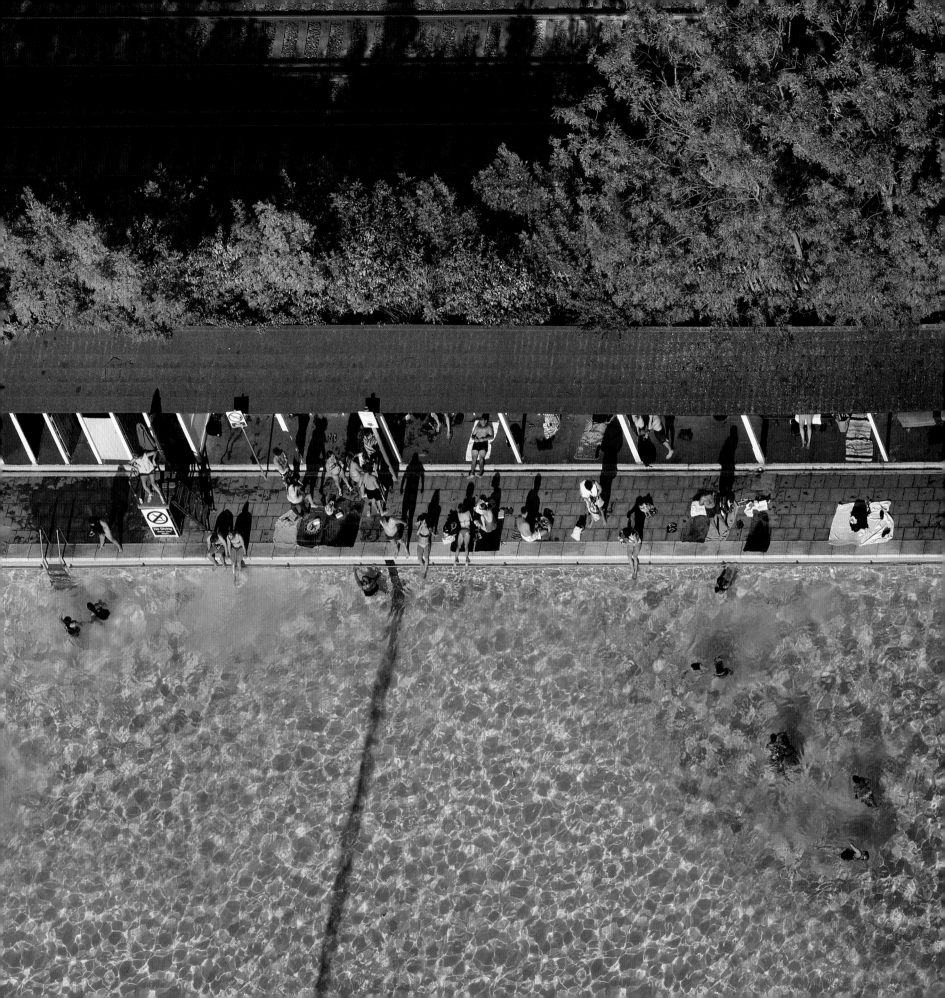

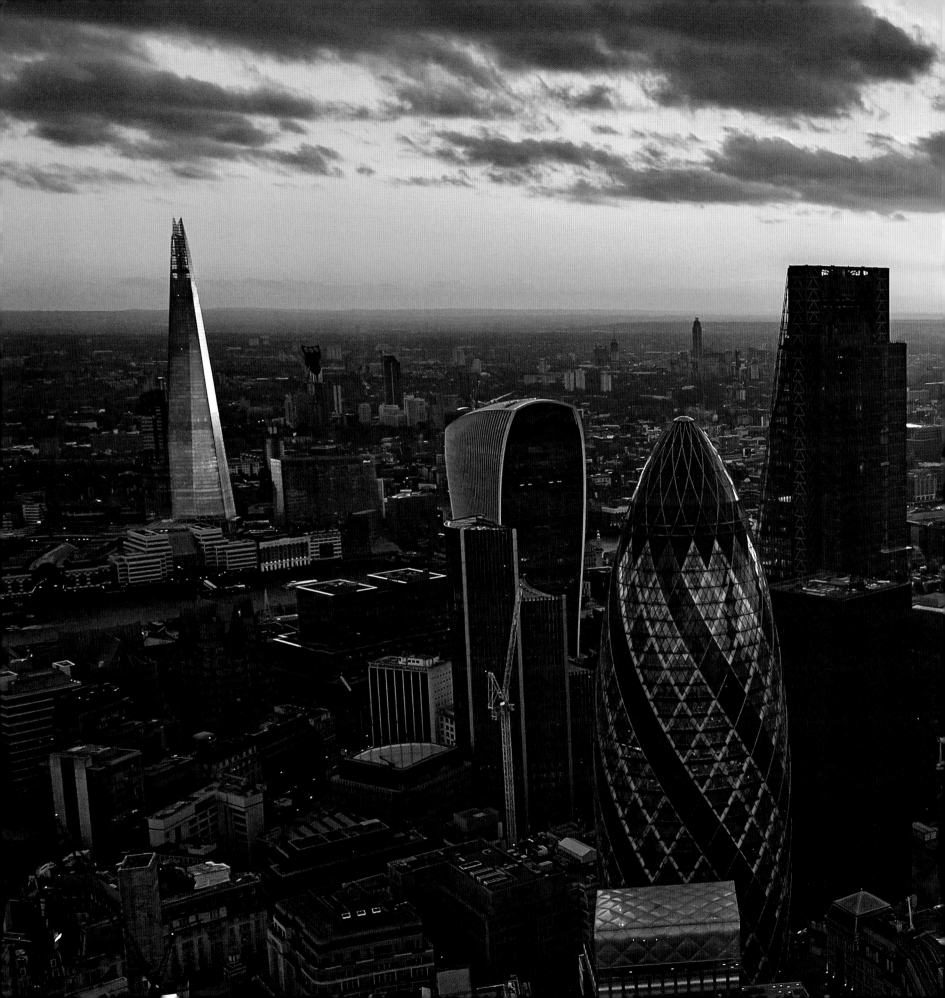

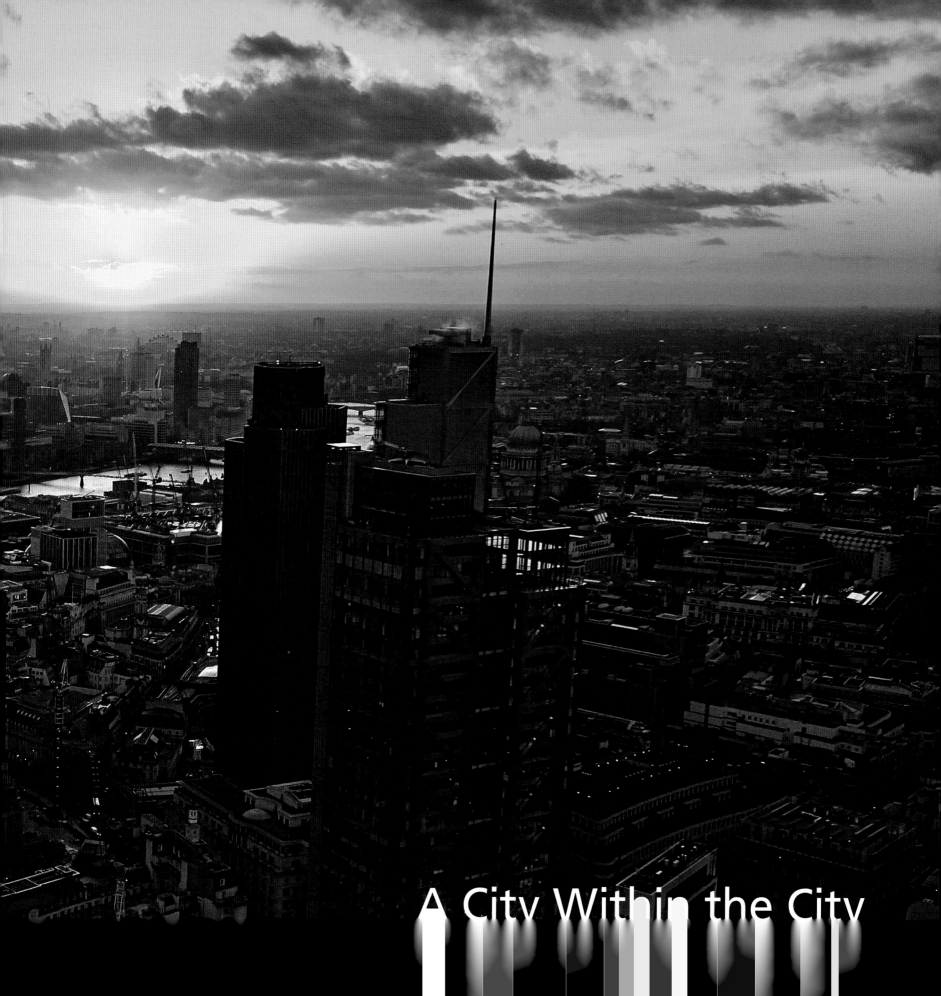

A City Within the City

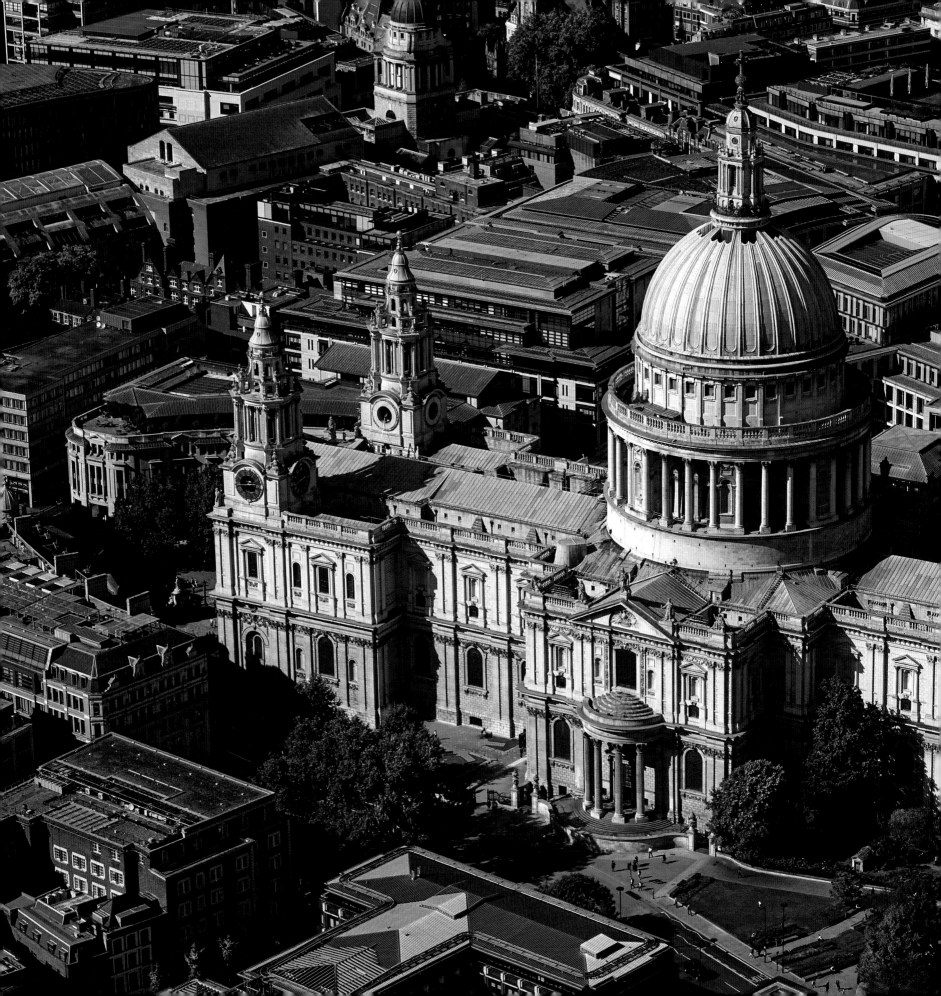

St Paul's Cathedral

Sir Christopher Wren's classic masterpiece of English baroque design is an Anglican cathedral and the mother church of the diocese of London. The site of a church since 604 AD, the present building dates to the late 17th century and was part of the rebuilding programme in the City following the Great Fire of London in 1666. Wren had a large design team composed of sculptors, surveyors and master masons working under him, as well as a budding architect called Nicholas Hawksmoor, who went on to design many other London churches.

St. Paul's Cathedral and Paternoster Square

The dome of St. Paul's has dominated the London skyline for over 300 years. It is 111m (365ft) high and until 1967 was the tallest building in London. The Stone Gallery which circles the dome can be reached by climbing 376 stairs. Numerous significant events have been held here, including the funerals of Admiral Nelson, the Duke of Wellington, Sir Winston Churchill and Margaret Thatcher, the wedding of Charles, Prince of Wales and Diana, and thanksgiving services for the Silver, Golden and Diamond Jubilees of Queen Elizabeth II.

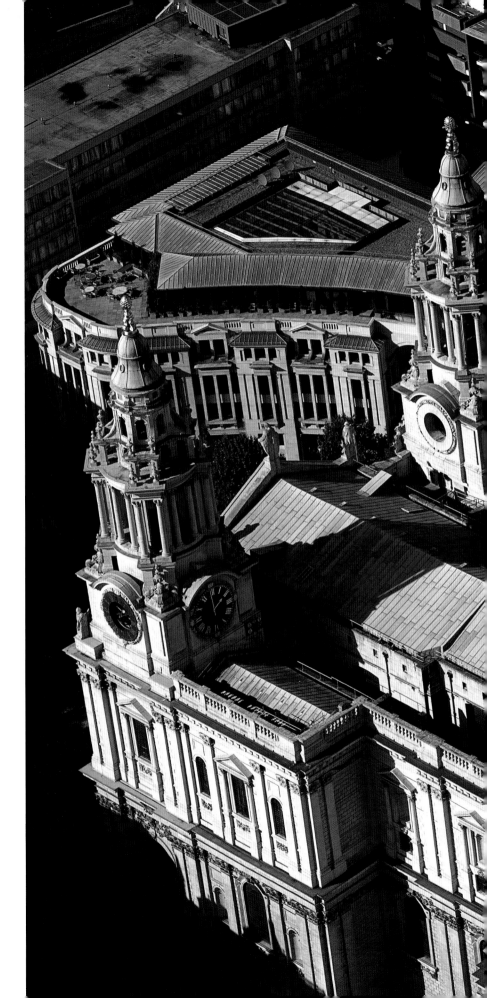

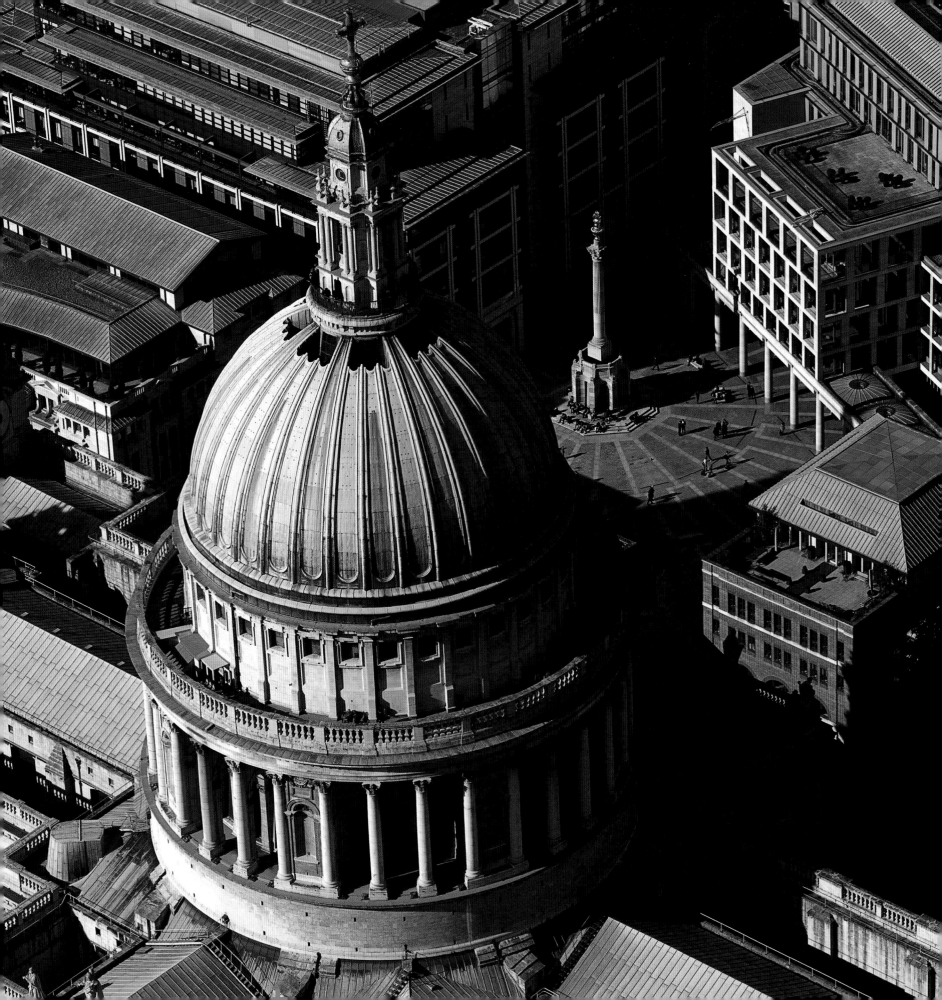

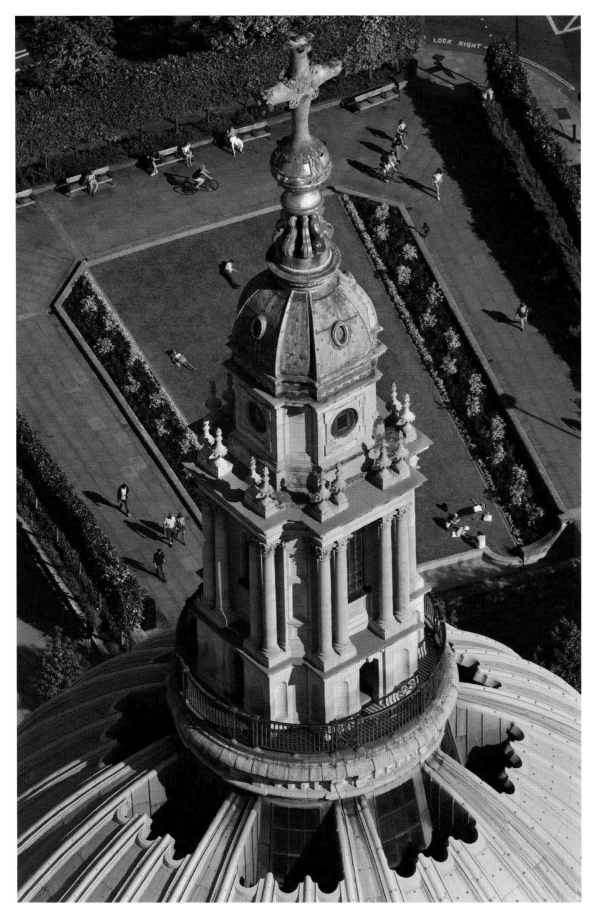

The Golden Gallery and cross of St Paul's Cathedral stands at a majestic height of 111m (365ft). To reach this eyrie, the Golden Gallery just below the cross, requires mounting 528 stairs.

St Paul's Cathedral (right) has the simple cross-like design of most churches which is the symbol of Christianity.

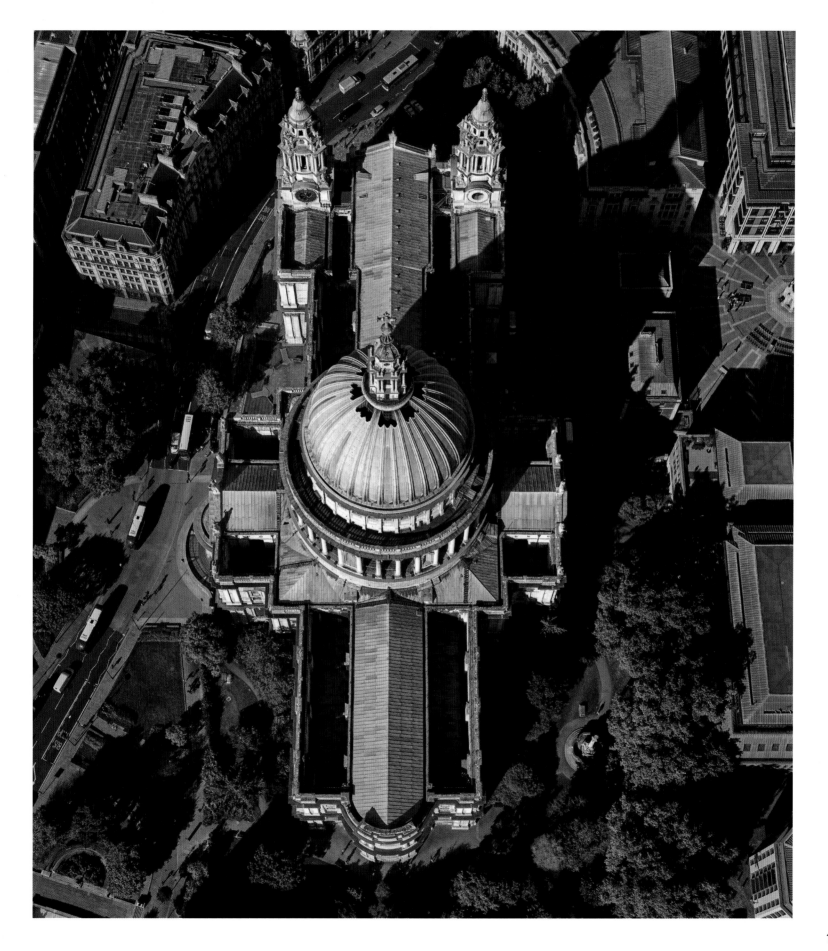

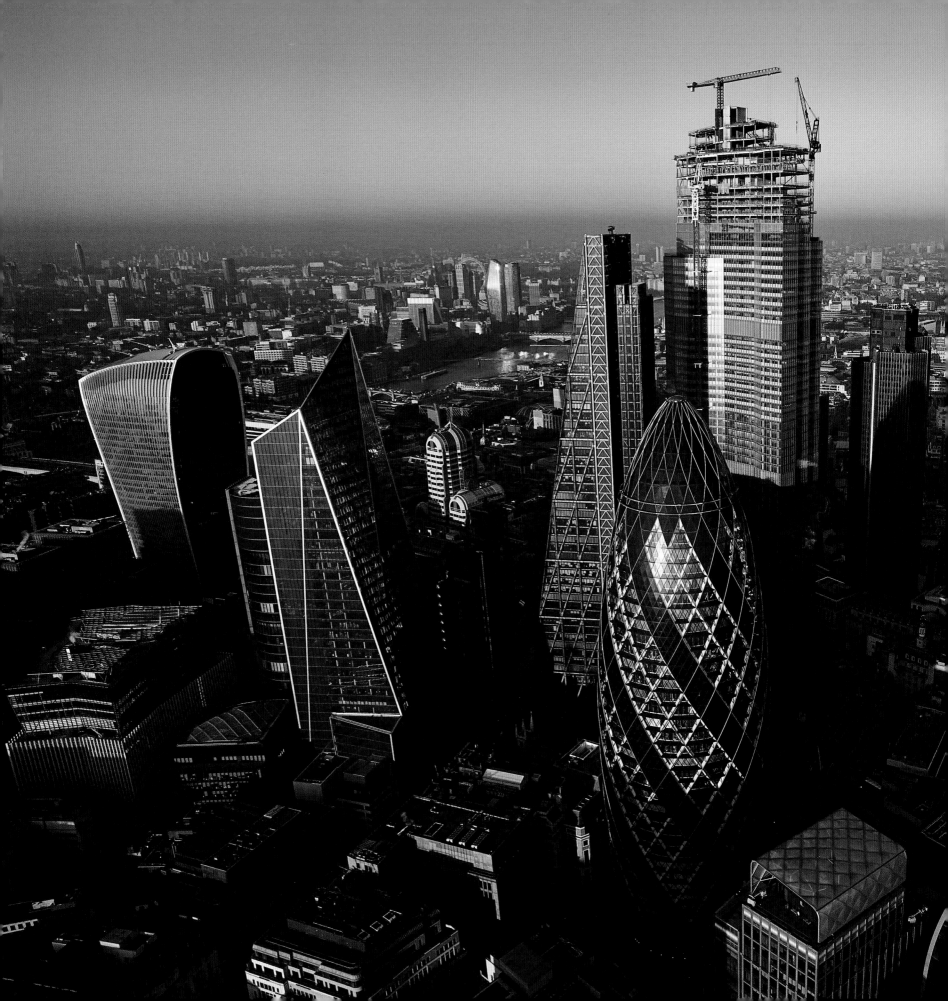

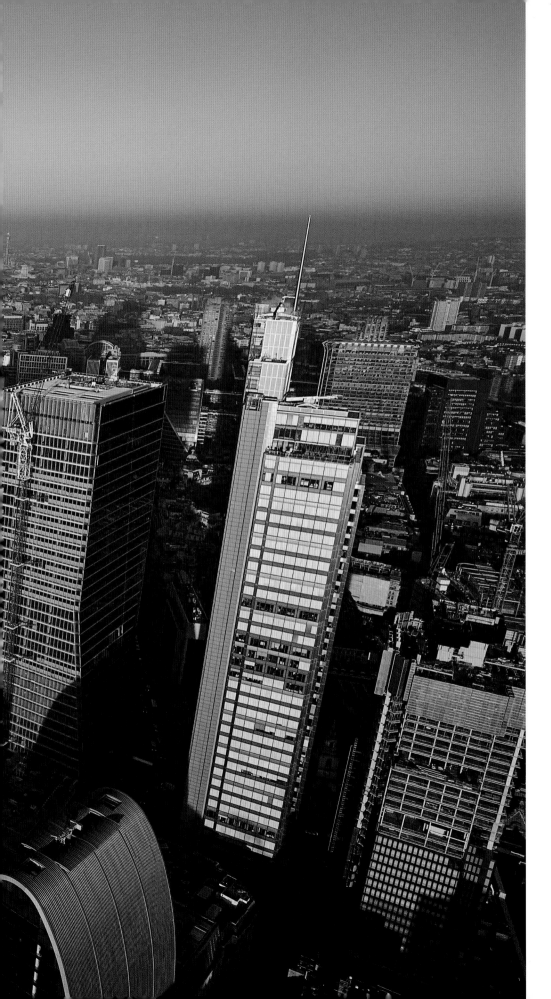

The City Hub is an impressive skyline of skyscrapers jostling for their position in the architectural hierarchy. Left to right they are: the Walkie Talkie, the Scalpel, the Cheesegrater, the Gherkin, the Pinnacle (under construction), Tower 42, 100 and 110 Bishopsgate (formerly Heron Tower), and the sculptured, curved top of the Can of Ham in the bottom right.

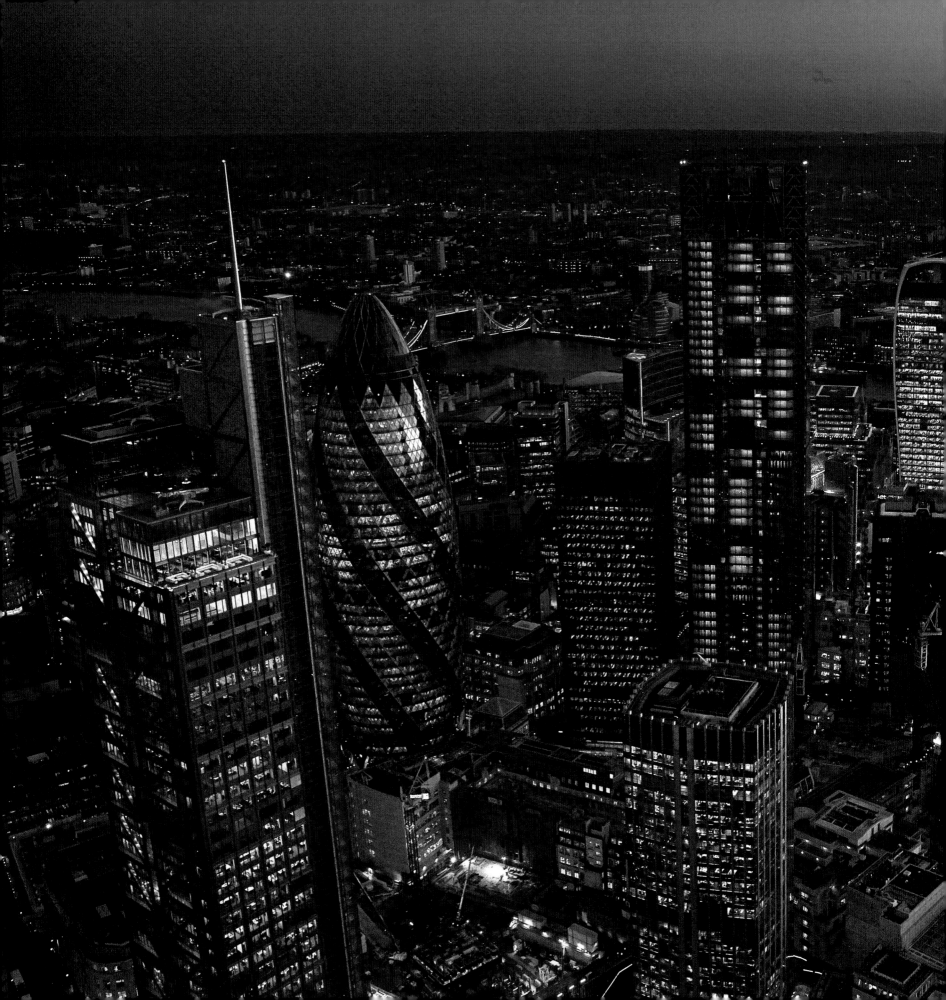

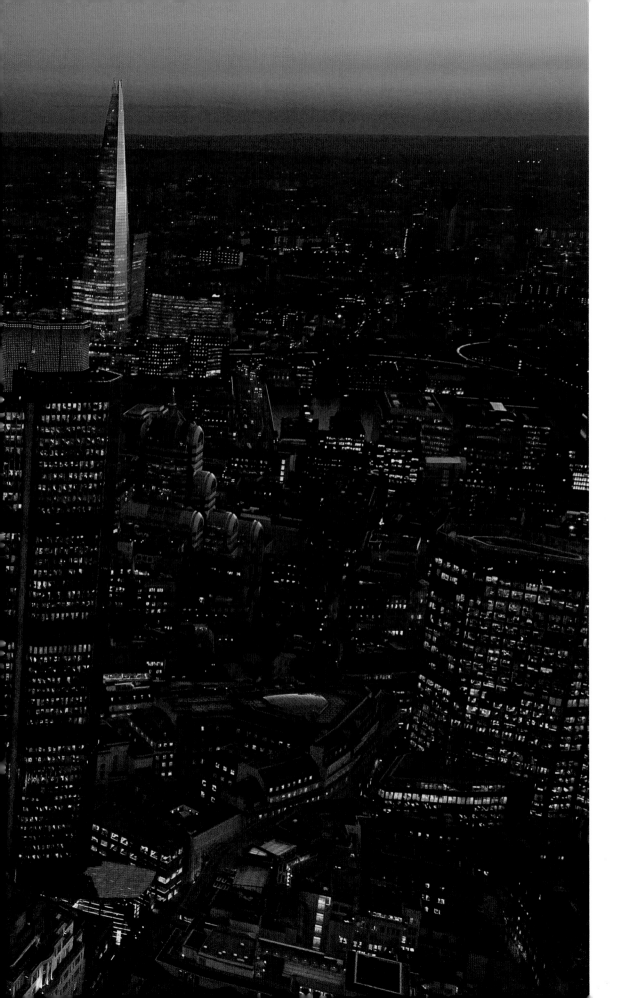

The City of London is a city within a city, also sometimes referred to as the Square Mile, due to its 1.12sq mi (2.90km²) area. It now has a population of less than 10,000 but 300,000 daily commuters. Since the 19th century it has consistently been the world's foremost business centre and remains so today. The boundaries of this small area are marked with black bollards bearing the City's distinct coat of arms, a silver shield bearing a red cross and a red upright sword, the cross of St George and a symbol of the martyrdom of St Paul.

The City of London, looking north,
has at the bottom left of the shot City
Hall, the London Assembly's HQ and,
behind that, HMS *Belfast*. Bottom right
is Butler's Wharf in the historic street
of Shad Thames, Bermondsey, with its
luxurious flats and restaurants.

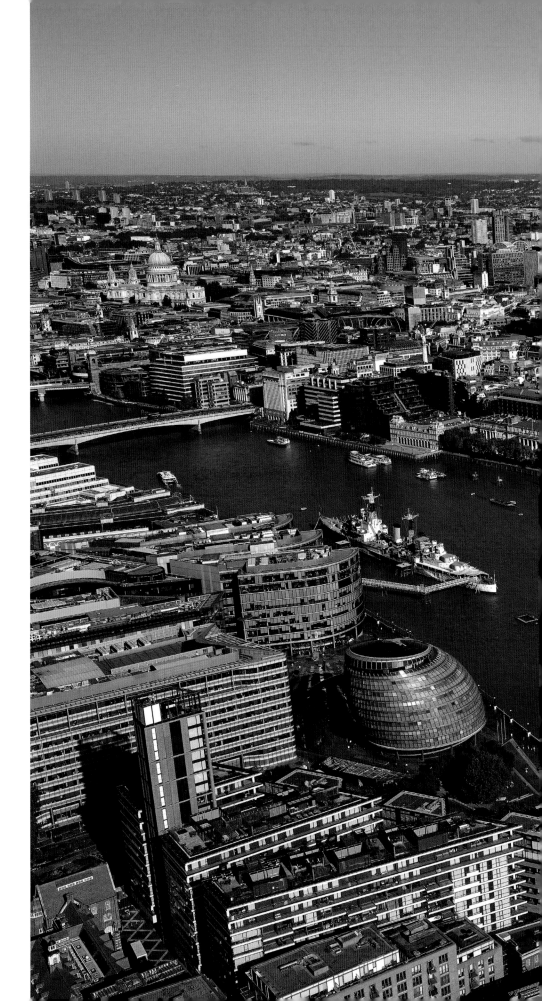

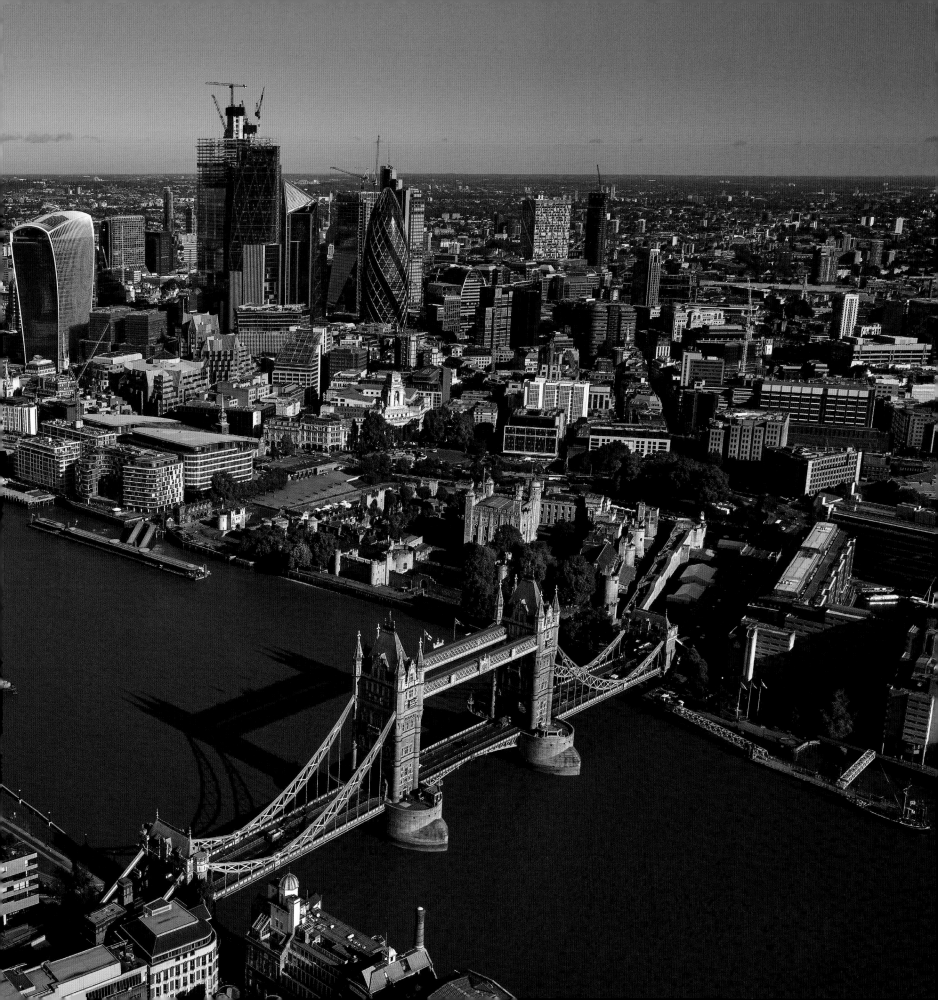

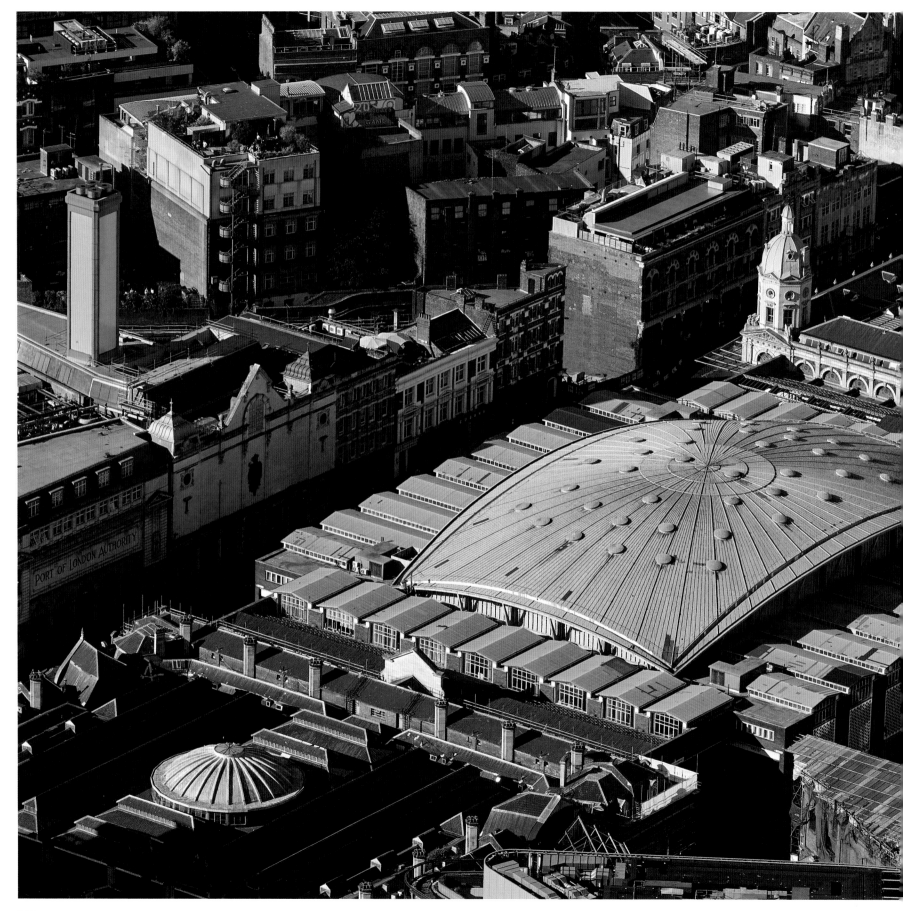

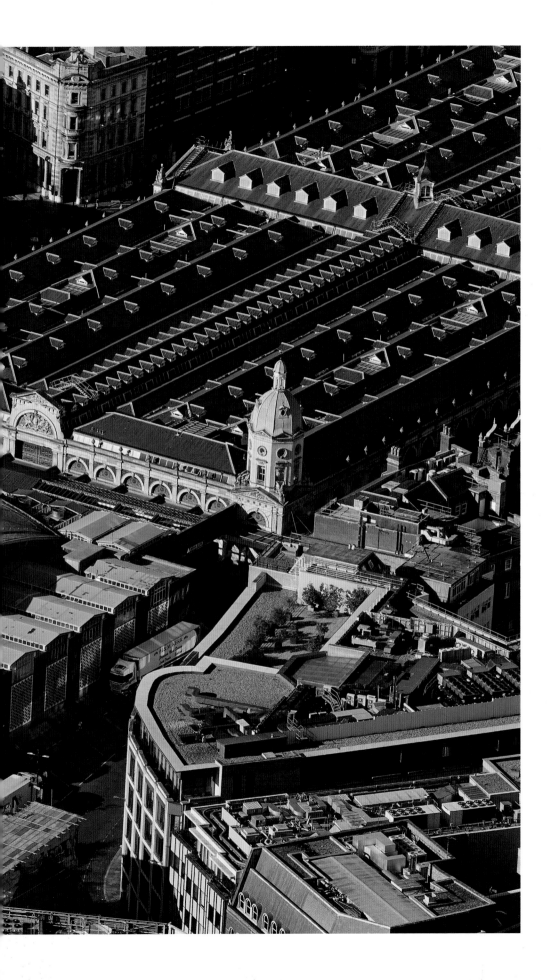

Smithfield Meat Market, West Smithfield, with its magnificent copper roof, is Grade II listed. The covered market was designed by the Victorian architect Horace Jones and completed in 1868. Meat has been traded at this site for over 800 years, making it one of the oldest working markets in London, and a livestock market previously occupied the site as early as the 10th century.

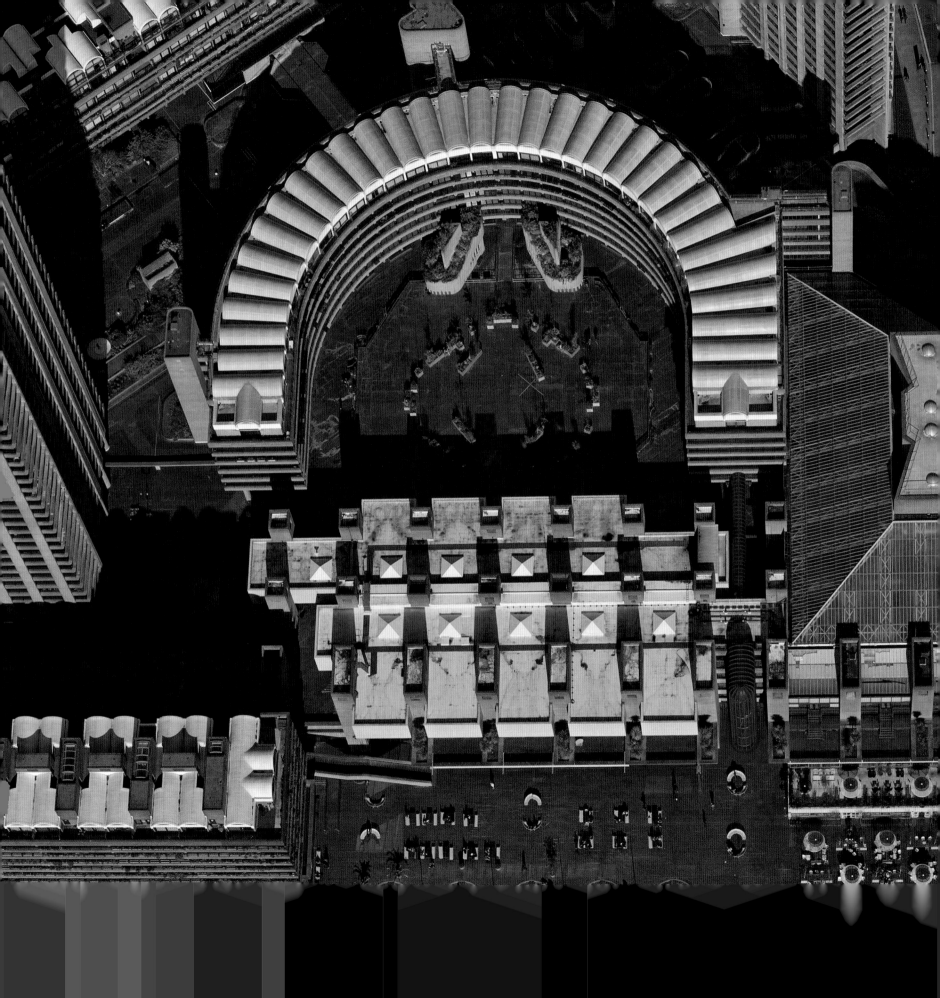

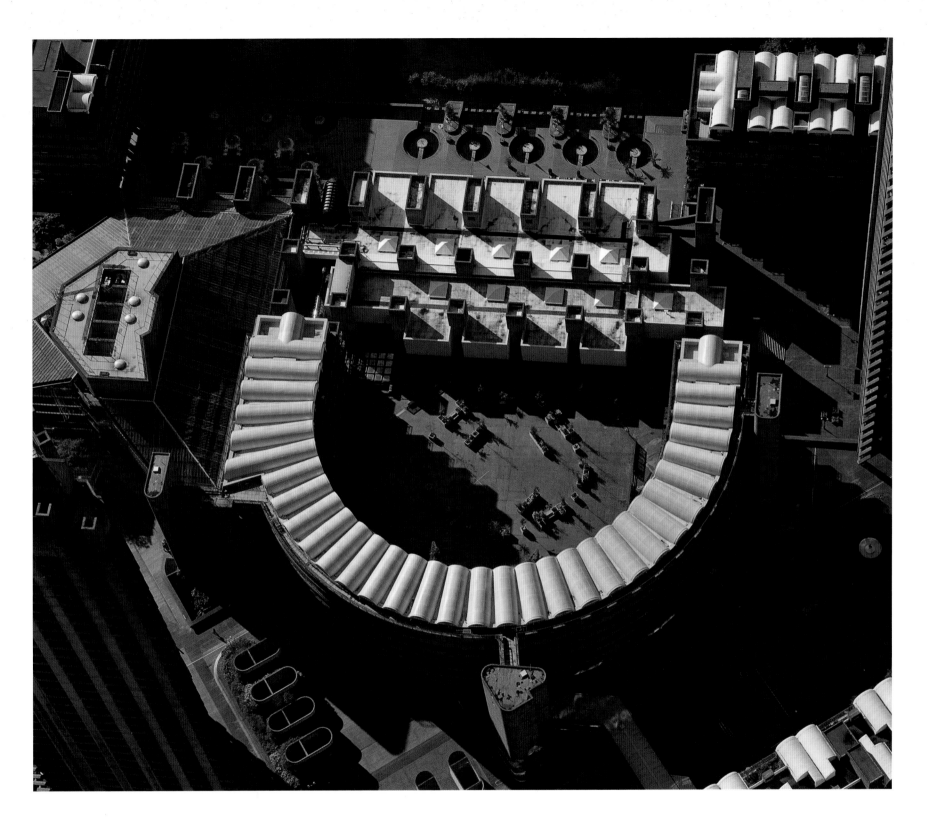

The Barbican Estate is a residential development built between 1960 and 1980 in an area devastated by World War II bombings.

The Barbican Centre, opened in 1982, is Grade II listed and an excellent example of the brutalist architecture of that period, designed by architects Chamberlin, Powell and Bon.

The Guildhall, Moorgate, is the town hall and administrative and ceremonial centre of the City of London and its Corporation. It is Grade I listed and was built between 1411 and 1440. George Dance's grand Hindoostani Gothic entrance to the east wing was added in 1788.

Exchange Square (page 116), is a popular lunchtime location for city office workers to enjoy the sun. Until the 1990s, when Canary Wharf appeared on the landscape, this was the largest office development in the city.

Broadgate Circle (page 117) is a shopping mall at the heart of the Broadgate Estate, designed by Arup Associates between 1987 and 2015. Previously host to an open-air ice rink, this is a historic link back to the 12th century, when Londoners skated on the frozen marshes upon which the site is built. During the rest of the year there are all sorts of fun events taking place.

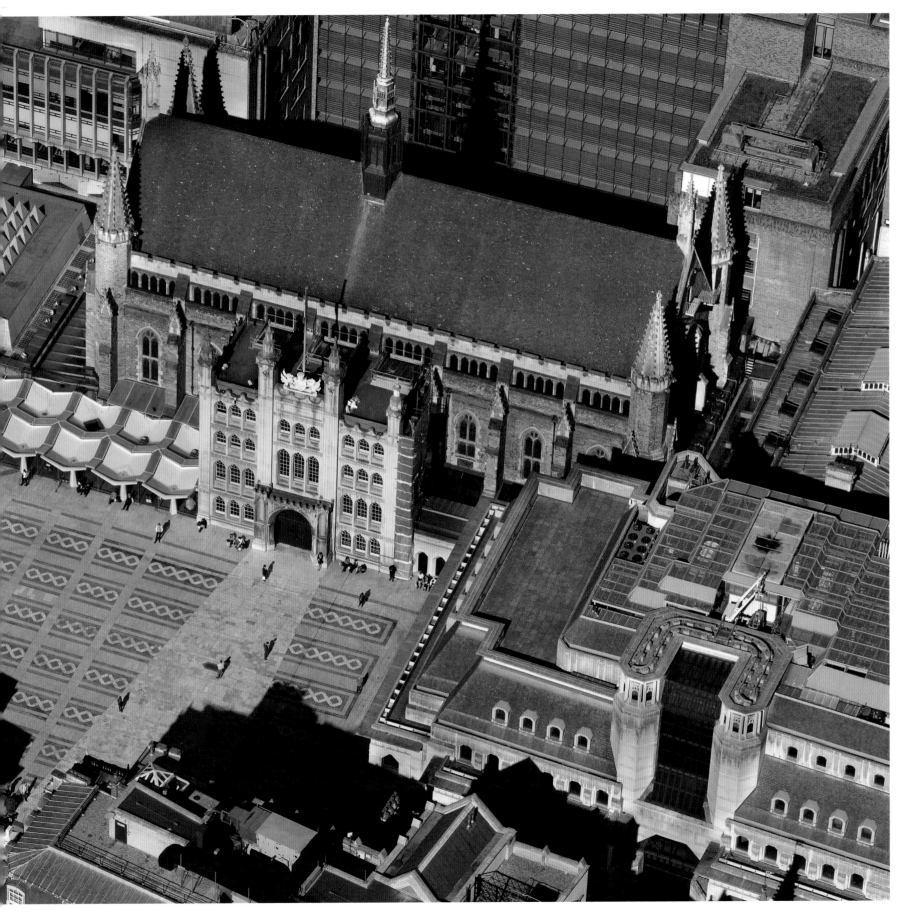

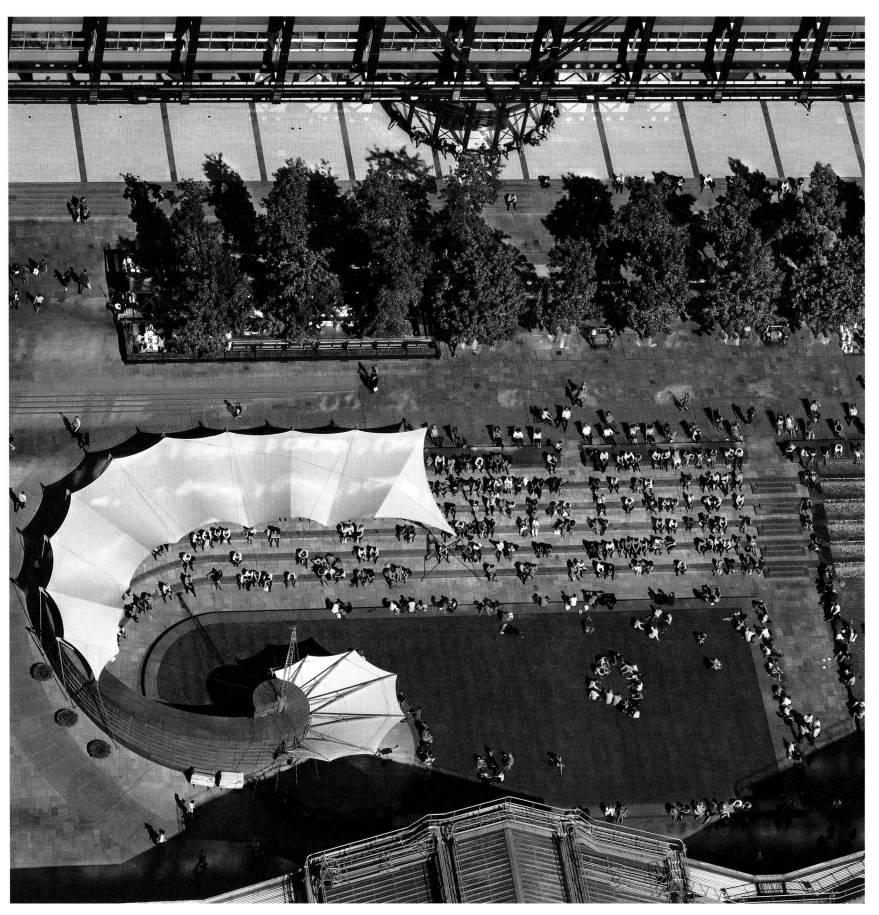

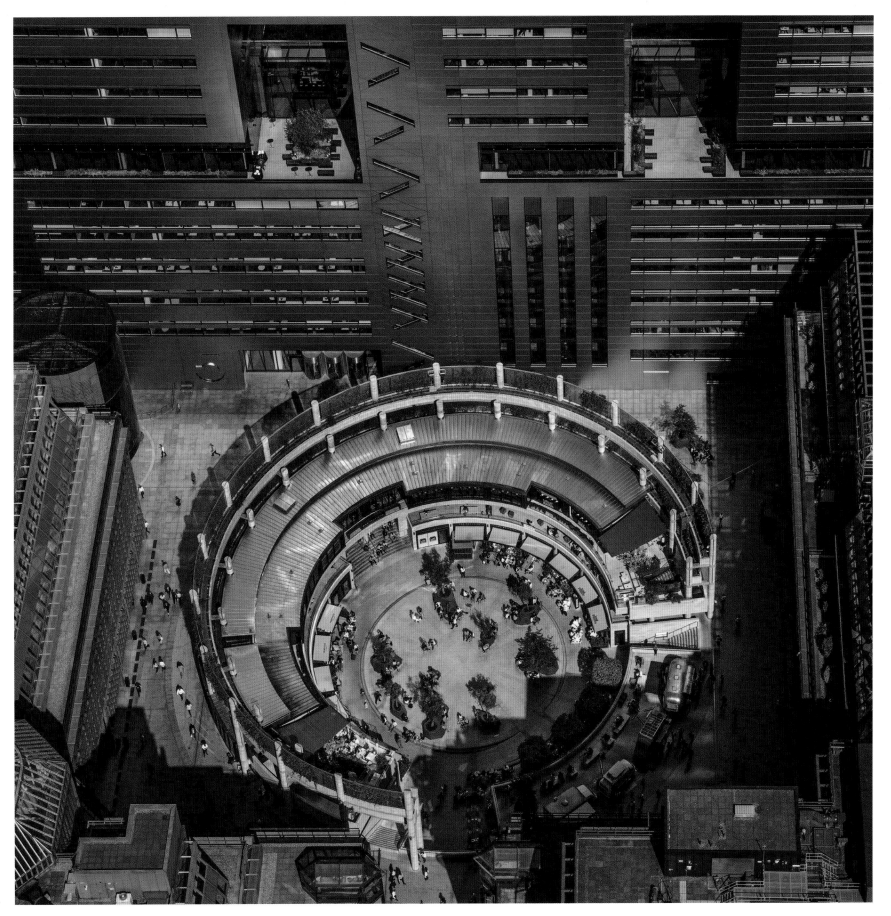

The Bank of England, Threadneedle Street, is the central bank of the UK. Established in 1694, it is the world's eighth-oldest bank. Its vaults contain a staggering 200 billion pounds of gold and opening them requires keys measuring 91cm (3ft). It was originally built between 1790 and 1827 under the direction of its chief architect, Sir John Soane. In the first half of the 20th century, Sir Herbert Baker demolished most of Soane's brilliant work, which has been described as the greatest architectural crime in the City of London.

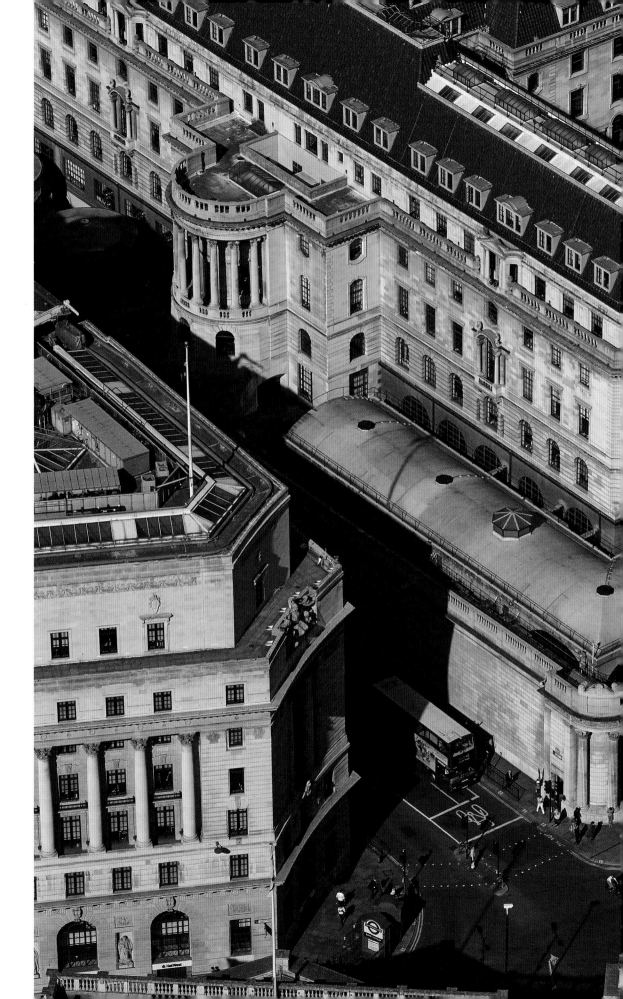

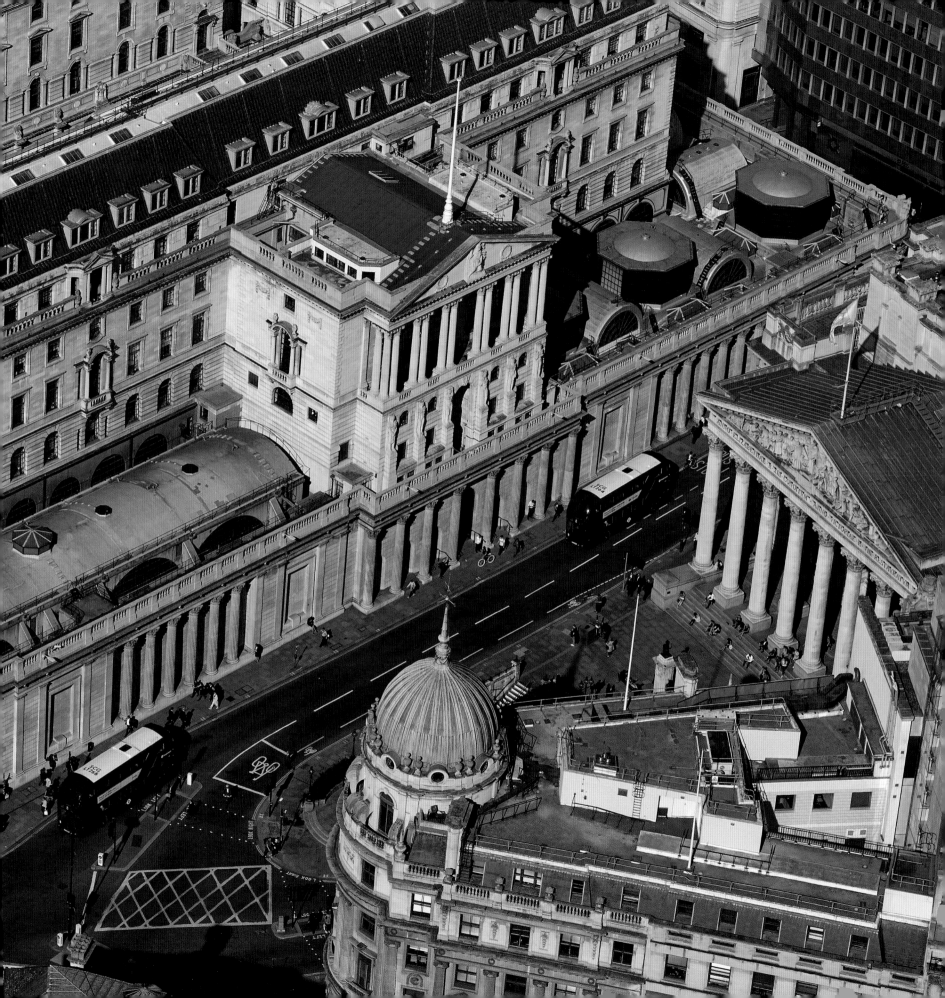

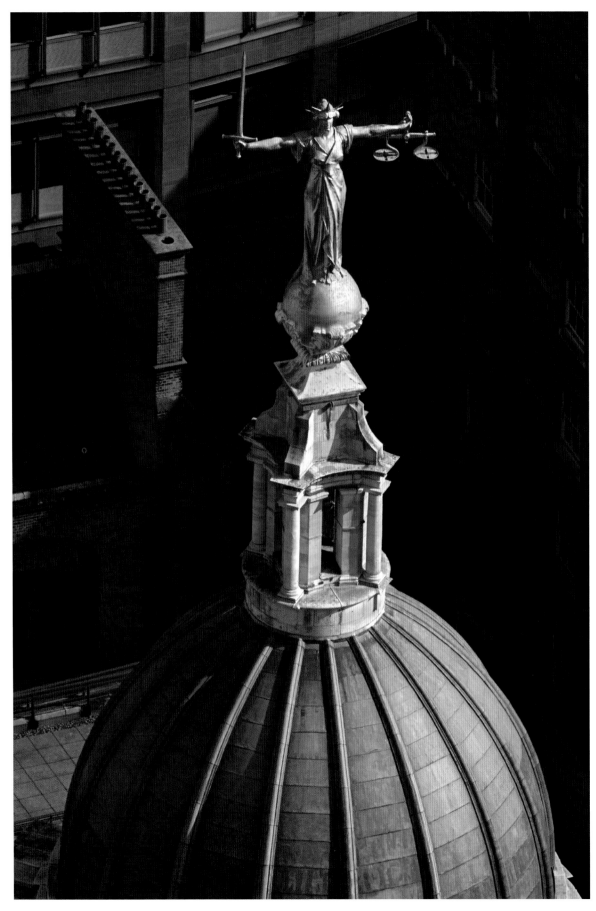

Scales of Justice, Central Criminal Court of England and Wales, was built on the site of the infamous Newgate Prison and is commonly known as 'The Old Bailey', after the street it is located in. The gilded statue of Lady Justice holding scales on top of the dome represents the weighing up of evidence, whilst the sword represents the administration of justice.

The Monument is a Doric column commemorating the Great Fire of London in 1666 and also celebrating the rebuilding of the city. Constructed between 1671 and 1677, it was designed by Sir Christopher Wren and his friend Robert Hooke, the scientist. It is only 62m (203ft) tall, its height marking its distance from Thomas Farriner's baker's shop in Pudding Lane, where the blaze began. Today it is dwarfed by the many skyscrapers which have sprung up around it.

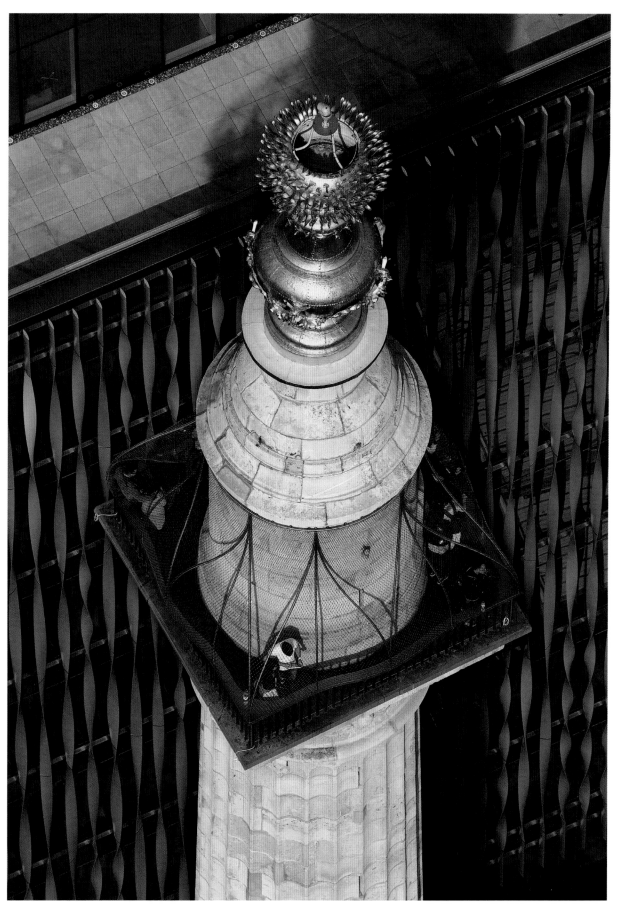

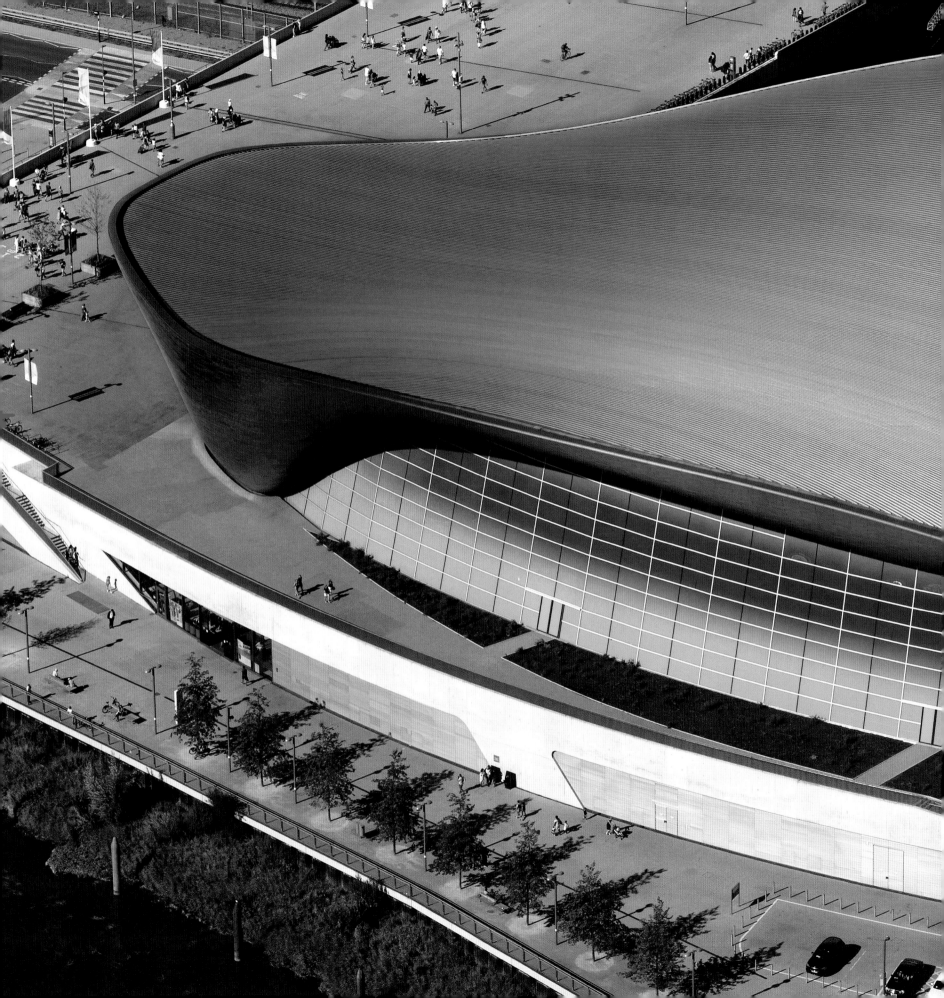

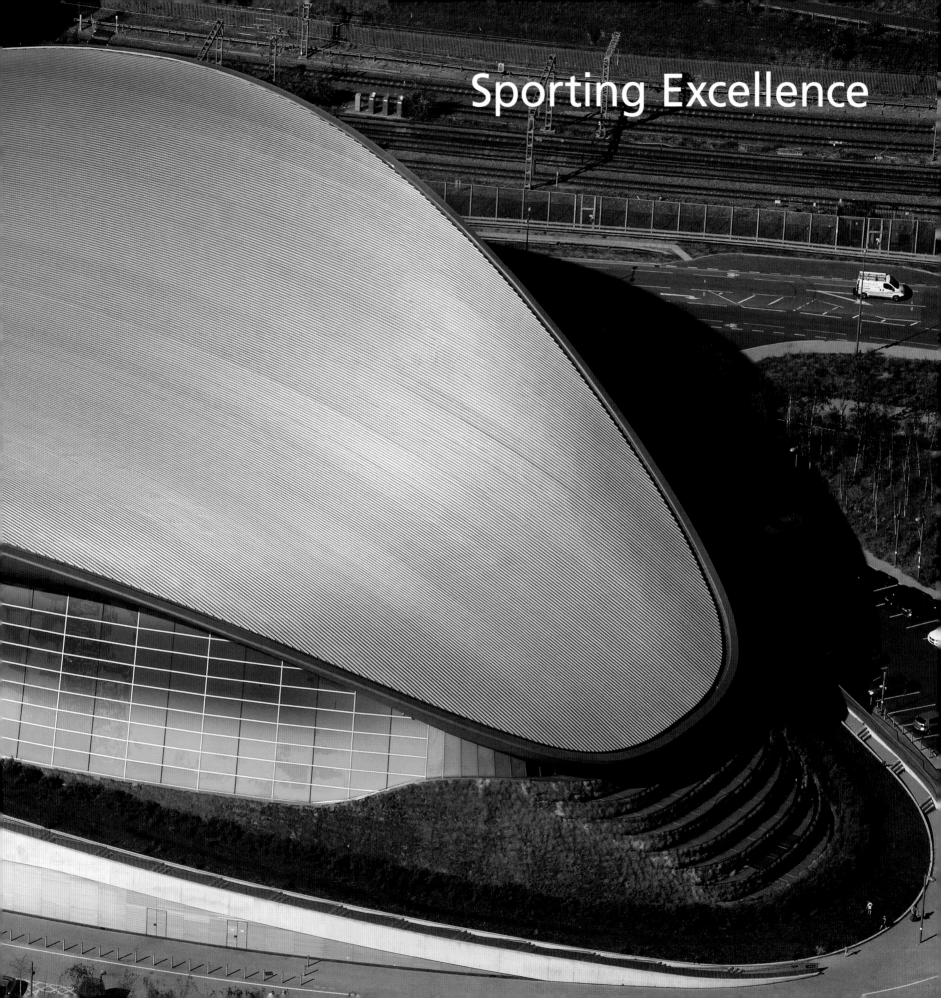

Sporting Excellence

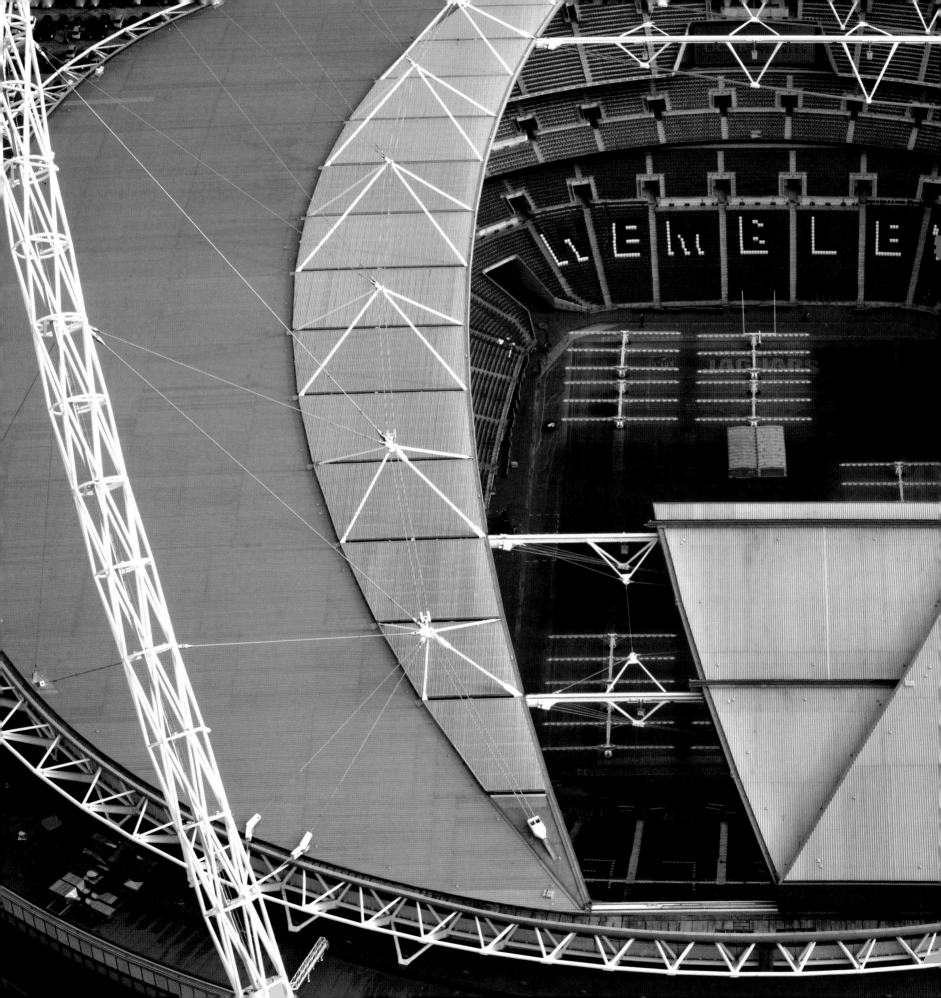

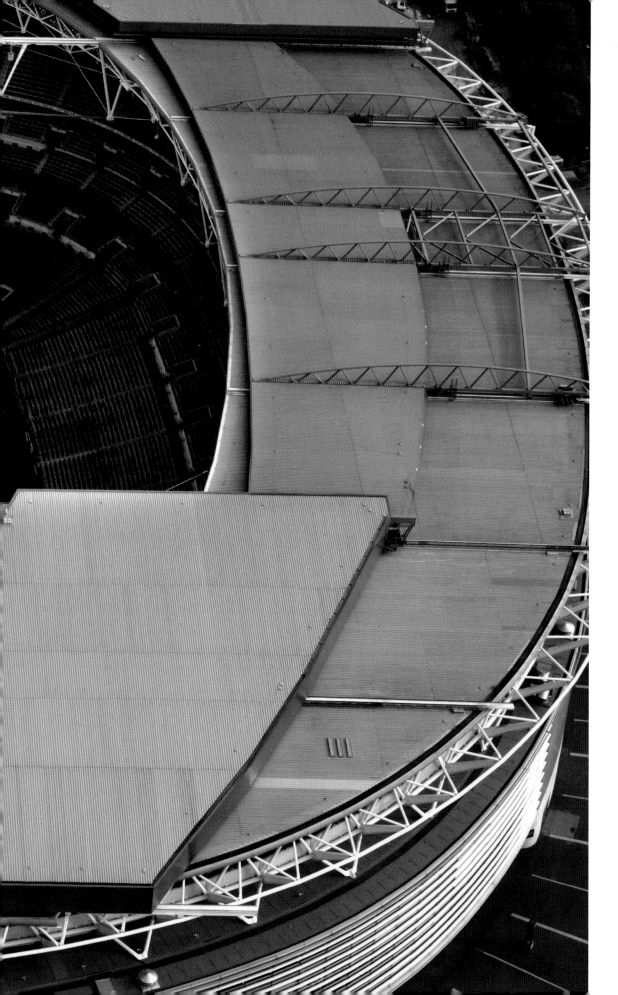

Wembley Stadium's iconic arch, which rises to 133m (436ft), is clearly visible as a landmark across London; at 315m (1033ft), it is the largest single span structure in the world. Contrary to belief, the sliding roof does not in fact cover the pitch and only opens partially to allow sunlight to propagate the growth of the grass.

The London Stadium (pages 126-127), Stratford, is a multi-purpose outdoor stadium in the Queen Elizabeth Olympic Park and is now the home of West Ham Football Club. It was constructed for the 2012 Olympic Games for field and track events and was also the venue for the opening and closing ceremonies. Designed by Populous and built by Sir Robert McAlpine, it has a capacity for 60,000 sports fans.

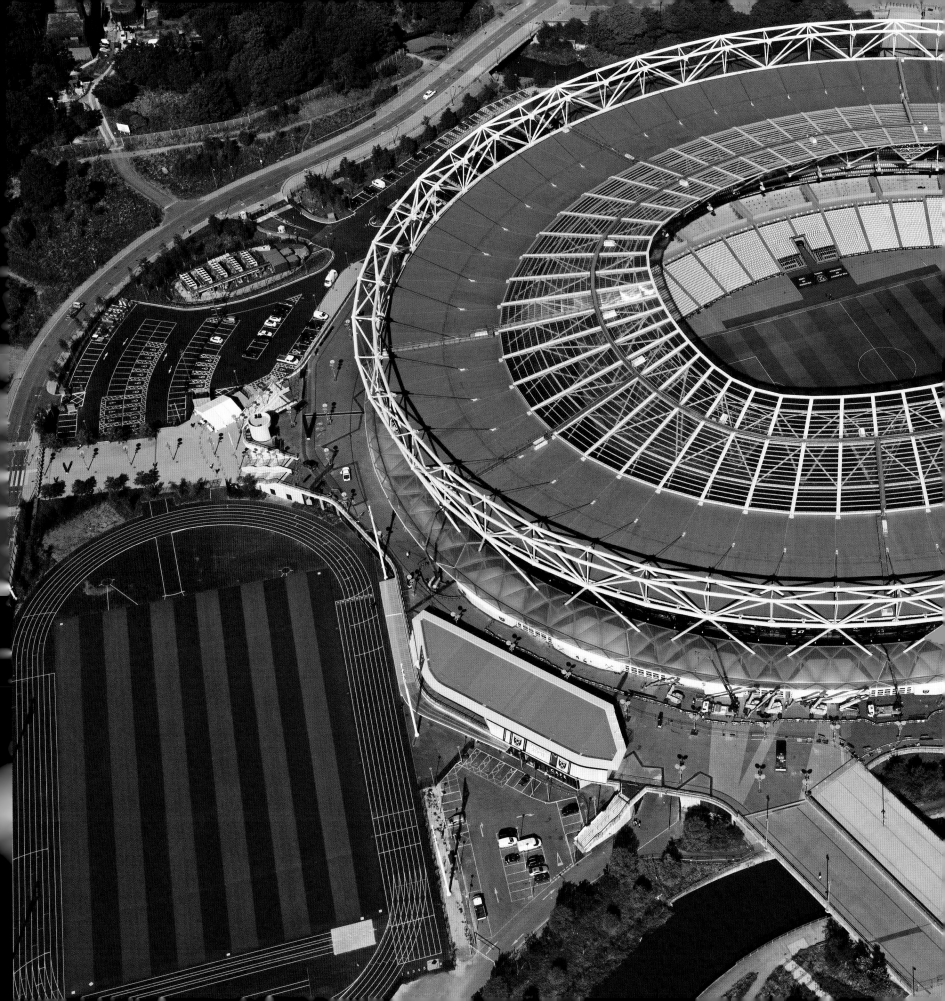

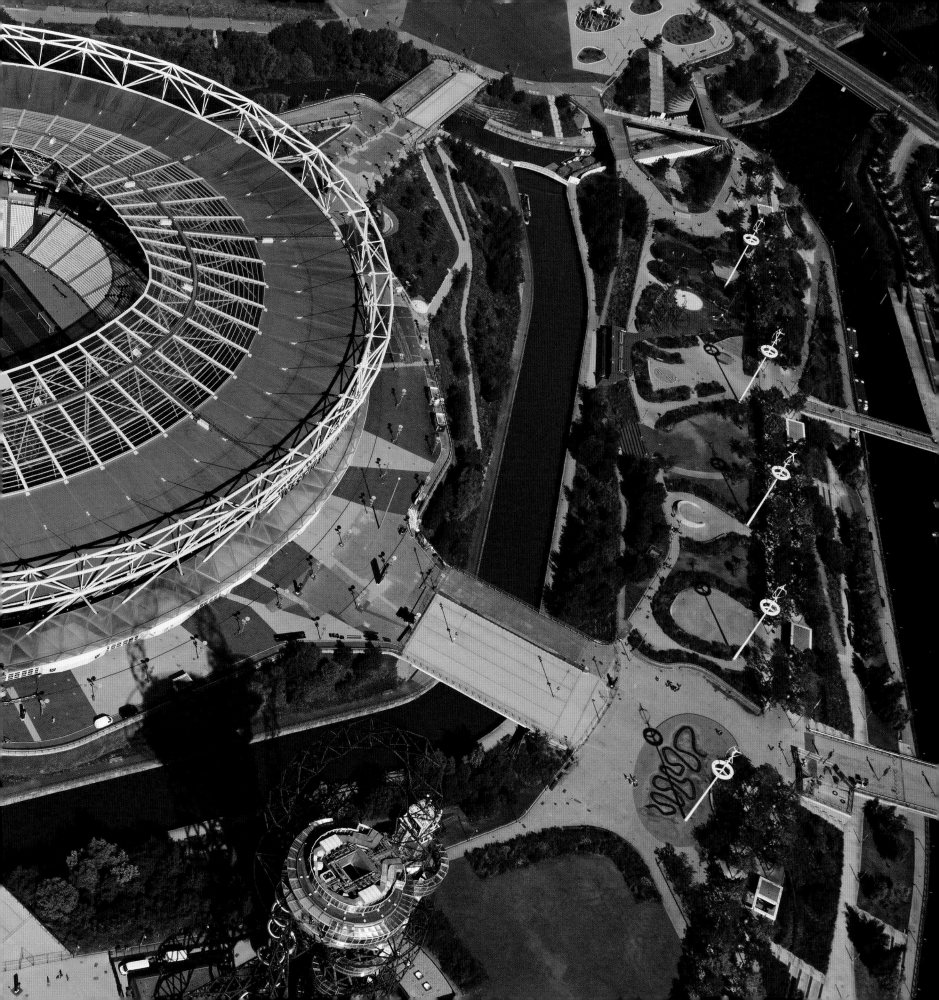

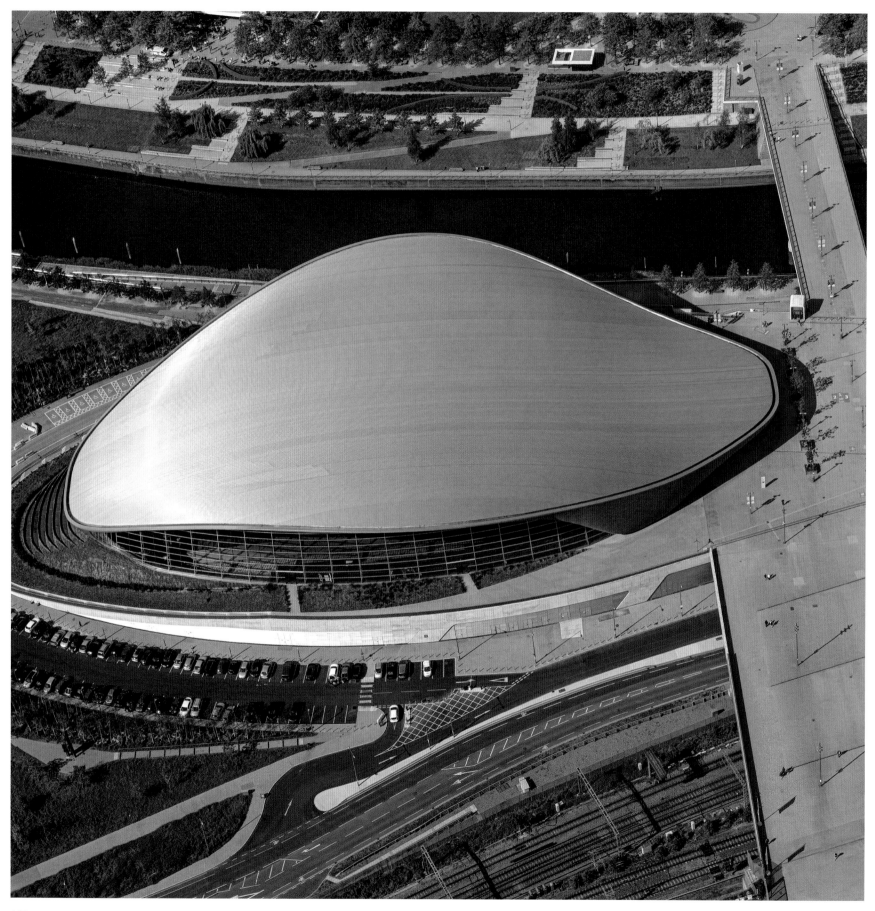

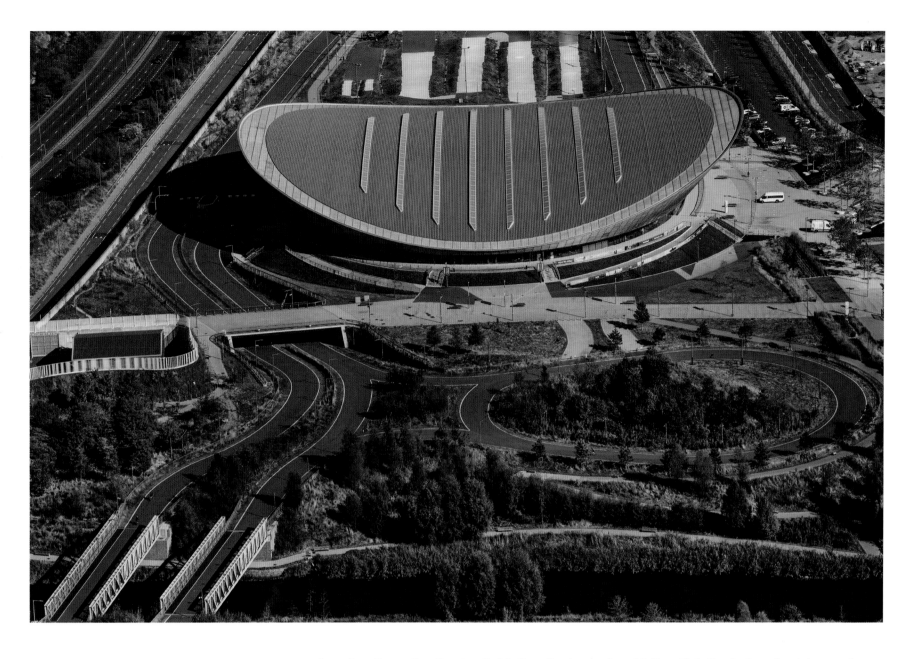

London Aquatics Centre (left), Stratford, located in the Queen Elizabeth Olympic Park, was designed by the celebrated late architect Dame Zaha Hadid for the 2012 Olympics. Originally it had two wings for increased seating capacity; these were removed after the Olympics. It has two 50m (164ft) pools and a 25m (82ft) diving pool which altogether hold 10 million litres (2.2 million gallons) of water.

Lee Valley VeloPark, Stratford, is a cycling centre located in the Queen Elizabeth Olympic Park. The VeloPark was one of the permanent venues for the 2012 Olympics and has a velodrome, a BMX racing track, a road course and 8km of mountain bike trails. The giant Pringle-like structure was designed by Michael and Patty Hopkins. The 250m track was constructed with 56km (35 miles) of Siberian pine, held in place with 350,000 nails.

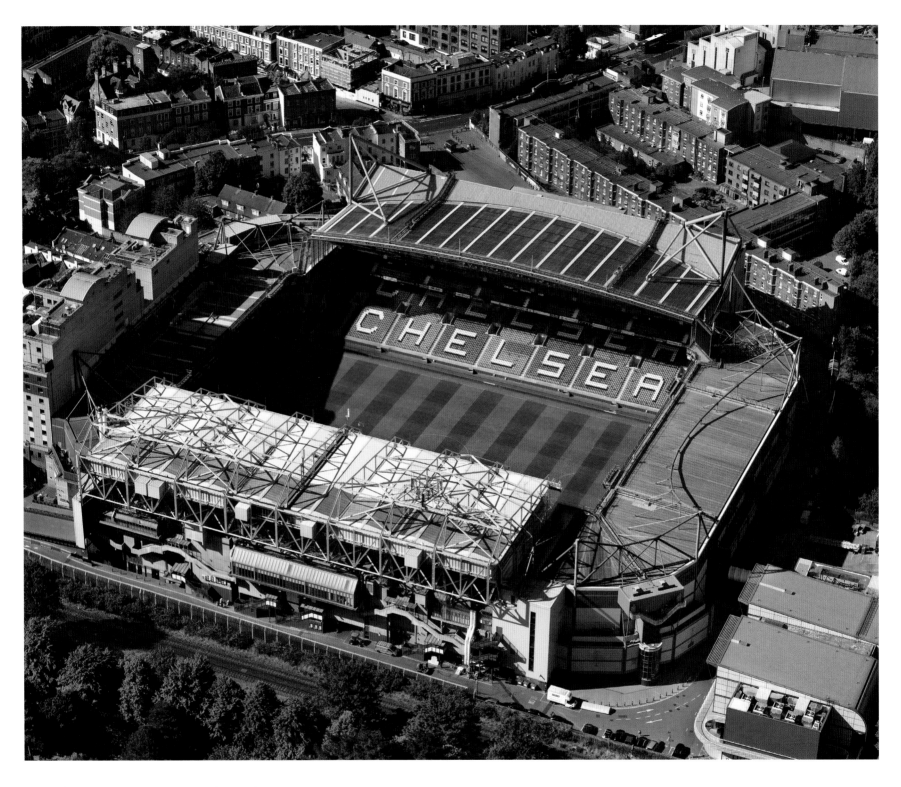

Stamford Bridge, known as 'The Bridge', has been the home ground of Chelsea Football Club since 1905. Ironically, the stadium is actually located in Fulham! Renovated during the 1990s, it has seating capacity for 40,853 fans.

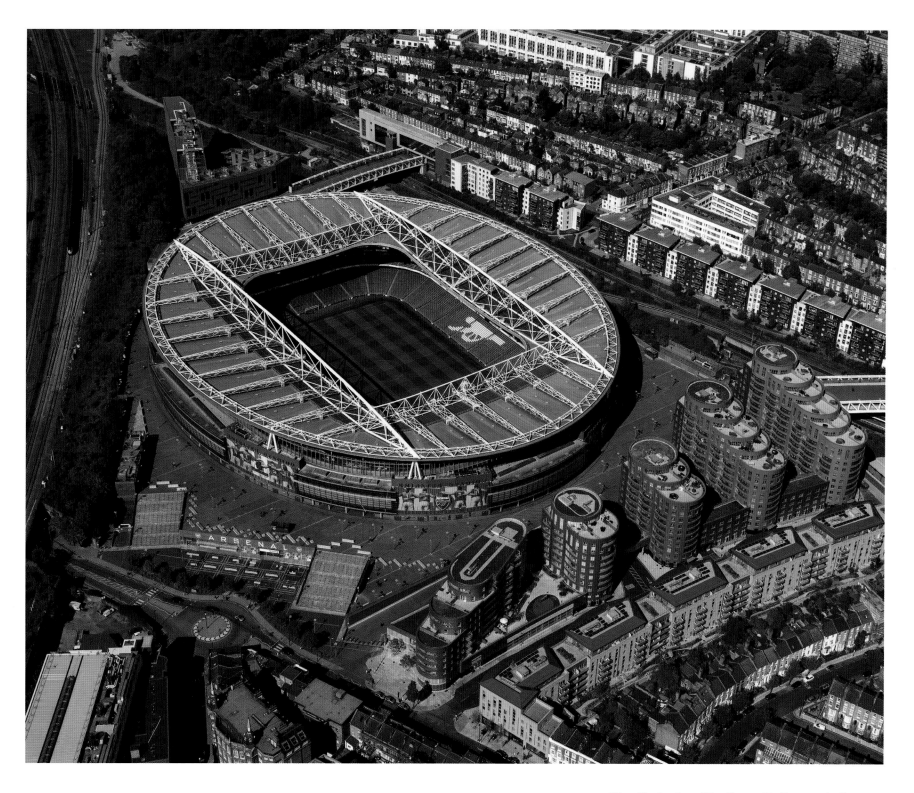

The Emirates Stadium, Holloway, is the home ground of 'The Gunners', Arsenal Football Club. The 60,000-seater stadium was designed by Populous and constructed by Sir Robert McAlpine. It was opened in October 2006 by HRH Prince Phillip, the Duke of Edinburgh.

Wimbledon Centre Court at the All England Lawn Tennis and Croquet Club, Wimbledon. Considered to be the most famous tennis court in the world, it is only regularly used for play during the two-week period that the Championships take place, which were first held in 1877. The court can seat 14,979 spectators and its retractable roof weighs an impressive 3,000 tonnes.

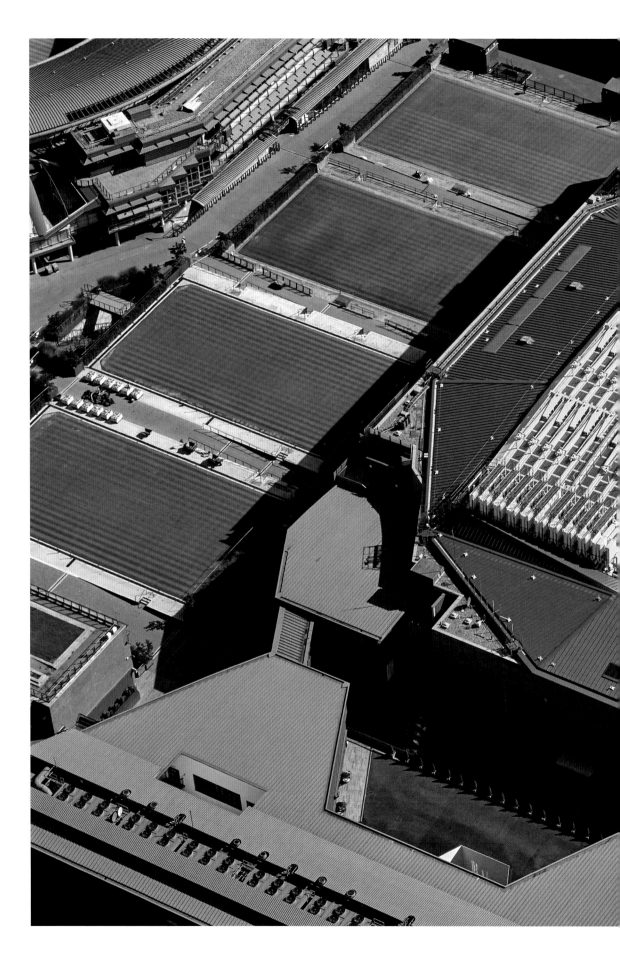

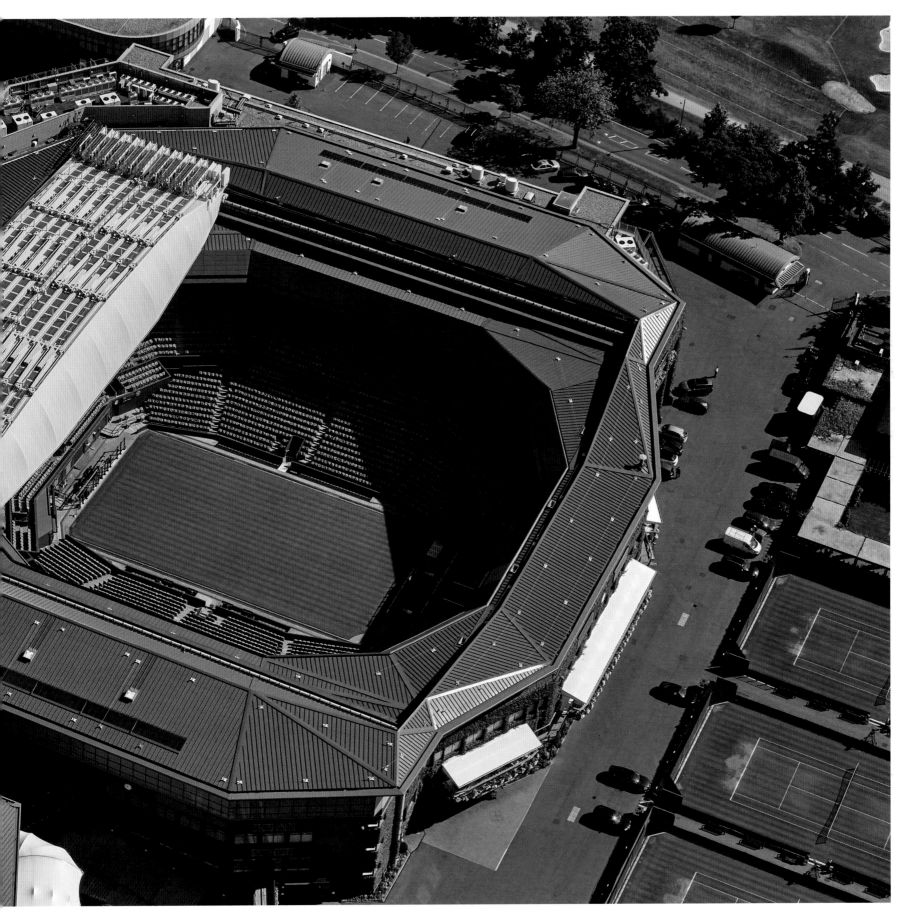

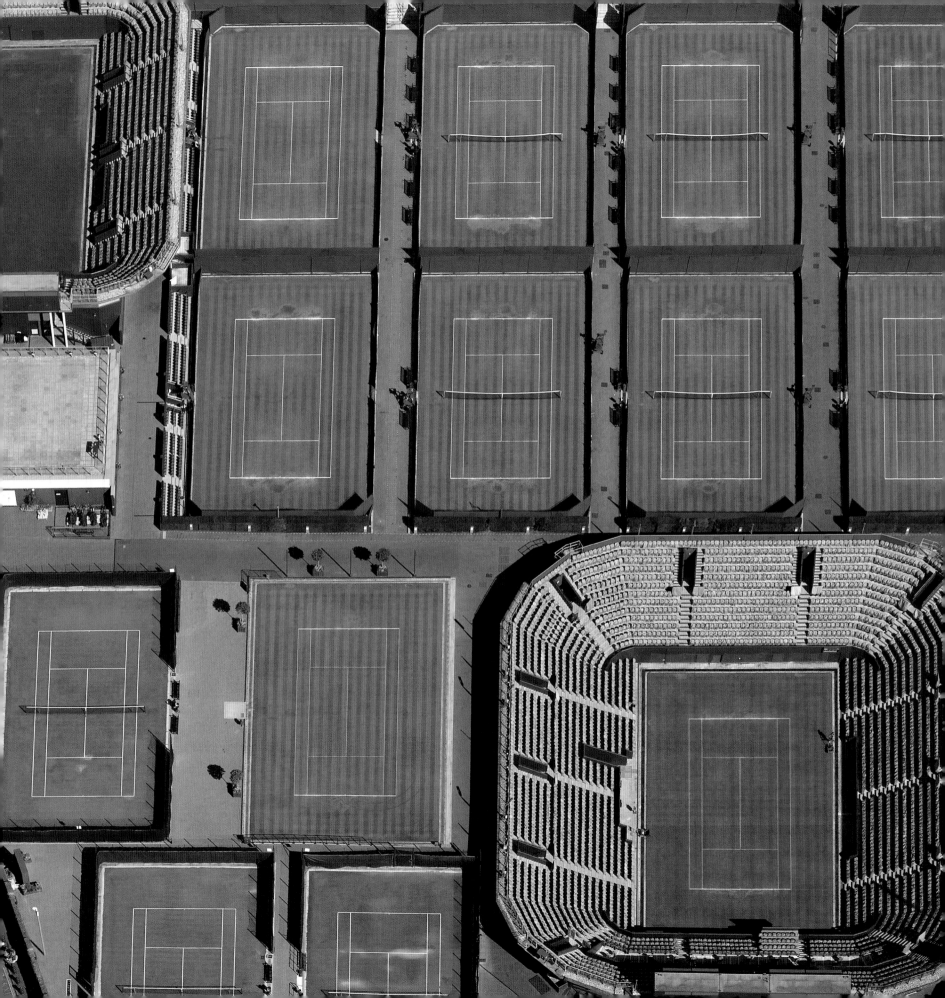

The intimate smaller courts and Number 2 Court of the All England Lawn Tennis and Croquet Club. The new Number 2 Court, bottom right of shot, is sometimes referred to as the 'Graveyard of Champions'. It was built on the site of the old court number 13 and has capacity for 4,000 spectators.

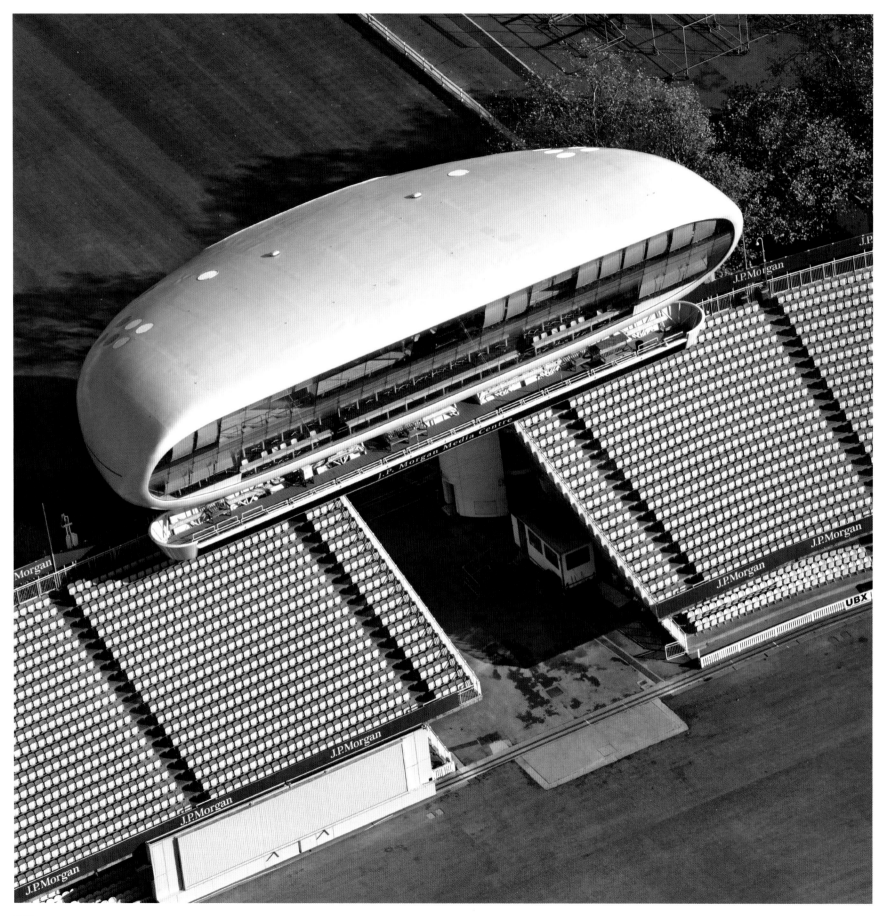

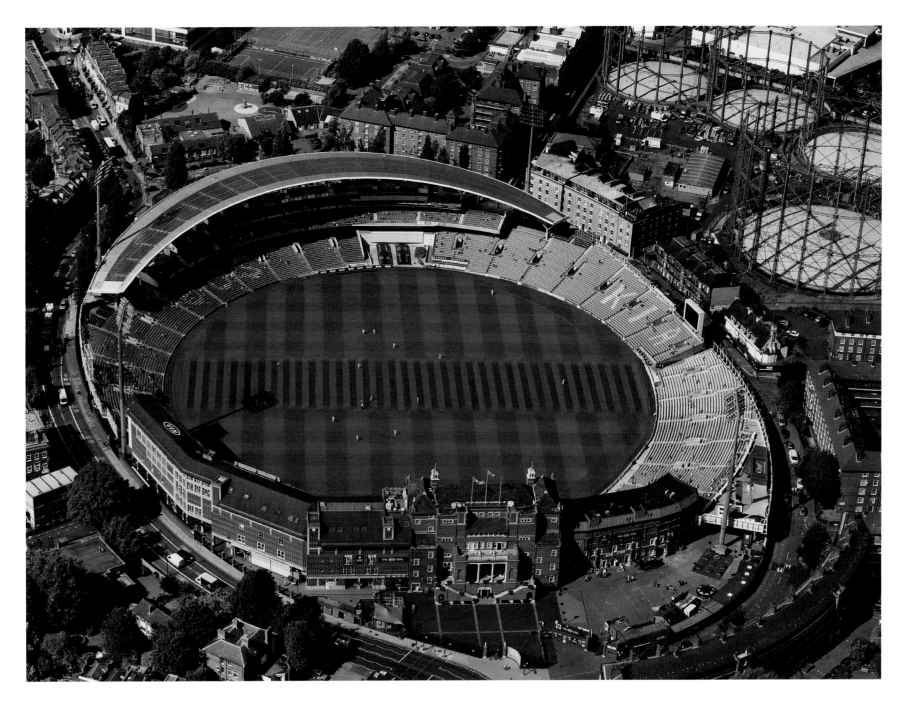

The Media Centre, Lord's Cricket Ground, St John's Wood (left). 'Lord's', named after its founder, Thomas Lord, is known as the home of cricket and is also the home ground of Middlesex County Cricket Club. Opened in 1814, it now seats 30,000 spectators. Czech architect Jan Kaplický's aluminium pod-like structure of the Media Centre opened in 1999 and was partly constructed in a shipyard in Falmouth, Cornwall.

Above: **The Oval**, Kennington, is the home ground of Surrey County Cricket Club and a firm favourite with all cricket fans. It is built on the former Kennington Common, where cricket was played throughout the early 18th century. First opened in 1845, it can now seat 25,000 spectators.

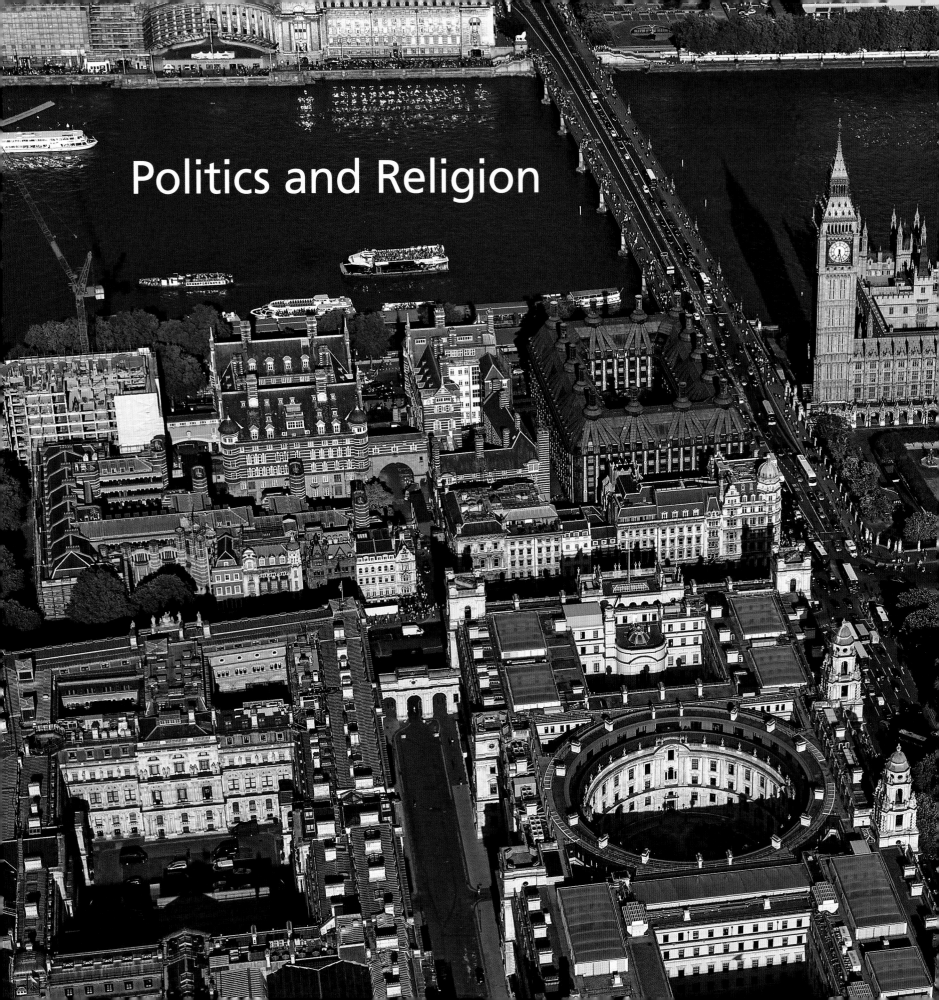
Politics and Religion

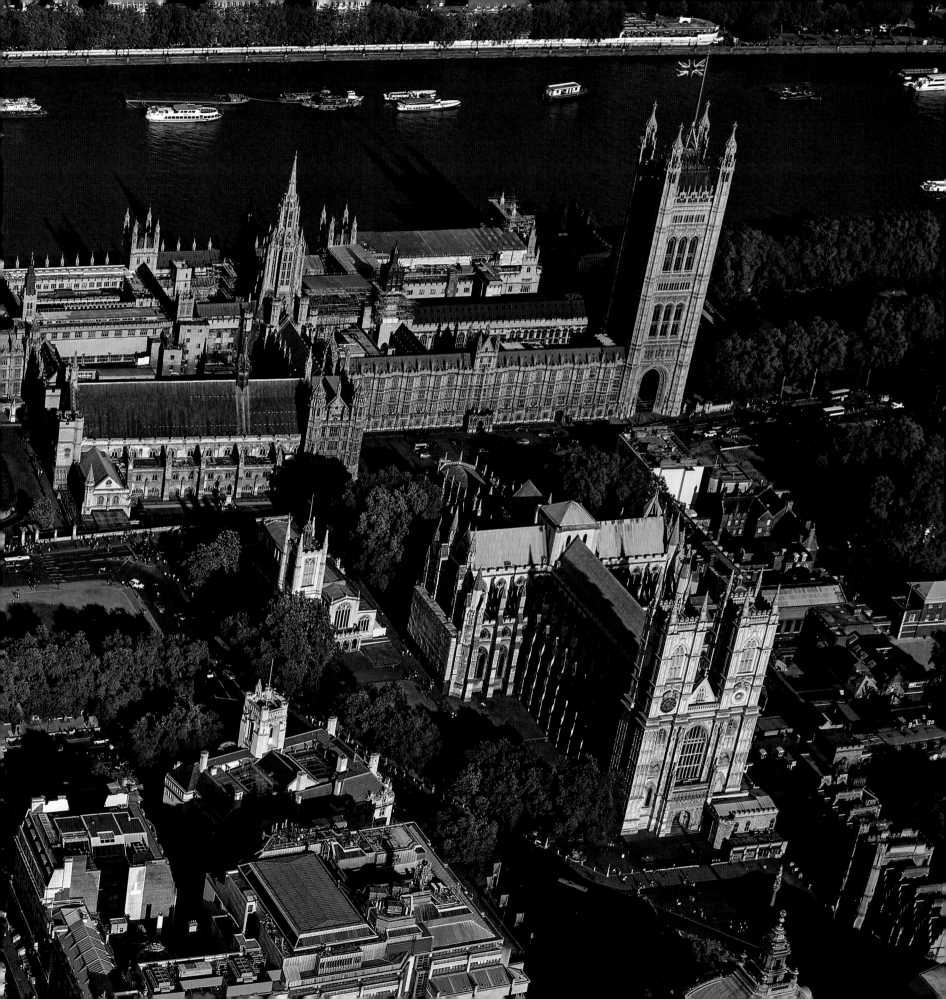

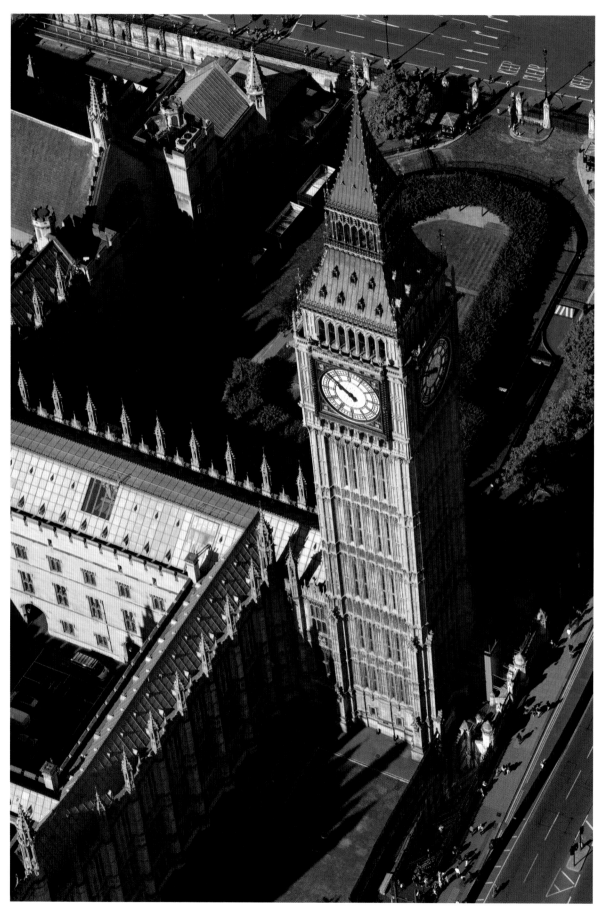

The Houses of Parliament, Palace of Westminster (pages 138-139), is the meeting place of the House of Commons and the House of Lords, the two houses which govern and make the laws of the UK. The first royal palace constructed on the site dated from the 11th century and was the primary residence of the kings of England until fire destroyed much of the complex in 1512. From then on it served only as the home of the Parliament which had been meeting there since the 13th century.

The Elizabeth Tower is commonly referred to as Big Ben, which in reality is the nickname of the largest of the five bells of the clock. It was renamed in 2012 to mark the Diamond Jubilee of Queen Elizabeth II. Augustus Pugin's magnificent neo-Gothic-style tower, built in 1859, stands at 96m (315ft). There are 334 steps to climb to the belfry and 399 to the lantern. It is globally recognized as one of the most prominent icons of democracy and of the United Kingdom.

Portcullis House, Westminster, provides offices for 213 members of Parliament and has a connecting underground tunnel directly into the House of Commons. Division bells are rung throughout the building to alert MPs that a bill is being voted on in the House. The Portcullis Arms of the Palace of Westminster are reflected in the austere neo-Gothic design by Michael Hopkins and Partners. The building opened in 2001.

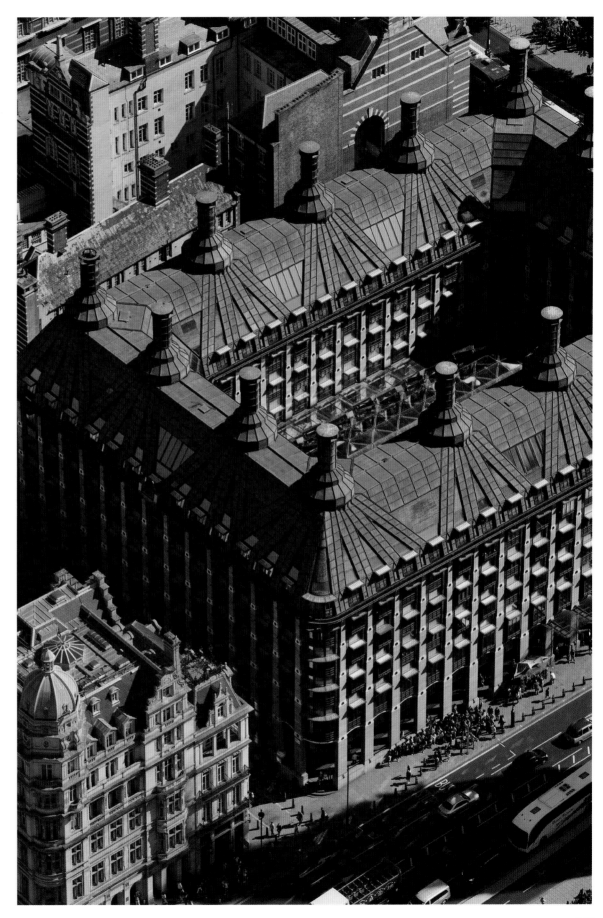

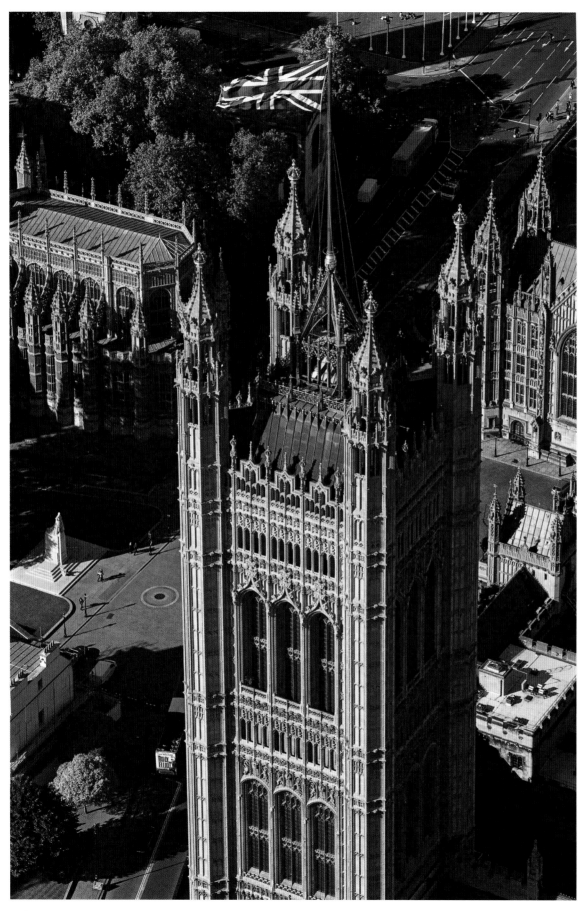

The Victoria Tower, situated at the southwestern end of the Palace of Westminster, faces Black Rod's Garden. The Gothic tower by Sir Charles Barry and Augustus Pugin stands at 98.5m (323ft). Queen Victoria laid the first stone on 22 December 1843. The main entrance at the base of the tower is called the Sovereign's Entrance, which the monarch uses at the State Opening of Parliament.

Westminster Abbey

The two 69m (226ft) western towers, with the main entrance to the Abbey between them, each has 10 bells in its belfry. They were completed in 1745 using Portland stone from Dorset. Nicholas Hawksmoor's design is an early example of the Gothic Revival.

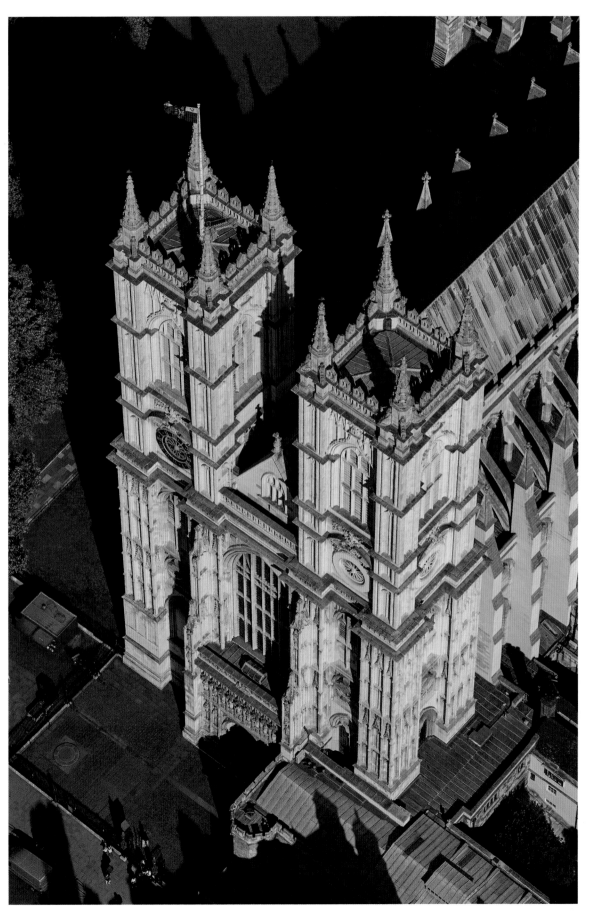

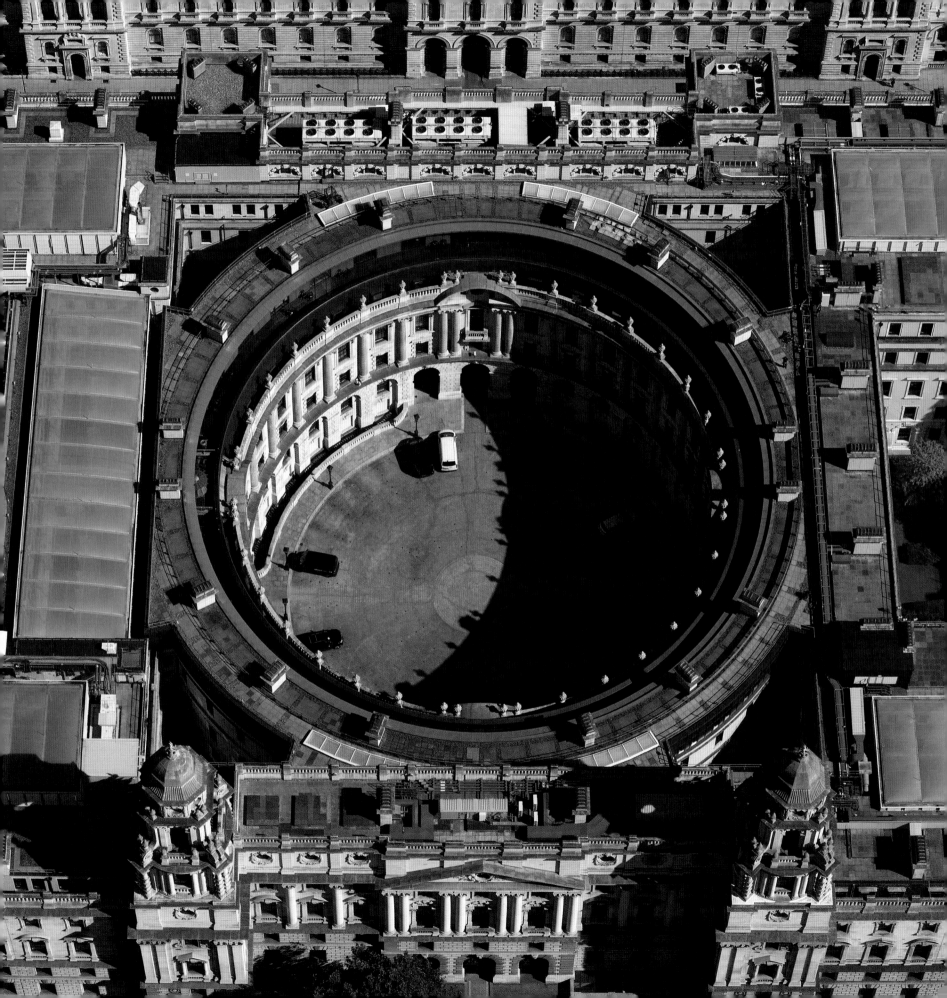

HM Treasury, 1 Horse Guards Parade, commonly known as the Treasury, is responsible for administering the government's economic and public financial policies and has its origins back in the reign of Henry I. The architect John Brydon won a competition to design the building, which took seven years. The work was completed in 1917 but HM Treasury did not move in until 1940.

City Hall (right), Queen's Walk Southwark, near to Tower Bridge, is the headquarters of the Greater London Authority. Inside sits the London Assembly, presided over by their chief executive, the Mayor of London. The neo-Futurist armadillo shell-like structure was designed by Foster and Partners. It is sometimes referred to as the motorcyclist's helmet, the glass testicle or the onion! Located next to it is the sunken teardrop-like amphitheatre called The Scoop, used in the summer months for open-air performances.

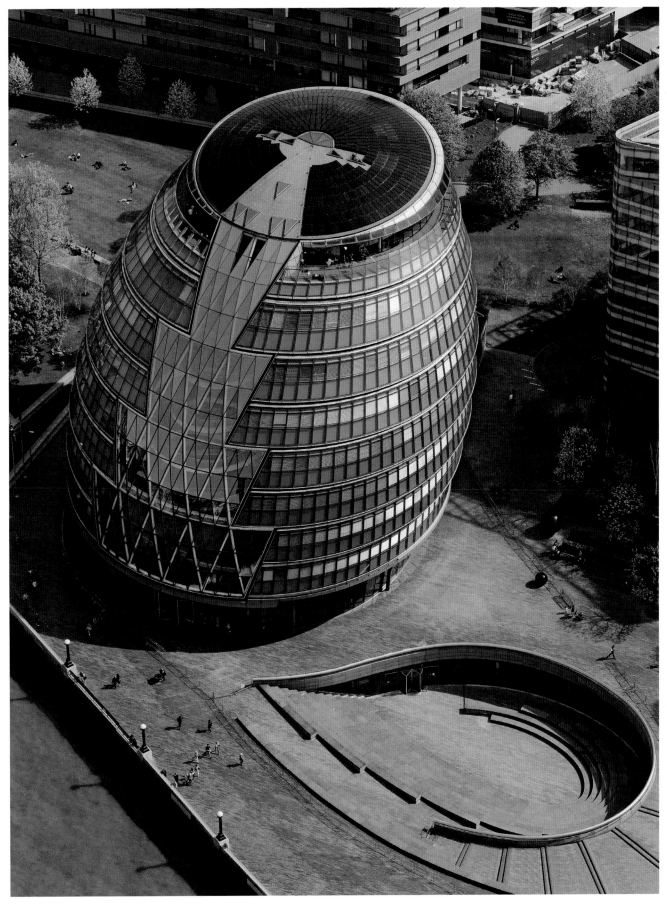

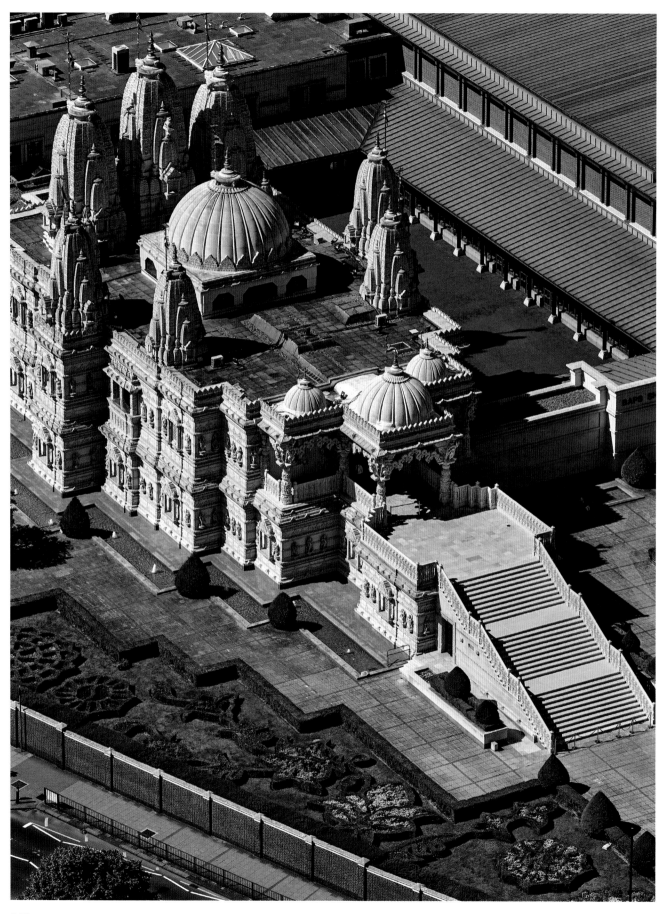

BAPS Shri Swaminarayan Mandir, Neasden. This magnificent Hindu temple was built by Pramukh Swami, the then spiritual leader of BAPS, who inaugurated the site in August 1995. Its construction used 2,828 tonnes of Bulgarian limestone and 2,000 tonnes of Italian marble. These were first shipped to India to be carved by a team of 1,526 sculptors. It is a remarkable engineering feat, as no steel whatsoever was used in its construction.

The London Central Mosque, Regent's Park. An open competition for its design was won by Sir Frederick Gibberd. There were over 100 designs submitted from both Muslim and non-Muslim applicants. It was built in 1978 and has a capacity for 5000 worshippers. The land it was built on was donated by King George VI to the Muslim community in return for the donation of land in Cairo by King Farouk of Egypt on which to build an Anglican cathedral.

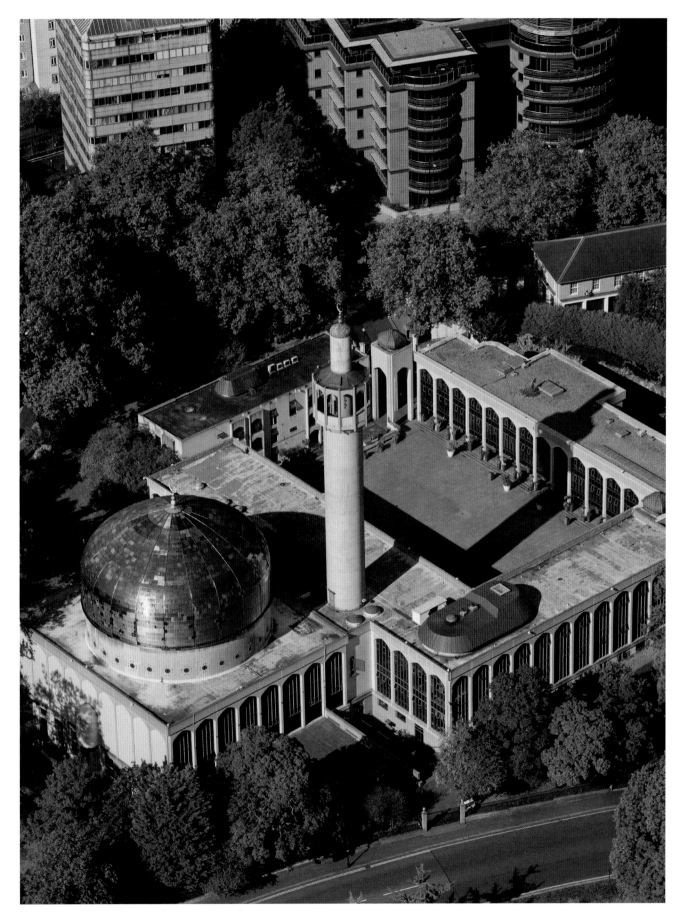

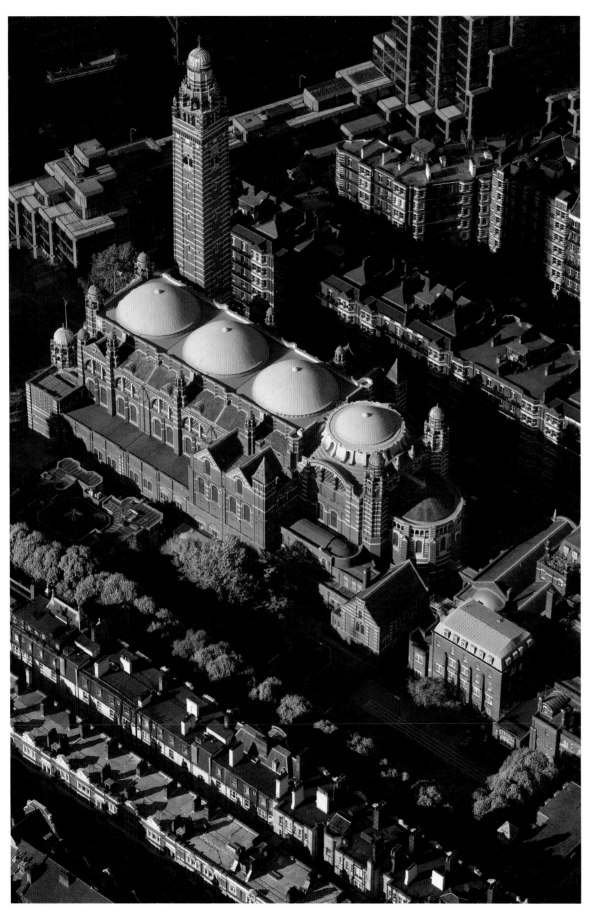

Westminster Cathedral
is the mother church of the Catholic
Church in England and Wales, a neo-
Byzantine design by John Francis
Bentley built in 1903 almost entirely
from brick.

Lauderdale Road Synagogue (right),
Maida Vale, is the home of the S&P
Sephardi Community. They are affiliated
to London's historic Portuguese and
Spanish Jewish Sephardic community.
The synagogue was built in 1896 as
a successor to the Bryanston Street
Synagogue.

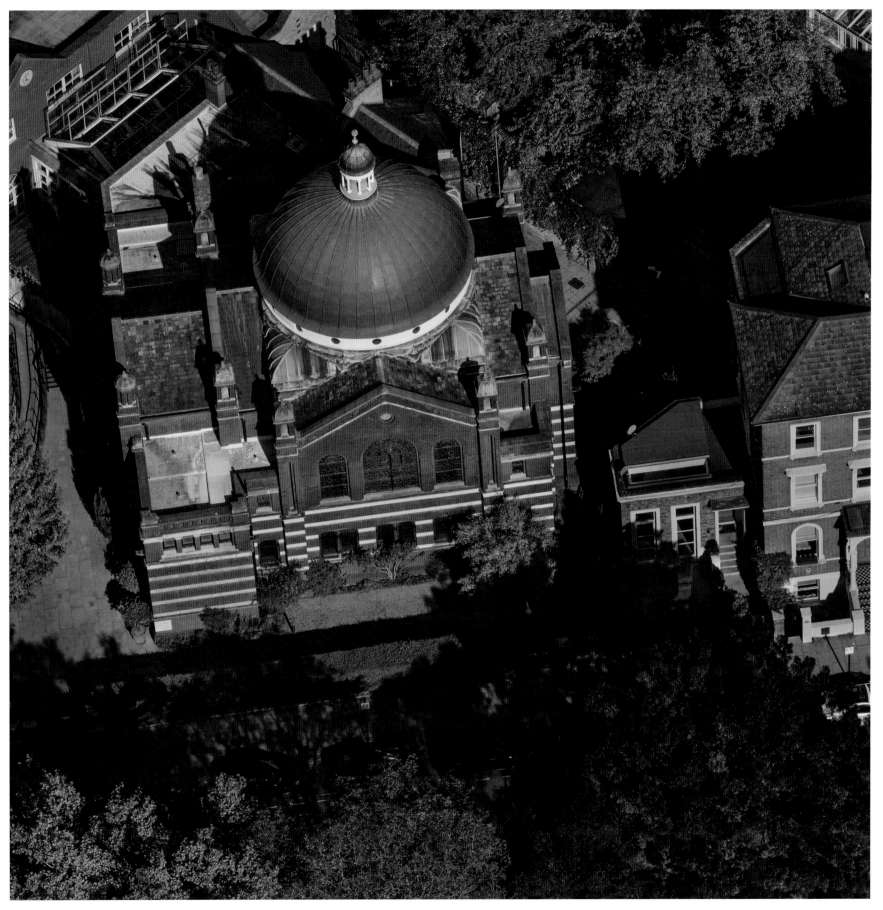

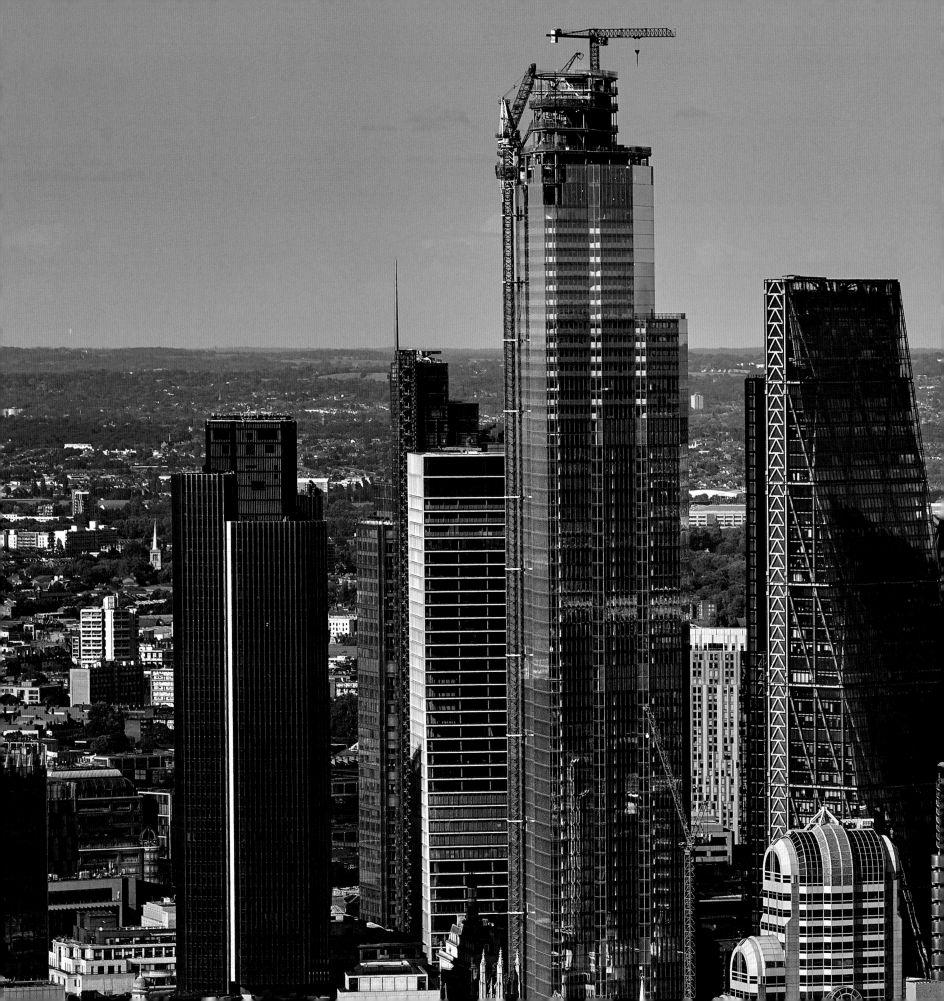

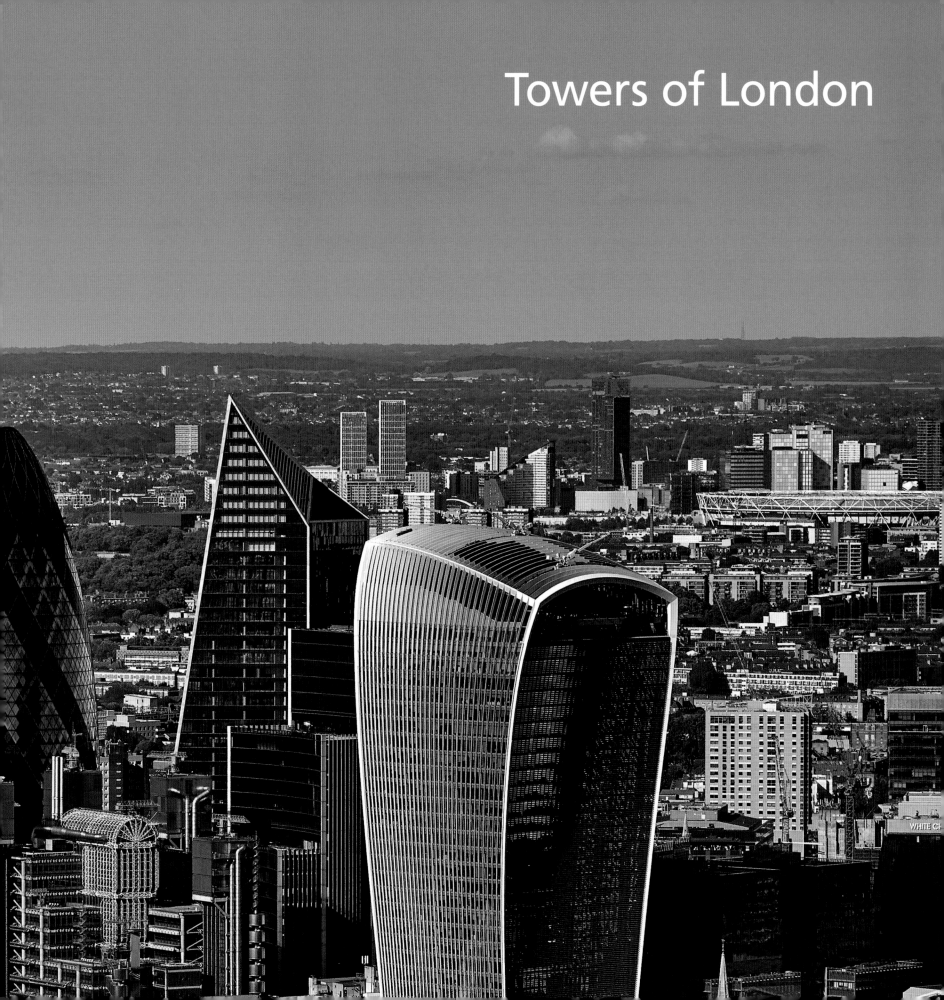

Towers of London

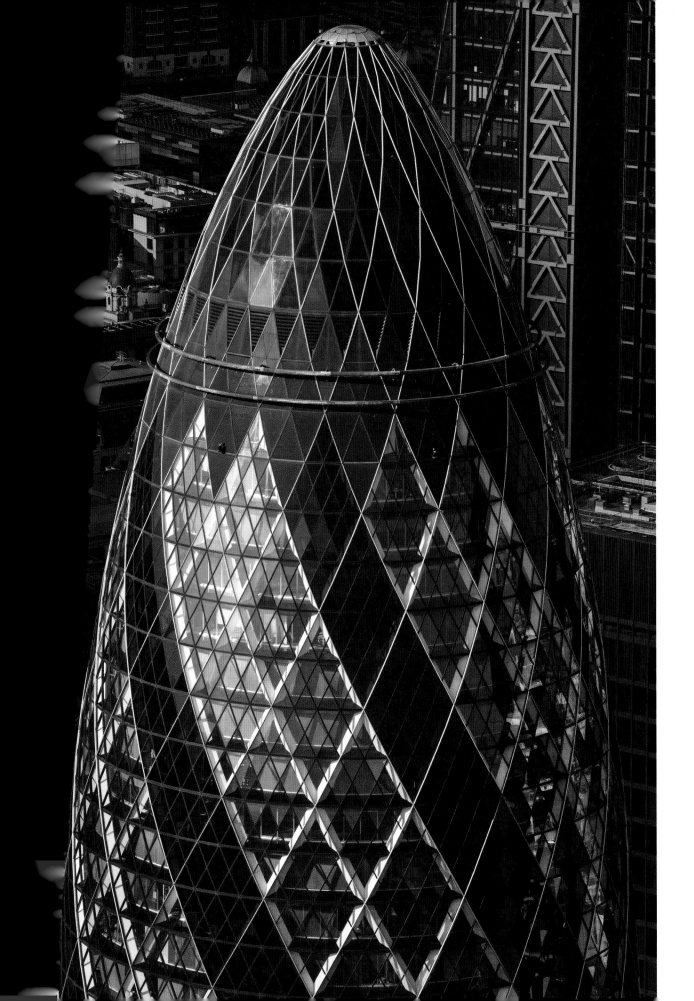

A massive forest of skyscrapers (pages 150-151), surging upwards. Left to right are Tower 42, 110, 100 Bishopsgate and the Pinnacle, 20 Gracechurch Street, the Gherkin, the Lloyds Building, the Willis Building, in front of the Scalpel, and the Walkie Talkie.

The Gherkin, 30 St Mary Axe, is 180m (590ft) tall and has 41 floors. Designed by Norman Foster and the Arup Group, it opened in April 2004. One of the first arrivals of modern architecture to the City, it has since been dwarfed by the addition of newer skyscrapers.

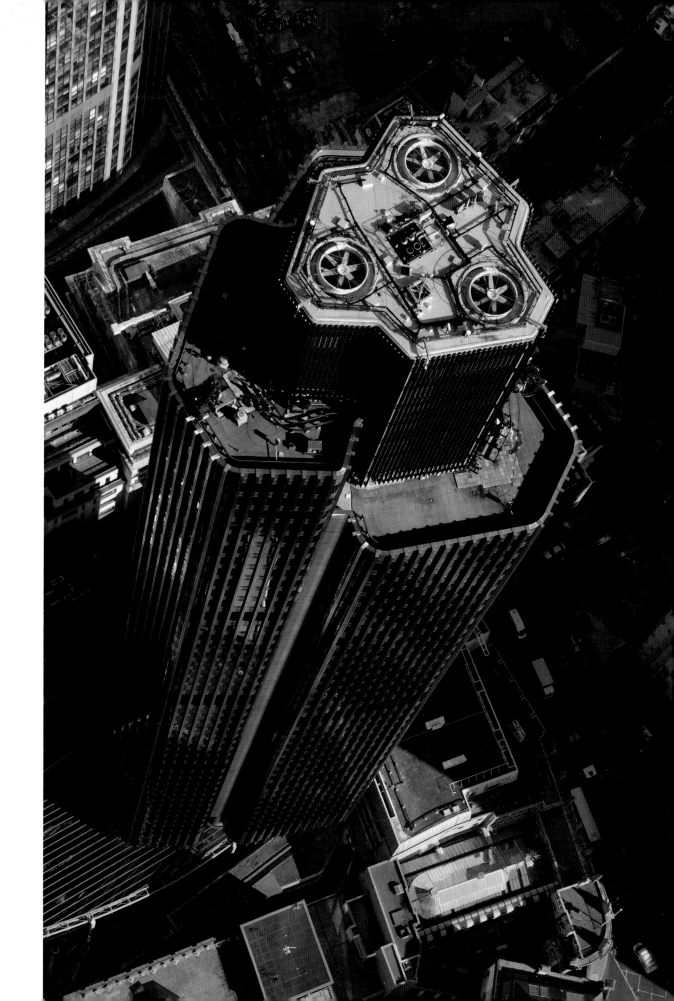

Tower 42, 25 Old Broad Street, was formerly the NatWest Tower and previous home to the bank's international headquarters. Designed by Richard Seifert, it was opened on 11 June 1981 by Queen Elizabeth II. At 183m (600ft), for 30 years the tower was the tallest building in the City.

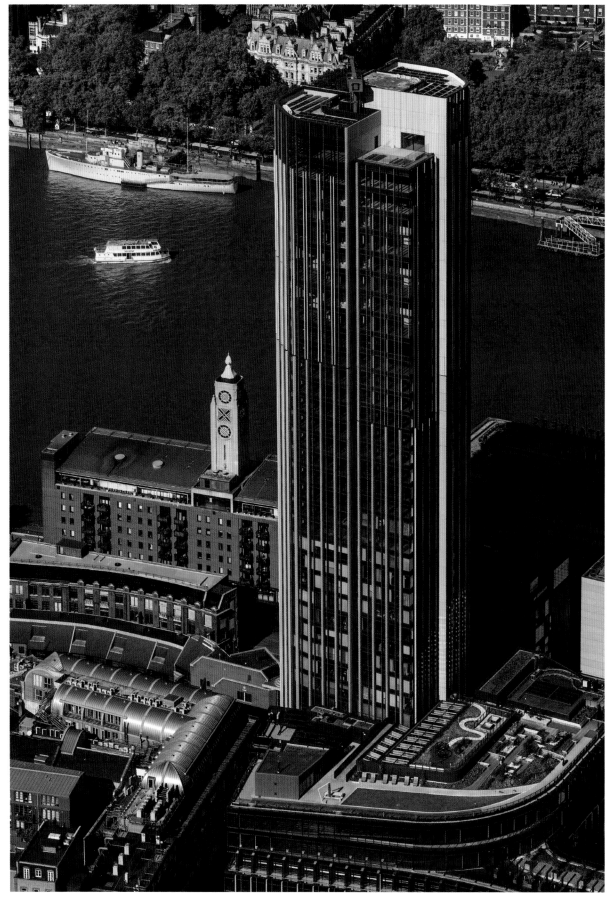

South Bank Tower, formerly
King's Reach Tower, which
began life at 111m (364ft) tall,
was designed by Richard Seifert
and completed in 1972. In 2015
10 more floors were added,
increasing its height to 155m
(508ft). The minute-looking Oxo
Tower stands at its foot.

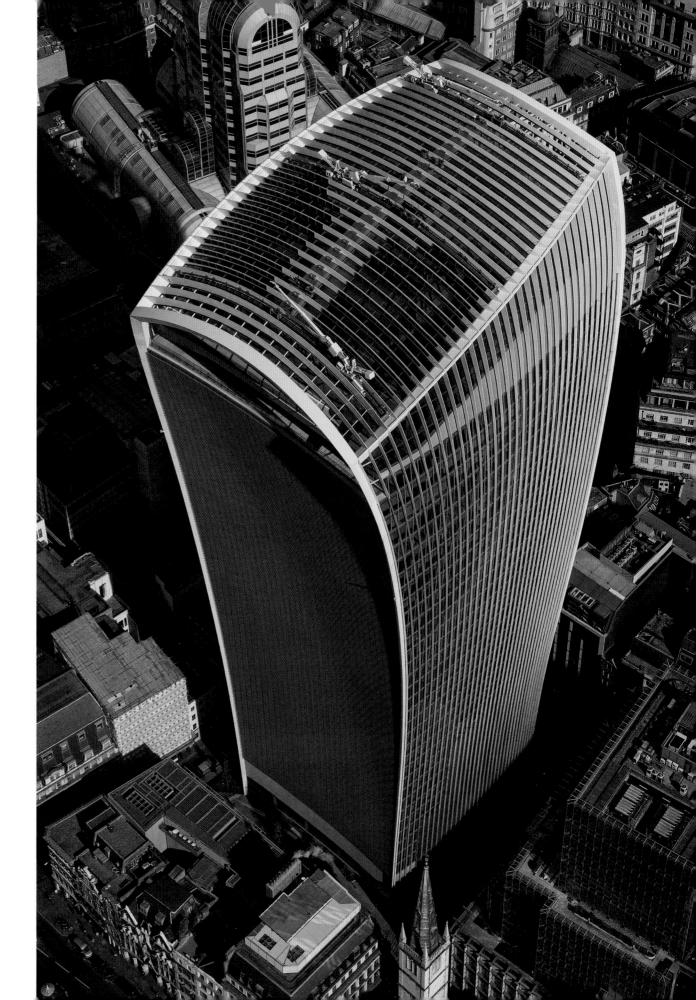

The Walkie Talkie, 20 Fenchurch Street, is a 160m (525ft) tall 38-storey commercial building. From the viewing gallery of the Sky Garden there are spectacular views of the river and south-east London. Your experience at 'London's highest rooftop garden' can also be enjoyed from the rooftop bars and restaurants. Architect Rafael Viñoly's controversial design was awarded the 2015 Carbuncle Cup for the worst new building in the UK.

Citypoint (pages 156-157), 1 Ropemaker Street, built in 1967, was then known as Britannic Tower when it served as the headquarters of British Petroleum. The building is 127m (417ft) tall and was the first in the City to exceed the height of St Paul's Cathedral. The design by architects F. Milton Cashmore and H.N.W. Grosvenor has a distinct *Star Wars* influence.

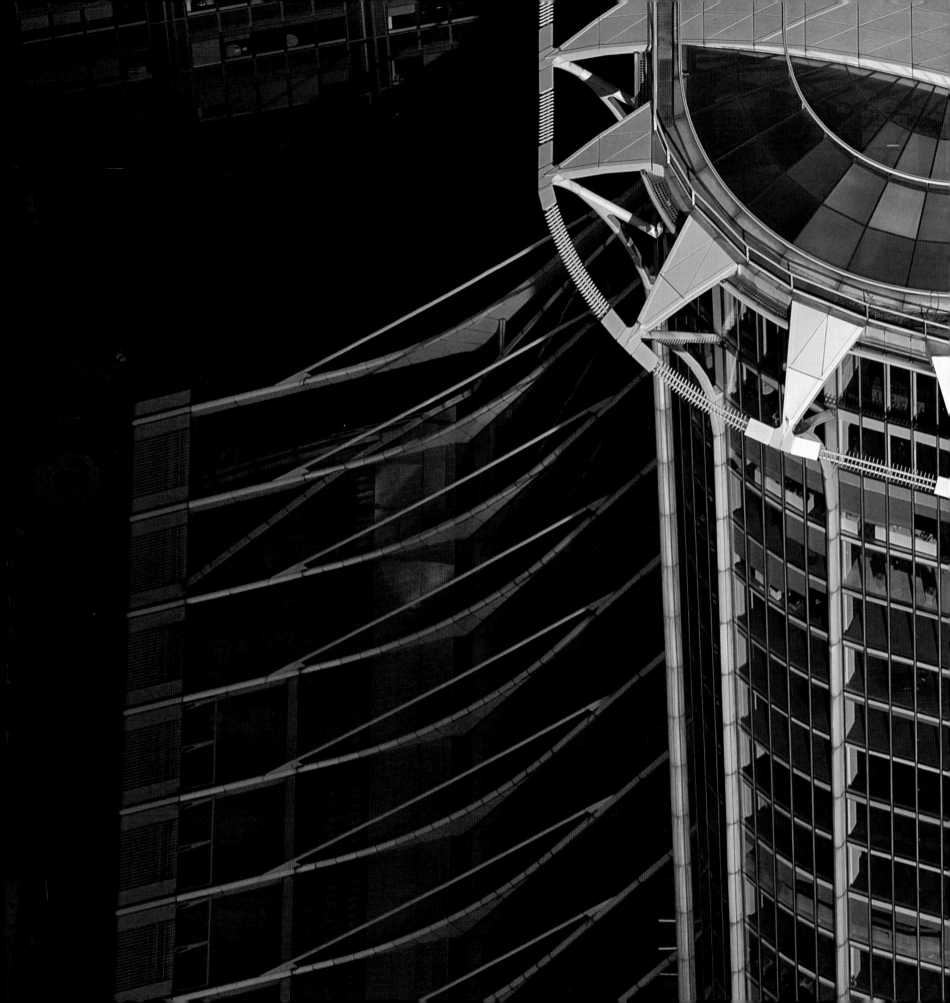

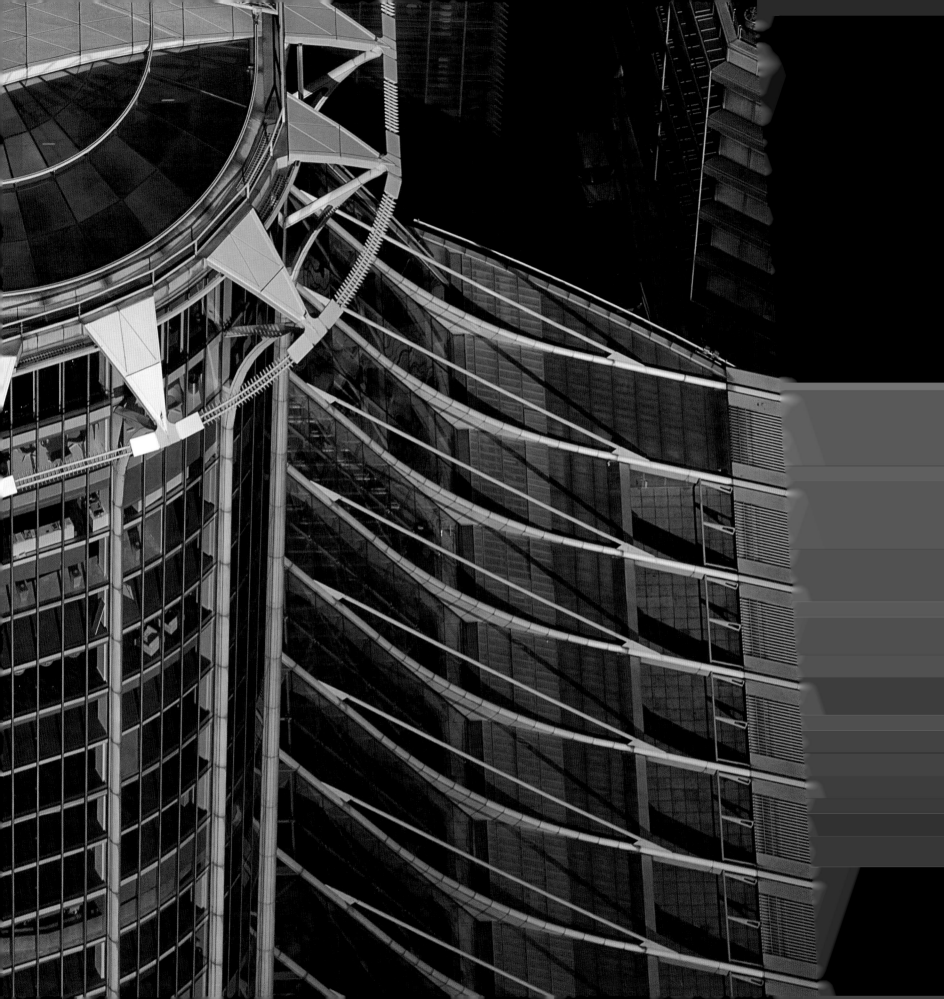

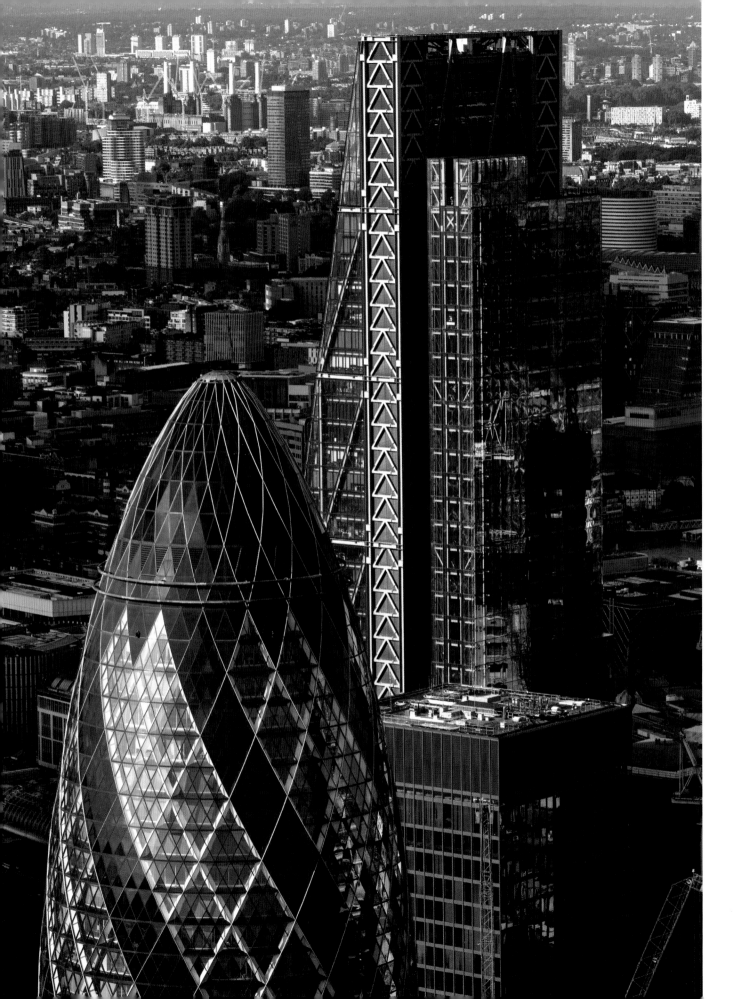

The Cheesegrater,
122 Leadenhall Street,
was formally known as
the Leadenhall Building.
The 224m (735ft), 52-floor
structure was designed
by Rogers Stirk Harbour +
Partners, opening in 2010.

110 Bishopsgate, formerly the Heron Tower, is a commercial skyscraper designed by Kohn Pedersen Fox which was completed in 2011. It stands at 230m (755ft) tall, including the 28m (92ft) mast, and has 46 floors. A 70,000-litre aquarium in its reception is home to around 1,200 fish.

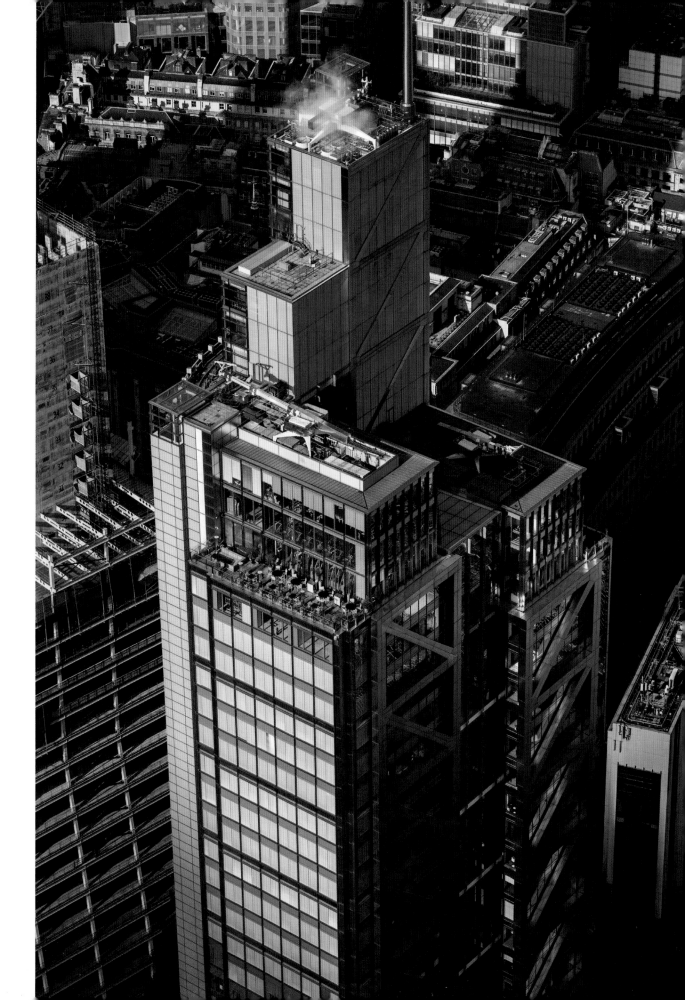

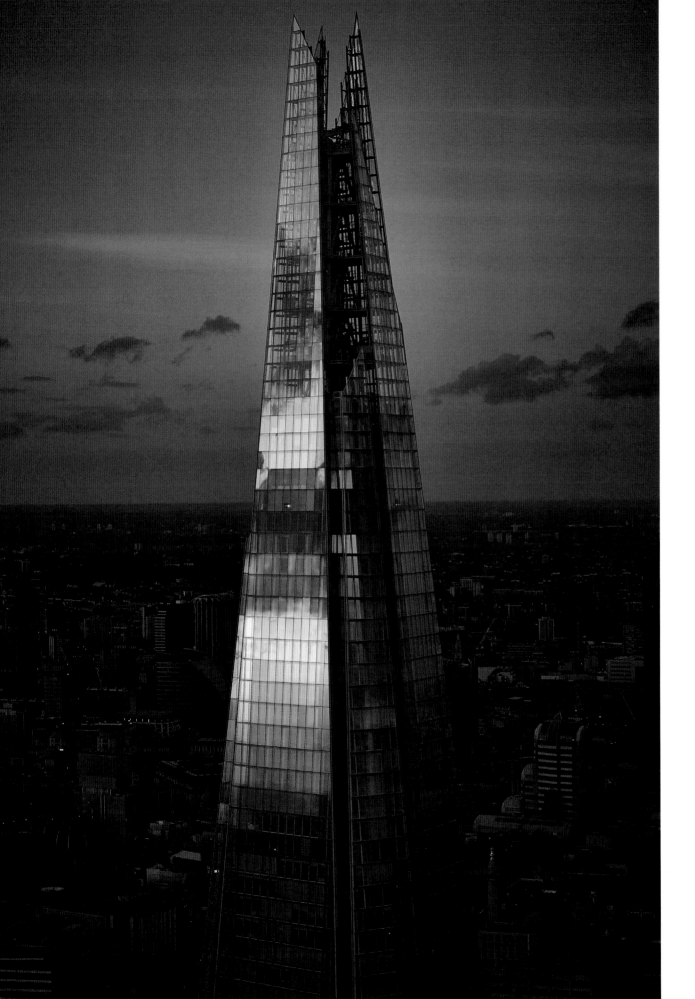

The Shard, London Bridge, is sometimes called the Shard of Glass. The Italian architect Renzo Piano's 95-storey showstopper skyscraper is 309.6m (1,016ft) tall and has 11,000 glass panes. On the 72nd floor, at 244m (801ft), a viewing gallery rewards you with a breathtaking 360-degree view over London; your very own bird's-eye experience.

The Vase, One Blackfriars, is also referred to as the Tummy. The 50-storey, 170m (558ft) mixed-use skyscraper is a recent addition to the London landscape, completed in 2018 and designed by Simpson Haugh Architects.

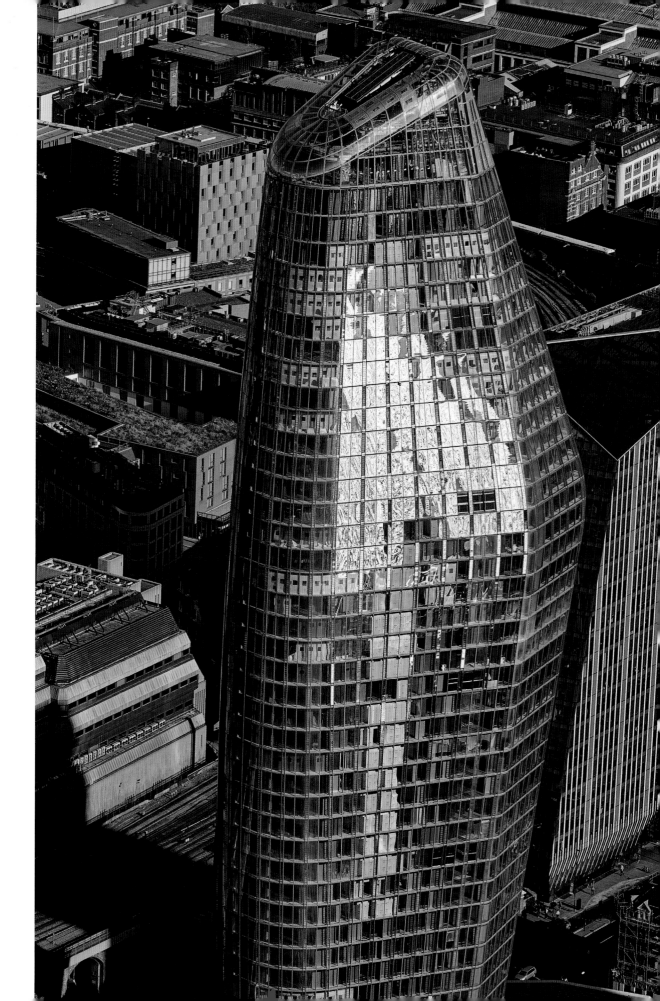

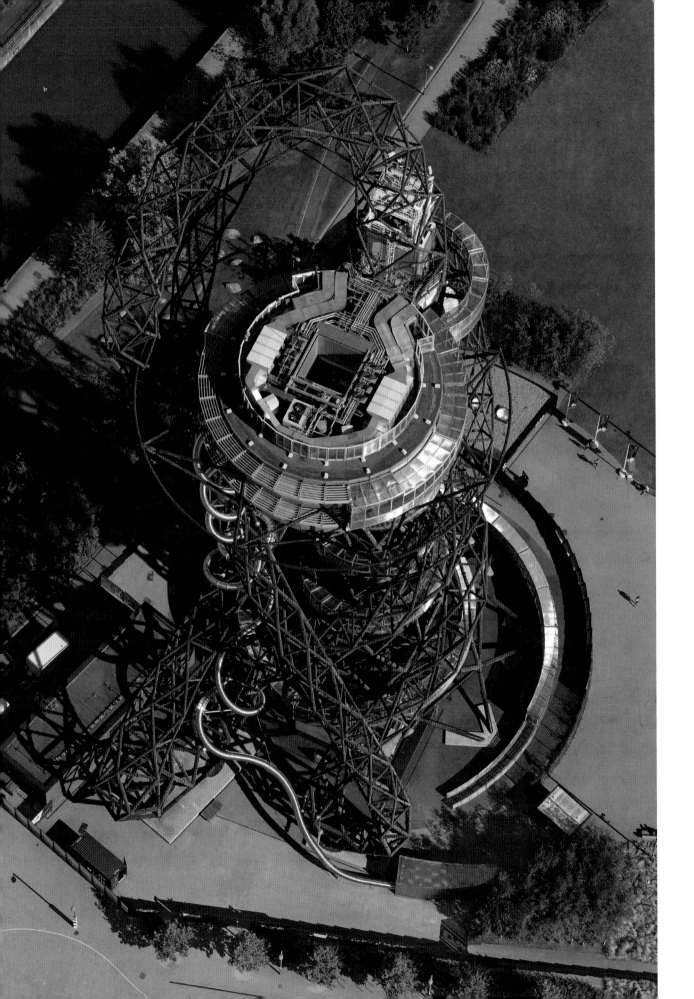

The ArcelorMittal Orbit is located in the Queen Elizabeth Olympic Park. The 114.5m (375ft) structure is Britain's largest piece of public art and was designed by Turner Prize-winning artist Sir Anish Kapoor and Cecil Balmond of Arup Engineering for the 2012 Olympics. It has the world's longest tunnel slide, at 178m (584ft), and adrenaline junkies can even take the opportunity to abseil from the top.

The BT Tower, Cleveland Street, formerly known as the Post Office Tower, is a major communications hub in the UK. Now an old lady amongst the height rankings of London's skyscrapers, it is Grade II listed, 190.5m (625ft) tall and held the accolade of being the tallest building in London until 1980. Construction was completed in 1964 to a design by Eric Bedford.

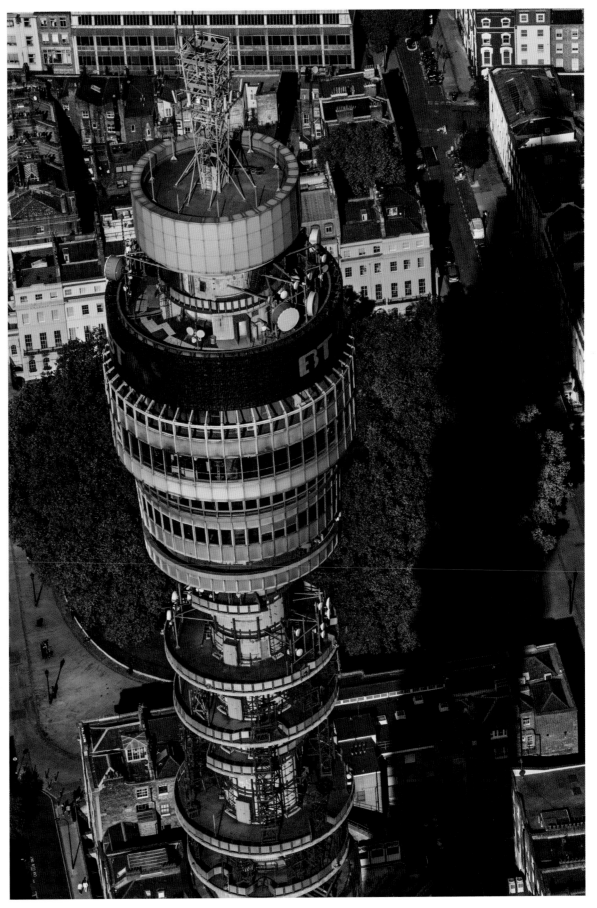

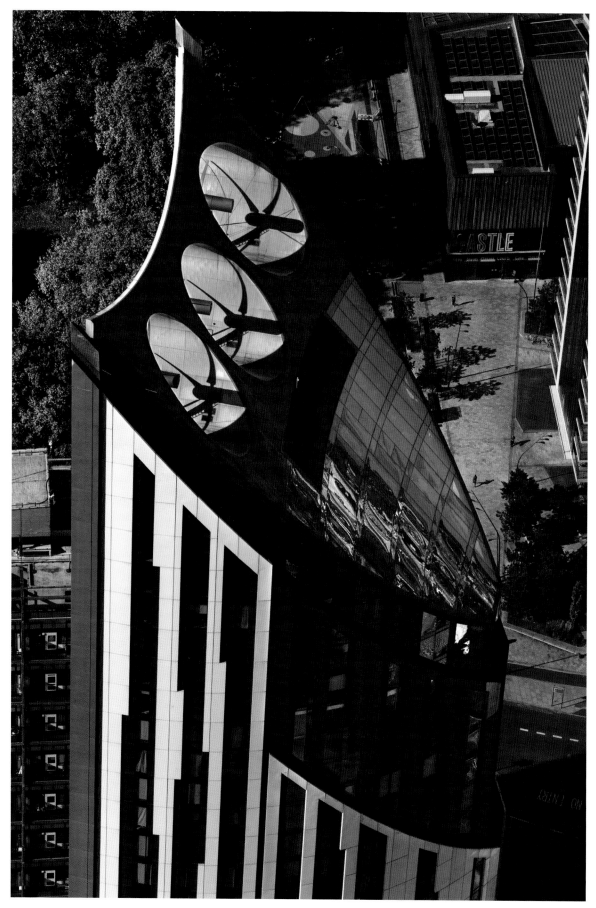

The Electric Razor, officially called Strata SE1, Elephant and Castle, is a 148m (486ft), 43-storey residential building. At its top are three 9m (30ft) wind turbines designed to generate electricity. The building was completed in 2010 and designed by architects BFLS.

Centre Point (right), New Oxford Street, has 33 storeys, is 117m (384ft) high, Grade II listed and has protected status from English Heritage. It was designed by George Marsh of Richard Seifert and Partners. Completed in 1966, the building remained empty until 1980, which was a commercial decision by the developers. This was considered to be socially wrong at the time because there was a crisis for homeless people in London, particularly in nearby Soho.

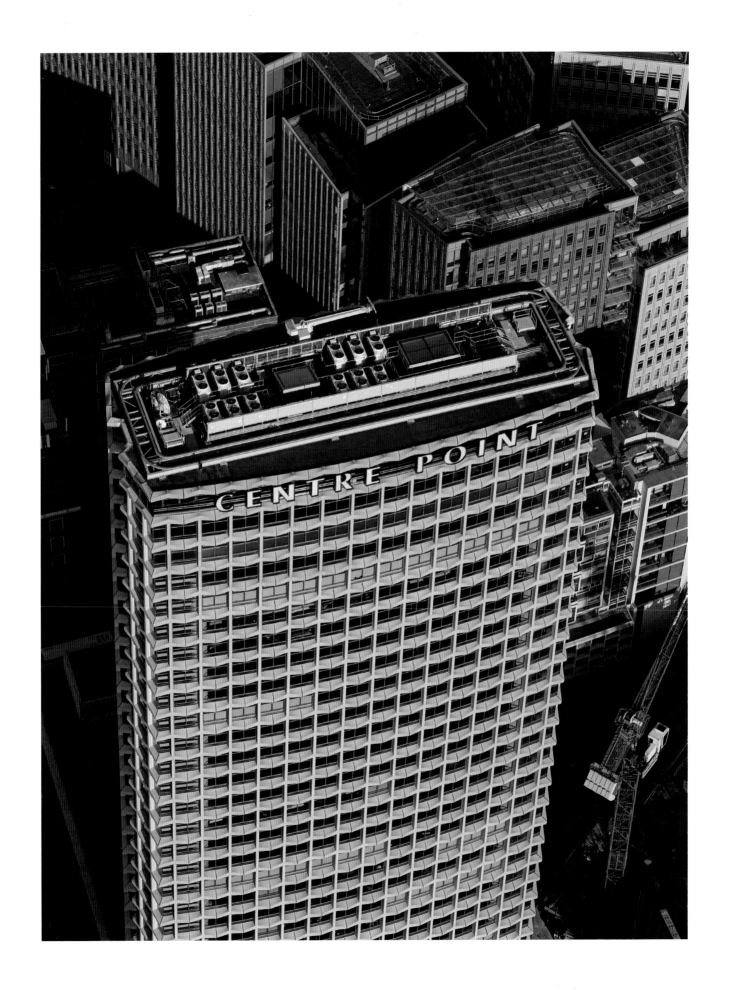

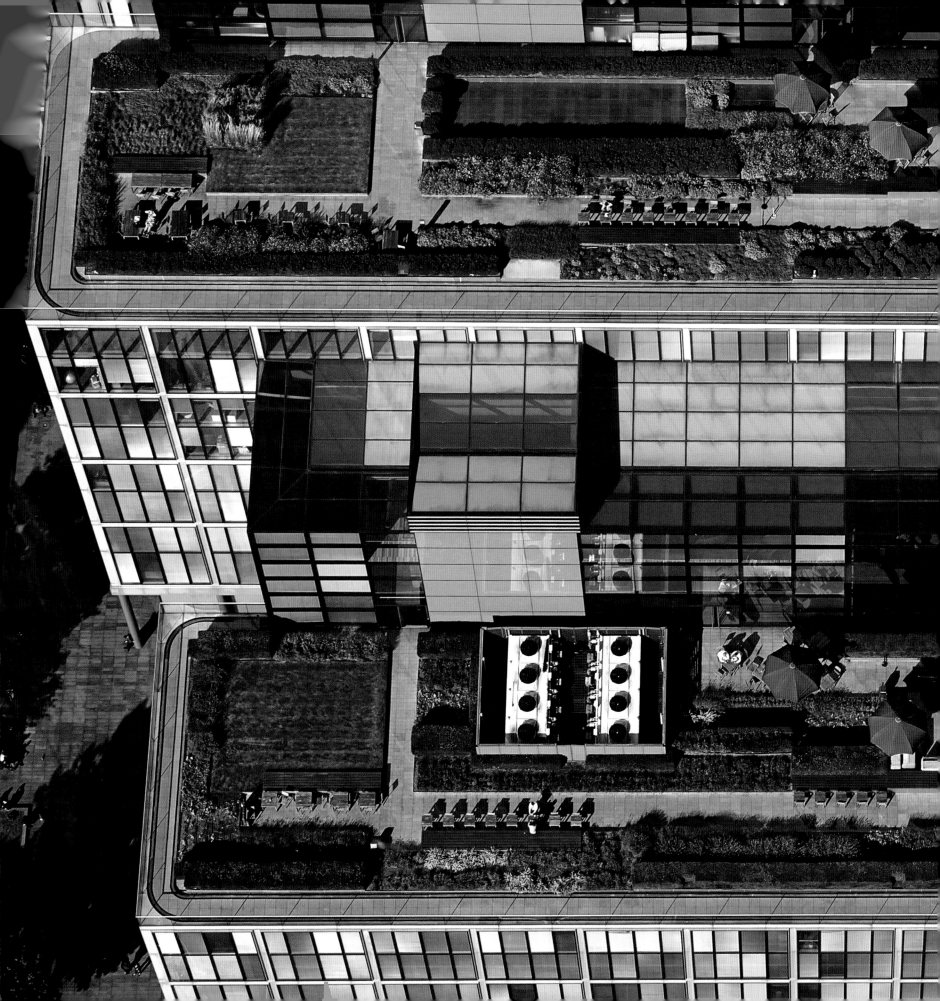

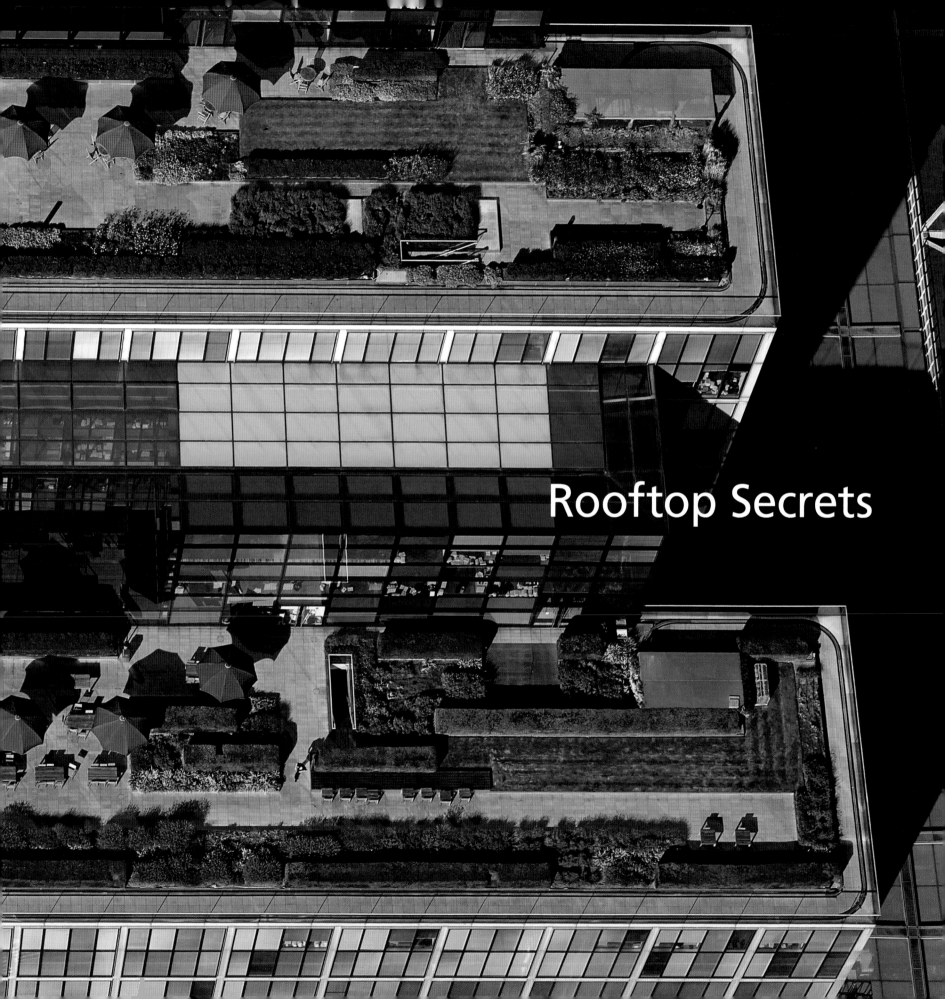

Rooftop Secrets

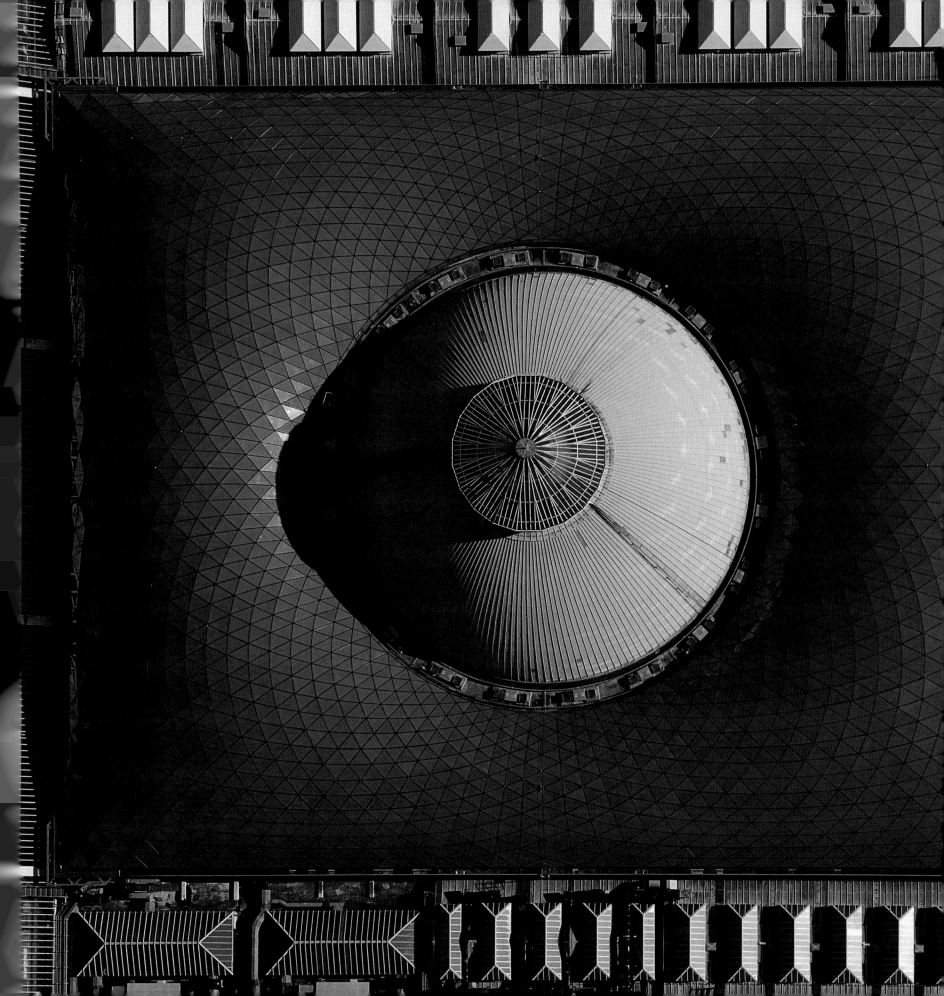

Roof gardens, Spitalfield Market, Spitalfield (pages 166-167).

Roof of the Great Court at the British Museum
Norman Foster's graceful cushion-like structure of glass and steel, completed in 2000, complements the classical architecture of the original 1847 building by Sir Robert Smirke.

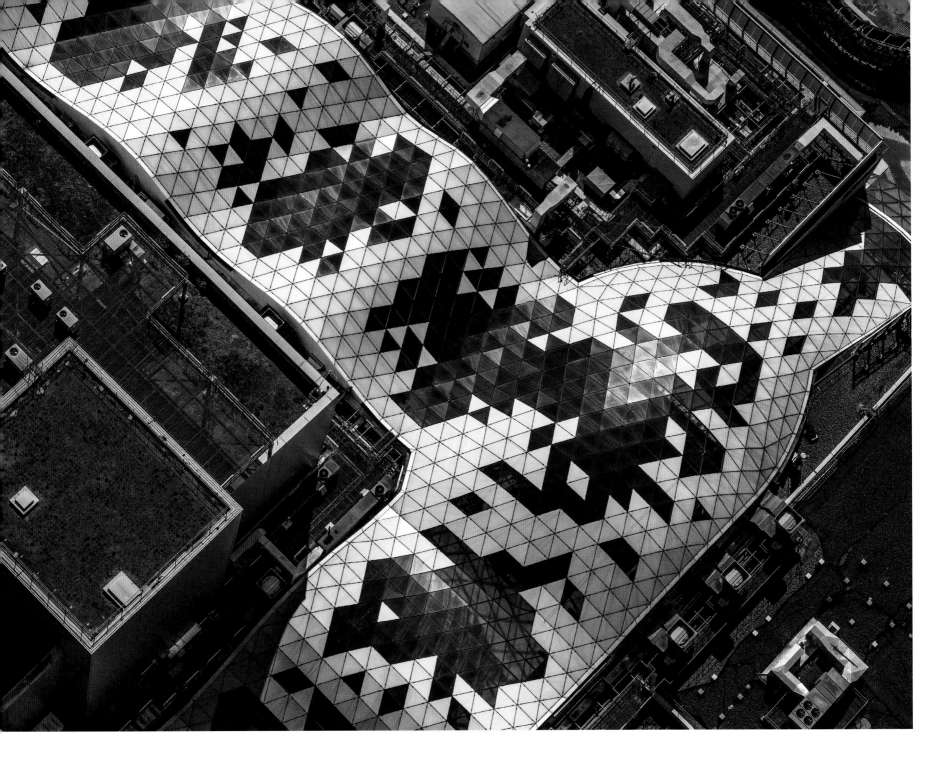

Westfield London, White City, opened
in 2008 and became the largest shopping
centre in Europe. The snakeskin-like roof
was designed by the German engineering
company Knippers Helbig.

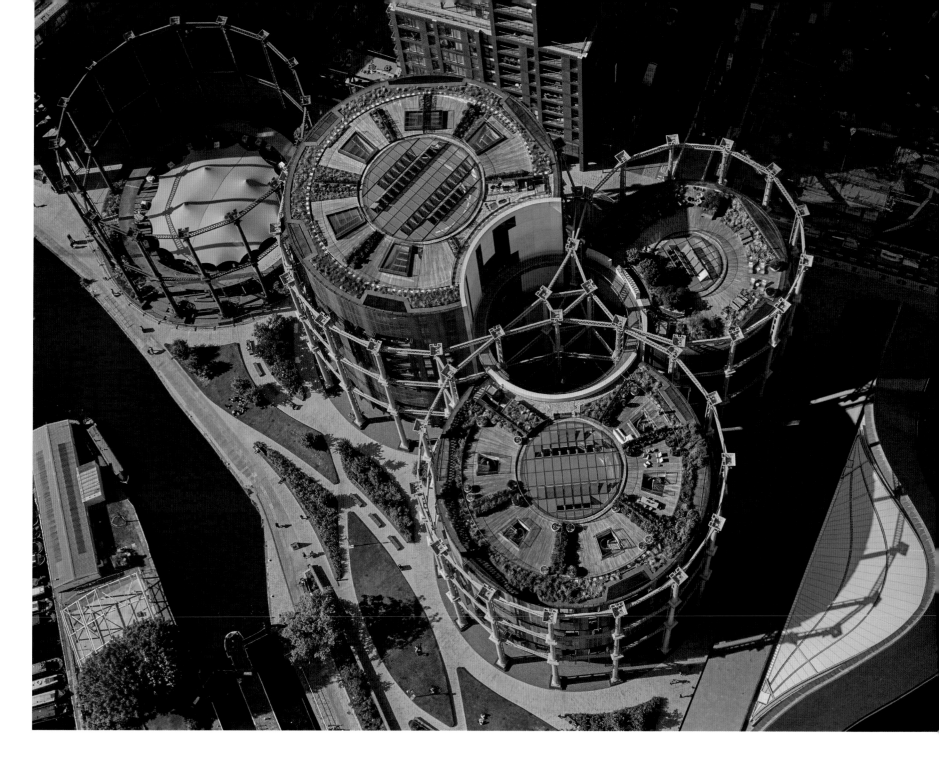

Gasholders, Kings Cross, is an imaginative use of the old Pancras Gasworks which once dominated the then industrial landscape of Kings Cross. Four intricate wrought-iron gasholder structures were dismantled and painstakingly restored, then moved into their new home overlooking the Regent's Canal and apartments built within their circumference.

The three residential structures were designed by Wilkinson Eyre, with Bell Phillips contributing the larger non-residential gas holder known as Gasholder Park.

Viewing Gallery and Sky Garden (pages 172-173) on the 43rd floor of the Walkie Talkie building.

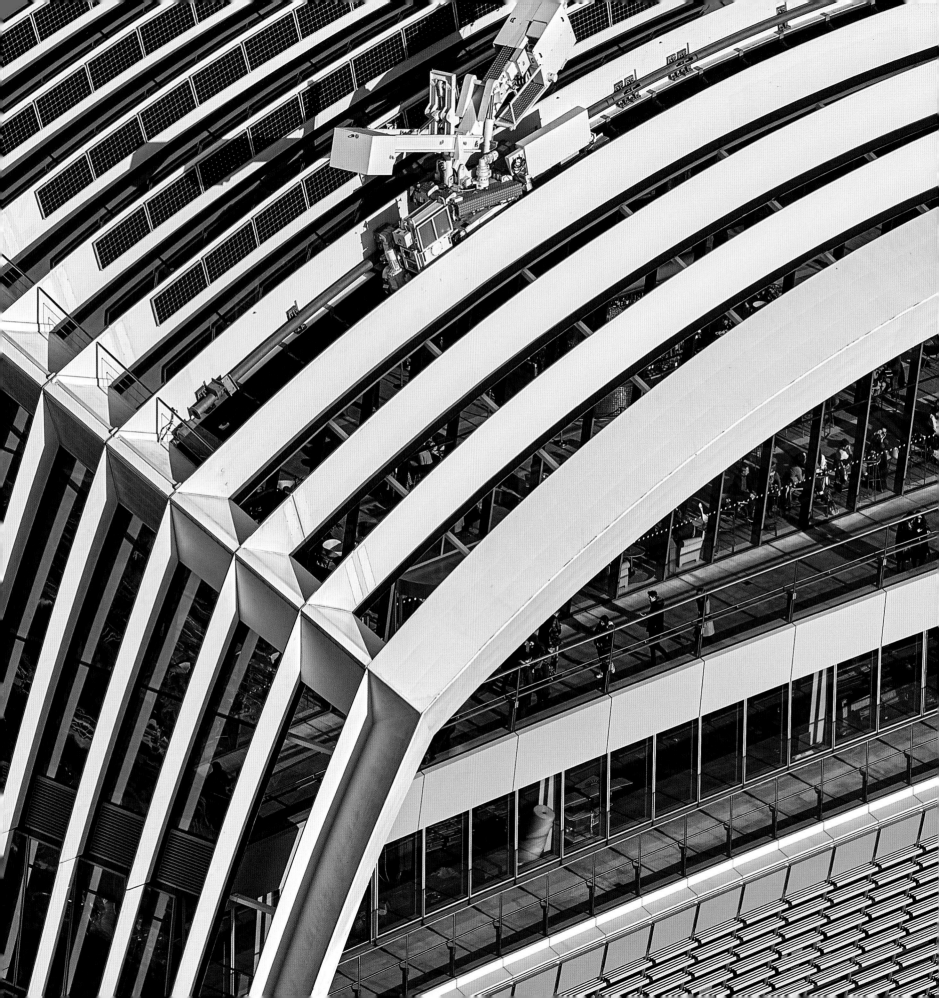

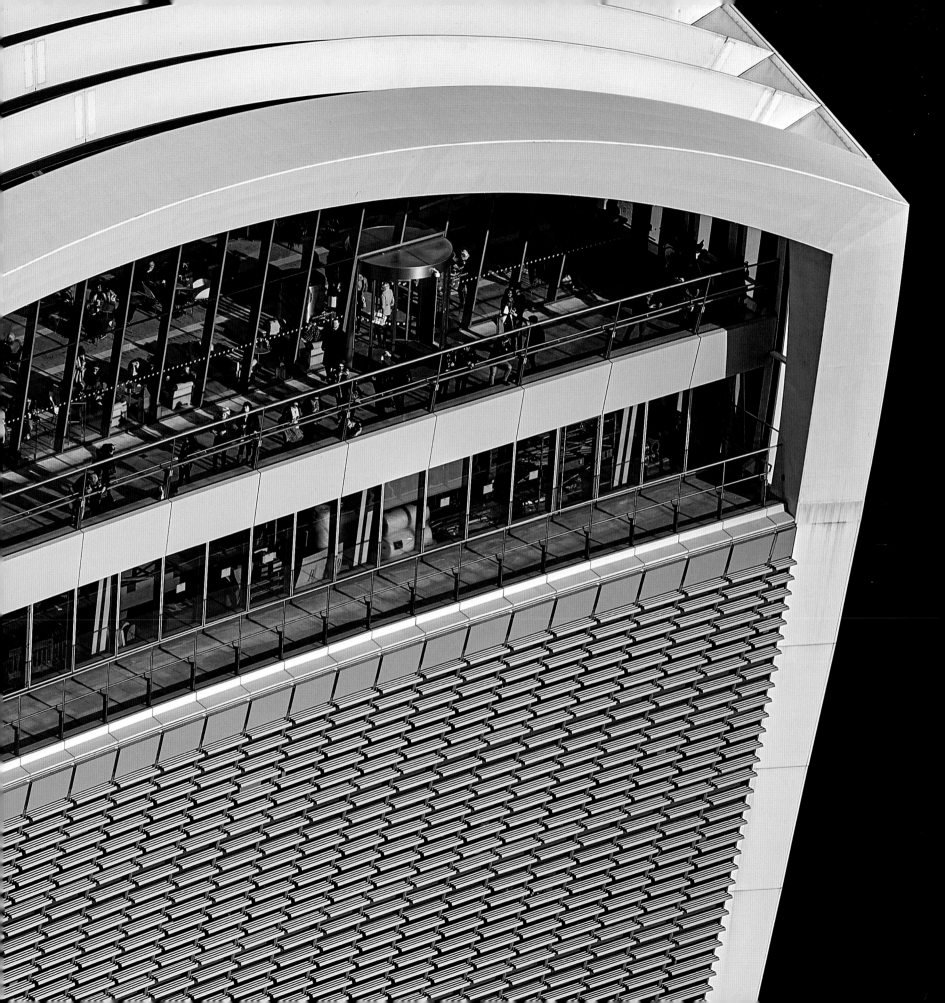

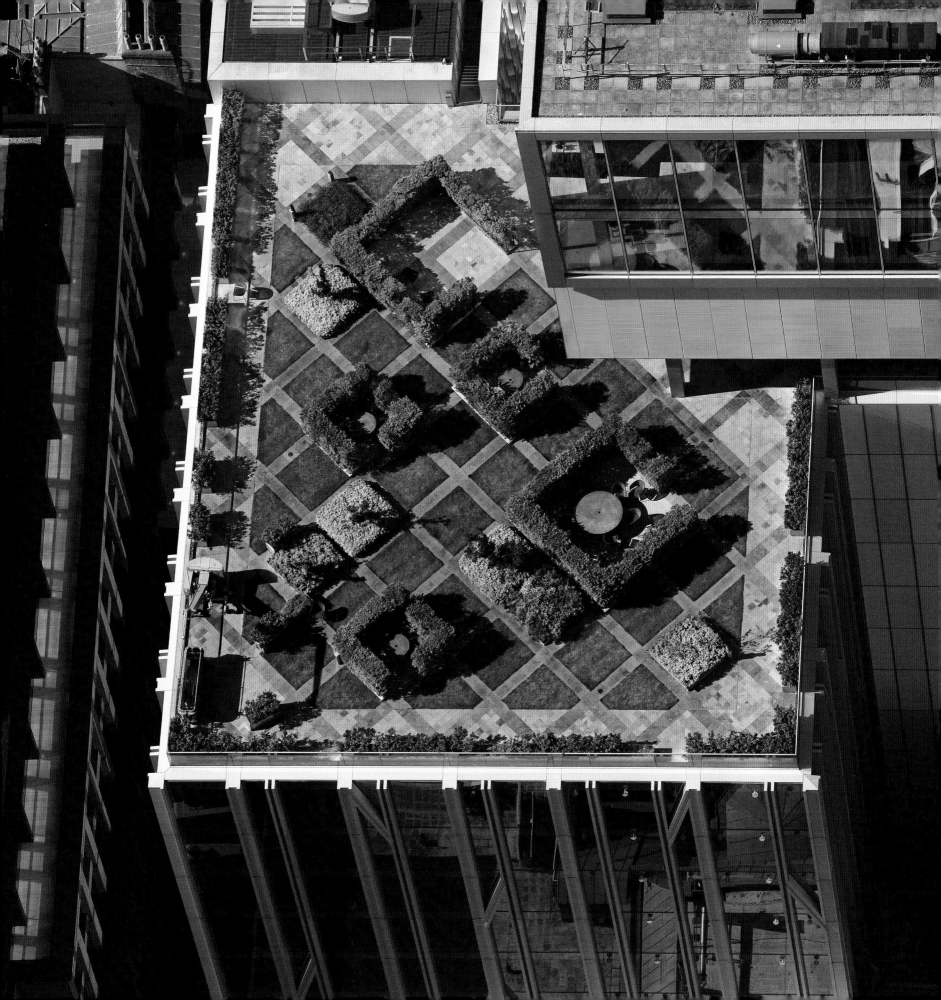

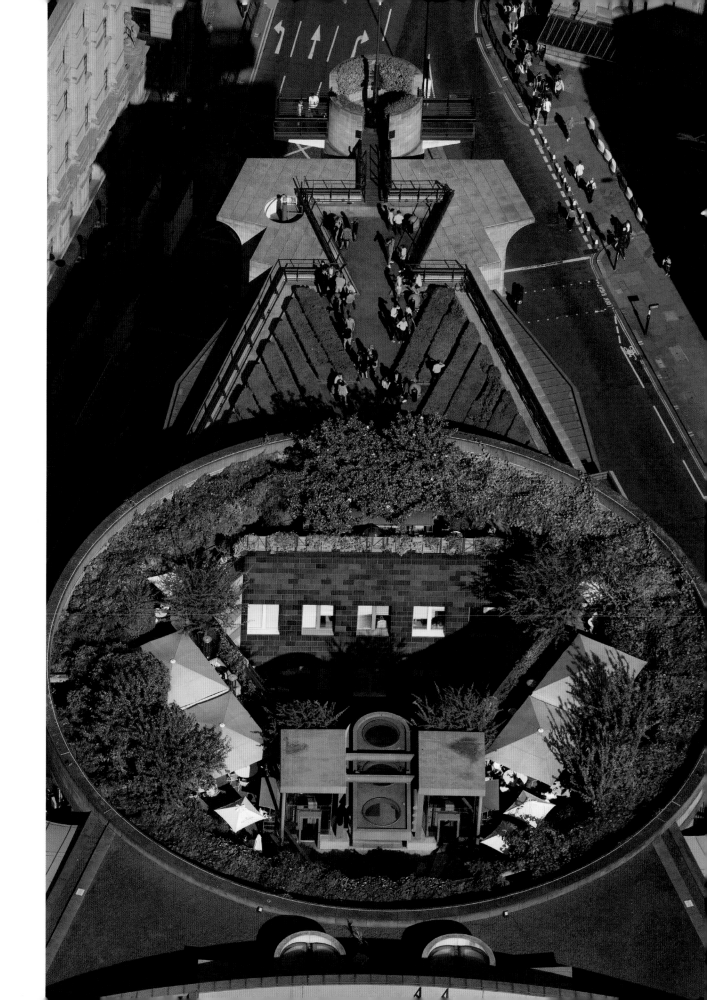

Roof Garden, Rothschild Bank New Court (left), St Swithin's Lane, is the fourth reincarnation of the Rothschild offices at the same address. It was designed by the acclaimed architect Rem Koolhaas of OMA and completed in 2011.

Number 1 Poultry is at the junction of Poultry and Queen Victoria Street. The Coq d'Argent restaurant's magnificent rooftop garden treats diners to a stunning view of the city skyline while sipping their aperitifs.

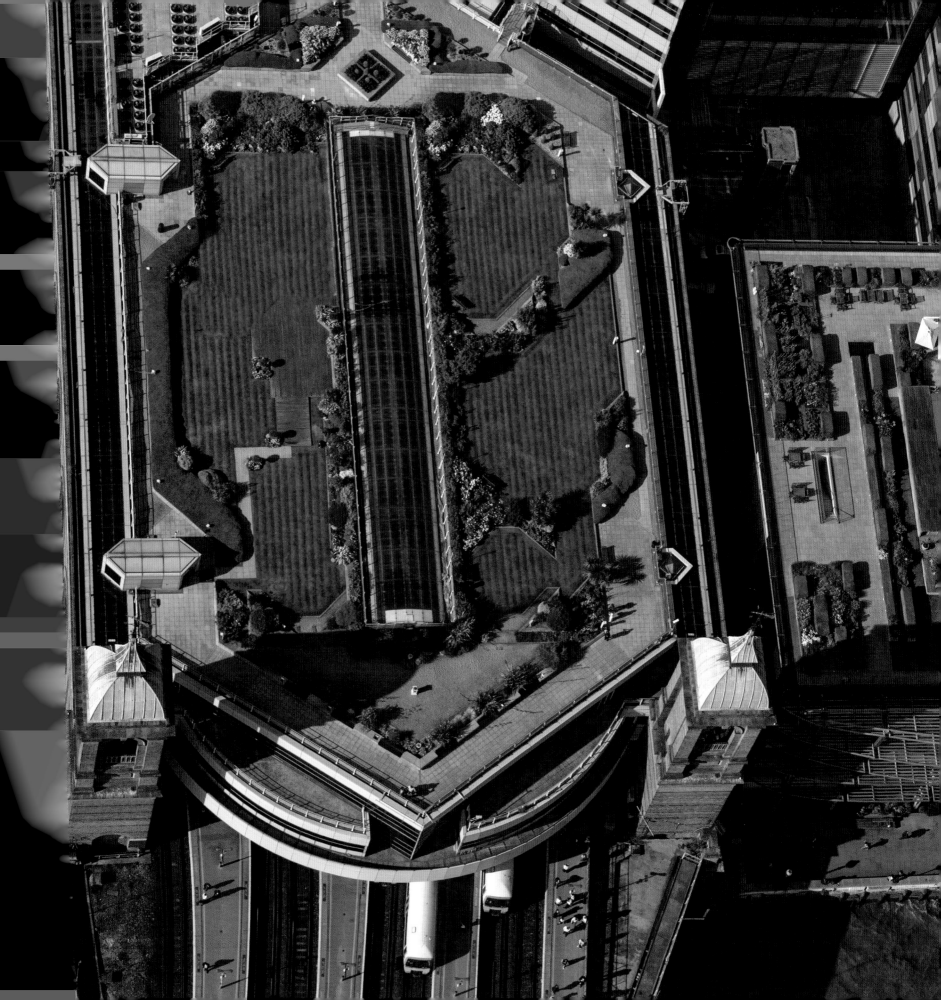

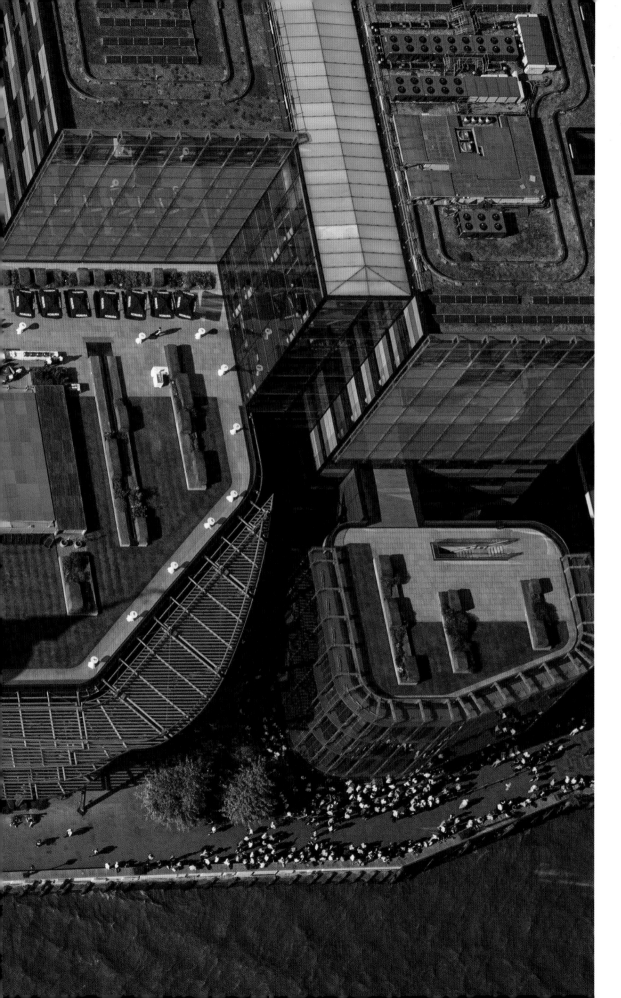

Cannon Bridge Roof Gardens, situated on top of Cannon Street Station, are privately owned gardens which pride themselves on planting for biodiversity and are a much-desired venue for private parties.

John Lewis Rooftop Garden,
overlooking the activity of Oxford Street.
In winter you can escape from the main
store onto the roof and hire a heated
cabin to eat and keep warm in.

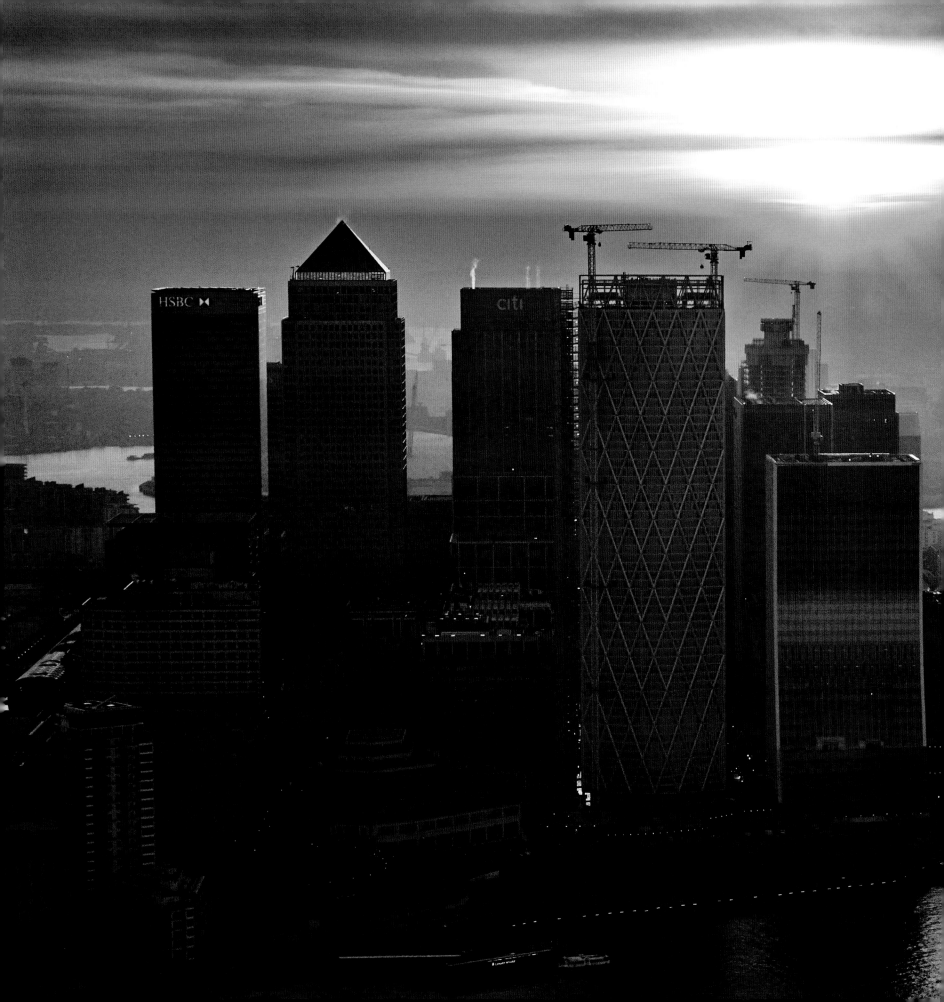

Canary Wharf and O2

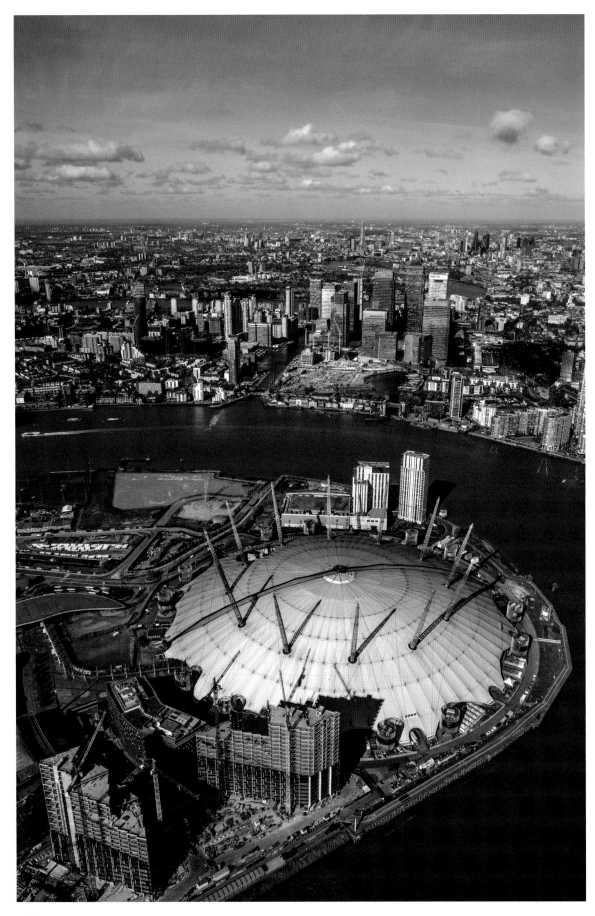

The 02, which is located at the tip of the Greenwich Peninsula, began its life in 2000 as the Millennium Dome and was built to celebrate the beginning of the third millennium. Its impressive structure was designed by Richard Rogers and Bruno Happold Engineering. In 2007 it became the O2 and today under the vast big top canopy is a 20,000 seater arena staging concerts from the world's top stars, elite sporting events, the smaller O2 Indigo, shopping malls and numerous eateries.

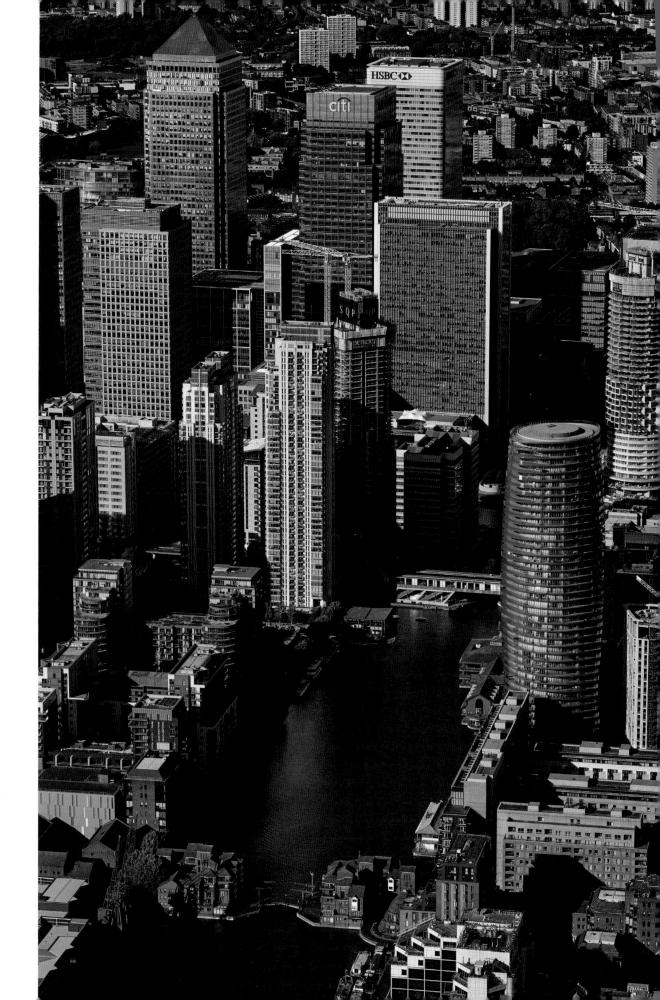

Canary Wharf, Isle of Dogs, is built on the old Millwall and West India Docks. Together with the City it is the financial centre for the UK and many banks have their European headquarters in its skyscrapers, in which over 100,000 people work. The tallest of them is One Canada Square, completed in 1991, which, at 235m (771ft), rises above the residential towers that have also sprung up around the old docks.

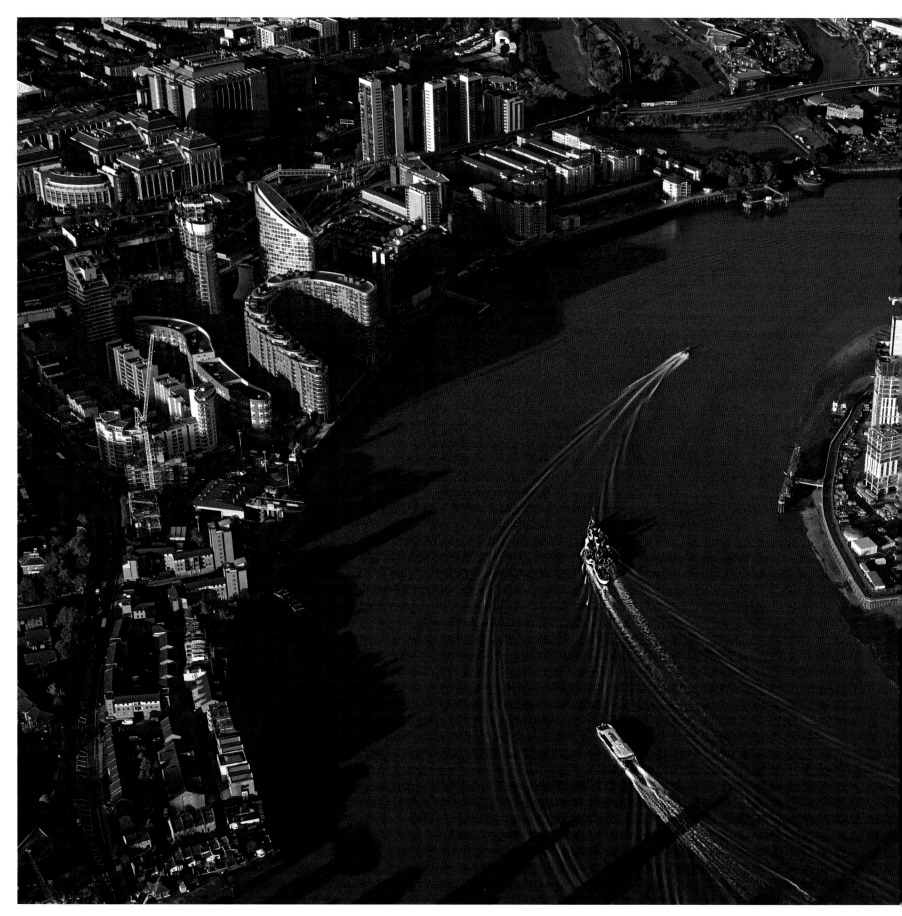

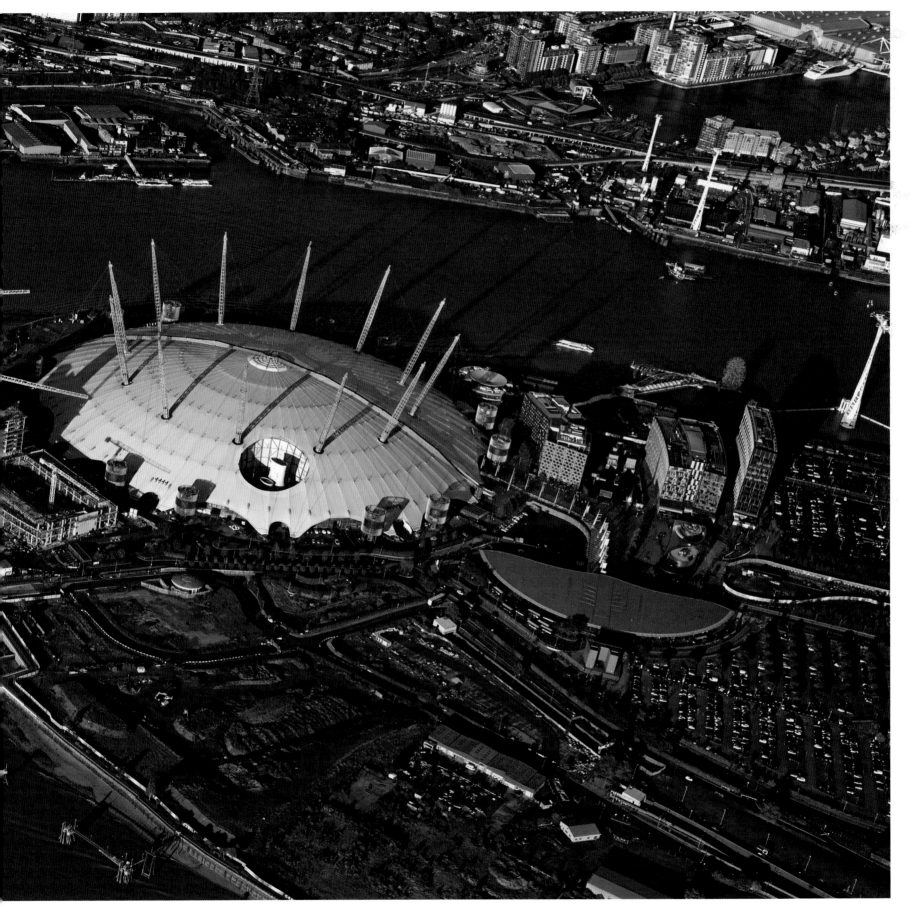

Railheads

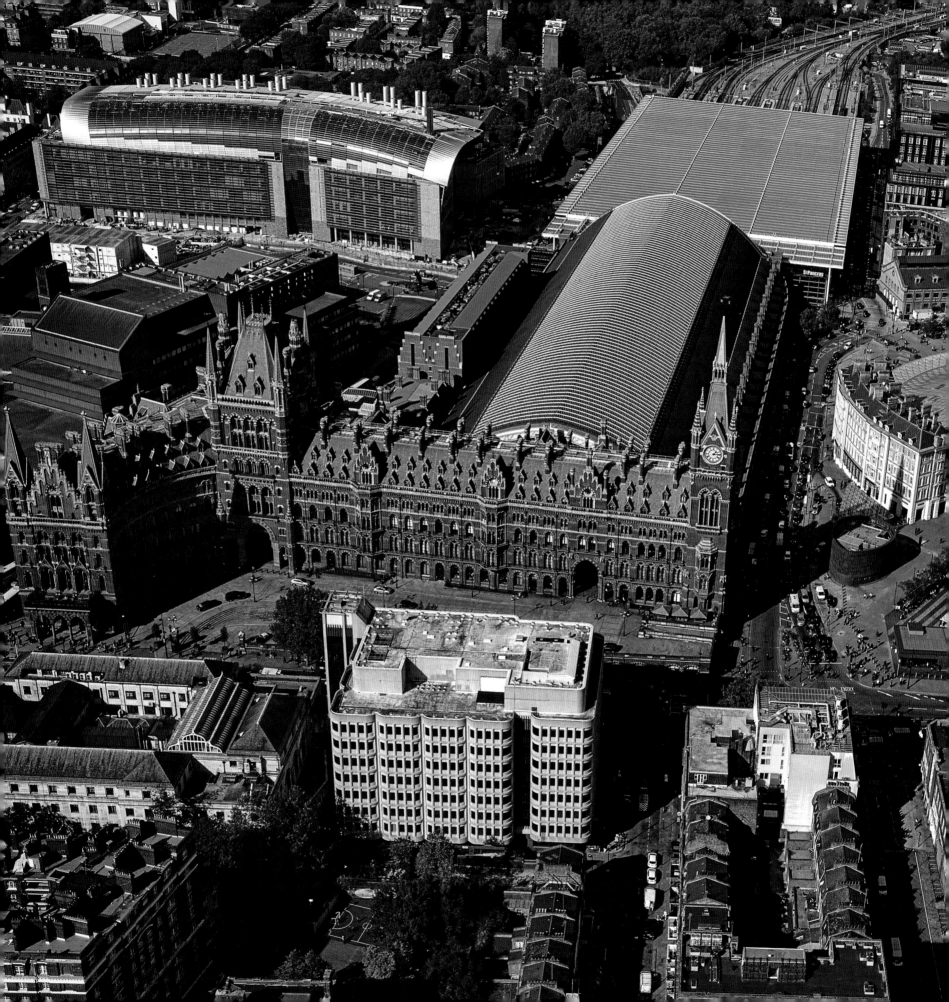

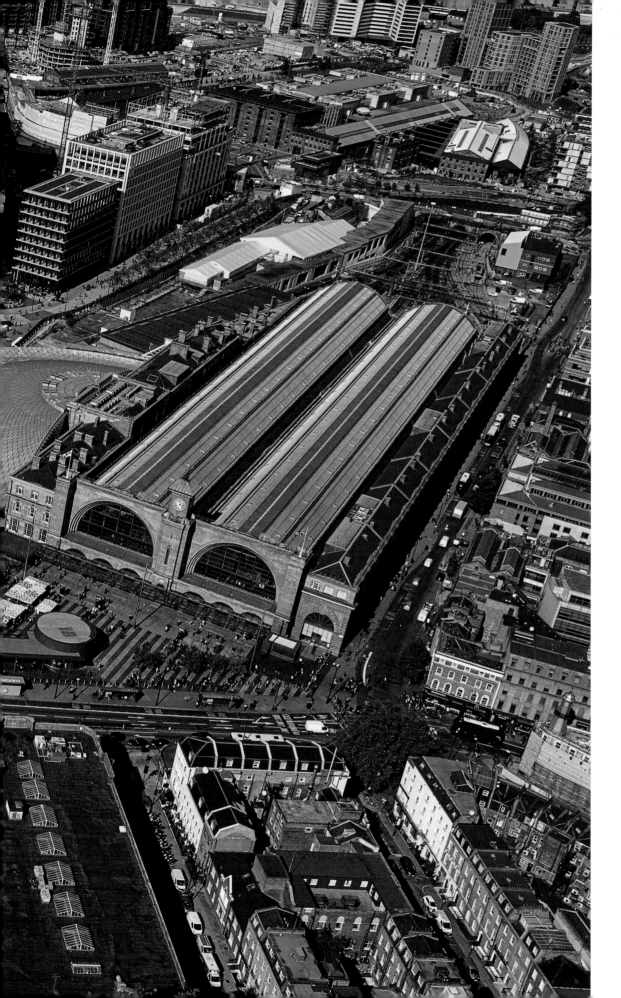

King's Cross Station's clamshell roof
(pages 186-187) umbrellas the semi-circular concourse which opened in 2012. The roof structure has a radius of 74m (243ft). It is constructed of more than 2,000 triangular panels of glass and steel and ingeniously incorporates the Northern Hotel. It was engineered by Arup and designed by John McAslan + Partners.

King's Cross and St Pancras International stations are in a landscape that juxtaposes diverse architectural styles. King's Cross opened in 1852 and was designed by Lewis Cubitt, while St Pancras International followed in 1868, designed by William Henry Barlow and built on the site of Agar Town, formerly a slum. A campaign led by then Poet Laureate Sir John Betjemen and Jane Fawcett during the 1960s successfully saved Gilbert Scott's iconic Gothic facade from demolition. In the 20th century it was reinvented with an £800 million refurbishment, becoming the terminus of the Channel Tunnel Rail Link in 2007.

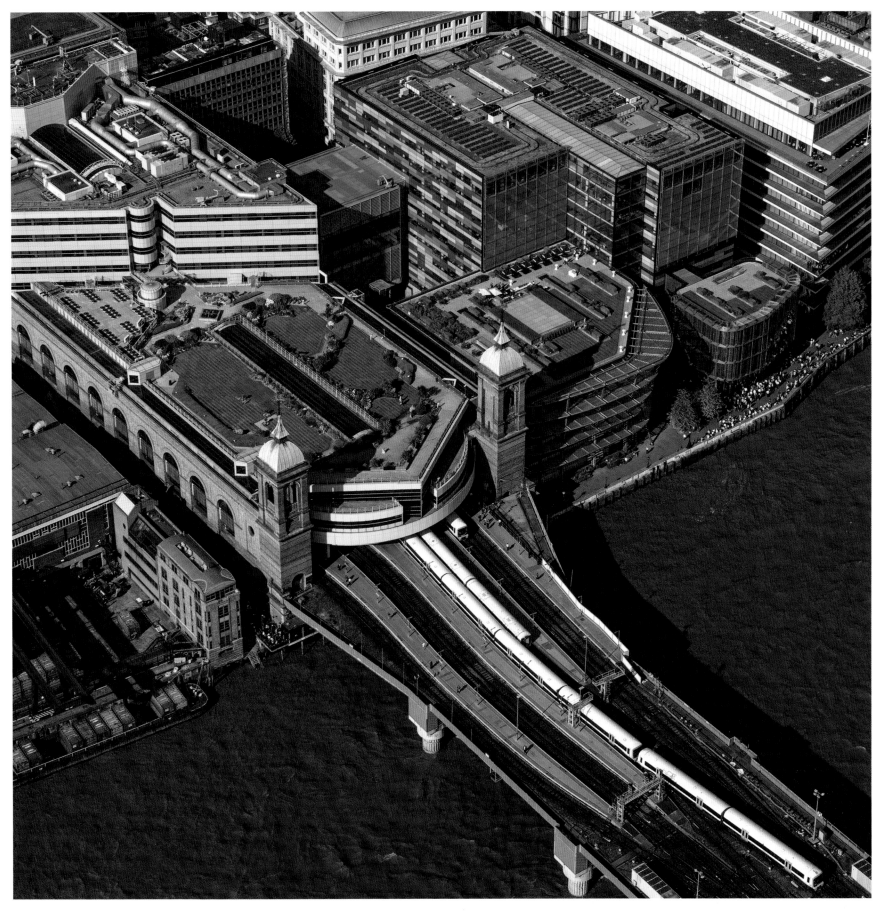

Cannon Street Station (left), servicing the Southeast, is operated by South Eastern Trains. The 41m (135ft) twin brick towers which face the river are Grade II listed and are the only survivors from the original 1866 building, designed by Sir John Hawkshaw and John Wolfe-Barry. The station's own bridge, Cannon Street Railway Bridge, built in 1886, was also designed by Hawkshaw, who was the chief engineer for the South Eastern Railway.

Liverpool Street Station, Bishopsgate, opened in 1874 and was designed by Edward Wilson of the Great Eastern Railway. Today the third busiest station in the UK, Greater Anglia Trains operate its services to the eastern counties. In 2013, during excavation work for Crossrail, a mass burial ground for victims of the Great Plague in 1665 was discovered a few feet from the surface.

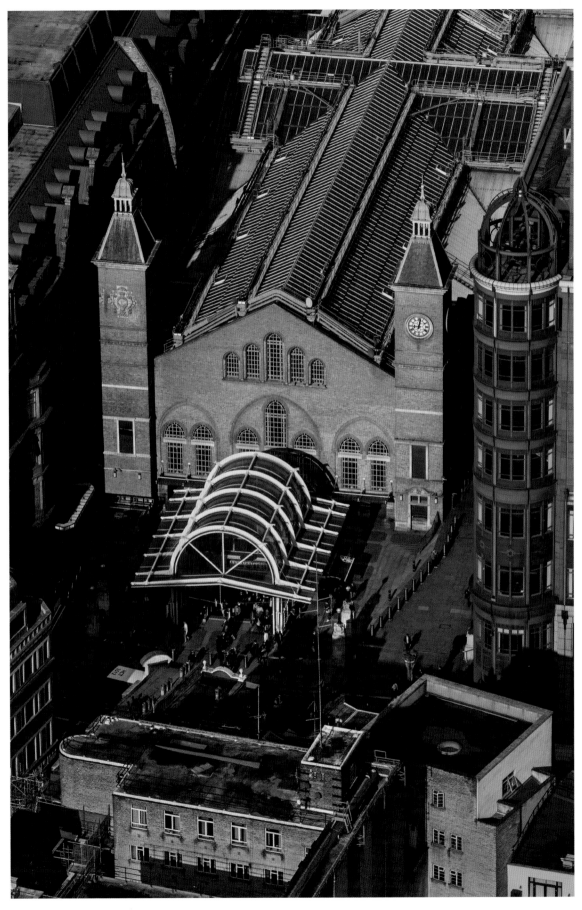

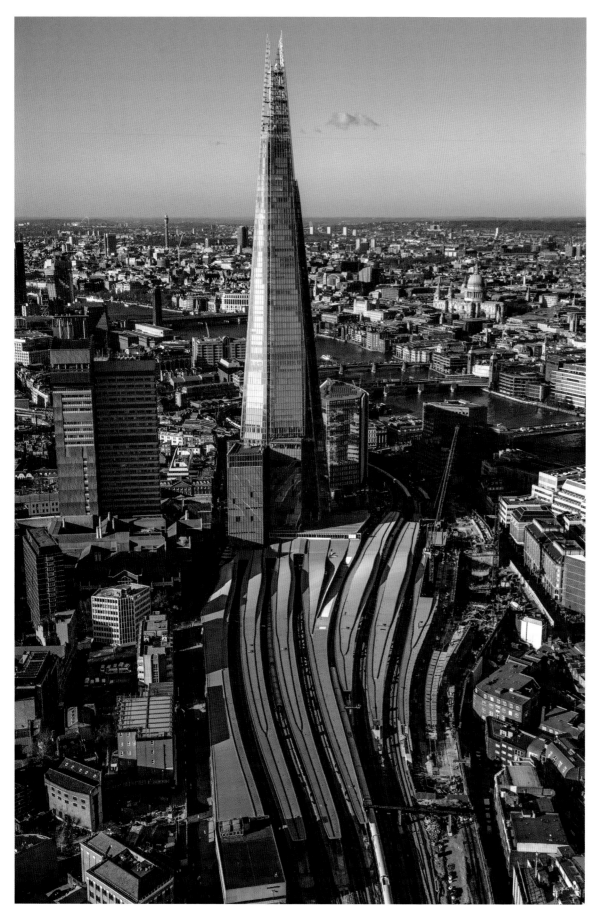

London Bridge Station sits at the foot of The Shard on Tooley Street. It is the oldest railway station in London and among the oldest in the world. First opened in 1836, many major developments were completed in 2017. Southern, South Eastern Trains and Thameslink operate services from here and it is the fourth busiest station in London.

Waterloo Station (right) is the busiest station in the UK. It has an impressive 24 platforms and nearly 100 million passengers cross its concourse annually. Designed by William Tite and opened in 1848, it was extensively rebuilt in 1922, with the opening ceremony performed by Queen Mary. Today it is the home of South Western Railway, which operates services to the south and southwest of England.

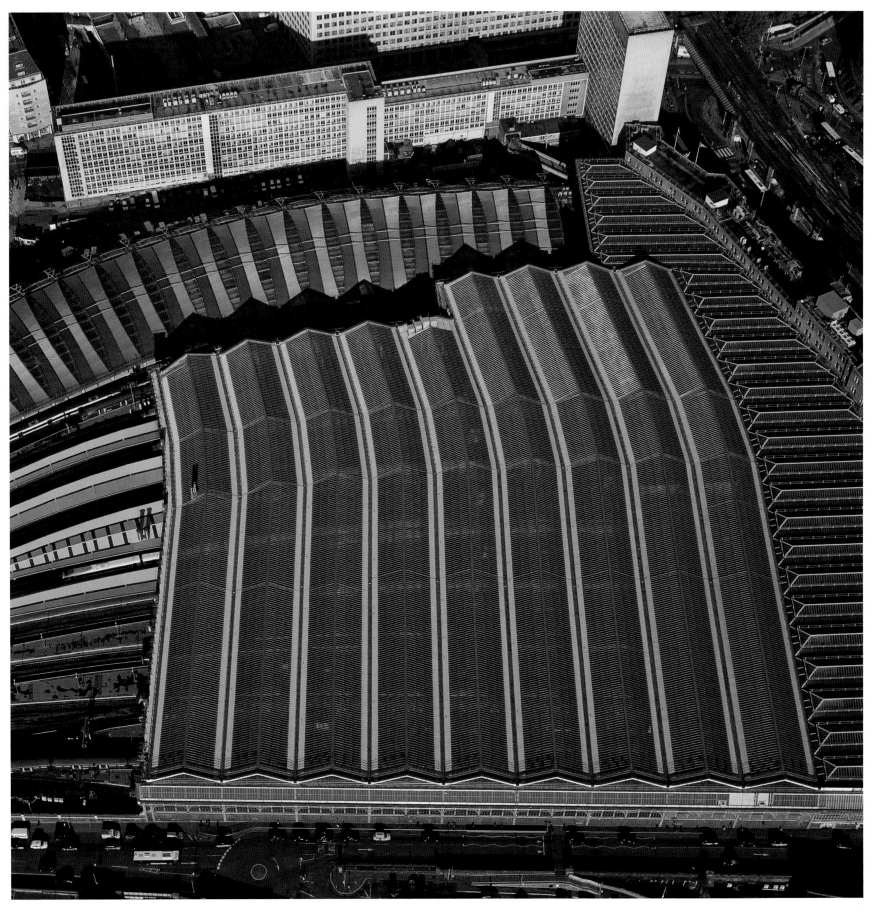

Charing Cross Station, originally opened in 1864, was designed by Sir John Hawkshaw. In the late 1980s it was rebuilt to Terry Farrell's futuristic design, which includes office space above the station. Charing Cross is served by Hawkshaw's 1864 Hungerford Bridge as well as two footbridges, added in 2002 and designed by Lifschutz Davidson Sandilands. Immediately to the left of the station is the luxurious Corinthia Hotel London, located at the corner of Northumberland Avenue.

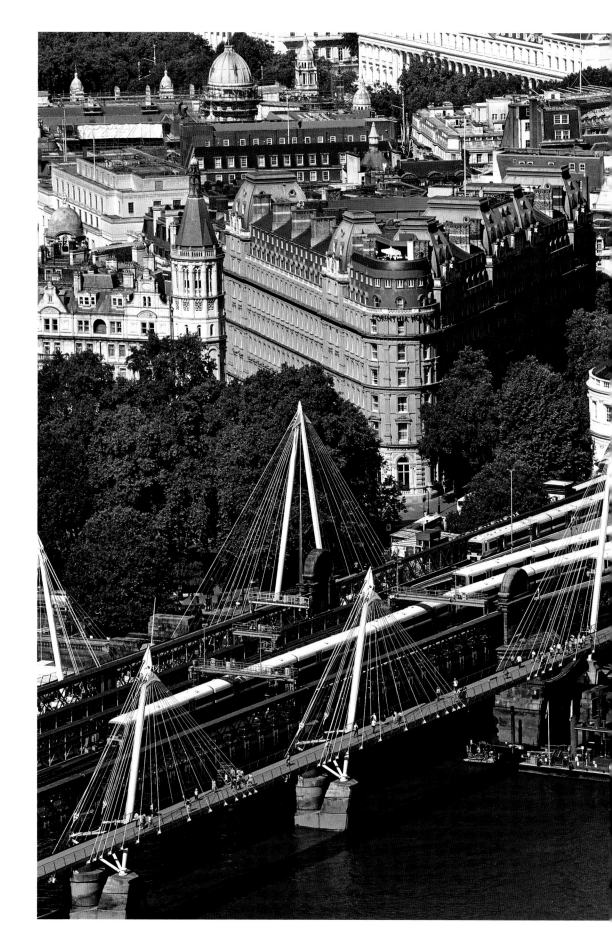

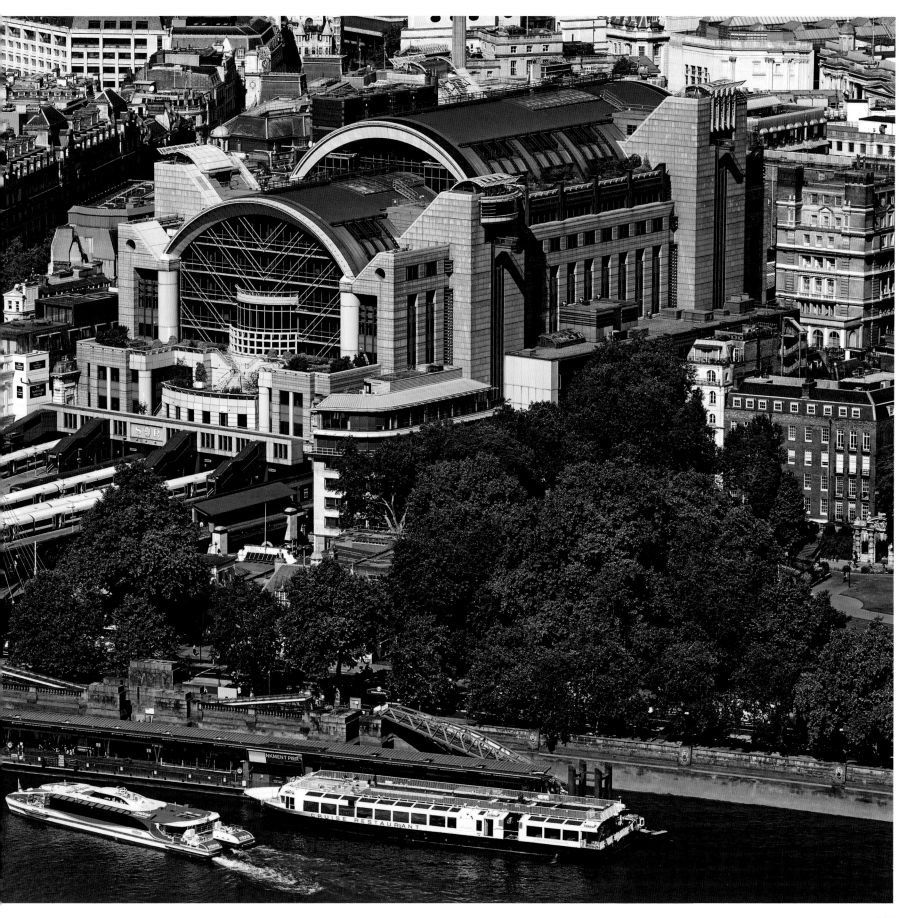

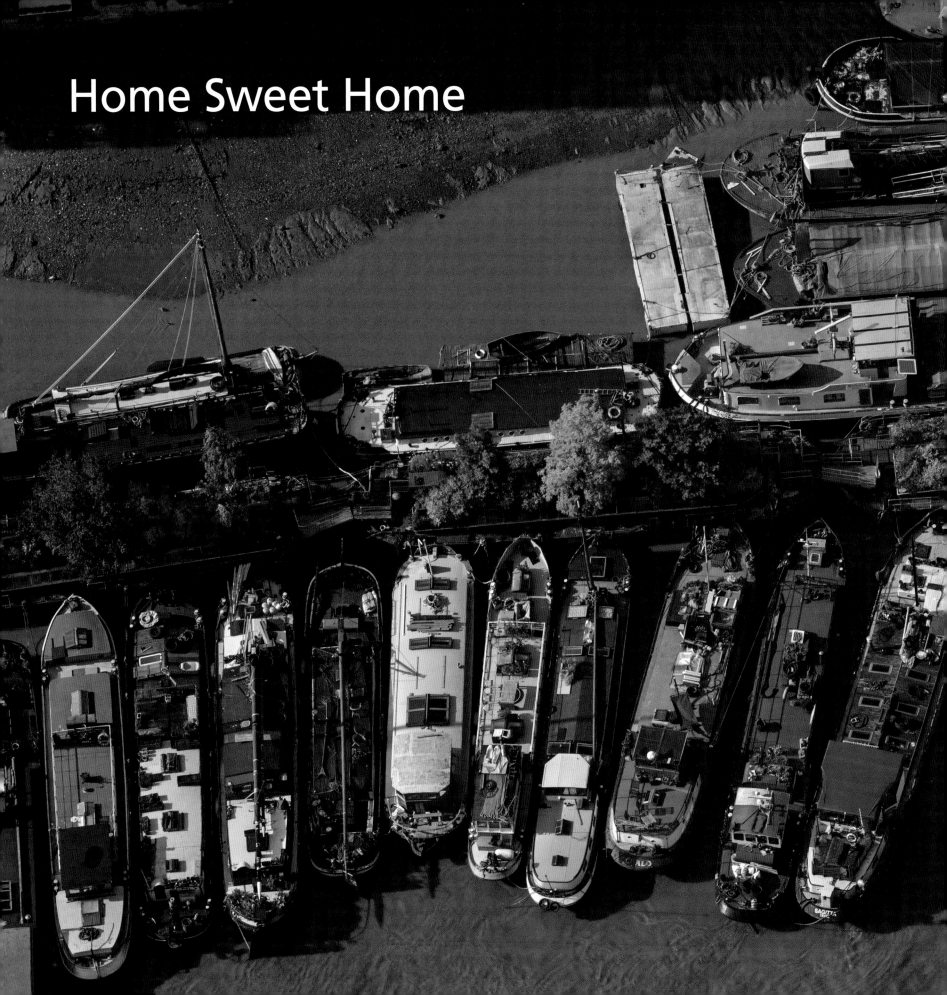

Home Sweet Home

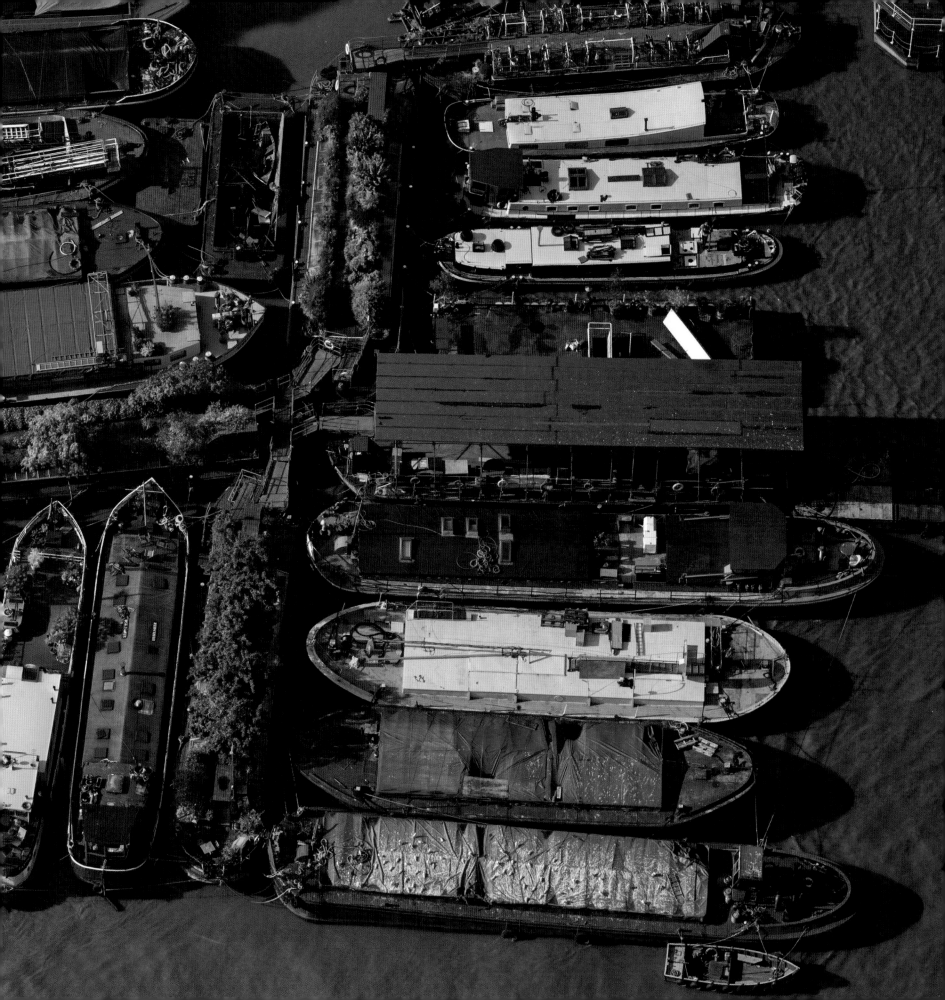

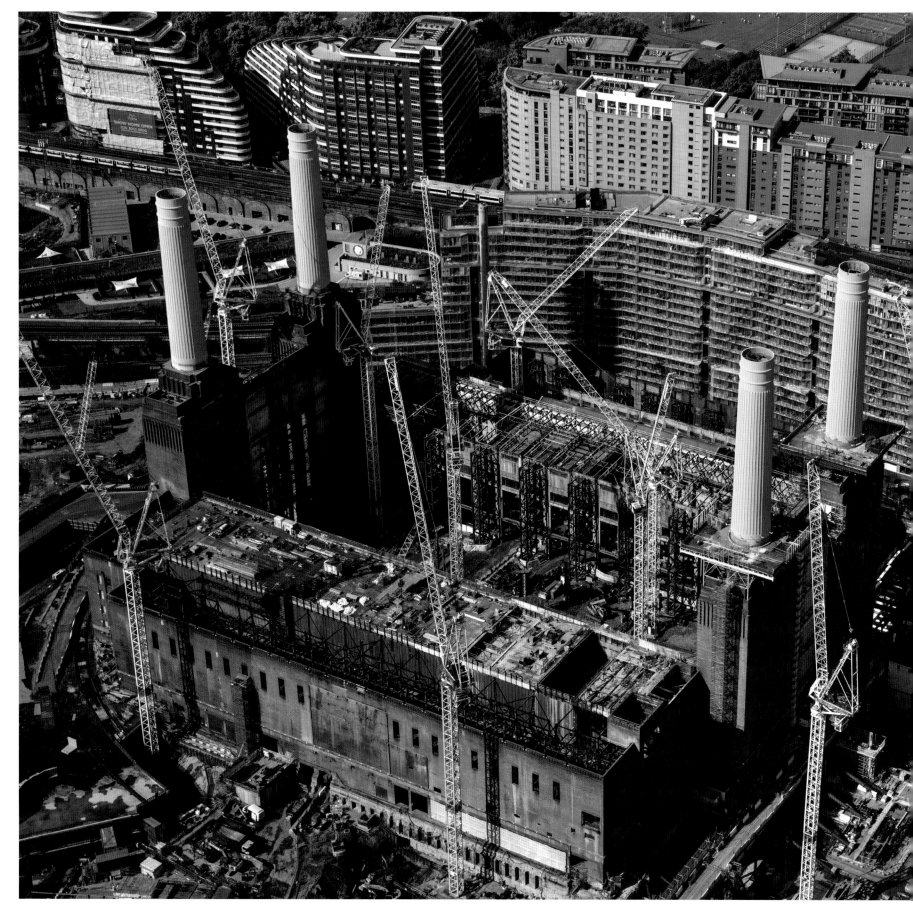

Thames Barges (pages 196-197),
St Saviour's Docks.

Battersea Power Station is a
decommissioned coal-fired power station.
One of the largest brick buildings in the
world, construction began in 1929 to a
design by Leonard Pearce, chief engineer
to the London Power Company, and was
finally completed in 1955. Since being
decommissioned in 1983 the power
station's iconic chimneys have been
preserved and the site is today a 46-acre
mega-development of housing, offices
and restaurants.

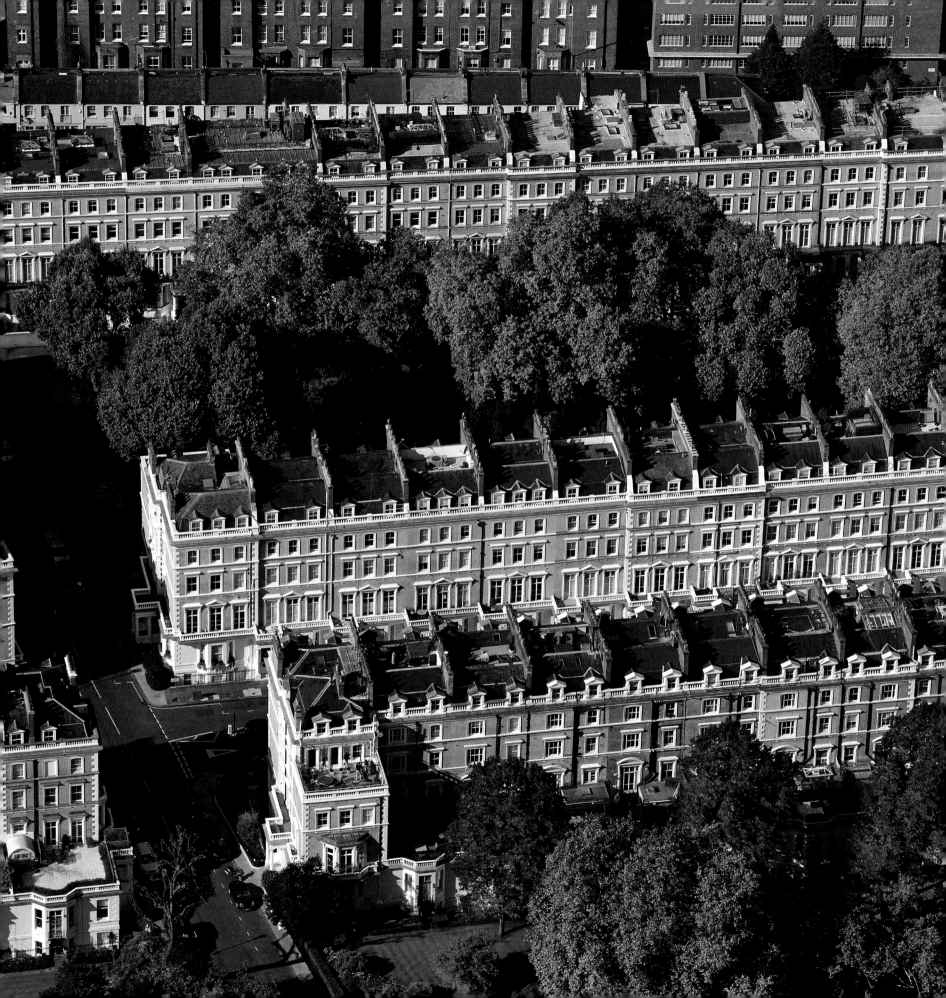

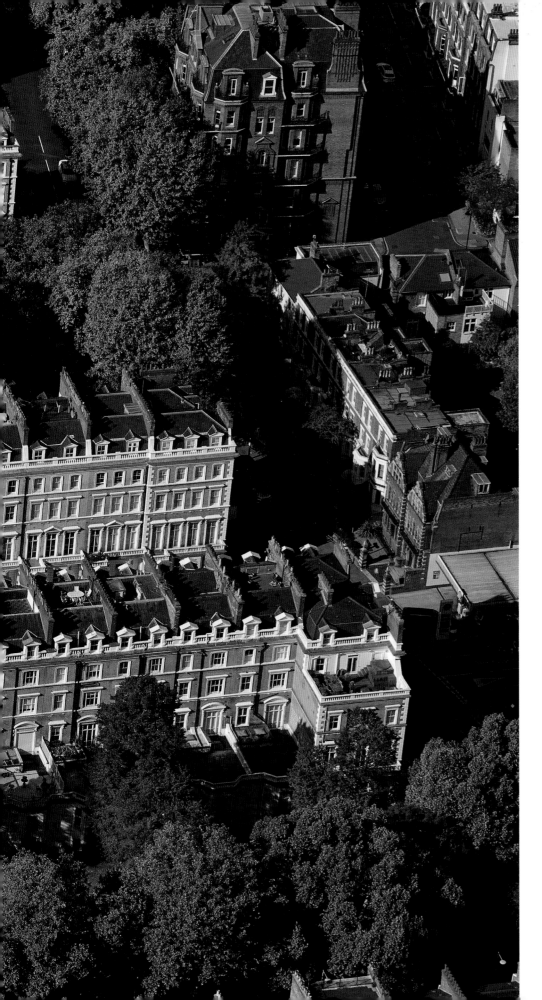

Onslow Gardens, South Kensington, an affluent area of South West London and once the home of novelist William Makepeace Thackery. The streets in this area are full of these elegant Victorian terraced town houses and each building was once a home for one family with their servants quarters below. Today some have been divided for multi-occupation on each floor.

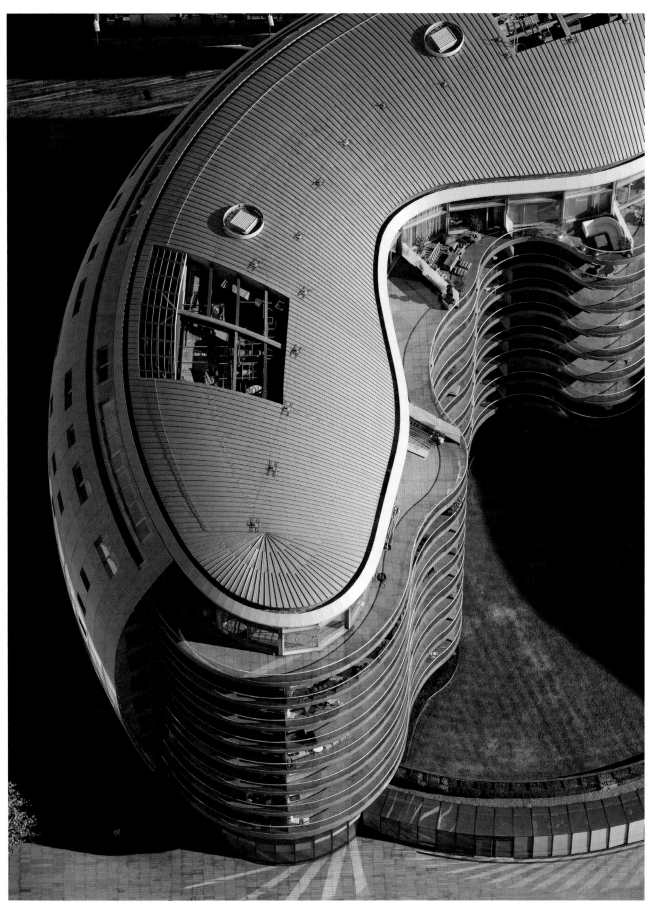

Albion Riverside, Foster and Partners' high-tech modernist design, was completed in 2003. The asymmetrical design of the primary building resembles a serpent's head.

Riverwalk (right), Millbank, are luxurious apartments overlooking the Thames designed by Stanton Williams and constructed in 2016. You have Tate Britain as your neighbour and MI6 on the opposite embankment keeping a watchful eye on you!

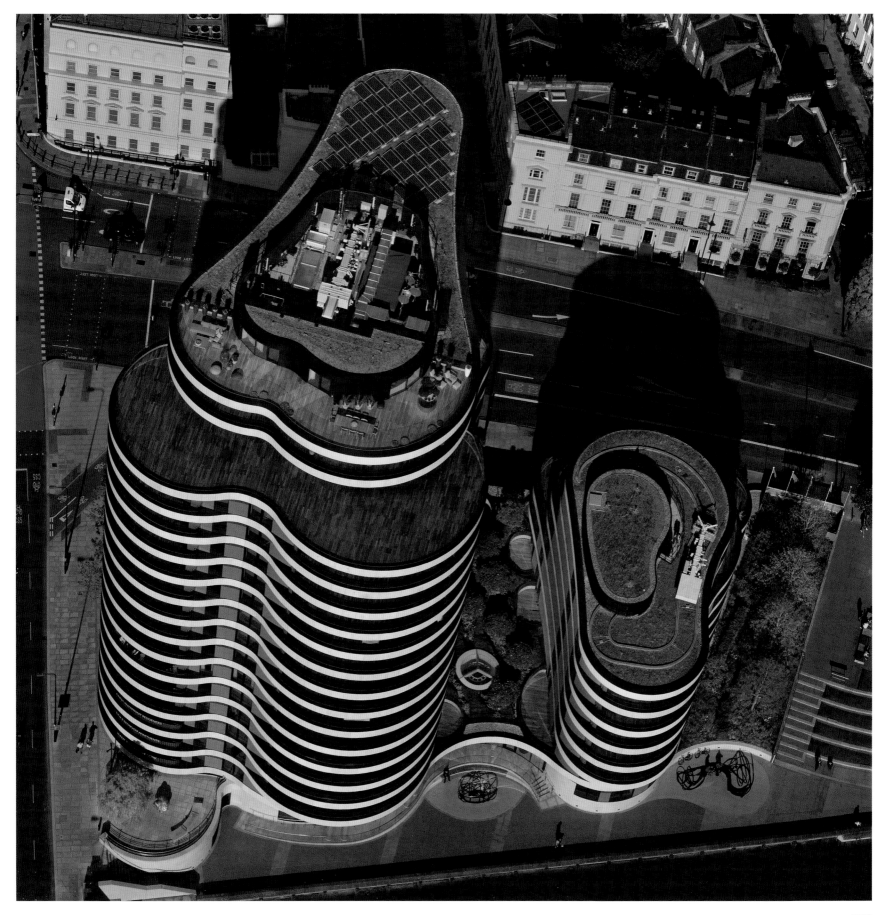

Alton West is part of the Alton Estate, Roehampton, which was built in 1958 and whose 13,000 residents have magnificent views of Richmond Park. Built as part of the post-World War II social housing programme, the distinct Corbusien/Scandinavian architecture was the creation of the London County Council architectural design team led by Rosemary Stjernstedt. Many architects of the time considered this to be a masterpiece of post-war social housing.

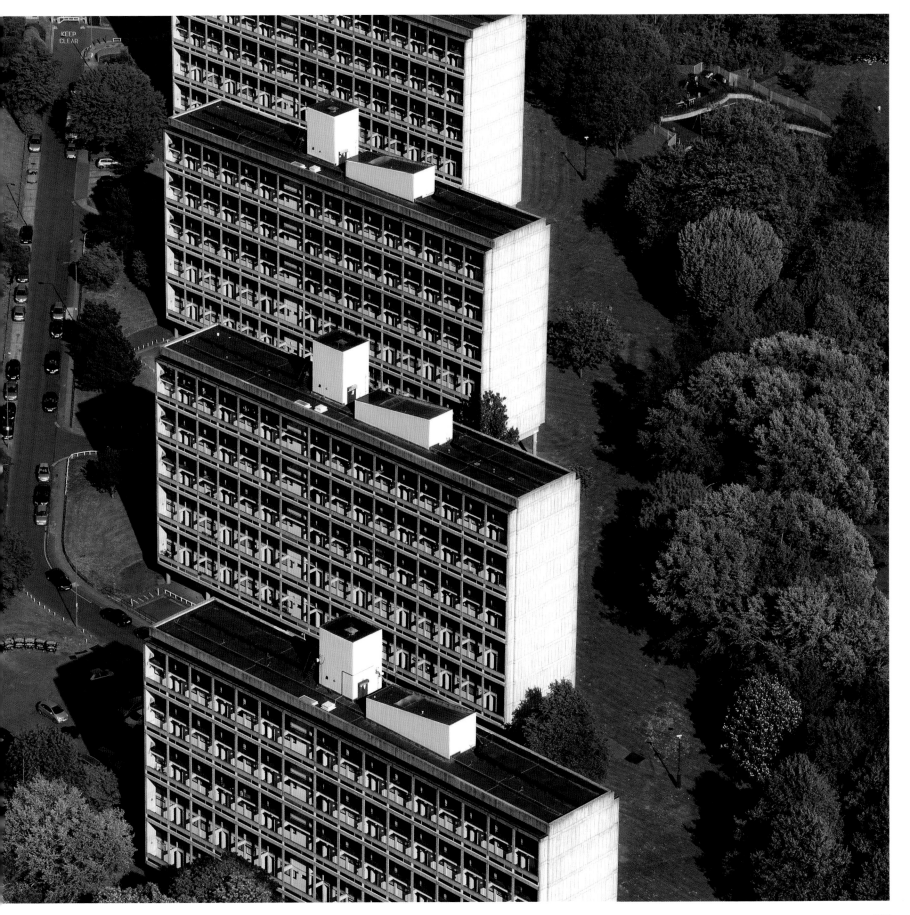

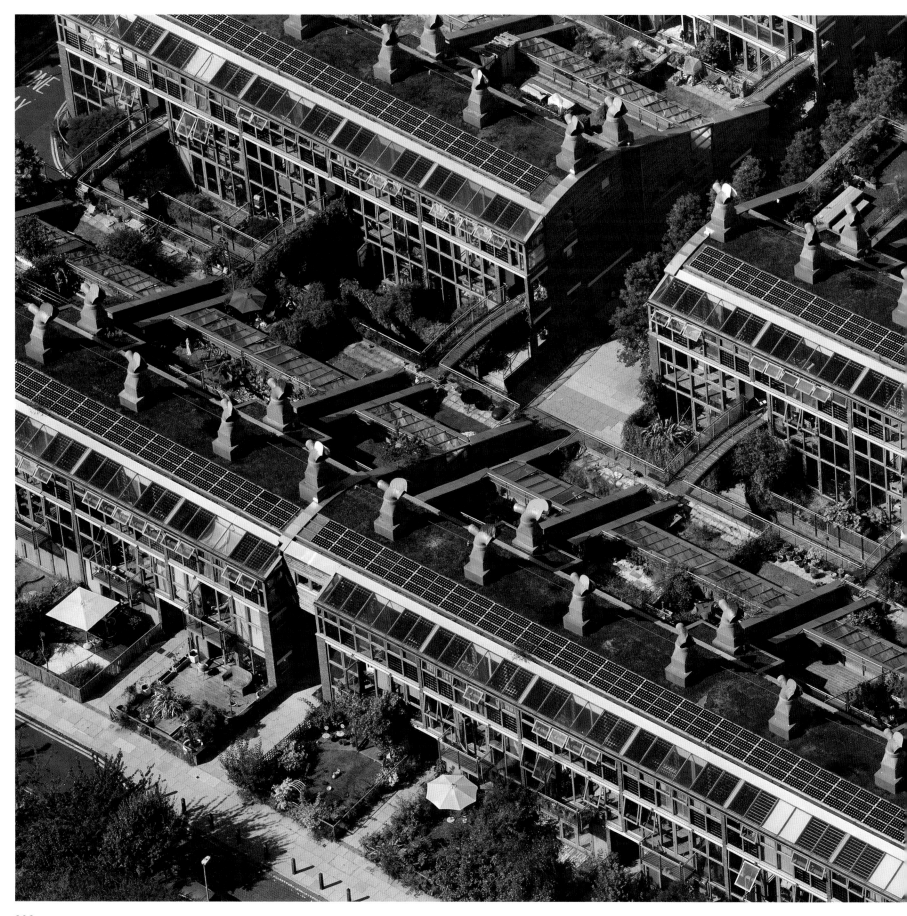

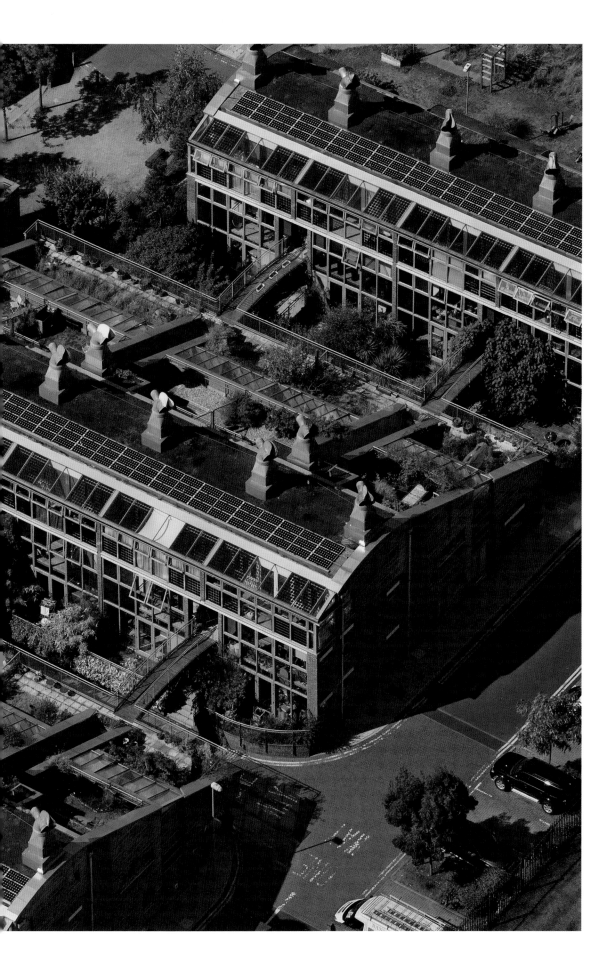

BedZED Energy Homes, Hackbridge, is an environmentally friendly development consisting of 82 homes designed to create zero emissions. They have 777sqm (8363 sqft) of solar panels and parking spaces are limited, as cars are very much discouraged. Designed by architect Bill Dunster, the homes were built in 2002.

Holland Park (page 208), Kensington, where the affluent tree-lined streets are flanked by grand Victorian townhouses in which the rich and famous live. There is a 54-acre open space park with two Japanese gardens and opera performances are held in the summer months. The Design Museum and the embassies of several countries are located in this prosperous area of the capital.

Grosvenor Estate (page 209)**,** Westminster, is four parallel blocks of Arts and Crafts/Art Nouveau residential flats located between Page and Vincent Street. They were built using the distinct Red Leicester bricks for the Grosvenor Estate, designed by Joseph and Smithem, and their foundation stone was laid by HRH The Prince of Wales in 1903. Nearby is the renowned Regency Café, which has been serving its famous 'Full English Breakfast' since 1946.

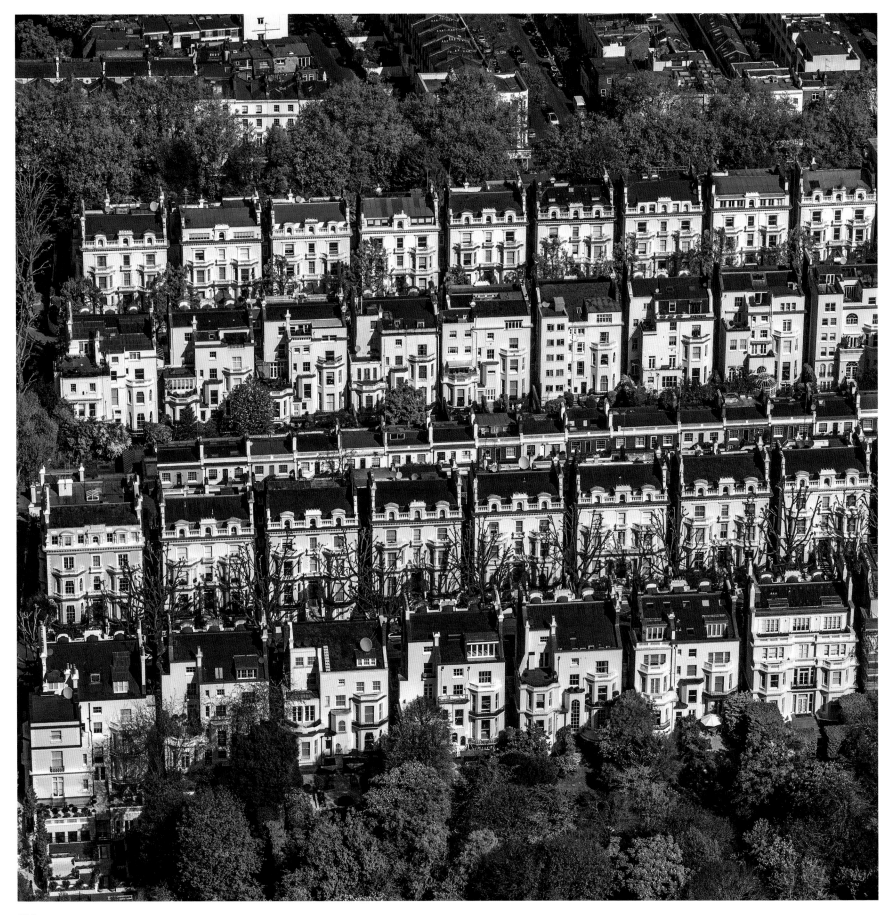

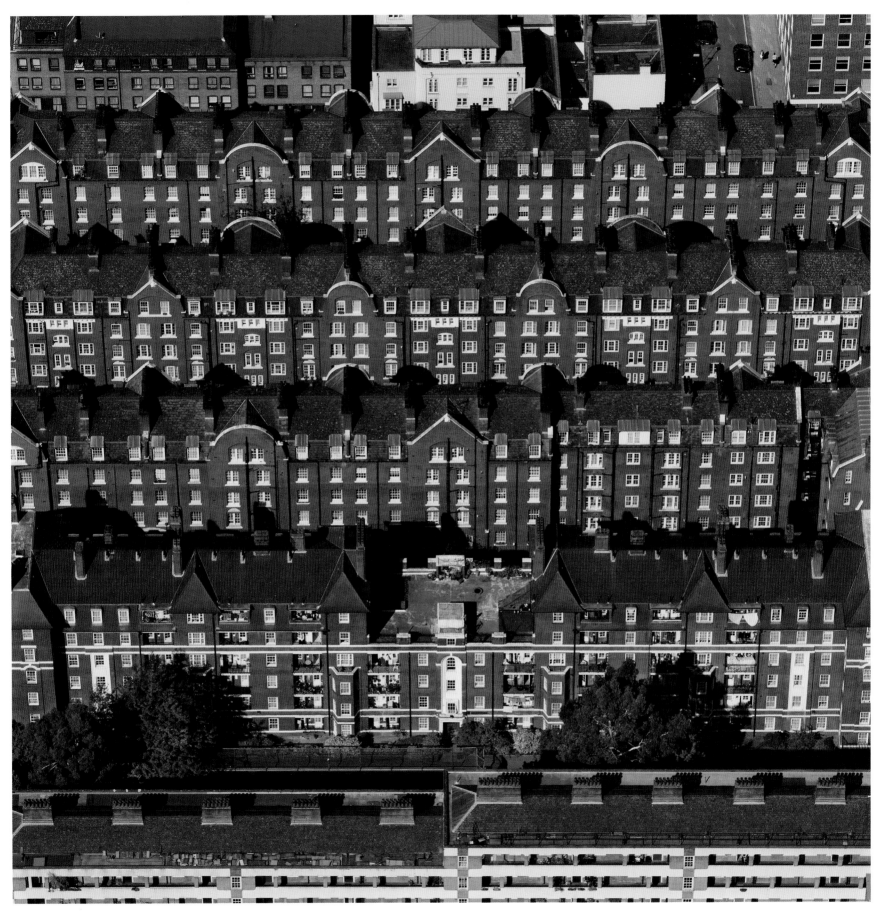

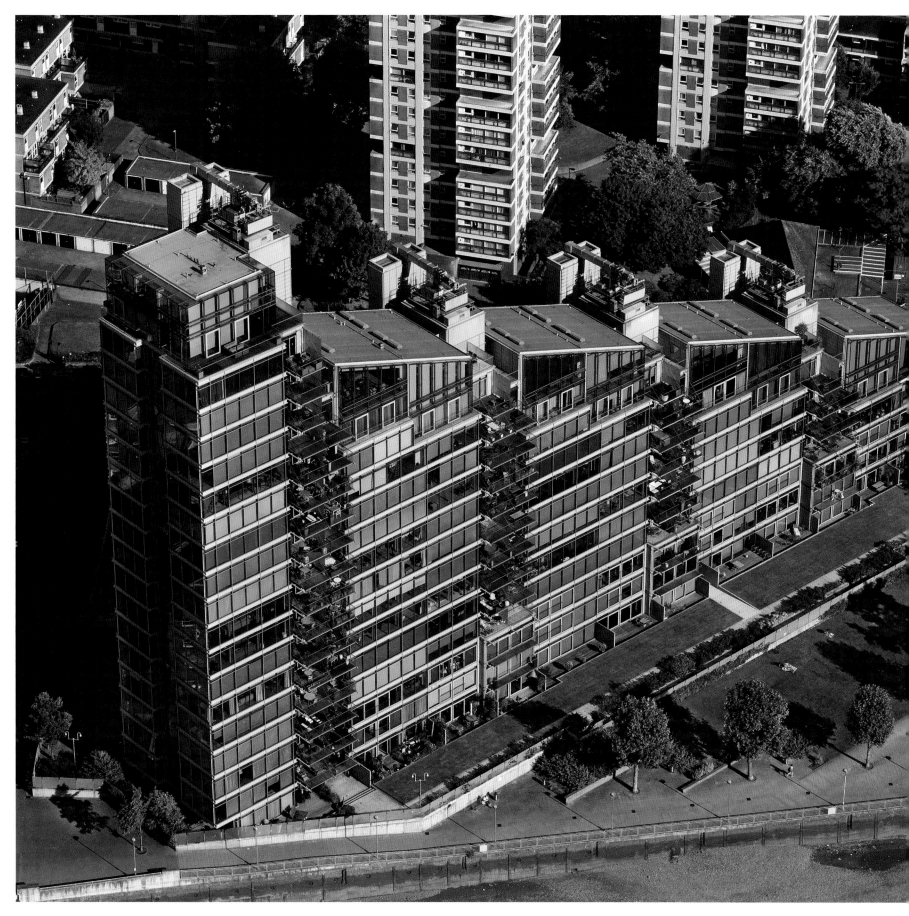

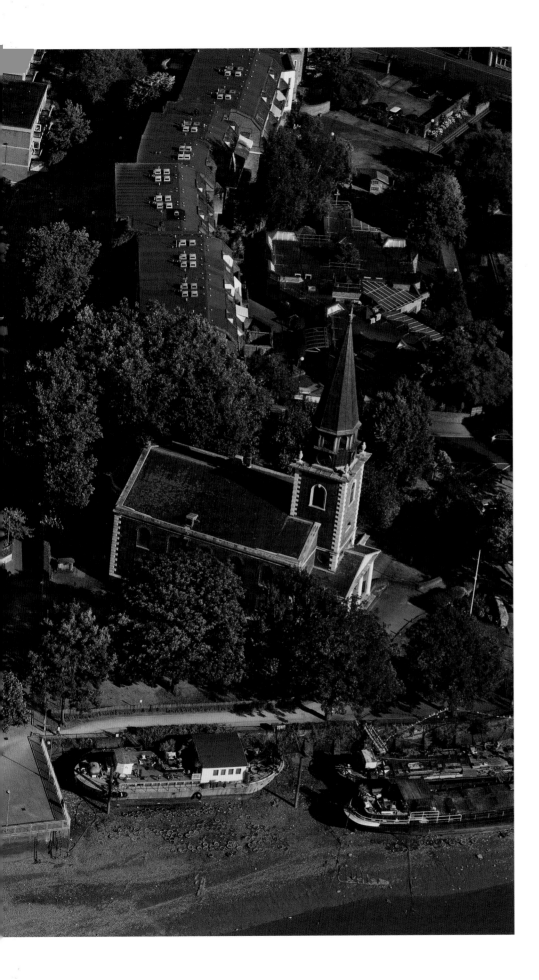

Montevetro Building, Battersea Reach, five connected blocks of riverside apartments with commanding westerly views of upstream river. Richard Rogers' striking ski slope building was completed in 2000. Below is St Mary's Church and houseboats stranded by the outgoing tide of the River Thames. *Montevetro* is an Italian word meaning 'glass mountain'.

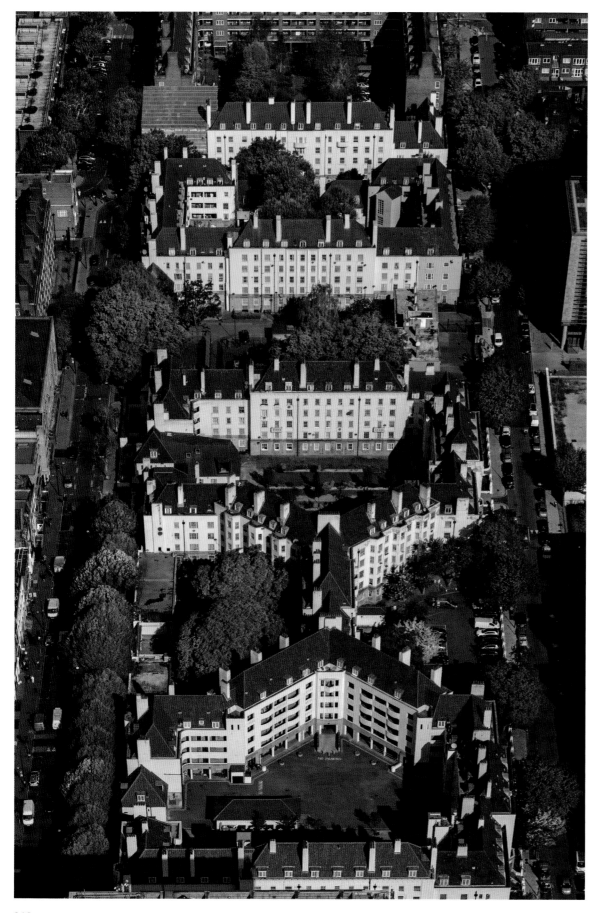

The Ossulston Estate, Somers Town, was built by London County Council between 1927 and 1931. It consists of two buildings, Chamberlin and Levita House, which are Grade II listed. The modernist design was by G. Topham Forrest, chief architect of the LCC, and his assistants, R. Minton Taylor and E. H. Parkes. They were all influenced by Viennese modernist public housing.

Stadium Place, Walthamstow, retains the distinct Art Deco facade of the former dog racing track which has been preserved by the developers of this housing development. It is a Grade II listed local landmark and was originally built in 1932. The final race meeting took place in August 2008.

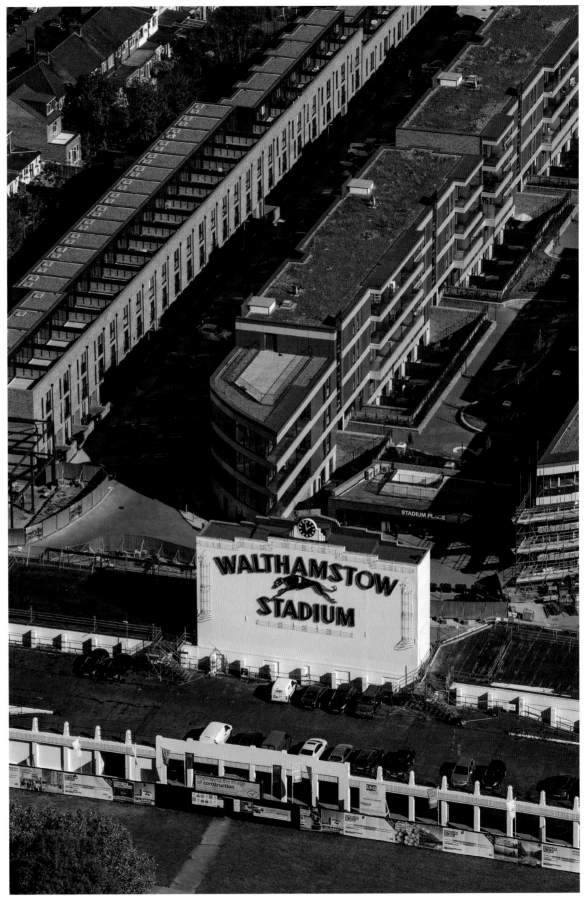

Television Centre, Wood Lane, White City, is an iconic design by architect Graham Dawbarn which was originally the headquarters of BBC Television between 1960 and 2003. After redevelopment, the complex reopened in 2017. It now incorporates apartments, offices, a cinema, a Michelin-starred restaurant and a rooftop swimming pool. There are also three state-of-the-art television studios producing prime-time live audience shows for all national TV stations. The reinvention and transformation was the work of architects Allford Hall Monaghan Morris.

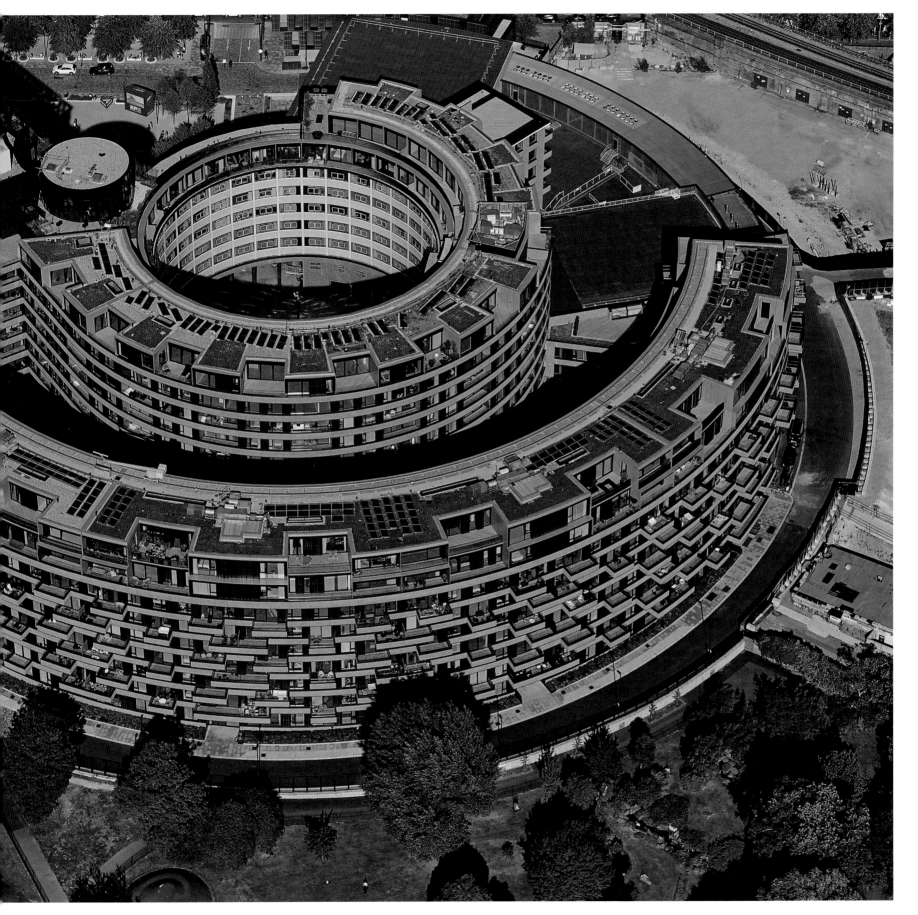

Paul Campbell

barrrywillis.com

Paul Campbell is a London-based photographer who has worked with leading advertising agencies and design groups on a wide range of accounts, from automotive to animal healthcare, cruises and supermarkets. His clients have included the British Army, the Royal Airforce, Fiat, Land Rover, Mercedes, Vauxhall, P&O Cruises and Sainsbury's.

Following his early career in the darkroom, printing black and white portfolio prints for leading advertising and fashion photographers, Paul went on to apply the knowledge he had acquired to become a freelance photographer in the advertising industry.

Being a photographer in the advertising industry is very much 24/7 and requires much imagination and resourcefulness. His briefs have included creating a snowy Antarctic in a Welsh quarry, taking camels to a beach in Sussex to become a desert, orchestrating a cavalcade of taxis in Trafalgar Square for a van advertisement and creating a full-scale authentic film set, complete with actors, film crew and all the paraphernalia involved making a feature film as location background for a car advertisement.

Over the past 15 years he has continued to add to these skills, aerial photography in particular, shooting cruise ships all over the world in locations which have taken him from tropical rainforests in South America to the frozen north.

In creating the images for *Bird's Eye London*, Paul has approached the subjects with the eye of a designer, producing images that offer a spectacular perspective without losing the reality of the city.

www.paulcampbellphotographer.com

Index

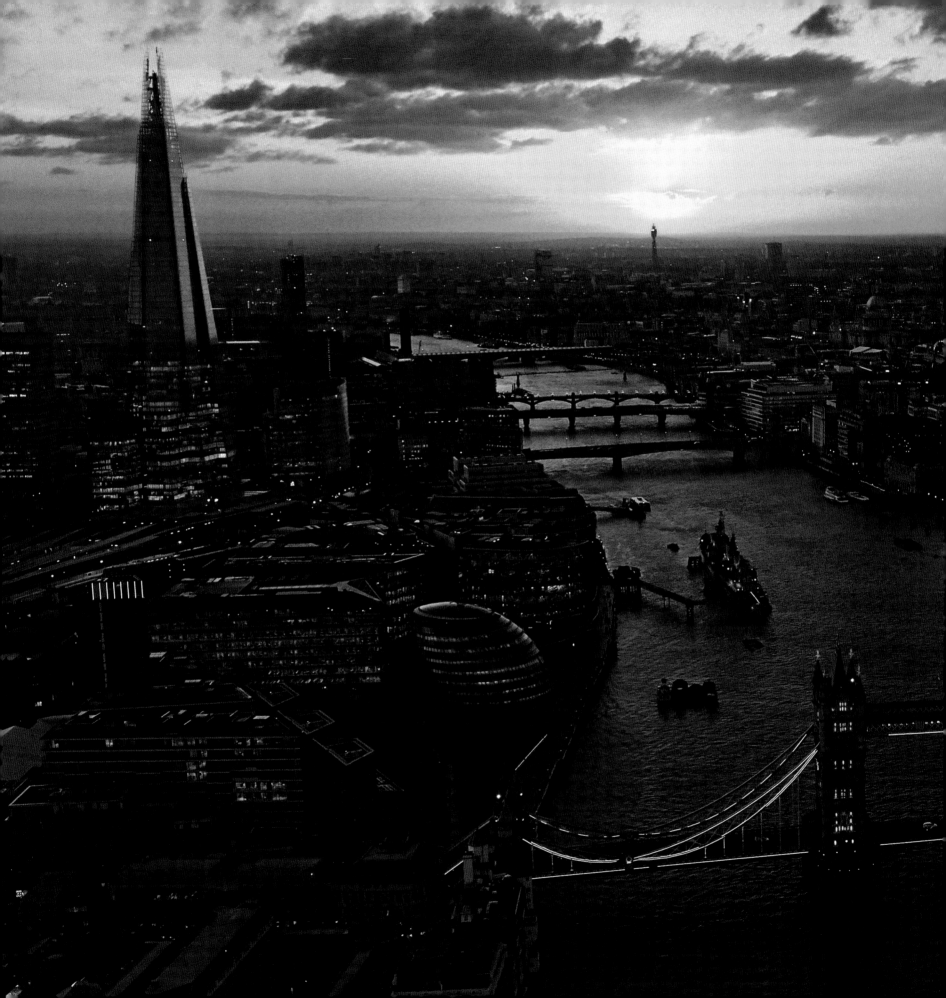